W9-BSO-432

Anasazi and Pueblo Painting

This publication was made possible
by generous support
from the Weatherhead Foundation.

ANASAZI AND PUEBLO PAINTING

J. J. Brody

A School of American Research Book

University of New Mexico Press

Albuquerque

Library of Congress Cataloging-in-Publication Data
Brody, J. J.
 Anasazi and Pueblo painting / J. J. Brody. — 1st ed.
 p. cm.
 "A School of American Research book."
 Includes bibliographical references and index.
 ISBN 0–8263–1236–5
 1. Pueblo Indians—Painting. 2. Pueblo Indians—Art. I. Title.
E99.P9B732 1991
750'.89'974—dc20 90–23678
 CIP

© 1991 by the School of American Research. All rights reserved.

First Edition

CONTENTS

FIGURES

COLOR PLATES

PREFACE

The Library of Congress classifies books—or stigmatizes them—so that they may be shelved correctly, like with like, in all of our libraries. While most of my previously published titles are clearly identified as art histories, all are classified by the Library as "anthropology." I dare not guess why that should be the case, but I find it suspicious that the misclassified volumes are all concerned with American Indian art. This book also is an art history dealing with American Indian art. Experience forces me to make an open request to the Library of Congress: Please classify this art history *as* art history, for it is both erroneous and embarrassing to the author to call it anthropology. (See Chapter 1 for more on this subject.)

I am an art historian, I do art history, and I come to American Indian art through art and not the other way around. The first Indian art that I recall, I saw in about 1947 through the eyes of the Santa Fe artist Agnes Sims. The event was an exhibition at the Brooklyn Museum, near where I grew up, that included rubbings and paintings Sims had made of Pueblo IV rock art of the Galisteo Basin. I was a teenage art student then with no knowledge of the Southwest and no particular interest in American Indian people, but I was suddenly made aware of an art that appealed greatly to me across barriers of time, space, and ignorance. I want to make clear that rock art and Agnes Sims started me on a road that led to art history, not to anthropology, for the people who made and originally used the art filtered into my consciousness slowly.

I avoided serious dealings with rock art for most of my professional life because I found it impossible to do

history when I had no sure grasp of either temporal sequence or pictorial structure. When I started this book in 1980 (actually, it was begun as an aborted thesis in 1957), it was to be about Anasazi painting, which, by the rules I then followed, meant pictures on framed, two-dimensional plane surfaces—Pueblo IV murals and little else. I wanted to put the murals in social and historical contexts and therefore paid some attention to other media and times, but, on the whole, the first draft was not very satisfying and for several good reasons it was left to marinate for a long while.

Two unrelated events led to some sharp changes in my thinking that helped to release the book. The first was a seminar in Anasazi painting that I taught at the University of New Mexico in 1982, and the second was a renewed interest in rock art. The students in my seminar forced upon me the realization that traditional Euro-American art classifications were not valid for the study of Anasazi art. Later, I came to understand that they did not work very well either for many other traditions, including modern and postmodern Euro-American art. The Library of Congress is not the only institution misdirected by obsolete taxonomies; art historians also need new rules for classification.

I needed a new format for classification, and that began to evolve about 1983—stimulated by a therapeutic back-packing excursion that took Jean Brody and me to rock-art sites in the Four Corners. Sore muscles and no plumbing led to enlightenment: rock art, kiva murals, pottery painting, architecture, sculpture—all visual expressive arts of the Anasazi and their Pueblo Indian descendants were parts of a single, uniform,

unifying tradition. No one unit of that mosaic can be analyzed without serious examination of the others, for they cross-reference each other as though they were all part of a single classification.

That is why this book took so long to write, and why it is a history of painting that encompasses many media.

Many people contributed to this work, and it is appropriate to acknowledge all of them by name. Public thanks is the least one can offer, but there are problems, not the least of which is knowing where to begin. It seems inevitable also that someone will be left out through inadvertence or simple carelessness. I've done it before, and I apologize beforehand if I've done it again.

I doubt that I would have begun this book without the support of Douglas Schwartz, president of the School of American Research, and a National Endowment for the Humanities Fellowship in the School's resident scholar program. And I know it would never have been finished without the patient urging of Jane Kepp, publications director at the School, and the assistance of editor Sarah Nestor. I am also grateful to photographer Rod Hook, who labored mightily on behalf of this volume. The other 1980 resident scholars, especially Barbara Tedlock, provided intellectual stimulation on an almost daily basis, and I am indebted to all of them, including Whiskey, a dog. Many others at the School and its Indian Art Research Center must be thanked, among them David Noble, the late Kate Peck Kent, Bud Whiteford, Barbara Stanislawski, Michael Hering, Lynn Brittner, Deborah Flynn, Katrina Lasko, and Pat Waganaar.

My field work was eased by the uncommon generosity of many people affiliated with the Rock Art Field School of the Archaeological Society of New Mexico. I must single out Mari King and Dudley King, Nan Bain and the late Colonel James Bain, Helen Crotty and Jay Crotty, Jane Kolber, and John Davis among many who freely shared information, speculation, goodwill, and guidance of every sort. A special word of thanks is due Dudley King for use of his photographs; I am only sorry we were not able to use more of them. Other field assistance and information, photographs, and ideas about rock art, murals, and the Anasazi world in general were generously shared by Connie Silver, Patricia McAnany, Mike Marshall, Henry Walt, Barbara Mauldin, Donald Weaver, Patricia Gilman, Charles Gallencamp, Nancy Hammack, and Larry Hammack. Melinda Fay gave most generously of her time and energy in searching through thousands of photographs for just the right ones.

This project started a long time ago, and while the begats of genesis are probably out of order, from the distant past I am indebted to Agnes Sims for her art; Lez Haas, who first showed me the rock art of Pueblo Blanco; John Sinclair, who shared his passion for the Kuaua murals with students whom he did not know; and most especially, Gordon Vivian, who in 1956 showed us the brilliant, battered fragments of painted wood from Chetro Ketl and then gave me slides of the Atsinna murals in the belief that I might someday use them. That day has arrived.

I wish to thank the museums and other institutions that opened their collections to me for this study, and the many museum professionals for their help and understanding as I tried to explain to myself as much as to them just what it was I wanted to see and why. In alphabetical order, I thank the American Museum of Natural History and Barbara Conklin, Anibale Rodriguez, and David Hurst Thomas; the Brooklyn Museum and Diana Fane; the Heard Museum and Robert Breunig; the Maxwell Museum of Anthropology, University of New Mexico, and Garth Bawden, Janet Fragua Hevey, Kriztina Kosse, Natalie Pattison, Marian Rodee, and Kim Trinkaus; the Museum of the American Indian and Roland Force, James Smith, and Eulie Wierdsma; the Museum of New Mexico and Nancy Fox, Laura Holt, Edmund Ladd, Curtis Schaafsma, Louise Stiver, and Rosemary Talley at the Laboratory of Anthropology, Arthur Olivas and Richard Rudisill at Photo Archives, Charles Bennett of the History Division, and Nathan Stone at Coronado State Monument; the Museum of Northern Arizona and Carol Burke, Linda Eaton, Laurie Webster, and David Wilcox; the National Park Service and Dave Brugge, Dabney Ford, Joan Mathien, Kim Mclean, and Tom Windes; the Peabody Museum of American Archaeology and Ethnology, Harvard University, and Melissa Banta, Mike Geselowitz, Barbara Isaac, Carl Lamberg-Karlovsky, Lea McChesney, and Ed Wade; the Southwest Museum and Susan Kenagy and Steven LeBlanc; the University Museum, University of Pennsylvania, and Rebecca Allen, Pamela Hearne, and Mary Elizabeth King.

And finally, of course, Jean Brody for everything.

ONE ▮ Creating an Art History

This is a history of painting as it was practiced by those people of the American Southwest whom we call the Anasazi. It is also, and necessarily, a partial history of that art as made by their Pueblo Indian descendants before about A.D. 1900. Although Anasazi painting began more than fifteen hundred years ago, very few written descriptions of it predate the late nineteenth century. Therefore, much of this history is based on information derived from archaeology and on the interpretations that modern people give to ancient objects. The fact that many of the paintings are fragmentary and were preserved by chance rather than because they were highly valued further complicates the story.

It is also a history that could hardly have been written before the second half of our century, for it is as much about concepts as it is about things—about ideas as it is about art. Anasazi and Pueblo painting, like most art that we keep in our art museums, was transformed into art by a process of reclassification, after first having been something else. That particular reclassification process is a twentieth-century phenomenon and our understanding of the art *as* art requires us to understand a contemporary metamorphosis (Maquet 1971:4). And yet the art was surely made within the context of the Anasazi and Pueblo world; and its making, the pattern and sequence of its forms and images, is a product of that alien environment. Thus, as with any history, to study it properly we are required to know both the past and the present, ourselves, and the alien "others."

The novel character of Anasazi and Pueblo painting extends beyond its use of unfamiliar conventions to depict strange things and beings. Much of it is conceptually alien to us as well. Except for decorated pottery, most Pueblo paintings made before 1900 were created as components of some ritual or ceremonial activity (Fig. 1). Existing paintings are often merely the tangible and static survivals of some dynamic event which combined ephemeral arts such as song, dance, music, and speech with more permanent ones including architecture, sculpture, costume, and mural paintings. The history of this art often refers only to one small part of a much greater and more complex whole.

In that one part there is enormous variation in form and media. Paintings were made on portable objects, including basketry, pottery, and stone containers; on the wooden slats of altars and on cloth altar screens; on three-dimensional wooden and stone carvings; on skins, textiles, costumes, human bodies, shields, and dozens of different kinds of ritual and ceremonial paraphernalia and regalia (Fig. 2, Plates 1, 2). They were made indoors on surfaces such as the walls of rooms, on room floors, and perhaps on ceilings. They were made outdoors on stone outcrops, in caves, and within the overhangs of rock shelters (Plate 3). Pictures that were not painted but made by being engraved, pecked, scraped, or otherwise drawn by mechanical means on rock surfaces share so many attributes with painted images that they must be analyzed as though they were the same thing.

Shared attributes, both conceptual and physical, support the argument that much of this great variety can be categorized as a single class of thing. On the conceptual level many paintings created as part of a complex ac-

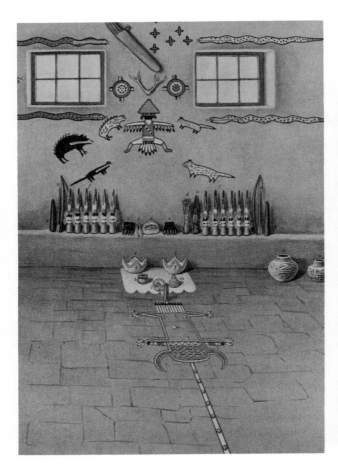

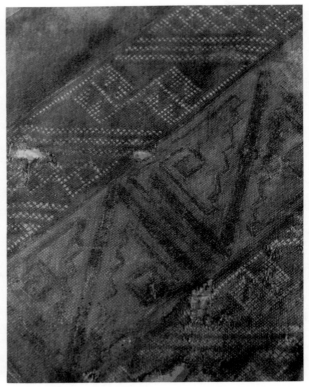

Figure 1. Sword Swallower Fraternity Room, Zuni Pueblo, late nineteenth century. Pueblo ritual art often combines many media in ephemeral constructions. Here are dry paintings on the floor; wall paintings; sculptures on the floor and attached to the wall; pottery; and complex three-dimensional objects made of feathers, corn, and many other materials. (After Stevenson 1904:Plate 108; Smithsonian Institution, no. 2359-C-2.)

Figure 2. Cotton textile from Painted Cave, northeastern Arizona, thirteenth century. This detail is of a woven blanket painted in an overall fourfold pattern that rotates around a square center space. The composition as well as motif details are typical of decorative patterns in all media placed on domestic and utilitarian objects in all Anasazi eras. Width of entire textile is 52 inches. (Amerind Foundation, cat. no. PC39-36.)

tivity had as their primary purpose some result that was artistically inconsequential. Often, paintings were conceived of as impermanent, and the making of a picture or its ritual or ceremonial utilization was of greater importance and value than the thing itself.

Even when the makers and users treated paintings as though they were as ephemeral as sound or motion, it is nonetheless true that these were tangible objects and those that survive share sets of visual and physical attributes that define a pictorial tradition. These attributes cut across media, time, space, and alien cultural, social, and value systems. Responses to them are both sensory and intellectual, and the paintings still have the power to stimulate the imagination of viewers. Their physical character describes an artistic system that is discrete and self-evident. Its rules can be deduced and its history re-created.

That re-creation requires analysis of the ways by which the artists consciously organized the elements of their art—lines, shapes, colors, textures, images—on surfaces that could be two- or three-dimensional, smooth or textured, bounded or unbounded, large or small. We can perceive illusions of interactions between and among these visual elements which create, among other effects, three-dimensional spaces on discrete two-dimensional surfaces, the integration of natural forms with man-made ones, and a sense of pictorial narration. Familiar and unfamiliar organisms and objects appear to inhabit these imaginary universes and, to the extent that illusions are patterned according to systematic and consistent mental schemes, we can be sure that we are dealing with artistic traditions that can be made comprehensible. In the virtual absence of documentation and faced by alien contexts, the threads of the art history must be teased out of the fabric of the art.

The painting traditions of the Anasazi were complex in both form and concept. That complexity can be made comprehensible by examining the utilitarian contexts within which paintings were made and of which they were a part, for those contexts provided the conceptual frameworks for the art. Artistic decisions concerning the selection of media and materials, forms, techniques, and subjects often were made in response to particular social, cultural, and historical circumstances that were otherwise not important to the picture-making craft. The Anasazi artistic system will be made more comprehensible to the degree that its conceptual framework is understood. While understand-

ing those contexts will not by itself explain the visual system and its history, sensitivity to the mechanisms of interaction between visual and social systems is essential if we are to have any sense of the history of the art.

Some parts of the Anasazi artistic system may seem less exotic than others to modern and alien viewers because of the use of more familiar forms, techniques, subjects, or artistic conventions. For example, the kiva murals made from the fourteenth to the seventeenth centuries are similar in many respects to wall paintings done elsewhere by other people in other times and which had been made known previously to modern audiences. Their painted illusionistic representations on two-dimensional plane surfaces provides yet another link to familiar artistic modes. This combination of visual familiarity and an interesting pictorial complexity makes them more easily analyzed, appreciable, and incorporable into our own artistic system. Even so, we cannot assume that the traits which make them familiar to us are evidence for any kind of historical or contextual parallelism.

A fifteenth-century kiva mural, when reproduced in the mid-twentieth century on the wall of a dining car of a transcontinental railroad train, is historically distinct from one that serves both as a backdrop for a ritual performance and as a window into a supernatural universe. The pictures may be almost identical, but they serve different purposes that have evolved in different ways, and their interactions with respect to the creation of other works of art are also entirely different. Even if they now look as identical as clones, each picture achieved its identity by following a different historical route. Each belongs to different artistic, social, and cultural contexts. The past has become part of an alien present, and it is the work of the historian to interpret the fact of the two pictures and the evident interactions of the two histories.

What follows is a brief discussion of how, when, and why those two histories first began to interact.

Discovery, Collection, Classification

The oldest written records that we have of the Pueblo people are those made by the Spanish explorers of the sixteenth century; their Anasazi ancestors do not enter recorded history until considerably later. In 1540, within two decades of the conquest of Mexico, a Spanish exploration force under the leadership of Francisco Vásquez de Coronado marched northward from Mex-

ico into the Rio Grande Valley; the chroniclers of that expedition wrote the first substantial eyewitness accounts of the Pueblo Indians. During the next half-century other Spanish exploring parties entered Pueblo territory, each adding detail to the slowly growing documentary history of the Pueblo people.

The most detailed chronicle of Coronado's expedition, that by Pedro de Casteñada, makes no mention of Anasazi or Pueblo paintings that might have been seen by the Spanish in 1540 and 1541. Other contemporary sources document the practice of the art at that time, and Coronado himself tells of commissioning an artist from the pueblo of Zuni to paint pictures of local animals for transmission to Spain. He noted that other artists there did better work (Smith 1952:78). Other sixteenth- and early seventeenth-century accounts reported that Pueblo people often plastered and sometimes painted elaborate pictures on the interior and exterior walls of their buildings (Smith 1952:73–75). They also noted that Pueblo people painted textiles, including shirts, shawls, and other garments (Dutton 1963:8, 9; Smith 1952:290); masks (Hammond and Rey 1929:79); skins that may have been used to send messages (Hodge 1937:97); and pottery.

Later mention of Pueblo paintings are scarcely more descriptive until about the middle of the nineteenth century, a period that also provides the first useful accounts of prehistoric art of the region. At that time, following American occupation of the Southwest, a spate of official reports concerning the newly acquired territory were published. Among the first of these was the journal of Lt. James H. Simpson, an army topographic engineer who saw wall paintings at Jemez Pueblo in 1849. Simpson's discussion of these paintings was supplemented by drawings made by another eyewitness, Richard H. Kern, who worked for Simpson as an illustrator. In that same journal, the two men also described and illustrated Anasazi painted pottery and rock art. Between them, Simpson and Kern provided the first reliable and detailed descriptions that we have of any Anasazi and Pueblo paintings (Simpson 1852:20–21, Plates 7–11; Weber 1985) (Fig. 3).

Simpson and Kern were also the first to describe at length as well as to illustrate the impressive Anasazi ruins at Chaco Canyon (Simpson 1852:33–47, Plates 20, 22–38, 40, 41). One of these, Pueblo Bonito, had been mentioned a few years earlier in a book by Josiah Gregg, an American businessman active in the Mexican trade. It is not clear that Gregg actually saw Pueblo Bonito or any of the other Anasazi sites that he discussed, but knowledge of the ruins prompted Gregg as well as Simpson a few years later to speculate in print about the prehistory of the Pueblo people of New Mexico and Arizona (Gregg 1844:270, 284). They were not the first to do so.

Although the Anasazi sites discussed by Gregg and Simpson were in the country controlled by often hostile bands of Utes, Navajos, and Apaches, they were also familiar to the sedentary Pueblo and Spanish people of the region. Among Simpson's guides were Pueblo and Navajo men and native New Mexicans of Spanish heritage. All theorized with practiced ease about the meaning of Anasazi ruins relative to the histories of their own people. All called many of the sites by the same Spanish or Navajo names that are used for them today and, presumably, had been in use for many years before 1849 (Simpson 1852:33, 44; Pepper 1920:14).

The Pueblos and Navajos with Simpson assumed that the builders of the ruined towns of Chaco Canyon were ancestors of the Pueblos. Although Simpson thought that was improbable, he did agree with Gregg (correctly, but for the wrong reasons) that the Chaco towns had been occupied during the twelfth century (Gregg 1844:284; Simpson 1852:45–46). Speculations of this sort stimulated scientific and historical investigations, and the Southwest soon became a major testing area for the emerging social science of anthropology and its subdisciplines of archaeology and ethnology.

The initial concern was for information, and the last half of the nineteenth century was a time when individuals with widely varying backgrounds and objectives contributed to the increase of knowledge about the Southwest. Anasazi sites and living Pueblo communities were studied by amateur and professional scholars who collected, organized, analyzed, and disseminated enormous amounts of information.

Military, political, and commercial interests first had to be served. Simpson was on a military campaign when he made his observations, and a few years earlier Lts. William H. Emory and J. W. Abert had each described archaeological sites and Pueblo towns while on separate surveying expeditions during the Mexican War (Emory 1848; Abert 1848). Later military and civilian parties whose primary tasks were to survey for boundaries, railroads, or highways or to map geologic and other natural resources also made observations about the archaeology and the indigenous peoples of the regions they explored.

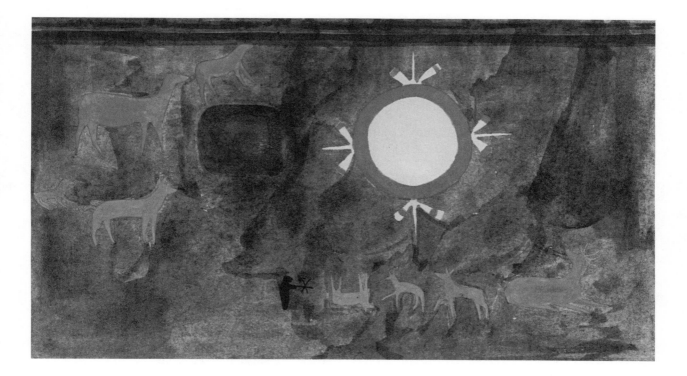

By the 1880s such incidental descriptions had diminished in importance. By then, new institutions as well as unsponsored observers had begun to make detailed studies of southwestern people and places for the sake of science or to satisfy their personal interests (Jackson 1878:431; Bourke 1884; Matthews 1887). Under the leadership of Major John Wesley Powell, the Bureau of Ethnology (later the Bureau of American Ethnology) of the Smithsonian Institution, United States National Museum, embarked on an ambitious anthropological research program (Holmes 1907). In 1879, James Stevenson was sent by the Bureau to make a systematic collection of artifacts from many of the pueblos; later, with his wife Matilda Cox Stevenson, he did ethnographic work for it at the pueblos of Zia and Zuni (Stevenson, J. 1883; Stevenson, M. 1894, 1904). Also in 1879, Powell sent Frank Hamilton Cushing to make collections at Zuni. Cushing stayed there for five years, learned the language, and perhaps was the first outsider to make observations at a pueblo that were more than cursory (Cushing 1967; Powell 1903).

During the 1880s Victor and Cosmo Mindeleff surveyed, described, and analyzed Anasazi and Pueblo

Figure 3. Wall painting from a kiva at Jemez Pueblo, 1849. This watercolor by Richard H. Kern, Jr., is one of five pictures of murals that he saw at two kivas there. Similar paintings were seen there by Alfred Reagan fifty years later. The small scale of the animals, as well as their natural postures and spatial relationships suggesting an illusion of real-world activities, are more like Pueblo III rock art than Pueblo IV mural paintings. (Library, Academy of Natural Sciences, Philadelphia.)

architecture for the Bureau, and in the next decade, J. Walter Fewkes went to work for it as an archaeologist and ethnologist at Hopi. Fewkes later made extensive archaeological surveys in northeastern Arizona and in the San Juan drainage (Fewkes 1897a, 1897b, 1898a, 1898b, 1904, 1908). Other important and pioneering archaeological work in the Southwest was done for the Bureau by W. H. Holmes, Walter Hough, and Frederick Hodge, among others.

Collection, description, analysis, and publication related to Anasazi and Pueblo studies also were accomplished under other public and private sponsorship. In 1880, the newly founded Archaeological Institute of America sponsored Adolph Bandelier's systematic survey of archaeological sites in the Rio Grande Valley, ethnological observations among the Rio Grande pueblos, and pioneer archival studies of related Spanish documents (Bandelier 1890–1892). Meanwhile, beginning in 1881, Alexander Stephen for his own interest spent the last thirteen years of his life as an ethnographer at Hopi (Stephen 1936). Less systematic ethnographic and photodocumentary work was begun about then by Charles Lummis, who became a protégé of Bandelier and amassed a large collection of Pueblo and Navajo craft objects.

Meanwhile, Richard Wetherill and his brothers became the most prominent, but by no means the only, local ranchers and entrepreneurs to explore the Anasazi ruins of the Mesa Verde and other districts of the Four Corners. They excavated and collected intensively, sold much of what they found, and guided researchers and collectors to Anasazi sites. With such aid, for example, Gustav Nordenskiöld of Sweden systematically surveyed the Mesa Verde ruins late in the nineteenth century, published detailed descriptions, and made collections of Anasazi art that were taken to Europe (Nordenskiöld 1893). A few years later, George Pepper, under the private sponsorship of the Hyde Expedition, supervised excavations and collecting at Pueblo Bonito for the American Museum of Natural History in New York (Pepper 1905, 1920).

The Lummis collections went to the Southwest Museum in Pasadena, California, which he founded. Major collections of Hopi archaeological and ethnographic objects were gathered from the 1870s and into the early years of this century by Thomas Keam, a trader at Hopi who befriended Alexander Stephen. Keam sold portions of his collection to the United States National Museum, the Brooklyn Museum, and the University Museum of the University of Pennsylvania in Philadelphia. The bulk of his collection, however, went to the Peabody Museum of Harvard University, which also received other southwestern archaeological and ethnographical collections amassed by the privately sponsored Hemenway Expedition (Wade and McChesney 1980, 1981; Haury 1945a).

Mary Hemenway was a New England philanthropist who supported archaeological explorations in Arizona led by Frank Hamilton Cushing in the 1880s; J. Walter Fewkes had also begun his work at Hopi under Hemenway's sponsorship as well as with the support of both Keam and Stephen (Haury 1945a; Fewkes 1892a, 1892b; Fewkes and Stephen 1892). During the 1890s H. R. Voth, a Mennonite missionary to the Hopi, had studied and published on Hopi ritual and collected ritual objects there, many of which went to the newly created Field Museum in Chicago (Voth 1901; Wright 1979). Meanwhile, the historian H. H. Bancroft was assembling and translating Spanish documents that were pertinent to the history of the Southwest (Bancroft 1889).

Thus, by the end of the nineteenth century, the initial flow of information about southwestern ethnology and archaeology had been assembled and absorbed and a tentative outline of southwestern prehistory was developed. This supported the native view that the Anasazi were indeed ancestors of the modern Pueblos. During the next few decades that outline was expanded as more institutions and the talents of many new, more highly trained researchers were applied to more specialized problems of southwestern prehistory.

Edgar Lee Hewett of the School of American Research and the Museum of New Mexico in Santa Fe and Byron Cummings at the University of Arizona in Tucson stimulated research in their respective regions (Hewett 1930; McGregor 1967:42). Among many others who contributed significantly to an increasingly precise and scientific knowledge of Anasazi prehistory during the period from 1900 to 1920 were Earl Morris, Alfred V. Kidder, Samuel Guernsey, Nels C. Nelson, and Leslie Spier (Morris 1919; Kidder and Guernsey 1919; Kidder 1924; Nelson 1914; Spier 1918; Willey and Sabloff 1980:85–127). In 1927, substantial agreement was reached among specialists about the sequence of cultural stages and the chronology of Anasazi–Pueblo development. This was codified as the Pecos Classification and, though considerably modified and refined since, it remains the basic framework for organizing Pueblo prehistory (Kidder 1927; Cordell 1984:54–56, 100–107) (Fig. 4).

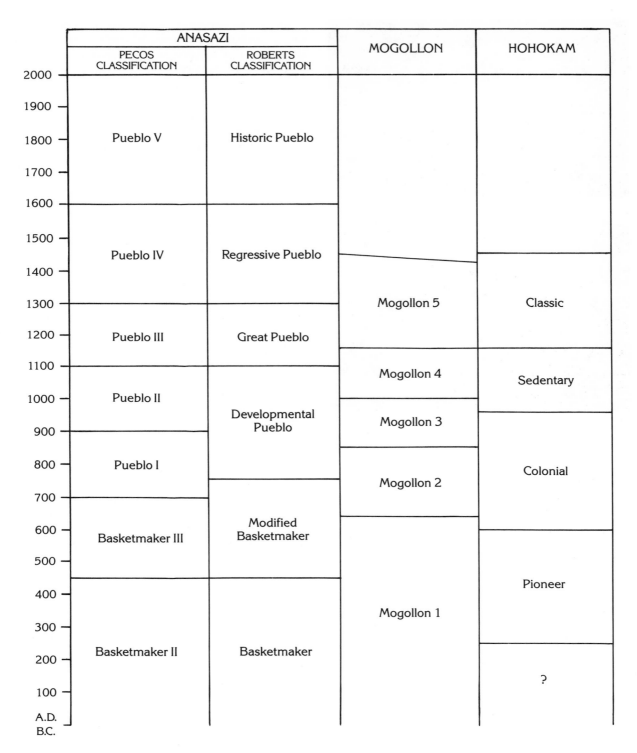

Figure 4. Temporal framework of several major cultural sequences of the American Southwest.

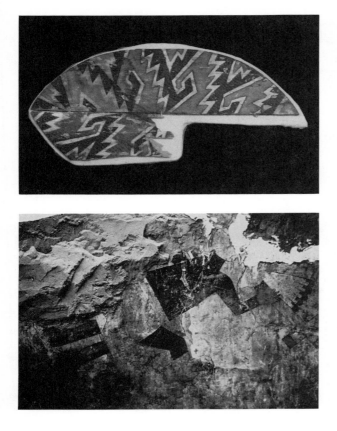

Figure 5. Painted wooden object (fragment), Room 93, Chetro Ketl, Chaco Canyon, northwestern New Mexico, ca. 1100. Both sides are painted with similar patterns in green and dark brown on a white ground. The narrow slats were tied together with sinew and a handle was once attached suggesting a wand or fanlike use. Compare to Anasazi basketry and pottery designs (Plate 6, Figs. 14, 15). (National Park Service and Maxwell Museum of Anthropology, length 10½ inches, photograph by Roderick Hook.)

Figure 6. Wall painting, Kiva 8, Pottery Mound, New Mexico, early fifteenth century. Layer upon layer of fragmentary wall paintings were found in sixteen kivas at this important Pueblo IV site west of the Rio Grande and south of Albuquerque. Humans, animals, deities, and composite beings, such as this human with bird head, talons, and tail, interact in many of these murals. The original is about five feet high. (Maxwell Museum of Anthropology, University of New Mexico, photograph by Dennis Tedlock.)

Few of the prehistorians were concerned about art and art history in any very special way, but all were well aware that their framework depended upon the classification of objects such as painted pottery and architecture that could also be considered as objects of art. The culture history as well as the chronology of the Anasazi as it was organized by Western scholars was inextricably linked to the art history of those ancient people; and to a lesser degree, the re-created early history of the Pueblos likewise was based upon certain of the Pueblo art traditions.

Therefore, the Pecos Classification, as modified by more recent scholarship, serves very well as both a framework and a point of departure for a history of Anasazi and Pueblo painting. Following that framework, the earliest Anasazi paintings can be no more than about fifteen to eighteen hundred years old, dating from Basketmaker II times. However, even earlier paintings and engravings on cliff walls are preserved that are considered to be the work of Archaic ancestors of the Anasazi (Schaafsma 1980) (Plate 3). Thus, the origins of Anasazi art may be several thousand years older than the Basketmaker period.

Fragmentary and occasional whole specimens of paintings on wood, basketry, and textiles have been recovered from archaeological sites of all Anasazi periods, although only a few are as ancient as Basketmaker II (Fig. 5). Relatively simple paintings on the plastered walls of kivas and domestic rooms are known from Pueblo II and Pueblo III sites, many of which have far more elaborate and compelling paintings and engravings on nearby cliff walls and boulders. A different and iconographically far more complex rock-art tradition is characteristic of the Pueblo IV period, coordinate with the appearance in that era of elaborate mural paintings.

Major suites of wall paintings have been recovered from three Pueblo IV sites (Smith 1952; Dutton 1963; Hibben 1975) (Fig. 6). Single pictures and fragments of paintings from many other contemporaneous communities are further evidence that mural painting was a major art form during that period. Many of the mural paintings include within them images of pictures that were done in other media, including textiles that have not been preserved or are otherwise known only from fragments. The bare descriptions of paintings in the Spanish chronicles have been made manifest by the archaeological discoveries of the last century.

Our knowledge of the Pueblo paintings made between about 1600 and 1880 is even less complete than

it is for most prehistoric periods, however. The observations of wall paintings made at Jemez Pueblo by Simpson and Kern in 1849 are the earliest full description that we have of any historic Pueblo painting, and thirty years were to pass before equivalent observations were made at any other pueblo. Few examples of painting were collected before 1880, and almost none are known from the rare Pueblo V sites that have been archaeologically excavated. Until very recently, and with some exceptions, paintings made on pottery were generally considered as a minor, "decorative" art.

Art and Artifact: 1880–1900

After 1880 many Pueblo paintings were described in detail by the Stevensons, Cushing, Stephen, Fewkes, Voth, and others. Drawings and photographs of paintings in all media and in many different forms were published, and some were collected and others reproduced for use in museum exhibitions (Fig. 7). Most were from the western pueblos of Hopi and Zuni, and with the notable exception of painted pottery, virtually all were directly associated with religious ritual. The emphasis given to ritual painting conformed to a major concern of the people who were then collecting and recording Pueblo art. Almost without exception, these investigators were far more interested in ceremonial practices, religious beliefs, and other kinds of social behavior than they were in any of the art objects that were the tangible aspects of the esoteric customs of an exotic people. To the scholars, the primary value of painted objects, whether they were of mundane or ritual utility, was as social artifacts.

The emphasis on ritual painting also conformed to Pueblo attitudes about art. A very high proportion of Pueblo paintings, other than those on pottery, were either ritual objects or had been made to serve some religious or civil ceremonial function. Others, including many painted pots, were so similar to ritual paintings in either form or content as to make distinctions between ritual and nonritual, secular and nonsecular difficult to recognize and perhaps meaningless.

Curiously, the most common nonritual, nonceramic paintings of this era appear to be those made on the interior and exterior walls of Catholic churches at some of the pueblos and which were recorded by photographers and historians whose primary interest was in the architecture rather than in the murals (Prince 1915). Most of the paintings on these buildings use decorative

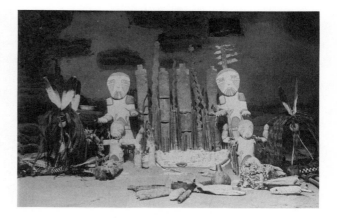

Figure 7. Summer Altar (replica), Mamzrautu (Marau) Society, Oraibi, Hopi, northeastern Arizona, ca. 1900. The original altar of this women's ritual society is very ancient, transported to Oraibi from Awatovi following the destruction of that town in about 1700. The larger carvings are male, and the smaller female. The spruce-wood slats of the original were carved with stone tools and tied together with yucca fiber (Stephen 1936:882). (Field Museum of Natural History, neg. no. 33306.)

motifs seemingly derived from pueblo rather than Catholic religious sources (Fig. 8). Some of the more spectacular images, for example horses and horsemen, appear to be secular illustrations, but in any event, there is little information concerning the symbolic intentions of the artists, and the bulk of paintings that we know which were done before 1900 seems to support the emphasis given to ritual art by the nineteenth-century scholars (Kubler 1972; Marshall and Silver 1983).

Interest in ceremonialism brought many nineteenth- and twentieth-century scholars to Zuni and Hopi in preference to the Rio Grande pueblos because the western communities were far more open to foreign spectators and investigators. Such visitors to Hopi and Zuni were permitted to witness esoteric rituals including dramas and masked dances, to enter kivas during ceremonials, to photograph, to make drawings and otherwise record observations, and to discuss questions of religious beliefs and practices with native participants. By the 1880s few of those activities were permitted to outsiders at Acoma, Laguna, or any of the Rio Grande pueblos. Access to ritual performance rather than the quality or quantity of art explains the

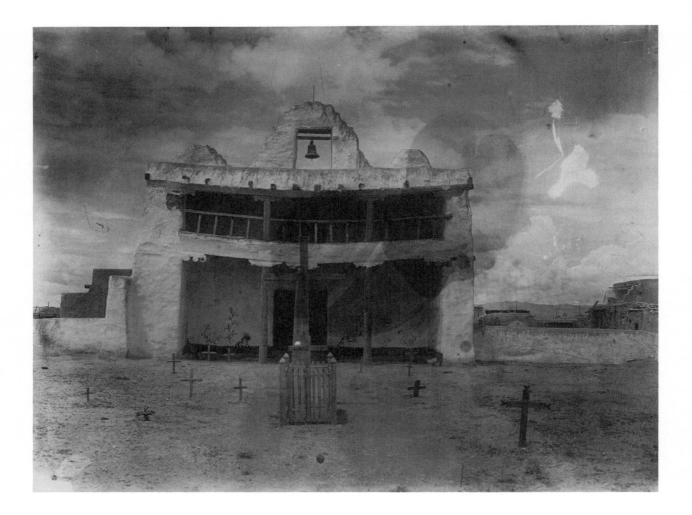

Figure 8. Cochiti Pueblo church, 1899. As in ancient kiva murals, a solidly colored dado acts as a transition zone between the floor and the picture space of the wall. The top of the dado is both ground line and bottom frame; corn grows from the ground line, and all other painted images use it as a fundamental spatial reference. This facade had no paintings in 1881, and other pictures adorned it later (Kessell 1980:Plate 14). (Smithsonian Institution, photo no. 2171A, photograph by Adam Clark Vroman.)

predominance of Hopi and Zuni paintings among the collections made in the late nineteenth century.

In 1881 Captain John G. Bourke had been expelled from a kiva at Santo Domingo Pueblo even though it was not in use at the time, and he had been allowed entry to kivas at nearby Cochiti and at Jemez (Bourke 1884:21–24; *in* Bloom 1938:235, 228). Less than twenty years later, Jemez kivas were also closed to most outsiders; only extraordinary circumstances made them accessible to Albert B. Reagan, an Indian Service Farmer assigned to that pueblo (Reagan 1917). In the early 1890s the Stevensons had forced their way into kivas at Zia Pueblo, where strategies were devised to restrict their access and limit their observations of ceremonial activities (Stevenson 1894:13; Zia consultant 1968). Reagan was perhaps the last non-Indian permit-

ted to witness a masked kachina dance at any of the eastern pueblos, and since 1900 few other foreigners have been allowed to see other esoteric rituals practiced by these pueblos.

Differences in attitude between eastern and western pueblos regarding outsiders is generally explained by the proximity of the Rio Grande pueblos to Spanish and, more recently, Anglo-American communities. The eastern pueblos were exposed earlier and more intensively to acculturative pressures, including religious persecutions by the Spanish clergy, and to other more recent forms of religious proselytization and intolerance. But if zealous Franciscans burned dance masks and destroyed other ritual artifacts at the Rio Grande pueblos, similar events occurred also at Hopi and Zuni; more recently, all have had their share of fundamentalist Protestant sects. It should also be noted that Spanish iconoclasm was inconsistent and that native ritualism was sometimes encouraged at the eastern pueblos by Spanish secular leaders (Schroeder 1972:60; Kessell 1979:110, 157, 182). It may be that other factors were also involved in the development of the strategy of secrecy concerning rituals that characterized the eastern pueblos before 1880 and intensified after that time.

By about 1900 foreign pressures on the western pueblos had increased and they also became less open to outsiders. Everywhere, but especially among eastern pueblos, a by-product of these restrictions was the limitation on the collection of information about painting and other kinds of traditional Pueblo art. The descriptions provided by Bourke (*in* Bloom 1938), Reagan (Reagan 1906, 1917), and Stevenson (Stevenson 1894) nonetheless confirm that the pictorial traditions of the eastern pueblos were generally similar to contemporary ones at Hopi and Zuni that were collected and described in far greater detail by Stephen, Voth, Fewkes, Cushing, and others.

This essential similarity is confirmed further by descriptions of paintings that appear in twentieth-century ethnographies of both eastern and western pueblos, but the comparative value of these is limited since conditions in this century changed both rapidly and radically. Of perhaps greater importance is the fact that the more modern descriptions of Pueblo ritual paintings are generally second-hand and often depend on black-and-white or colored illustrations made from memory by Pueblo informants with variable drawing skills and, perhaps, faulty knowledge (Hill 1982; Goldfrank 1967; Lange 1968; Parsons 1932; Stirling 1942;

White 1932a, 1932b, 1935, 1942, 1962). Not enough is known about eastern pueblo traditional and ritual painting to permit detailed comparison with Hopi and Zuni paintings, and the future prospects for an outsider to obtain fuller documentation are dim.

Despite these limitations, the paintings and pertinent documentation about them which was collected after 1880 are of major importance to reconstructing a general history of Anasazi as well as Pueblo painting. All media, including ephemeral ones such as dry painting, were described, reproduced, or collected by the scholars of the late nineteenth and early twentieth centuries, who also provided a wealth of contextual information about art as practiced at Hopi and Zuni. Thus, these places and that period provide the main interpretive source for all earlier Pueblo paintings, including those of the Anasazi ancestors. Without such information, interpretation of most earlier Pueblo art is hardly possible on even the most elementary level. Without those collections, most of the fragmentary Anasazi paintings that have survived would be incomprehensible (Vivian et al. 1978).

At no time did any of the early investigators conceive of Pueblo painting as comparable to any Euro-American "fine arts" tradition, for, aside from all else, they assumed that all Pueblo arts were made to serve utilitarian purposes and were therefore "craft" or, at best, "minor" arts. Some investigators, such as Fewkes and Holmes, accepted and appreciated an aesthetic component in these useful Pueblo objects (Fewkes 1919; Holmes 1907); however, the combination of utility and an alien aesthetic made it impossible for Pueblo paintings to be classified as a fine art in the nineteenth and early twentieth centuries (Goldwater 1967; Rubin 1984). Parallel attitudes having to do with the classification of social, economic, and political systems as well as of race, added to the fact that much of this utilitarian art was made by women, further restricted any possibility of considering Anasazi or Pueblo art as a fine art.

Under the art classification system which was then employed, a hierarchy of values was defined for different kinds of art. The highest valued term, *fine art,* was generally reserved for nonuseful objects such as paintings and sculptures that attempted to give the illusion of perceived three-dimensional reality. More useful and less representational things such as furniture, ornamental objects, textiles, and so forth were classified among the less valued "minor," "applied," "craft," or "decorative" arts.

Within the fine arts, an old ranking system persisted into the twentieth century that valued painting more highly than sculpture, possibly because it required greater illusionistic skills. As well, pictures that were expressive of high ethical ideals were placed on a higher plane than others. By the 1880s that system was changing, and the Impressionists were not the first group of artists deliberately to select ethically neutral or negative kinds of subject matter for their paintings in conscious revolt against the established order. Simultaneously, the place of the useful minor arts in the hierarchy was under attack in the industrial countries by handicraft movements such as the arts-and-crafts movement led by William Morris in England (Kubler 1962:14–15; Ackerman 1963). But the system changed slowly, and useful objects had no place in fine-arts museums until the twentieth century; even then they had (and still have) unequal status. Rank ordering of pictures by subject class continued for decades after 1880 and, along with other isolated aspects of an obsolete classification system, persists in some fine-arts institutions to the present day.

Although some of the scholars and enthusiasts working among the Pueblos in the late nineteenth and early twentieth centuries, such as Charles Lummis and George Wharton James, were active in arts-and-crafts movements, most were not at all involved with the reexamination of the art classification system that characterized the contemporary artistic avant-garde. They were students of the nascent social sciences, of history, or of religion and had other classification problems to worry over. Among those problems that were relevant to the specialized study of Pueblo painting were attempts to classify human sociocultural systems according to models based on biological evolutionary theory modified by reconstructions of European culture history (Morgan 1877; Spencer 1885). One popular scheme assumed that social evolution was progressive and hierarchical and that it occurred in a succession of stages that led from savagery through barbarism to civilization. An analyst working within the constraints of such a mental construct could not possibly classify Pueblo painting as a fine art because the fine arts were, by moral and ethical definition, the products of civilizations, and the Pueblos were not classified by them as civilized.

Few, if any, nineteenth- and early twentieth-century scholars attempted to place Pueblo or Anasazi paintings or information about them in art museums. It would have been anachronistic for them to have done so. Art museums existed in order to provide contexts for useless objects that were exemplary of nineteenth-century Euro-American civilization and its ethical ideals. Pueblo paintings that were removed from the pueblos were placed in natural history or anthropology museums. They existed in a category apart from the fine arts and belonged in institutions that were devoted to the study of the natural universe and of human behavior.

Toward Art: A Twentieth-Century Transformation

A modern history of Anasazi painting could be said to begin with Paul Cezanne and his contradictory desires to paint pictures such as the illusionary ones seen in the museums of his day that were also "true" to the two-dimensional surface of the picture plane. We may doubt that Cezanne had any revolutionary objectives in mind, but before his pictures could be comfortably housed in art museums it was necessary to change radically the taxonomic system by which art was classified. Before Cezanne, it was not possible for Anasazi or Pueblo painting to be classified as art in the Western art classification system. However, when his ideas about the picture plane were first accepted and then logically extended, the whole conceptual system of Western art was inverted. As structural anthropologists might put it, the code underwent a transformation.

Before Cezanne, for about five hundred years in the life of art in the Western world, from the fifteenth through the nineteenth centuries, the operative principle of painting was to create illusions of three-dimensional reality on two-dimensional plane surfaces. That concept of representational illusionism became so deeply ingrained as virtually to have disappeared from consciousness. The goals of painting came to be defined by the ways in which paint was applied to a surface in order to achieve illusionistic objectives and, also, by relative values that were given to the various subjects represented by these illusions.

One consequence of the illusionistic concept was the general rule that three-dimensional objects—real things in real space—could not be both painted and classified as art. The substitution of real-world dimensionality for the two-dimensional picture surface was unacceptable. The impasto used by Frans Hals was a daring test of this unstated "rule of dimensionality" that

barely passed. The thicker paint used by Vincent Van Gogh went beyond the rule, and Van Gogh's paintings were not acceptable as "art" until after the triumph of the modernist revolution. Painting had become a highly specialized artistic domain with arcane rules for making a two-dimensional surface appear to be a window looking onto the deep and atmospheric space of a "real" world. Those rules regarding perspective, atmospheric illusions, lighting, and so forth also affected other artistic domains such as sculpture and architecture; their purpose was to make difficult the achievement of some highly esoteric, unstated, but universally understood pictorial goals.

Cezanne was a kind of fundamentalist who had no desire to challenge the operative principle of representational painting. Rather, he insisted that nature was the proper model for representationalists to use and that the task of the artist was to analyze, understand, and represent the fundamental geometry of the observed world while respecting the integrity of the real-world, two-dimensional painting surface. The deep spatial illusions of traditional Western painting were inappropriate for him, and he found it necessary instead to emphasize the two-dimensional picture plane, the painting surface, by painting illusions on it of shallow real-world space. Inventing pictorial devices to maintain the integrity of the picture plane served Cezanne's representational and philosophical goals, which were not vastly different from those of the past. However, within a few years of his death in 1906, traditional concepts of representationalism had been shattered by other artists who carried some of his ideas to some of their logical conclusions.

The fundamentalist approach to the geometry of nature and philosophical respect given to the picture plane soon led to the incorporation of real objects within the surface of a painting as well as to abstractions that appeared not to be representational at all. Pictorial space could be made so shallow that painted images as well as real objects sometimes seemed to project outward. These concepts of flat pictorial space and the fusion of painting with low-relief sculpture were more than alien to the rules of post-Renaissance illusionistic art; they were subversive of them. If neither the illusion of real space nor the representation of real things were the objectives to be achieved by applying colors to a two-dimensional surface, what then was the art of painting? The answer was not long in coming. If real things could be incorporated into paintings,

then paint could be applied to real things; if paintings could incorporate real-world dimensionality within themselves, then the art of painting became, simply, the act of applying color to a surface. Rather than being illusionary images of things, paintings in what we now call the modernist era came to represent nothing more nor less than themselves. The special nature of the art had undergone a transformation so profound that, hardly a half-century after Cezanne's death, postmodern painting had become indistinguishable from sculpture. What does this change in the morphology of Western art have to do with Anasazi and Pueblo painting? Nothing and everything.

This history of an ancient and alien painting tradition, which begins as though it were committed to an anachronistic taxonomy, develops as a postmodern story. It is about Anasazi and Pueblo painting in all of its variety, necessarily perceived and classified by the international rules of the late twentieth century. But those rules are unclear, inconsistent, and still changing dynamically. The habits of half a millennium are not easily broken, and we still generally talk of modern Western European painting as though it were a kind of art categorically distinctive from other arts, such as sculpture. Yet we know that it is not a separate category, and it has not been since the time of the Cubists before World War I.

The vast majority of Anasazi and traditional Pueblo paintings could not have been classified as art in our system prior to the conceptual revolution that followed on the death of Cezanne. Except for one brief period from about the fourteenth through the seventeenth centuries, representationalism on two-dimensional plane surfaces was never an important operative principle of Anasazi painting, and ritual wall paintings of that period are virtually the only Anasazi and Pueblo pictures made before 1900 that are directly comparable to traditional Western European paintings. But the long and complex history of ancient Pueblo painting can only be perceived and appreciated by reclassifying all other Anasazi pictorial forms as though they fit our fine-arts classification system. Quite clearly and paradoxically, that process of reclassification places Anasazi painting squarely in the modern and postmodern taxonomic box. Thus, the art history of ancient Pueblo painting must also be about modern Western painting, for that is its new context.

When the outlines of the new taxonomy in art began to emerge at about the beginning of the twentieth

century, African and Oceanic tribal arts, European folk arts, and other exotic forms associated with anthropology came to be used as models for new fine-art productions by some of the urban European artists caught up in the profound stylistic and intellectual revolution of modernism (Goldwater 1967; Hofmann 1972; Rubin 1984).

A critical aspect of the incorporation of these exotic art forms as models for fine-arts production was the widely held belief that at some deep social, cultural, and psychic levels the so-called primitive arts were products of a nonrational "primitive mind" (Gordon 1984:369–71). As such, they were thought of as, perhaps, more the products of nature than of culture; they could be made useful to fine-arts production, but they could not themselves be categorized as fine arts. In that regard, the primitivising movements in modern art are heirs to a long tradition in Western thought which, among its less positive aspects, makes rational analysis of many alien art systems virtually impossible for, by definition, it assumes those systems to be irrational.

It is true that many of the twentieth-century art movements that consciously incorporated primitivism into their systems did so to support different and sometimes mutually contradictory philosophies. But whatever the philosophy, in every case the social alienation that is a fact of life for the professional fine-arts communities of modern, urban societies seems central to that incorporation. These exotic arts were brought into new contexts and ultimately reclassified because they were thought of as the products of integrated societies that were the polar opposites of modern urban culture. Their formal attributes were imbued with various sets of imagined psychic and social meanings that had everything to do with their new contexts and perhaps little or nothing to do with the realities that originally had informed their creation. To the degree that the discipline of anthropology contributed to these conceptions and misconceptions, its art-classification procedures and taxonomic principles acted upon this artistic revolution.

By about 1912 all traditional artistic categories were brought into question when the keystone of the art-classification system, representational illusionism, was discarded by many artists, critics, and patrons. From then on, the hierarchical values of the old system no longer pertained. With the rejection of illusionism, the characteristics of media, dimensionality, and utility were no longer relevant as attributes for making qualitative judgments about art. Real objects as well as their representations could freely be incorporated into paintings, and utilitarian objects could be transformed into art by acts of imagination. Even former constants of the fine arts such as craftsmanship, aesthetics, timelessness, and universality were now provisional. Ironically, the consequence of Cezanne's impact was that art itself, with man as its measure, rather than the natural universe could become the proper subject for art. Ultimately, an uneasy kind of pragmatic relativism became the keystone of the new taxonomy (Hofmann 1972).

Art museums flourished as never before, expanding physically and philosophically in order to absorb the old and new objects that now had become classified as art. The first museum exhibit of any tribal art *as* art took place in 1912, and from then on "the objects of 'primitive' art were aesthetically domesticated" (Hofmann 1972:247). By about 1940, Anasazi and traditional Pueblo painting also had become incorporated into some art museum collections as another "art by metamorphosis" (Maquet 1971:4; Graburn 1976b:3; Douglas and d'Harnoncourt 1941). Enough time had passed since the beginning of the artistic revolution for retrospection, and some acceptance was now given to the notion that the meanings applied to metamorphosed art in its new contexts were independent of any intellectual or social factors that had led to the production of the art in the first place.

The deliberate creation of art by discovering and transforming existing objects rather than by making new ones had been done by Euro-American modern artists at least since 1912, when Marcel Duchamp exhibited his first found-art "ready-made" object. However, until 1937, when the art historian Robert Goldwater analyzed the conceptual interactions between "primitive" and modern art, discussions of the processes by which metamorphic art was created tended to be in poetic rather than analytic idioms (Goldwater 1967). Though he did not stress the point, Goldwater did observe that the intention of new meanings for old objects was a fundamental, and at times the only, step in transforming them into art. Nonetheless, the traditional study of art focused on ideas about style, and most especially on the assumption that art styles were closed systems with discrete historical and cultural boundaries. If the boundaries of an art style in time, space, or culture were immutable, then metamorphosed art objects were theoretical impossibilities. They had no

place in the history of art until or unless new modes of art-historical thought and analysis were devised (Schapiro 1953; Ackerman 1963).

A conceptual system for dealing with the problem of stylistic anachronism was articulated by George Kubler (Kubler 1962). His analysis is traditional in accepting art objects as elements of particular temporal, spatial, and social sequences that may be called "historical styles." However, it rejects the traditional biomorphic assumption that styles are born, flourish, and die within particular historical environments as though subject to Darwinian laws of biological evolution. Instead, Kubler insists that all style sequences are open-ended and that all man-made objects, though formed as integral parts of one sequence, have the potential for being inserted as integral units within any other sequence. Style is thus perceived as a function of the human imagination rather than as the by-product of some metaphysical or social Darwinian "historic force."

Kubler's theories make it possible to analyze all attributes of a style including those invented to fit an alien sequence. All objects that are the components of a style may be studied individually in all of their temporal, spatial, and social manifestations regardless of sequence, for they are potentially independent of the history that gave them form. An artistic tradition such as Anasazi painting can (and should) be studied as an integrated system of made objects, each one the result of a multitude of choices which conform to a pattern that has parallels throughout the larger sociocultural systems within which it was made. When individual Anasazi paintings become incorporated into other traditions they can (and should) be studied as metamorphosed objects, each one chosen rather than made, and conforming to selective criteria that are patterned to serve an entirely different sociocultural system.

These concepts stress the appearance of objects rather than their purposes, their forms rather than their meanings, and are compatible with iconographic theories formulated by other contemporary art historians (Panofsky 1955; Gombrich 1960). At least as important, they are a repudiation of the notion that art can be the product of an irrational, "primitive mind." Art is conceived of as an intellectually expressive activity wherein systematic, rational decisions are made by individual artists, each guided by his or her own cultural and social history. The essential rationality of art production as well as the idea that objects and the meanings given to them should be studied as independent variables are concepts stressed also by contemporary archaeologists and ethnologists whose research or theoretical interests occasionally intersect with those of art historians (Linton 1933, 1941; Redfield 1971; Binford 1971).

By the end of the nineteenth century many anthropologists had found that theories of cultural evolution and related speculations about race and primitivism were inadequate for the study of human social and cultural behavior. When applied to art and other material forms of culture, such theories focused on questions of origin and psychic motivation that could not be answered and led to fruitless speculations rather than the development of testable hypotheses. The parallel to biomorphic art-historical assumptions concerning style was also close (Fraser 1971:20–24; Goldwater 1973a; Gerbrands 1973:60–61).

Other anthropological studies of art concentrated on technological details. While descriptively valuable, their mechanistic emphasis on the craft of art production and utilitarian functionalism inhibited social analysis, the real business of anthropology, by factoring out the aesthetic and expressive functions of art (Mason 1904). However, although (or perhaps because) these early studies proved to be theoretically sterile, there was for a long time little impetus within anthropology toward creating more fruitful approaches to the study of artistic behavior. Anthropologists concentrated on inventing theoretical constructs and analytical techniques for understanding social institutions rather than their material products and manifestations.

Nonetheless, some important anthropological contributions were made to the study of art. In 1927, Franz Boas published a comprehensive analysis of art in "primitive" societies (Boas 1955). One student of his, Ruth Bunzel, studied Pueblo potters at Zuni during 1924 and 1925, gaining new insights into the Zuni aesthetic system and the creative interactions which occurred between individual artists and that system (Bunzel 1929). Other innovative analyses were performed in other parts of the world, but generally as isolated activities, for the systematic study of art by anthropologists required the conviction that aesthetic phenomena were universal as well as culturally and socially meaningful, and could be subject to cross-cultural analysis (Maquet 1986; O'Neale 1932). These beliefs were by no means generally accepted until after the end of World War II (Maquet 1971:1–14).

In the postwar period, a major impetus for system-

atic studies of art came from the notion of structural anthropology, a "series of interconnecting... disciplines and attitudes" that were based on linguistics and focused on "a total field of communication" (Poole 1973:10, 13). In structural analysis, art objects are considered as parts of a communication system; they are among the raw materials of symbol systems which may be analyzed to decode meanings that are below the level of direct expression (Douglas 1966; Leach 1973; Levi-Strauss 1973, 1982).

Song, dance, ritual, painting, kinship structure, and food habits—virtually all categorical social expressions—may be perceived as phenomena occurring within a larger unity. As such, they are organized—structured—according to parallel principles of classification. One kind of activity may be understood in terms of another, and the codes of the classification system are always binary: they occur in paired oppositions that are subject to inversion. In fact, transformation of meaning by inversion, as for example by punning, is considered to be an essential element of change and of creativity. The expectation of inversion makes the position or context of a coded message all-important, for "the principle underlying a classification can never be postulated in advance. It can only be discovered... by experience" (Levi-Strauss 1966:58).

Although structuralism has had little direct effect on the study of Anasazi and Pueblo painting, its indirect effects are potentially great. It provides a unified theory as well as a methodology for analyzing any form of art as an integrated and integrative social activity (including objects that are out of their original created sequence—metamorphosed art) (Heib 1972; Ortiz 1972a, 1973). As well, structuralism has prompted criticism and debate within anthropology and has stimulated alternative methodological and theoretical means for the study of art and its products (Geertz 1973; Hatcher 1974; Maquet 1986; Turner 1967). It has helped bring the study of art by anthropologists back toward the mainstream of anthropological thought while providing art historians with novel theoretical tools (Leach 1983; Graburn 1976a).

Until recent years, neither discipline—neither art history nor anthropology—had the theoretical, methodological, or classificatory bases to allow for much interpretive interest in Anasazi painting. The major kiva mural sites of the Pueblo IV period were not discovered until the 1930s, and before then virtually the only known Anasazi paintings were on three-dimensional utilitarian objects that could hardly yet be classified as art. While these paintings converge stylistically with later twentieth-century Western European painting, the conceptual framework for classifying them as art did not exist when most were collected, and methods for analyzing their meanings either as sociocultural or artistic phenomena had not yet been invented.

Few early investigators of Anasazi or Pueblo painting attempted interpretations that went beyond the iconographic. Some of them classified pictures found in archaeological contexts or in modern Pueblos according to one or another social evolutionary theory, but with little consistency or apparent conviction (Fewkes 1892b; 1916:107–8). Most were content to try to identify the beings and emblems represented in paintings and to discuss their use in ritual. J. Walter Fewkes was perhaps the first to consider Pueblo paintings as units of a formal communication system, and his analysis of Hopi painted altars and their morphology is surprisingly modern in tone (Fewkes 1897b, 1927). But the essential fact is that most Anasazi and Pueblo paintings collected before 1900 were deposited in anthropology and natural history museums and have hardly been looked at since.

Few Anasazi paintings, other than rock art or paintings on pottery, were known archaeologically before 1900, and archaeologists have generally been content merely to describe most that have been found since that time. However, some important attempts have been made to correlate painted images and emblems with ethnographically documented iconography, to use paintings in efforts to reconstruct culture history, and to organize paintings into perceived stylistic groupings.

The study by Watson Smith of suites of late prehistoric murals found at the Hopi sites of Awatovi and Kawaika-a includes an exhaustive summary of Anasazi and Pueblo wall paintings that were known at the time of publication (Smith 1952). The analysis of the Awatovi paintings includes a basic iconography of the images and a seriated classification of the compositional systems used by the muralists. The murals recovered from the Rio Grande Pueblo IV site of Kuaua were analyzed by Bertha Dutton (Dutton 1963). Dutton summarizes the archaeological and historical contexts of the murals, but her basic theme is interpretive and based on the assumption that the paintings comprise an integrated series of illustrations of legendary and supernatural events. She further assumes that those

narratives are closely analogous to some still known to contemporary Pueblo people. Finally, the much more difficult task of classifying the many hundreds of rock-art sites with their tens of thousands of pictures into chronological and stylistic groupings has been attempted by a number of scholars. Polly Schaafsma's comprehensive overview and classification of rock art throughout the Southwest (Schaafsma 1980) provides the basis for useful future discussions and analyses of this important pictorial medium.

These studies provide the framework for comparative stylistic and iconographic interpretations of Anasazi painting. Smith's discussion of the evolution of a local stylistic sequence and Dutton's convincing demonstration that some Pueblo paintings represented events in an imaginary world which had spatial and temporal dimensions combine to form the foundation for all future studies of Anasazi mural art. Schaafsma's style-classification system and her iconographic suggestions concerning the identity of some rock-art imagery with figures in kiva murals makes it possible to consider the pictures made at open-air sites in conjunction with other pictorial traditions. Parallels to other world arts also are obvious now, so that for the first time ever the history of Anasazi painting can be studied both systematically and cross-culturally.

Notes on Procedure

Prehistorians use the word *Anasazi* to identify certain ancient people who are considered to be among the immediate ancestors of modern southwestern Pueblo Indian people. The term *Pueblo* refers to some of the historic-period people who are among the direct descendants of the Anasazi. Since the concern here is with paintings of both historic (Pueblo) and prehistoric (Anasazi) people, some term that combines the two names should probably be utilized. However, the word *Pueblo* will instead be used here to refer generally to the painting traditions of both the historic and prehistoric periods, while the word *Anasazi* will be reserved for use in discussions of southwestern prehistory.

The terminology is further confused by the fact that southwestern prehistory was characterized by dynamic population movements and widespread interactions among all of the peoples of the region. The fact of the matter is that the Anasazi were not the only ancestors of modern Pueblo people, and the term *Anasazi* can have only the most generalized value to culture history.

An end date of about A.D. 1900 for this history is not arbitrary. By then, intensified pressures from the outside world were impinging on the Pueblos, and it was as evident to contemporary observers as it is obvious in retrospect that radical changes in Pueblo art were in process or had already taken place. There had never been a "pure" form of Pueblo painting, and often before, the Pueblos had been in contact with foreign people, but few if any influences on Pueblo art prior to 1900 had so strong an impact as those that occurred during the years following 1900.

Transition from an old era to a new one began with the coming of the railroad in about 1880 and continued for about forty years. The best and most complete documentation of Pueblo painting and its traditional contexts was made during the first half of that transition period, and a history of earlier Pueblo or Anasazi painting that ignored the decades from 1880 to 1900 would have to depend almost entirely on archaeological inferences. Even if the historical documentation of those years were less important, the changes which occurred in Pueblo painting during that time were not so great as to exclude those two decades from this history. By contrast, the following twenty years added relatively little to the slim documentary record but saw the invention of a Pueblo easel-painting tradition characterized by new contexts and content as well as by novel media and techniques. The older painting continued, but its associations were with traditional ways of life and with religious ritual. Access to it by outsiders became increasingly difficult as many of the Pueblos reacted to alien pressures by conducting in secret increasing proportions of their traditional and ritual activities.

It is more difficult to arrive at a beginning date for this history that is not arbitrary. Anasazi culture began about eighteen hundred years ago, but knowledge of early Anasazi pictorial art is primarily limited to undated and possibly undatable paintings and engravings at open-air sites, collectively called "rock art," and to nonfigurative pottery painting. From about A.D. 1000 to 1350 there are fragmentary evidences of an emerging complex figural painting tradition, but no comprehensive collections of such paintings are known that date much earlier than about the middle of the fourteenth century. Almost two thousand years of Pueblo painting history can be reconstructed, but the first thousand years of that reconstruction are poorly detailed. The issue is further complicated by the slow early evolution

of distinctive Anasazi styles, which makes difficult the sure identification of many early paintings with Anasazi culture.

The region occupied by Pueblo people during prehistoric and historic periods provides the spatial boundaries for this history. Its borders changed considerably in the course of time, and the movement of people from one point to another is one of the markers used by archaeologists to define various segments of Pueblo prehistory. At one time or another, the Pueblo world included and even spread beyond most of what is now northern Arizona, northern New Mexico, southern Utah, and southwestern Colorado. The physical boundaries associated with the various periods of Anasazi and Pueblo history are described more fully in succeeding chapters.

From earliest historical times the Pueblos have been recognized as linguistically varied and politically heterogeneous. Their identification by outsiders as a corporate group has often been a response to the contrasts between them and other southwestern native peoples rather than the recognition of a self-conscious Pueblo unity. At the time of their first contact with Europeans, they differed from their neighbors by being town dwellers who depended on agriculture for their sustenance. Then as now, they shared a broad spectrum of practices, attitudes, and styles of behavior having to do with their material and spiritual well-being. Differences among them were and still are recognized by variations in those modes of behavior as well as by more obvious linguistic and political distinctions.

Painting was often ancillary to some other activity, and the probability is that painting style and history at any one Pueblo or Anasazi community differed from the generality in significant ways that parallel the differences which existed among them in other spheres. Nonetheless, it is valid to generalize about the art, for, in a broad sense, it is very much alike at all Pueblos. It is also necessary to make such generalizations.

There is great variability, archaeologically and historically, from site to site and from pueblo to pueblo in the quantity and quality of paintings that have been preserved and in the documentation of their history. In some instances, except for geometric designs painted on pottery, no paintings are known and there is no information about the art. Everywhere, selection of paintings for preservation and analysis has been random and generally unrelated to the quality of the work or to any cultural value placed on it by any people. All information about Pueblo painting must be evaluated in terms of its accessibility rather than by any controlled or rational measure of significance. At present, a history of Pueblo painting must be both general and cautionary.

The published literature on the Pueblos and their Anasazi forebears is extensive, but there is relatively little about painting and its history. Written eyewitness accounts of the practice and use of painting are few and generally deal with the art only incidentally. Until well after 1900, most descriptions were by amateur and professional anthropologists, soldiers, religious missionaries, and travelers, all of whom were more interested in recording or analyzing their impressions of an exotic culture than in understanding or describing its art.

There is more about painting in the considerable archaeological literature of the prehistoric Southwest, but, except for pottery painting, most references are descriptive and brief, incorporated within the body of a lengthy site survey or excavation report. There are, however, several monographs and comprehensive analyses that provide a foundation for a history of early Pueblo painting, most notably those by Watson Smith (1952), Bertha Dutton (1963), Polly Schaafsma (1980), and myself (Brody 1977).

Examination and analysis of Pueblo paintings are the primary materials for this history. Except for rock art seen in the open-air locations where it was made, most of the paintings discussed here have been removed from their original physical contexts as well as their ideological and social ones. They have been studied at archaeological sites, in use at modern Pueblos, and in museums and private collections. Photographs and other pictures of works that no longer exist or were otherwise unavailable were also examined.

Mural painting is one of the most compelling Pueblo painting traditions. Unfortunately, the greatest number of known prehistoric wall paintings either no longer exist or have been radically altered by time and circumstances. In consequence, our appreciation as well as our analysis of them depends on reproductions done in several media and a variety of techniques that are of variable accuracy and often have considerable alteration of scale. For these reasons, it is often necessary to postulate imaginative reconstructions of the original appearance of many of these important paintings. The potential for error in those instances is both great and already recognized. Similarly, many of the better-

documented paintings of the historic period are fragmentary, badly faded, or poorly preserved; or they have been modified by Pueblo or non-Pueblo hands for ceremonial or ritual reasons, to improve their appearance, or to simulate or restore their original character.

To a considerable degree, the present condition of existing paintings is due to the vagaries of archaeological circumstances and to the fact that the artists often painted for the moment rather than for posterity. With preservation of originals so chancy, a considerable amount of modern alteration was inevitable, as was the irretrievable loss of many details. Ruins have their own fascination, and the contemporary transformation of many Pueblo paintings into art is certainly as much a response to Euro-American romantic tastes as it is to changing philosophies and aesthetic perceptions. Whatever our preferences, we must recognize that the appreciation and analysis of ancient Pueblo paintings, as though their present ruinous condition were original and intentional, distorts the understanding of both Pueblo aesthetics and the history of Pueblo art. An exception to these generalizations may be seen in open-air locations where rock art is found in great numbers and, often, in a reasonably unmodified state.

The research procedures used here are, therefore, a modification of those which are normal to art historians. They include an extensive review of primary documents, such as nineteenth- and early twentieth-century ethnographic descriptions and analyses of activities that used paintings, and of secondary documents organized according to subject categories that synthesize earlier documentary sources. The primary and secondary archaeological literature, which is the only documentation that can exist for prehistoric painting, is reviewed as well. Additionally, there has been some consultation with Pueblo people who make and use art and with archaeologists, those who are best able to interpret the sometimes confusing data of their trade.

The works of art that are the primary documents of the history are studied here with less confidence than is customary or desirable because so many have been so radically altered. In many cases, I have placed greater faith in my postulated reconstructions than in surviving works which I am certain have been randomly or deliberately modified by nature or by man. The materials are organized chronologically, and are followed by a concluding chapter that reviews general historical and social contexts and discusses the art in relation to world-art traditions, especially those of our own time.

TWO ■ The Beginnings: From the Archaic to about A.D. 900

Pueblo pictorial art has a venerable history extending back to pre-Anasazi Archaic beginnings. Although relationships between any of the Western Archaic or Desert Culture groups and the Anasazi or Pueblo peoples are not known in detail, it seems probable that the Pueblos evolved in place as descendants of one or another group of Archaic hunter–gatherers who adapted to a sedentary life dependent upon maize agriculture.

The Pueblos are not the only native peoples of the Southwest whose roots are ancient in the region; the non-Anasazi, non-Pueblo southwesterners also had pictorial art systems. It is necessary, therefore, to sort out Anasazi art from that of other ancient southwesterners and to recognize and describe, if possible, what is uniquely Anasazi from what was once a widespread, generic southwestern pictorial tradition.

Before Agriculture

There have been people in the Southwest for at least fifteen thousand years. Among the earliest groups that can be identified today were Pleistocene-era hunters and gatherers who made distinctive chipped-stone spear points, knives, hide scrapers, and other tools that we identify with Clovis, Folsom, Midland, and other paleo-Indian cultures. Almost no evidence remains of any of these very early people other than their stone tools and some fragmentary and problematic engravings on bone which are the earliest known pictorial images in the Southwest.

The end of the Pleistocene and beginning of the modern era in the Southwest was marked by a change in climate about seven thousand years ago. That shift from a period that was generally cool and wet to one more like the present hot and dry climate of the region was accompanied by changes in the plant and animal populations. Some animal species that were hunted earlier, such as the mammoth and certain large bison, now disappeared entirely. The people of the region appear to have replaced the economic value of those large animals by exploiting a wider range of other animal and plant species. Their tool inventory was broader and, to some degree, less specialized; a variety of seed-grinding tools were used to prepare the wild plant foods that were basic to their diet, and chipped-stone knives, projectile points, and hide scrapers were more generalized in form and less delicately made than in the paleo-Indian past. Perishable goods made of vegetable materials, including baskets, cordage, finger-woven textiles, sandals, mats, and figurines, have been preserved in dry caves in many parts of the Southwest. These cave sites provide us with a much broader picture of the Archaic or Desert Culture life-style, including their arts, than is currently available to us for any earlier peoples.

There is presently no clear understanding of what relationships, if any, may have existed between any Archaic group and earlier paleo-Indians. Several different southwestern Archaic traditions have been described principally on the basis of stylistic variations in the appearance of stone tools (Irwin-Williams 1979:31–42). A number of different styles of Archaic pictorial art have also been described, but correlations between art styles and tool-defined Archaic cultures are not clear

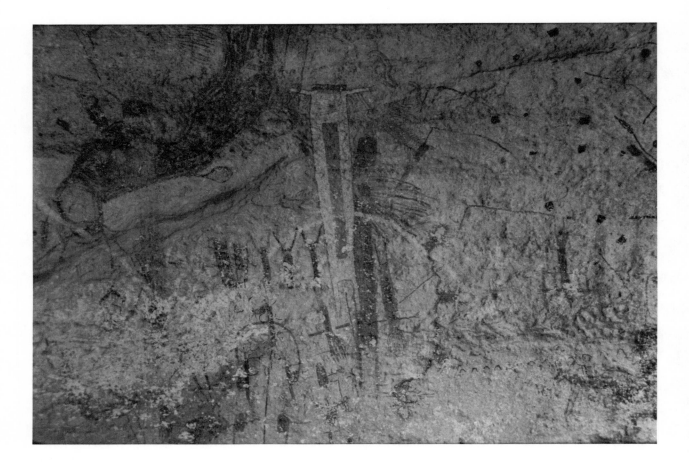

Figure 9. Pictographs, White Shaman Cave, junction of the Pecos River and the Rio Grande, south-central Texas, Archaic era. The walls of this and other shallow caves in the vicinity are palimpsests of overlaid images. The oldest, largest, and most impressive pictures may be three to five thousand years old and suggest relationships to some Archaic art of the Colorado Plateau. (Photograph by J. J. Brody.)

(Schaafsma 1980:33–80). Virtually all of the known Archaic pictorial art exists in the form of rock art, both pictographs and petroglyphs, art media that are notoriously difficult to date or even to attribute, with much confidence, to any given culture. Thus, any discussion of Archaic painting is tentative and qualified at best.

Southwestern rock-art pictures that are generally thought to be of the Archaic period are usually found in clusters rather than as isolated images. Many are found in open sites, and some are near springs, ponds, or game trails, suggesting the association of the art with hunting activities or rituals. Others are found in rock shelters and caves or in isolated and relatively inaccessible canyons. Subject matter varies greatly, ranging from detailed, realistic, and action-packed pictures of humans and animals (Plate 3), to large, stately, human-like images (Fig. 9), as well as to clusters of marks whose representational intentions are indecipherable even when clearly patterned. The stylistic range is also

quite wide, varying from carefully rendered pictures that were placed on prepared surfaces to the apparently random distribution of haphazardly drawn images that seem to have been placed on any surface that came to hand. Implicit in this variety are two assumptions that may be unrelated; namely, that Archaic rock art served several different functions, and that surviving examples represent distinct temporal or cultural traditions.

At least two separate painting modes, one figurative and the other nonfigurative, have been identified as distinctly separate pictorial traditions, each with several variations (Schaafsma 1980:33–80). The nonfigurative mode is best known from sites in southwestern New Mexico and eastern Utah, and it is characterized by the use of motifs such as triangles, rakes, zigzags, and circles on unprepared surfaces within rock shelters or caves (Fig. 10). The motifs often appear to be in haphazard relationship to each other as well as to the rock surfaces on which they appear, and some are superimposed over others. It is debatable whether their sometimes considerable visual power is the intentional result of planning or the accidental by-product of the accumulation of images, color, and the patina of antiquity.

The general location of these paintings in caves and rock shelters, which show no evidence of contemporaneous use either as habitations or for food storage, suggests ideological purposes for the sites and ritual purposes for the art. This class of painting is limited in number but very widely distributed, thus lending support to the notion that, despite regional variations, late Archaic people of the Southwest participated in a "large-scale, low-level communication network" (Irwin-Williams 1979:38). Paintings in the nonfigurative mode are poorly dated, but most are thought to have been used throughout the first millennium B.C. to about A.D. 100 (Schaafsma 1980:36–55).

Overlapping in time, from about 400 B.C. or earlier to about A.D. 500, are a number of late Archaic representational rock-painting traditions which are widely separated geographically throughout the Southwest. Among these, the Barrier Canyon Anthropomorphic Style of southeastern Utah is especially noteworthy, characterized by its use of life-sized frontal images of humanlike forms painted on sandstone cliffs or on cave walls in isolated canyons (Schaafsma 1980:61–70). While they are sometimes shown singly, on other occasions they are grouped in linear compositions, of-

ten organized to conform to natural scars and other unique qualities of the rock surface on which a painting was made. Figures occasionally seem to interact, but superpositions are uncommon. These sometimes armless, spectral figures are usually broad-shouldered, have wedge-shaped bodies tapering downward, and were sometimes painted with feathered brushstrokes so that they appear to merge seamlessly with the rock surface. Some have antennalike protuberances on their heads, wear necklaces and other ornaments, and may have large goggle-eyes; those with arms and hands often carry objects and may have snakes, small quadrupeds, and other animals associated with them (Plate 3). Some were painted on prepared surfaces, and most are dark red in color, sometimes enhanced with white lines or dots.

Overlapping in time and comparable with paintings in the Barrier Canyon Anthropomorphic Style are those of an older pictorial tradition that was practiced far to the southeast in the Pecos River area of west Texas (Newcomb and Kirkland 1967; Schaafsma 1980:55, 56, 70). Many Pecos River Style images are large, frontal, and as imposing and iconic as the Barrier Canyon–style anthropomorphs (Fig. 9). They also carry objects and often are accompanied by small or large animals. The Pecos River paintings tend to be more complex than those of Barrier Canyon, use more colors, include more details, and show many more interactions between and among the personages that are depicted. While superpositioning occurs far more frequently among Pecos-style paintings, many over-images appear to be considerably later than the Archaic period. As with Barrier Canyon Style paintings, those of the Pecos also seem to have been composed with care, suggesting that the paintings themselves had permanent value to their makers (Schaafsma 1980:72).

It has been suggested that both traditions were inspired by presumed shamanic practices of the Archaic hunter–gatherers and that they also relate to very widespread Mesoamerican ritual procedures (Schaafsma 1980:71–72). The Pecos paintings, especially, have been interpreted as the ritually inspired art of "a ceremonial hunting cult . . . in response to cultural emanations originating in Mesoamerica" (Kelley 1974a:51). This suggestion of ritual interaction between the Southwest and Mesoamerica at so early a date fits well with a presumed Mesoamerican orientation of the variant late Archaic culture of southeastern New Mexico and west Texas that has sometimes been called the Hueco Bas-

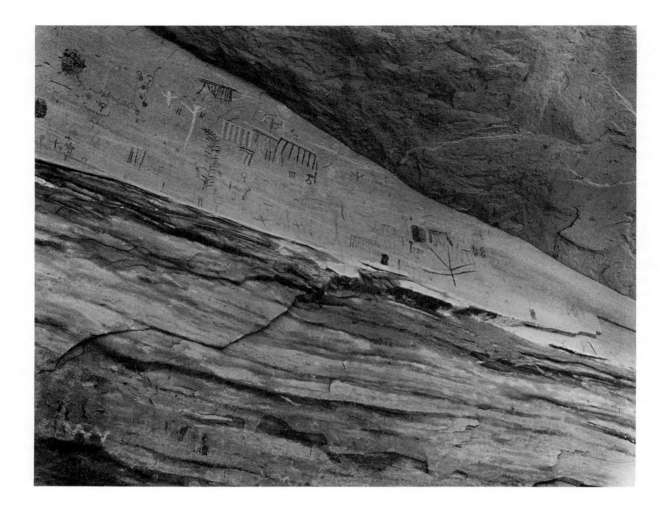

Figure 10. Pictographs, rock shelter of Green Mask Spring, Grand Gulch, southeastern Utah, Archaic era. These paintings are high above the ruins of Basketmaker and Pueblo III residences that were built among boulders fallen from below this panel. Masklike images are here, as well as linear abstractions that suggest the elaborate altar constructions of modern-day Pueblos. Basketmaker and later Pueblo paintings are found on other panels and walls at this site. (Photograph by David Noble.)

ketmaker tradition (Irwin-Williams 1979:41–42). Also, and perhaps more fundamentally, it parallels the introduction from Mexico during this time of maize, the technology for growing it, and, presumably, rituals associated with its success. Consideration of prehistoric southwestern painting in the context of the Mesoamerican northern frontier appears to be warranted at a very early date.

Regardless, many late Archaic paintings of the Southwest appear to be associated with ritual or an aspect of the spiritual life of those ancient people. In some instances, superposition of images seems to support an argument that the act of painting was of far greater value than the finished products. In effect, earlier pictures were "thrown away" by being covered over in

whole or in part, while the later ones were obscured by being intermixed with pictures that they only partly covered. In other cases, paintings were isolated and cared for, leading to the assumption that the iconic images were themselves powerful and highly valued. The only supportable conclusions to be drawn from these contradictions is that different values were placed on different kinds of pictures, perhaps by different peoples including some of much more recent eras than the Archaic period.

There are complex ideological implications in the prehistoric southwestern painting of this very early period, but suggestions that the iconography of some southwestern Archaic paintings may have been related to shamanic practices as well as to Mesoamerican prototypes seem to be both attractive and unprovable (Schaafsma 1980:76–79). In any case, the Archaic representational paintings are good evidence of a rich ideological and intellectual life for those times and provide an important precedent for the later art of the area. Even though historic connections between the Archaic and any later southwestern peoples are most tenuous, it seems clear that some of the basic intellectual principles of southwestern painting were established during Archaic times.

Early Village Life

The transition from late Archaic foraging to a more sedentary way of life that depended on the cultivation of corn, beans, and squash was gradual throughout most of the Southwest. It occurred at different times after about 300 B.C. in different parts of the region. The Anasazi were only one among a number of ancient, village-dwelling southwestern societies, and they were by no means the earliest.

Among the more prominent sedentary, agricultural neighbors of the Anasazi were the Hohokam of southern Arizona (Haury 1976) and the Mogollon of southeastern Arizona and southern and central New Mexico (Wheat 1955; Martin 1979), both of whom influenced Anasazi and Pueblo history. Other prehistoric villagers of the region known to us by their archaeological remains include the Hakataya, Patayan, Salado, Sinagua, and Fremont peoples (Colton 1946b; Gunnerson 1969; Martin and Plog 1973; Plog 1979; Schroeder 1979) (Fig. 11). With the possible exception of the Hohokam, identification of any of these people with any of the groups first described by Spanish chroniclers is problematic,

and none can be identified surely with any modern Pueblo society (Ellis 1967). Almost certainly, some people from all of these groups joined one or another Anasazi community during the unsettled times that marked the end of Pueblo III and the beginning of the Pueblo IV periods; and all interacted with the Anasazi on some level in ways that bear upon the history of Pueblo painting.

The Hohokam were among the first sedentary societies of the southwest. Early Hohokam villages, such as Snaketown located near the junction of the Gila and Salt rivers in southern Arizona, are associated with extensive irrigation-canal systems which, with other material evidences, suggest one or several migrations of marginal farmers from western Mexico to the Arizona desert perhaps as early as 300 B.C. (Haury 1976:336) or, more likely, a few hundred years later (Cordell 1984:109–12). These villages are relatively simple and their frontier character makes the designation of Pioneer period an apt one for Hohokam beginnings. In succeeding centuries, there was considerable elaboration off the Pioneer period base, which was modified by contact with other indigenous southwestern cultures as well as by occasional surges of influence from the south.

Most surviving examples of Hohokam pictorial art are in the forms of painted pottery and rock art, but they also used other pictorial media, including textiles, best known from their representations on clay figurines, elaborate mosaic ornaments, and carved and etched shell ornaments.

In contrast to the Hohokam, who appear to have been quite homogeneous, the Mogollon people of southern and central Arizona and New Mexico were heterogeneous. As early as 300 B.C., some Mogollon people had adapted to a semisedentary life that combined the cultivation of food crops with a continuing dependence on older foraging and hunting methods. Most early Mogollon communities were small, and their production of pictorial art generally seems to have been quite limited before about A.D. 900 or 1000. Pottery painting was not widely practiced by any Mogollon group before that time, and rock art is the best preserved of earlier Mogollon pictorial media.

The earliest Anasazi sites are identified with the Basketmaker II period (circa 100 B.C.–A.D. 500). Evidence for Basketmaker II occupations comes from relatively few cave sites and rock shelters along the drainage of the San Juan River (Plog 1979:113) and from sites in the

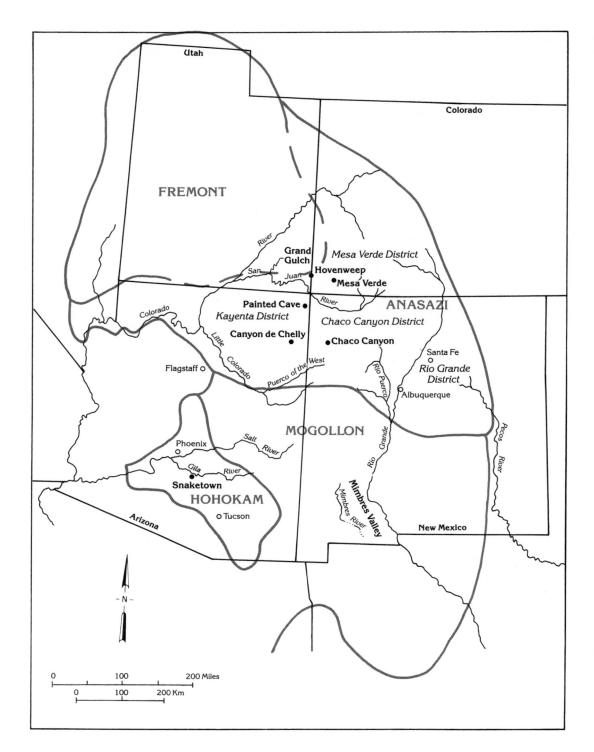

Figure 11. Distribution of some major cultural traditions of the prehistoric Southwest, ca. A.D. 200–1350.

Rio Grande Valley as far south as modern Albuquerque (Cordell 1979:134). In that early time, villages may have been occupied only seasonally by people who planted crops but still relied on foraging for their sustenance. No painted pottery was made, but decorated baskets are known. A more sedentary life-style is evidenced during the following Basketmaker III period (circa A.D. 400–700), when houses and villages were larger and more complex but left little obvious evidence of community planning. Specialized ritual rooms (kivas) as well as more elaborate food storage and work areas are also characteristic. Basketmaker III people made a variety of different painted pottery containers as well as elaborately decorated baskets. They seemed to have relied more on agriculture than did people of earlier times, and there is considerable evidence for trade contacts with different parts of the greater Southwest (Cordell 1979:148). There were many more Basketmaker III villages and they were more widespread than those of Basketmaker II, but villages were still relatively small and the social system appears to have been quite egalitarian.

There was a marked increase in the number of communities during Pueblo I (circa A.D. 700–900) as well as evidence for widespread alliance networks and a considerable degree of local diversity. Architectural innovations during this time included development of multiroom surface houses and of more coherent and rigidly patterned village plans. There was increasing reliance on agricultural foods. Before about A.D. 900, during the Basketmaker and early Pueblo periods, the pictorial art of the Anasazi is best known from rock art and painted pottery traditions, even though there is considerable fragmentary evidence that many other media were also important.

Anasazi Painted Objects

Most known examples of Anasazi pictorial art made before about A.D. 900 are on the hard surfaces of rocks or of pottery, materials and media that allowed little scope for pictorial subtleties. Also, a few imperfectly preserved paintings are known done on organic materials such as cloth and leather, which are more amenable to variety in brushwork, color, and texture. Because so few paintings on "soft" materials have been preserved, we do not know how the aesthetic attitudes and styles of the early Anasazi may have differed when their paintings were on skins, textiles, or human bodies. The many differences between the paintings made on pottery and those done on rock walls or boulders support speculation that different materials were characteristically treated with different aesthetic attitudes by the ancient Pueblo artists.

Many examples of woven and sewn decorations on textiles, baskets, and sandals also have been preserved in the dry cave and rock-shelter habitation sites of the San Juan Basketmakers, some of which surely predate as well as prefigure the first painted pottery of the region. Fewer examples of art in these media have been recovered from later, more open village sites; but even the oldest known Anasazi basketry and textiles evidence stylistic maturity. Their rigidly structured decorative systems generally depended on the repetition of a limited number of geometric motifs that were placed within evenly spaced and well-defined decorative zones (Fig. 12). It is clear that the arithmetical rhythms, inversions, and symmetries as well as the motifs and design elements used in these early Anasazi textile and basketry patterns provided the basis for later traditions of Anasazi nonfigurative pottery painting.

Some ancient Anasazi baskets with life-form motifs such as birds and humans have also been preserved. In one coil basket, a series of birds, not unlike some contemporaneous pictographs at Cañon de Chelly, are in unframed registers in a repeat pattern (Fig. 13). Though carefully placed and precisely rendered, each bird is drawn as an isolated figure, and the composition is more like that of a rock-art painting than an integrated basketry or textile pattern. Despite their isolation, the bird figures, as often happens in rock art, suggest natural interactions, as when, for example, all in one register face in the same direction as though grouped in a flock or moving in a line. Most known figurative basketry designs are woven rather than painted, and consequently, they are far more rigid than similar subjects in the media of painted pottery or rock art.

There were many more pictorial images made on perishable objects and in ephemeral forms than we know of. Body paint is suggested in many pictographs, as are patterned textiles and shield paintings. But no examples of the former and very few of the latter have actually survived. Cured hides and a variety of wooden objects were also painted; there may well have been pictures made of colored sands and other dry materials, and some ornaments of shell and stone were patterned in ways that parallel the decorative systems

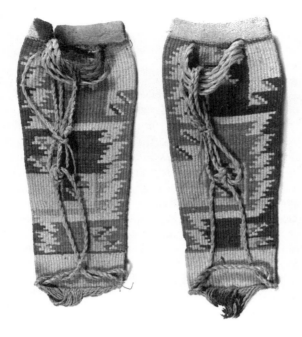

Figure 12. Yucca fiber sandals, Cañon del Muerto, north-eastern Arizona, Basketmaker III. The structural logic of the pattern and its use of color inversions, negative forms, stepped terraces, and other regular geometric motifs are fundamental to all later forms of Anasazi and Pueblo decorative painting. (University of Colorado Museum, photograph by Joe Ben Wheat.)

Figure 13. Coiled burden basket, Broken Flute Cave, San Juan drainage, northeastern Arizona. Basketmaker III. Stylized birds and even-armed crosses are placed in registers rather than within framed panels in an innovative composition that suggests contemporary rock art and figurative painted pottery. (Department of Library Services, American Museum of Natural History, neg. no. 2A13721, diameter 18 inches, photograph by A. Anik.)

used in basketry and pottery. Our knowledge of early Anasazi painted objects is based on a limited and biased sample which must distort all judgments. Since our information about similar, contemporaneous arts made by other peoples of the region is equally limited and biased, there is little to be gained by comparing miscellaneous Anasazi painted objects of this era with those of their neighbors.

Painted Pottery

During Basketmaker and early Pueblo times, pottery painting became a major art medium that was not only distinctly Anasazi but possessed several well-developed regional variations within the main tradition. Nonetheless, most painted pottery was utilitarian, created in the form of bowls and jars that were often decorated on one surface with linear designs. As the Anasazi tradition matured, painting surfaces came to be treated with considerable care and were usually slipped with a fine white or, much less often, red clay, which was then smoothed and polished in preparation for the application of black paint. Paint was usually applied in a tightly controlled manner, and in strong contrast to the spontaneity of contemporary Hohokam painted wares or the heavy, though more precise, lines that characterized the rare painted Mogollon pottery of that time.

Two major variations or traditions evolved, one stressing the use of fine lines on a surface that tended to be chalky white, and the other emphasizing heavy black masses on a surface that tended to be highly pol-

ished. As time passed, many variants of each tradition developed, each serving to identify Anasazi subgroups. Though there are many exceptions, the fine-line tradition came to be used most often with an iron-based, reddish-black paint by people of the southern and eastern Anasazi regions. The heavy black tradition was more often practiced in the northern and western Anasazi regions, where a carbon-based paint that fired with a soft, gray-to-black tone was generally used. While fundamental design procedures were much the same in all variants, the fine-line designs tended to be lighter in tone and tenser in character than the heavier painted vessels which developed strong negative patterns. In the early periods, though, there is little to distinguish the painted designs of the two major painting traditions (Figs. 14, 15).

Figure 14. Pottery vessels, southern and eastern Anasazi. Use of red–black mineral paint that sits on the surface of chalky white slips and preference for hachured fillers and a thin, tense line characterizes the Chaco–Cibola painting tradition. From left to right: bowl, Red Mesa black on white, 700–950 (diameter 10 inches, cat. no. 70.60.25); bowl, La Plata black on white, 600–800 (diameter 7 inches, cat. no. 42.12.3); jar, Chaco black on white, 1050–1125 (height 6½ inches, cat. no. 72.10.39). (Maxwell Museum of Anthropology, photograph by Roderick Hook.)

Figure 15. Pottery vessels, northern and western Anasazi. Dense carbon paint, polished white slip, a preference for solid filling and positive–negative patterns characterize Mesa Verde and Kayenta pottery. From left to right: bowl, McElmo black on white, 1075–1275, Mesa Verde (diameter 8½ inches, cat. no. 47.11.16); gourd effigy, Black Mesa black on white, 875–1130, Kayenta (height 4 inches, cat. no. 66.93.10); bowl, Kana-a black on white, 725–875, Kayenta (diameter 7½ inches, cat. no. 42.12.100). (Maxwell Museum of Anthropology, photograph by Roderick Hook.)

Most often, Anasazi pottery paintings were nonfigurative and incorporated a limited number of geometric motifs within carefully defined and framed zones that can be thought of as picture spaces. These design areas were generally structured with arithmetical logic and symmetrical regularity, and the zones were often laid out to conform with and reinforce the vessel form. Rarely, life forms were included as decorative motifs within the design zones, and even more rarely, human or other animal images were made to dominate a design area (Figs. 16, 17). As a rule, such pictures were painted with considerably more expressive freedom than was characteristic of the more precise, uniform, and tightly controlled nonfigurative pictures.

The images used in representational pottery painting often resemble contemporary Anasazi rock art in style as well as subject matter, tending to be simplified

and rendered with minimal detail. In some instances, they have the same sort of uncertain relationship to their picture space and its boundaries as was characteristic of so much early Anasazi rock art (Fig. 18). Usually, however, no such uncertainty exists with regard to representational paintings that were placed on the more easily perceived, limited and globular surface of a pottery container.

Anasazi pottery painters were also severely limited by the technical requirements of their medium. They normally made monochromatic brush drawings with black lines on even-toned and smoothed white surfaces. The scale and composition of their pictures were limited by the small size, globular forms, and utilitarian purposes of the containers on which they were placed. The paintings were portable; when the containers were in use the pictures on them could not be perceived as

Figure 16. Pottery bowl (fragment), La Plata black on white. Basketmaker III, eighth century. The broad-shouldered, triangular figures painted on this vessel from Chaco Canyon resemble contemporaneous rock-art representations. At the same time, the evenly segmented quadrants suggest design structures of basketry and other domestic, utilitarian arts. (University of Colorado Museum, cat. no. 744, diameter 8½ inches.)

Figure 17. Pottery bowl, Chapin black on white, Basket-maker III, eighth century. The realism often implicit in early Anasazi rock art is made explicit in this Mesa Verde vessel where figures define space by standing vertically on the upper wall of a three-dimensional picture space. (Mesa Verde National Park, cat. no. MEVE 5105, diameter 10½ inches, photograph by Liz Bauer.)

Figure 18. Pottery jar, Cibola white ware, Pueblo II, tenth–eleventh centuries. "Lizard-men" such as these are common in contemporaneous rock art of the Zuni–Cibola region. The pictorial treatment on unframed, unstructured space is also analogous to that of local rock art. (Maxwell Museum of Anthropology, cat. no. 78.1.129, height 5½ inches, photograph by Roderick Hook.)

Figure 19. Pottery bowl, Piedra black on white, Mesa Verde region, Pueblo I, ninth century. As in Figure 17, narrative relationships are established within the physical confines of a clearly defined, three-dimensional picture space. This vessel also has some of the rigid structural organization of basketry designs. (Mesa Verde National Park, cat. no. MEVE 1762, diameter 10 inches, photograph by Bill Creutz.)

unified compositions because some portion was always hidden. The geometric motifs that were their ordinary subject matter may or may not have carried symbolic information, but they are stately, rhythmically predictable, and emotionally under control. Symmetry and repetition stabilized the paintings: Even when large portions of them are hidden, it is possible accurately and consistently to predict their patterning and their impact.

The occasional pottery painting with representational subject matter was usually organized into a far less predictable though still easily perceived composition when figures were framed within the interior surface of a small bowl. Interactions between figures that are generally shown in a spatial void are presumptive and contextual; gesture and spatial contiguity rather than explicit detail provide the basis for interpretation (Fig. 19). And even when symmetrically composed, such pictures carry more emotional weight and power than do most nonfigurative paintings. Figures painted on exterior surfaces usually lack the contextual unity that comes with perception of a uniform, restricted picture space, but sometimes they were composed to interact with narrative clarity (Fig. 20).

Comparisons with other southwestern pottery painting traditions can be useful. Pottery painting was not widely practiced by any Mogollon group before about A.D. 950, and Mogollon pottery paintings that predate 900 appear to be very much like contemporary Hohokam wares except for a tendency to apply the paint more precisely on more highly polished surfaces. Likewise, the geometrical structure, arithmetical logic, and motif inventory of pre-900 Anasazi black-on-white painted pottery is similar to contemporary and earlier Hohokam styles, even as the quality of brushwork and surface finish of rare Anasazi red-on-brown wares make them almost indistinguishable from equally rare Mogollon red-on-brown paintings. But the characteristics that distinguish these traditions should be discussed, for the residue of their similarities can help to define a pan-southwestern pottery painting tradition.

For the most part, Hohokam pottery paintings used a broad and free-flowing line of red or brown paint on a buff- or brown-colored surface. Lines, color masses, and motifs tended to be distributed evenly over a painted surface so that there was little sense of a single dominant image or even of a bounded picture space. Interior surfaces were often divided into four or more even-sized segments that radiated outward from the

Figure 20. Pottery jar, Red Mesa black on white (?), Pueblo II, ninth–eleventh centuries. The horizontal bands of triangles are made to suggest mountain peaks by the frieze of flying birds. Compare also to the flying birds in Figure 53. (Brooklyn Museum, no. 4209, height 4¾ inches.)

center to a weakly framed or, sometimes, unframed rim (Fig. 21). Exterior surfaces were often covered by diagonally organized repeat patterns or ringed by concentric bands or registers. In either case, small-scale motifs might spiral outward or upward, or any other compositional systems that had the potential for infinite expansion beyond the bounds of the vessel surface could be used (Fig. 22).

As with most other prehistoric painted pottery of the Southwest and northern Mexico, Hohokam wares may generally be considered workshop products, utilitarian containers decorated more or less skillfully in accordance with the tenets of some local or temporal variation of a widespread tradition. As elsewhere, occasional innovations in Hohokam painted pottery suggest a concern with a pictorial image that transcended the

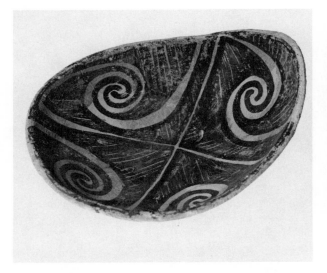

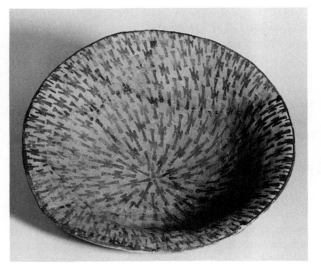

Figure 21. Pottery dish or scoop, Santa Cruz red on brown, Hohokam, Colonial Period, eighth–tenth centuries. Hohokam painted pottery differs technically and stylistically from Anasazi wares, but the two traditions share organizational patterns such as the tendency to divide painted surfaces into equal quadrants. There is also common use of positive–negative imagery, interlocking forms, and many motifs. (Arizona State Museum, University of Arizona, cat. no. GP49837, length 18.5 cm, width 15.4 cm, height 6.0 cm; photograph by Helga Teiwes.)

Figure 22. Pottery bowl, Santa Cruz red on brown, Hohokam, Colonial Period, eighth–tenth centuries. Fluidly painted, repetitive designs that are unbounded and expand and contract in response to vessel shape are characteristic of Hohokam painted pottery from about the seventh to thirteenth centuries. (Arizona State Museum, University of Arizona, cat. no. GP49781, maximum width 18.4 cm, height 8.7 cm, photograph by Helga Teiwes.)

utilitarian character of the vessel. Representations of birds, humans, or lizards that suggest in their style as well as in their subject matter some Hohokam rock paintings were also made on Hohokam pottery with some frequency and a great deal of vitality. But unlike their rock-art compositions, which tend to ramble over unframed surfaces, most Hohokam painted pottery is framed to some degree and symmetrically composed.

Hohokam painted pottery of all eras is distinctive technically, stylistically, and iconographically from other southwestern traditions. Similarities to Anasazi traditions appear to be more generic than specific and involve the use of motifs, techniques, and compositional systems that were common to other southwestern and northern Mexican cultures. Spontaneous brush handling, color choices, and a great preference for overall patterning and use of expanding designs as opposed to zonal subdivisions and restricted pictorial fields are characteristics that distinguish the Hohokam

painting tradition from that of neighboring peoples, most especially the Anasazi.

Rock Art

One of several rock-art traditions of the San Juan Basin that were practiced during Basketmaker times appears related both stylistically and iconographically to the late Archaic Barrier Canyon anthropomorphic pictographs. Called the San Juan Anthropomorphic Style by Schaafsma, these pictures are found on cliff surfaces or beneath sandstone overhangs associated with Basketmaker II occupation sites (Schaafsma 1980:109–21). Characteristic of the style are large, outlined, solid-color paintings and petroglyphs of broad-shouldered humans with trapezoidal torsos. Many have hands and feet drawn in detail and embellished with carefully rendered and elaborate headdresses, hair ornaments, earrings, necklaces, and sashes. They are most often

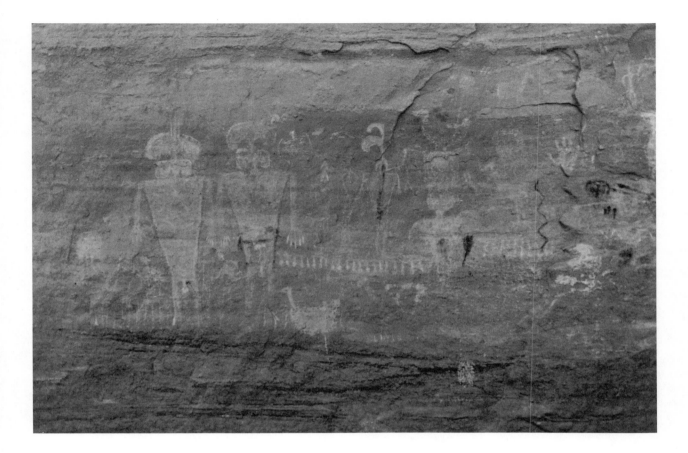

drawn in frontal views and are static in posture; sometimes, rows of these figures are shown, apparently holding hands or depicted in pairs (Fig. 23). Among smaller images associated with these hieratic anthropomorphs are human handprints that were sometimes applied directly over a large painted figure or all around a series of figures.

Sometimes, great visual similarities exist between these and the more ancient spectral anthropomorphs that characterize the Barrier Canyon Style. But the differences between them are also great; and it is hardly possible to judge the significance of either the similarities or dissimilarities, especially with regard to any meanings that may originally have been given to either set of images. Among the more obvious distinctions between the two groups are those of size, scale, and degree of elaboration. Most of the Basketmaker II anthropomorphs are considerably smaller than those of the Archaic period, and they may be embellished with

Figure 23. Pictographs, Green Mask Spring, Grand Gulch, southeastern Utah, Basketmaker II, first–sixth centuries. The largest of the front-facing white figures is about 4 feet high. The elaborate headdresses, trapezoidal bodies, and long-fingered hands are typical of Basketmaker II rock art. Unlike Archaic art at this location, which is high above the floor of the rock shelter, these paintings are on ground level (see Figure 10). (Photograph by J. J. Brody.)

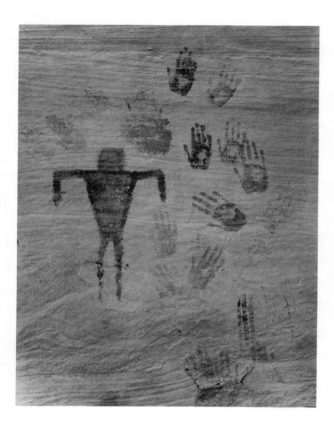

Figure 24. Pictographs, Grand Gulch, southeastern Utah, Basketmaker III, sixth–eighth centuries. Outlined, monochromatic figures with broad shoulders and triangular or trapezoidal bodies are common in Basketmaker rock art of the San Juan region. The human handprints give scale and may be contemporaneous with the painted human. (Photograph by David Noble.)

many more details of ornament and costume, especially on and about their heads; some appear to interact with each other more often and more obviously. These factors combine to reduce the mystical qualities of the Basketmaker II pictures and to lessen their visual impact when compared to Barrier Canyon Style art. The Basketmaker rock pictures are less ethereal, less forbidding, and, if not more human, at least more approachable by humans than are the somewhat similar Archaic anthropomorphs.

Further reduction in the size and hieratic quality of anthropomorphic art characterized the succeeding Basketmaker III period. During that time, many new subjects were introduced, including birds, other animals, and hunting scenes involving interactions between humans and game animals. There seems also to have been a marked increase in the production of Anasazi rock art after about A.D. 500 (Schaafsma 1980:121–22). The increase in rock art seems to correlate very neatly with an increase in the number of habitation sites, especially in the canyons of the San Juan Basin where the art was very often incorporated within a village.

Several different but related traditions of Anasazi rock art have been described for the period from about A.D. 500 to 900 (Basketmaker III–Pueblo I). Throughout the San Juan Basin, pictographs of the era are commonly found in rock shelters and along cliff walls. The painted anthropomorphs tend to be smaller than those of the Basketmaker II period, and may have long necks and triangular bodies that lack arms and legs. Human and animal stick figures appear in a great variety of active and passive postures, and the earliest known flute-player images come from this time (Schaafsma 1980:122–27; fig. 85). Variations of these personages persist to the present day. Birds are a common motif, as are human handprints often found repeated in clustered masses on cliff walls (Fig. 24, Plate 4). Petroglyphs are also common and widespread. These include stick-figure images of quadrupeds, humans, and narrative hunting scenes, as well as lines of frontally posed humans with triangular bodies often shown holding hands (Schaafsma 1980:128–37; figs. 90, 91) (Plate 5).

A shift in the form and content of Anasazi rock art that began during Basketmaker III and continued into the Pueblo II period is characterized by the decreasing size and number of anthropomorphic images relative to other animal subjects. There were increases in the number and variety of bird and quadruped figures, and

a new emphasis on representational realism. The hieratic figures of earlier times were replaced by pictures of animals or humans whose postures and interactions told of the real world and its activities. During this time, a shift in the relationship of open-air sites to habitation sites also became quite significant. The hidden canyons and rock shelters so favored by Archaic artists were now favored locations for agricultural communities; rock art was now made near or actually within villages, on boulders atop mesas, near game trails, or in other accessible locations. The sum of all of these changes was to make Anasazi rock art increasingly more human, approachable, and perhaps better integrated with everyday Anasazi life.

Anasazi rock art of this era differs from Hohokam and most Mogollon rock art that may be contemporaneous with it, but it is similar in many respects to that of the Fremont culture. There are a large number of Hohokam pictographs of stick-figure humans, birds, snakes and lizards, as well as circles, spirals, lines, squiggles, and other indescribable marks apparently placed randomly on rock surfaces. Many are painted in brown with broad, spontaneous lines that resemble the brushwork characteristic of Hohokam paintings on pottery. The dating of most Hohokam rock art is uncertain because there are few recognizable stylistic or iconographic variants to support suggestions of temporal sequences or regional variations (Schaafsma 1980:83–103).

There were at least two different Mogollon pictographic traditions during this time, although neither one is very well dated. In the mountain areas of the west-central parts of their territory, Mogollon artists made rather simple renderings in red of small human and animal figures on the rock walls of isolated canyons (Schaafsma 1980:187–96). These paintings are generally found in small clusters, and often there seem to be no obvious interactions between individual figures. Superpositioning is rare, and most paintings give the impression of being the result of quick and casual sketches. Rock paintings found in the eastern or desert parts of Mogollon territory, especially in the Jornada District, seem to be an extension of late Archaic "Abstract" traditions which apparently lasted well into the first millennium A.D. in that region (Schaafsma 1980:196–97).

North of the Grand Canyon of the Colorado River, in Utah, the rock art of the Fremont culture has as its hallmark deeply engraved representations of broad-shouldered human figures in ceremonial regalia. Frontal, hieratical, and perhaps masked, these are generically similar to both the nearby late Archaic Barrier Canyon pictographs and Basketmaker rock art of the same region. Other Fremont culture images include shield-bearing anthropomorphs and a variety of game animals, especially bighorn sheep, which also resemble Basketmaker and early Pueblo rock art (Fig. 25).

Dating of the Fremont culture is uncertain: Fremont pictographs may be as early as A.D. 500 or as recent as A.D. 1300 (Marwitt 1970); or the range may be more narrow, from about A.D. 900 to 1200 (Gunnerson 1969). Fremont people, like those of the Jornado Mogollon, may have been less sedentary than most other southwestern farmers, perhaps continuing an Archaiclike reliance on hunting and gathering even as they practiced horticulture. Their use of ancient economic techniques and, presumably, of associated rituals, lends some support to the premise of ideological continuity suggested by similarities between their art and that of the Archaic period (Schaafsma 1980:180–81). Conversely, other similarities to Basketmaker and early Pueblo rock art appear to evidence a complex history for Fremont art as well as support the assumption that different forms of Fremont art served different economically related ideological ends: hieratic and large-scale art fit their Archaic traditions and worldly and small-scale art their horticultural ones. The Fremont variations also support, then, an interpretation of Anasazi art which correlates its drift toward mundane subjects and human scale with increasing domestication of the Anasazi world.

Early Paintings on Pottery and Rock Art: A Comparison

In contrast to the rationality of early Anasazi pottery compositions, their rock paintings generally seem to reflect a concern for creating evocative images that are in uncertain structural and narrative relationships to each other. As with pottery paintings, pictographs are also generally monochromatic with occasional use of secondary colors to define borders or to render details. Many rock paintings are in white or use warm-toned earth colors: ochers, reds, and browns on equally warm-toned sandstone cliffs. Cool greens and blues were also used in combinations that are enormously attractive, especially when there is variation in the colors and textures of the cliff walls. Painting sur-

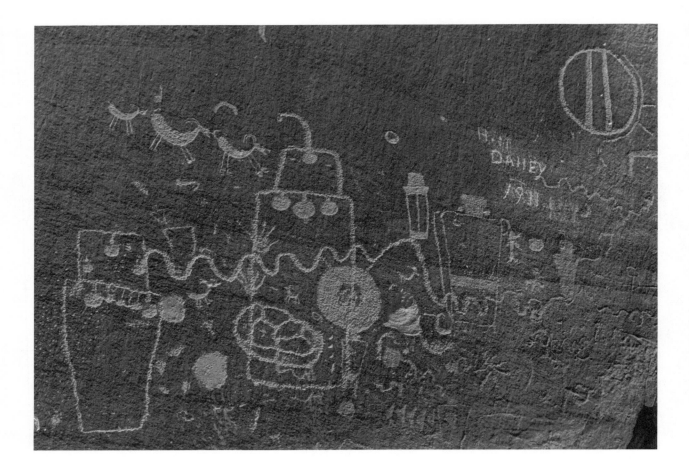

Figure 25. Petroglyphs. Fremont culture, southern Utah, ca. A.D. 1000. The large, armless figures with cryptic, masklike faces are reminiscent of the Archaic art of the region, but the small, realistic animals are like Pueblo II Anasazi art. The sway-backed sheep are reminiscent of Kayenta-style Pueblo III rock art. All appear to be contemporaneous. (Photograph by Dudley King.)

faces were sometimes prepared by being rubbed smooth or more rarely plastered, but most often the artists simply applied paint to a naturally smooth rock wall. The absorbent and granular rock surfaces often make it difficult to recognize brush from finger-applied lines, but finger painting may have been common (Fig. 26). Spattering and smearing as well as the linear application of paint were common. Lines are almost always broad and even-sided with considerably more variation than is evident in pottery painting. In contrast with many Archaic paintings, large color fields were usually outlined, a procedure similar to the drawing methods used in pottery painting, the ancient Mexican decorative technique called pseudo-cloisonné, and other pictorial techniques used throughout Middle America.

Pictographs of this time are found very often within the confines of a village or very close to one. In some

instances, paintings that are now on cliff walls high above ruined buildings and visible from great distances were once only a few feet above a roof and partially hidden by it, and others, which are now in the open, may once have been within the walls of a room. Framed picture spaces are rare and most compositions are perceived today as open-ended and ambiguous: our understanding of their compositional relationships is ruled either by uncertainty or by a deceptive reliance on photographic images. When rock art was organized within picture spaces that are restricted by some natural frame, its compositions tend to be horizontally extended and lack the tight symmetry and closed character of paintings on pottery or basketry designs (compare Plate 5 and Fig. 19). The compositional freedom as well as the use of natural textures, colors, and three-dimensional characteristics of the rock surfaces all combine to give many rock-art sites an

Figure 26. Pictograph, Grand Gulch, southeastern Utah, probably Basketmaker III, seventh–eighth centuries. These lively, spontaneous figures were finger-painted in white on the back wall of a rock shelter used as a habitation site. (Photograph by J. J. Brody.)

aesthetic character that conforms to modernist and postmodern aesthetic ideals (Varnedoe 1984).

Most rock paintings are considerably larger in scale than those on pottery, and their subject matter is far more often representational and dominated by humanoid, human, and other animal images. Styles of imagery and application can vary considerably even within a single site. Some representations are active, some hieratic; some images are drawn to interact with each other while others are isolated; and some are realistic while others are highly stylized. The net effect of all of these variations and, most especially, of our general inability to recognize the boundaries of a picture and to know where any one picture was intended to begin or to end is to place emphasis on imagery rather than on pictorial structure. We thus tend to read these pictures as icons and to analyze them as though they were isolated and disassociated images (which some certainly were) rather than as ruined and fragmentary narrative compositions (which some certainly were also). The key difference between these perceptions is that, in the one case, each image carries its own meaning, while in the other instance, compositional structuring as well as the relationships among images in a group gives complex and dynamic meaning to them all.

Some late Archaic rock-art panels of the Barrier Canyon and Pecos River styles appear today to have greater visual impact than do most Basketmaker and other early Anasazi rock paintings. In both older traditions, more colors and textures seem to have been deliberately manipulated by artists who thus appear to have been involved with a more "painterly" aesthetic than that of the Anasazi. The static, frontal, and hieratic images that were the compelling subject matter of these Archaic paintings are larger and visually more dominating than Anasazi versions of somewhat similar subjects. Despite differences in style and effect, apparent iconographic similarities have led to suggestions that these widely separated groups may have shared common imagery and basic ideologies that are subsumed by the term *shamanism* (Kelley 1974a; Schaafsma 1980:71–72; Wellmann 1979). These suggestions need to be examined, for they not only bear on our understanding of what the art may have meant to the makers but also direct us to assume knowledge about the personalities of the artists and the larger role they may have played within their societies. In point of fact, even if the iconographic assumptions are accepted, the ideological ones need not follow. But if we do not question the ideological assumptions, we must assume that shamanic religious specialists—most likely older men whose ritual training required them to be artists—made, or at least directed the making of, the art.

The term *shamanism* classifies the activities of people who practice any of a wide variety of shamanic techniques, usually concerned with curing or divination; it does not describe an ideological system. Shamans and the people who use their services subscribe to many different ideologies. Shamans are individuals who "receive[d] power to cure and divine direct from supernatural beings through dreams, visions, or spirit possession" (Madsen 1955:48, *in* Tedlock 1978:58). There is a great variety of widely practiced shamanic techniques and paraphernalia, but not all shamans use all of these; and none of the techniques or their paraphernalia are used exclusively by shamans. Shamanism may occur in almost any social or cultural situation, from the most modern, postindustrial urban environment to foraging bands of hunting–gathering societies. Hereditary shamanism can exist side by side with shamanism bestowed on an individual directly by the gods (Eliade 1964:20–21). Shamans may even be formally organized, ranked by seniority, and have high social status—all attributes commonly used to differentiate between shamans and the priests of more formal religious systems. Even the selective process for shamans may be inclusionary rather than exclusionary. For example, about ten thousand shamans are active in a single Mayan community comprised of only about forty thousand people (Tedlock 1978:66–67).

Classification of artistic behavior as shamanistic, without describing more specifically the kind of shamanism and its ideological content and character, is merely an initial taxonomic step that has no explanatory or analytical value. To then assume that paintings we know to be widely separated by time, space, and culture are evidence of shared ideologies because they also share some generalized iconographic features is neither very reasonable nor very useful, as can be demonstrated by a closer examination of them.

The compelling paintings of anthropomorphs that we associate with the Barrier Canyon Style are found on the cliff walls of isolated canyons and appear to be physically distant from habitation sites. Those of the Pecos River Style are in caves that were used for habitation. Somewhat similar pictures from Basketmaker II times may be found within village boundaries in rock shelters. The assumption of ideological similarity

seems to be denied by these contextual differences, especially in the cases of the Pecos River and Basketmaker paintings which are located as though they are part of a community interaction rather than the esoteric property of presumed shamans. The physical context of these paintings seems to isolate them ideologically from the Barrier Canyon pictures. There are other reasons to question ideological assumptions.

For example, a single Pecos River Style image is identified by one scholar with shamanistic spirit possession (Schaafsma 1980:71–72) and by another with priestly worship of a feline deity who is conceived of as an armed warrior–hunter–priest–god (Kelley 1974a:50). Although mutually exclusive, both identifications are perfectly reasonable; neither is subject to verification, and they demonstrate that in the absence of more substantial kinds of documentation, ideological assumptions based only on iconographic similarities are unsupportable.

All that can be said with confidence is that at some remote time in the past, two contemporary but widely separated Archaic groups and a later Anasazi one all painted relatively large images of frontally facing humanoid figures on rock walls which modern sensibilities sometimes find awesome and associate with religion, ritual, and alien mystic systems. Yet it seems certain that speculations about Archaic and Anasazi ideologies that are based on iconographic aspects of their respective painting traditions are more revealing of our own ideologies than they are of those of the past.

The very categories of sacred and secular may have had no meaning to any of these early people, for that dichotomy and the gradations it implies is more suited to the post-Renaissance Western world than to that of the Pueblos and their Anasazi ancestors. The concepts of harmony central to the Pueblo world view would seem to rule out any possibility of separating the sacred from the profane realms, in art as in most other activities. Judgments that any Anasazi painting was more or less sacred than any other must be presumed to be false until proven otherwise.

Some other kind of explanation is required if we are to understand why one class of Anasazi painting differed visually, stylistically, or iconographically from any other—as, for example, why those paintings that were made on domestic objects such as pottery or basketry appear to be different from those made on other classes of artifact.

By far the most common examples we have of domestic paintings are those found on pottery containers. There is little doubt that their prototypes were woven baskets that predated pottery manufacture and that the two technologies coexisted for a very long time and shared a single design system. That system may be classified as a closed one which used visual structures, such as rectangular and trapezoidal panels and bands, as framed spaces within which all pictorial activity was confined. Very often, design elements within a framed space were repeated in a sometimes complex series of symmetrical reversals. Panels themselves were often repeated in reverse configurations on the surface of a container, creating continuous series of nonfigurative images (Figs. 12, 14, 15). The apparent complex variety of Anasazi pottery and basketry design is often an illusion made plausible by the careful and systematic manipulation of line, geometric elements, motifs, framed design areas, and blank spaces.

There is no way to know if the motifs used by these early Anasazi decorators that are today sometimes identified as symbols of clouds, lightning, or corn by Pueblo people had such meanings attached to them at the time they were originally made and used (see, for example, the negative "lightning lines" on Figs. 14 and 15). Some of these motifs, such as spirals or zigzags, were also commonly used on Anasazi rock art as well as by contemporary Hohokam and Mogollon artists.

Perhaps nothing better illustrates the distinctive qualities of Anasazi and Hohokam pictorial styles than the contrasting ways in which the two groups handled designs that were virtually identical. The Hohokam aesthetic goal seemed always to be the creation of open-ended harmonic compositions by the simple device of repeating design units in potentially infinite spatial situations. Visual interest was created by use of subtle variations in scale. The harmony of Anasazi designs depended, instead, on the systematic patterning of design zones each of which was filled with several small-scale design units. It was a visually complex but closed system. Hohokam pottery painting tends to appear spontaneous and casual; Anasazi pottery painting is studied and controlled (compare Figs. 14, 15, and 21).

The pictorial space of a pot or basket is limited and easily perceived, and the logic of compositional structure on such spaces is unambiguous. In early Anasazi art an occasional picture on a pot or basket was composed according to some alternative logic, and in those instances the subject matter was often representational.

Stylistic and iconographic similarities to contemporary rock art could be specific, and compositional schemes could be used that were adapted from rock art rather than from the domestic art systems (Figs. 17–20).

Most rock art appears to be unframed, so that the artistic universe has no boundaries; it is as large, or as small, as the viewer decides. Pictorial compositions which, on bounded picture surfaces, provide the logical and orderly framework within which artists create an imaginary universe are, in rock art, either irrelevant or problematic and controlled by the viewer rather than the artist. If art is a "structuring out of the universe," then much rock art appears to be a different class of activity than framed paintings, for the two are not comparable on a structural level. Images used in the two kinds of art may be similar or even identical, and production technology—as in the application of paint—may also be similar, but the contexts that give the images meaning are vastly dissimilar.

Subjects similar to those commonly found in rock art throughout the San Juan Basin in this era may be painted on pottery using compositional devices within the framed pottery that suggest the boundless space of the rock-art pictures (Fig. 20). The equivalent occurs when drawings on rock have both the imagery and the structure of geometric painted pottery (Fig. 27). Similarity in both function and meaning is suggested by such relationships, even though we know nothing of either the function or the meaning of any of the pictures. At the least, the identities are useful, for they provide ideographic links between Anasazi domestic and nondomestic art. Anasazi rock art occasionally made use of images derived from domestic art traditions, and the reverse is true as well. Contexts may have been different, but imagery and, to the degree possible, structural forms also overlapped.

By A.D. 900 the Anasazi had at least two distinct, widely practiced pictorial traditions: painted pottery, closely associated with domestic activities whose history extended back to pre-Anasazi times; and rock art, which also had a very long and complex history whose outlines are only barely understood. The isolated images that dominated late Archaic rock art, and which suggest esoteric ritual functions, were replaced in Basketmaker II times by rather similar but smaller images that were set in domestic contexts. These less awesome pictures also may have had ritual uses, but there is no tangible evidence to support that surmise or, for that matter, any other. Somewhat later, even smaller an-

thropomorphic and animal figures, which were both active and interactive; hunting scenes; and pictures of ritual events came to dominate imagery at open-air art sites throughout the Anasazi regions. These images were often placed on free-standing boulders, perhaps near hunting areas and far distant from dwellings. Their emphasis on realistic representations as well as the change in locus for the art suggests a major shift in the purposes of Anasazi rock art and, perhaps, in the nature of Anasazi ritual.

While it is simple enough to identify the highly structured art that was placed on utilitarian objects with domestic functions, it is much more difficult to assign a realm for the rock art, particularly toward the end of the period under discussion. It is tempting to associate it with ritual and also to assign to the ritual sphere those utilitarian objects that were painted with similar images. But there is no archaeological evidence to suggest surely any particular secular or ritual use for any early Anasazi pictorial art; while the occasional picture of a ritual event argues for a historical rather than a ritual purpose—a record of the fact that a ritual took place. And ethnographic analogies support a view that the lines separating secular from sacred and ritual from nonritual were at least blurred in those early times.

Who, then, made the art? By analogy with historically recorded practices, we may assume that the pictures on containers were generally made by women and that most others were generally made by men. It then follows that most figurative paintings were made by men, most nonfigurative ones by women; small-scale, tightly organized pictures in closed compositions were made by women, and large-scale, loosely organized, and boundless pictures were made by men. By extension, we can interpret these differences as responding to other kinds of gender distinctions in the daily lives and, perhaps, the ritual lives of these earliest Anasazi people.

In both classes of art, there is a suggestion of a moderate degree of self-selected specialization. The quantity and distribution of painted pottery, for example, suggests a large number of potters, but consistency in the character and quality of the paintings tells of artists whose skills have been honed by an uncommon discipline. Similarly, there are vast numbers of paintings on cliff walls, most of which are characterized by skillful adherence to a dominant aesthetic tradition. Thus, we may tentatively conclude that, as in so many

other aspects of early Anasazi life, painting was an activity which could be practiced by almost any individual with the interest, the skill, and the opportunity to learn. There were many different physical and social contexts in which paintings could be made, and there were separate stylistic and iconographic traditions that were appropriate for each. Art functioned as an integrative mechanism, announcing both social cohesion and individual skill, pride, and self-worth.

Figure 27. Pictograph, Hovenweep district, southeastern Utah, Pueblo II or III, eleventh–thirteenth centuries. The geometric pattern is clearly related to Anasazi pottery design and other decorative art on domestic objects, while the animal is in the more usual rock-art tradition. The paintings are adjacent to the doorway of a small storage room. (Photograph by Dudley King.)

THREE ▮ Tentative Painting: A.D. 900–1300

Anasazi achievements in architecture from about A.D. 900 to 1300 have helped to characterize that period as one of cultural florescence. In the San Juan Basin, the great buildings at Chaco Canyon are the best known of many large and elaborate stone architectural monuments of the time (Fig. 28). Others, including the many smaller but no less elaborate ruins at Mesa Verde in Colorado and in the Kayenta district of northern Arizona and southern Utah, testify to regional variations within the complex network of Anasazi communities. This was a period of population growth fed by increasingly intense exploitation of the fragile, arid environment. Religious, political, economic, and social systems became more complex and stratified, and the material evidences of stratification were everywhere expressed by architecture. There is little evidence of significant elaborations in painting traditions during the period, however. Nonetheless, during this time the foundations were established for both the form and content of the rich pictorial traditions of later periods.

Elsewhere in the Southwest, Anasazi styles in building, village organization, economics, ritual, and many other aspects of intellectual life became widespread. By the end of this period, the Anasazi reached well beyond the San Juan and Rio Grande watersheds, encroaching deeply into territories formerly identified with the Mogollon. Even the more distant Hohokam were deeply influenced by Anasazi ideas. Relationships between the Southwest and Mesoamerica also may have intensified during this period, though the evidence is at best equivocal.

The Greater Southwest

Before the tenth century, cultural innovations and elaborations in the Southwest tended to start in the south and move northward to Anasazi territory. The Anasazi modified these new ideas, and in the realms of art and material culture patterned them to conform to one or another variant of a generic Anasazi style. During the tenth century and later, as Anasazi communities grew in size and complexity, their economic and social networks expanded and the direction of cultural influences within the Southwest was reversed. By about A.D. 1000, many of the more northerly Mogollon and Hohokam communities—as well as those of traditions that were less widespread or are not as well understood, such as the Hakataya and Sinagua—had begun to take on an Anasazi character, and Anasazi styles had deeply influenced pottery decoration and other kinds of manufacture everywhere in the Southwest. By the twelfth century many Mogollon and even some Hohokam communities were virtually indistinguishable from those we call Anasazi.

During the tenth and eleventh centuries there was a great increase in the size and number of Anasazi communities in the San Juan Basin, with apparently equivalent increases in population. At about the same time, similar growth was occurring in the south. Hohokam communities expanded northward into mountain and high valley country where their irrigation techniques and architectural styles, which were so well suited to the hot and flat deserts of the south, proved to be no

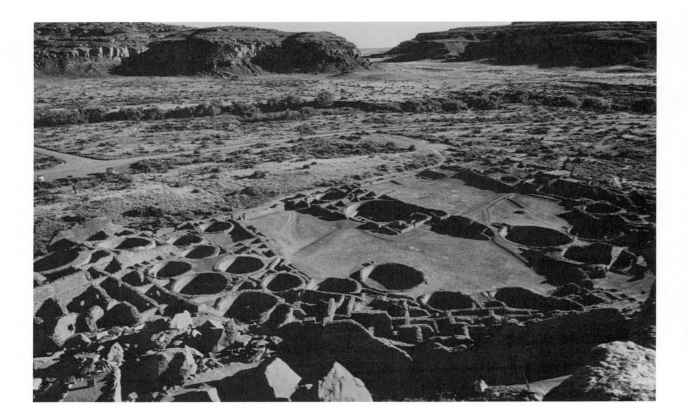

Figure 28. Pueblo Bonito, Chaco Canyon, northwestern New Mexico, tenth–twelfth centuries. The clearly articulated geometry of Chacoan architecture, its use of closed spaces, and exploitation of sharp contrasts of light and dark are expressions in another medium of fundamental Anasazi decorative principles used on domestic and utilitarian objects. (Photograph by David Noble.)

longer practical. These northern Hohokam people adopted the successful methods of neighboring Mogollon and Anasazi groups to their new environments. Also in northeastern and north-central Arizona as well as to the east, many Mogollon communities experienced rapid growth. Their architectural and social solutions to the novel problems posed by larger community size seem to have been modeled on those developed by the Anasazi of the Four Corners. The material remains of many Hohokam and Mogollon villages built between the twelfth and fourteenth centuries are so like variations on an Anasazi theme that cultural classification grows difficult from that time forward and the nature and extent of Anasazi expansion become problematical.

Part of that expansion was simply a function of Anasazi population increase; part resulted from the accretion or recruitment of other peoples into Anasazi communities; and part was due to voluntary changes made

in nonmaterial and material aspects of their culture by communities and people who were not closely related to any of the Anasazi. In turn, these newly made Anasazi no doubt affected changes in the material and intellectual culture of the San Juan and Rio Grande Anasazi and succeeding generations of Anasazi and Pueblo people. Ultimately, Anasazi pictorial arts were deeply influenced by those Mogollon, Hohokam, and other peoples who adopted Anasazi forms of material culture and are now classified as Anasazi.

Much that was fundamental to the material and intellectual realms of Anasazi culture had originated in Mexico and came to the San Juan Basin by way of the Mogollon and the Hohokam. Despite this long history of contacts and demonstrated influences, the rich pictorial traditions of Mesoamerica had little obvious impact on any southwestern painting tradition, except for pottery and other so-called decorative arts, before the fourteenth century.

Painted Objects

Paintings and other kinds of patterned or colored decorations on textiles, basketry, and other portable and perishable manufactures are more fragmentary and rare than pottery paintings, and a perverse fate seems to ensure that the most perfectly preserved specimens are virtually undocumented. For example, what may be the finest decorated baskets of the era were recovered accidently by children from caves in the lava beds near Grants, New Mexico (Plate 6). Despite the scarcity of fine pieces, the evidence is clear that these media supported rich and mature decorative pictorial traditions which had grown from Anasazi protototypes modified by contact with neighboring peoples. These traditions were related to each other and to pottery painting.

Characteristic basketry and textile decoration, whether painted or a by-product of the manufacturing process, included the use of geometric motifs such as stepped figures, scrolls, and frets in rhythmic and symmetrical arrangements that were confined within panels and bands within framed spaces. The motifs used on these objects as well as the structural relationships between the forms of the manufactured objects and the decorations applied to them parallel those that guided pottery painting.

Only a few examples of painted basketry are known. In one, a painted pattern much brighter than the origi-

nal is superimposed over an identical design woven into the coiled basket (Haury 1945b:44) (Fig. 29). Burned fragments of another coiled basket recovered from Pueblo Bonito at Chaco Canyon were covered entirely by a thick coat of smooth clay on which elaborate designs were painted in four colors. The applied design appears to have been a continuous series of long, narrow, and serrated rectangles in paired oppositions which were interlocked as though woven in a diagonal twill pattern (Judd 1954:321). In its original condition, the painting probably resembled one on a stone mortar and others on wooden boards of unknown use that were also recovered from Pueblo Bonito (Pepper 1920:158–59) (Fig. 30). Similar patterns were also painted on now fragmentary wooden slats recovered from the nearby site of Chetro Ketl (Vivian et al. 1978) (Fig. 5). Also, there are at least two examples from northern Arizona of baskets covered with very thick layers of clay and ash and then painted with interlocking serrated patterns in red, yellow, blue, and other colors (Plate 2).

The motifs used in all of these paintings as well as their organization closely resemble the decorative modes of contemporary painted textiles such as those recovered from Painted Cave in the Kayenta Anasazi district of northeastern Arizona and from the Sinaguan site of Hidden House in the Verde Valley of eastern Arizona (Haury 1945b; Dixon 1956) (Fig. 2). They are consistent also with the decorative organization of woven Colonial period Hohokam textiles and pottery paintings, contemporary painted pottery of the Kayenta region and the Chaco district, and rock-art motifs found near several Anasazi sites and elsewhere in the Southwest (Mindeleff 1897:181, fig. 77) (Fig. 31).

Thus, Anasazi decorative methods of this period used motifs and organizational principles that transcended media and technology and served many different kinds of utilitarian and ceremonial objects. Further, the decorative system was widespread and may even have been pan-southwestern, moving northward as it was adopted by the Anasazi from Hohokam or other southern prototypes. Except for occurrences on rock art and pottery, paintings that conform to this system are both rare and portable, raising questions in many instances about their actual place of manufacture and cultural provenience.

Several painted basketry shields are known from this period; all differ significantly in motif and organization from the decorative painting system described above.

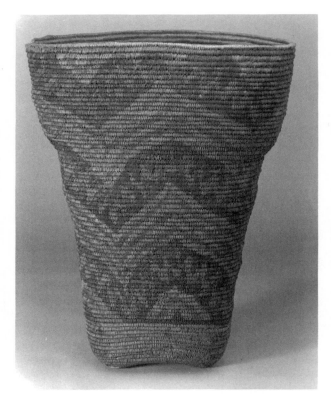

Figure 29. Coiled burden basket, Painted Cave, north-eastern Arizona, Pueblo III, ca. 1200–1250. The original woven design in red and black was painted over, presumably to freshen a worn pattern. Red paint was applied over the original red and dark green paint over the black. Yellow was used as a filler within the green areas. (Amerind Foundation, cat. no. PC28-01, height 20¾ inches, photograph by Robin Stancliff.)

Figure 30. Sandstone mortar painted in red, orange, blue, and green, Pueblo Bonito, Chaco Canyon, northwestern New Mexico, eleventh–twelfth centuries. The layout of interlocking, serrated diagonals is found on pottery, textiles, and baskets from all Anasazi regions, and on painted ritual objects from Pueblo Bonito and Chetro Ketl (see Figure 5). (Department of Library Services, American Museum of Natural History, neg. no. 412132, height 8½ inches, photograph by William Orchard, 1901.)

One, a round plaque about a yard in diameter, is painted with a series of concentric rings. It was included among grave offerings that accompanied the burial of a man at the large Chacoan outlier now called Aztec in northwestern New Mexico (Morris 1924:193). Another, from Mummy Cave in Cañon del Muerto, northeastern Arizona, is dominated by a splayed, vertical, froglike figure with a large circle in its middle (Morris and Burgh 1941:51) (Fig. 32). That central circle suggests the framed space often reserved in the middle of Anasazi painted pottery bowls, especially after about A.D. 1000. The entire painting also resem-

bles some contemporaneous Mimbres pottery pictures (Fig. 33).

The allusion in shield painting to pottery design structures is reinforced by the two framing lines painted around the outer margin of the Mummy Cave shield. This congruence in design structure is difficult to evaluate. Similar compositions and motifs occur in rock art of all periods, as for example in the so-called shield figures of Fremont and many Pueblo IV rock-art sites. A rock painting at the thirteenth-century Tsegi Canyon site of Betatakin in the Kayenta District is also typical of what may have been a widespread tradition of

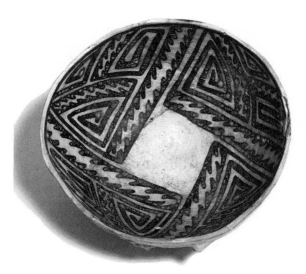

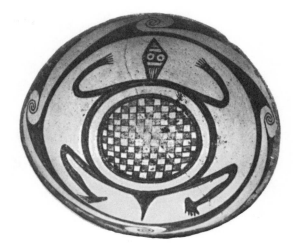

Figure 31 (upper left). Pottery bowl, Flagstaff black on white, Pueblo III, twelfth century. Fourfold patterns that rotate around a blank center space are common pottery and textile layouts in the western Anasazi Kayenta district. The black carbon paint applied over a polished white slip has a rich luster which brightens the negative serrated designs. The motifs closely resemble painted objects from Chaco Canyon (see Figures 5, 30). (Laboratory of Anthropology, Museum of New Mexico, cat. no. 46427/11, diameter 5¾ inches, photograph by Roderick Hook.)

Figure 32 (lower left). Painted basketry shield, Mummy Cave, Cañon del Muerto, northeastern Arizona, thirteenth century. The barely legible painting is of a circular figure with splayed limbs. The shield was found in 1903 and became faded by the sun between then and 1911. A 1907 hand-colored photograph (Culin 1907:frontispiece) clearly shows the figure to be a frog or toad, but its accuracy is questioned (Morris and Burgh 1941:51–52). Compare to Figure 33, Plate 7. (Department of Anthropology, Smithsonian Institution, cat. no. 34162, diameter 31¼ inches.)

Figure 33 (right). Pottery bowl, Mimbres black on white, Mimbres Mogollon, Galaz Site, early eleventh century. Frogs, toads, and lizards are often laid out centrally with all four limbs displayed in bent position. Compare to Anasazi paintings such as Figure 32 and Plate 7. (Museum of Anthropology, University of Minnesota, cat. no. 15B-377, diameter 8 inches, photograph by Mimbres Archive, Maxwell Museum of Anthropology).

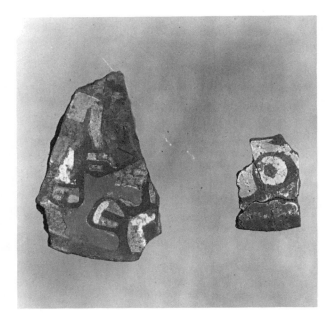

Figure 34. Stone fragments painted in a pseudo-cloisonné technique, Pueblo Bonito, Chaco Canyon, northwestern New Mexico, eleventh–twelfth century. The painting method used on these pyrite mirror backs is Mesoamerican, but it is not known if they were made at Chaco or imported. Parts of a human head and feather headdress can be seen in the lower right-hand corner of the larger (height 2 inches) fragment. (Department of Library Services, American Museum of Natural History, neg. no. 125352, photograph by William Orchard.)

heraldic painting (Schaafsma 1980:fig. 109; Wright 1976:4) (Plate 7). Several modern Hopi clans identify sites in Tsegi Canyon as ancestral homes, and those that interpret the shieldlike painting at Betatakin as a clan symbol reinforce the notion that shield paintings generally as well as that particular image were intended to be ideogrammatic (Courlander 1982; Yava 1978:57, 146).

Further removed from the rigid decorative structuring that patterned most portable utilitarian artifacts are the paintings applied to a variety of objects which appear to have had ceremonial utility. Among the most intriguing of these paintings are fragments of painted sandstone decorated in a variation of the technique called pseudo-cloisonné used on gourds and pottery in prehistoric west-central Mexico. Several specimens of west Mexican pseudo-cloisonné were recovered from the Hohokam sites of Snaketown and Grewe, and fragments of two others were recovered from Pueblo Bonito in Chaco Canyon (Holien 1974; Pepper 1920:51–53). The technique resembles cloisonné in the use of flat areas of color isolated from each other by narrow walls which act as contour lines. The walls separate the color blocks at the same time that they integrate them into coherent motifs. On sandstone, the technique involved application of a thick, tarry substance to a smoothed stone surface. When it hardened, most of the applied material was cut away, leaving only the raised walls to define the zones that were to be filled with colored pigments.

The motifs described by the black contour lines of the Pueblo Bonito specimens are difficult to interpret because both had been shattered and only fragments were recovered. Enough was preserved to indicate that each was circular and had on it an elaborate, bordered picture that included stylized human figures and decorative elements suggestive of feathers and fans (Fig. 34). Eminently portable and iconographically, stylistically, and technically suggestive of a west Mexican or even Mesoamerican origin, it is probable that the sandstone discs were pyrite mirrors with paintings on their backs, paraphernalia associated with the important Toltec deity called Tezcatlipoca (Smoking Mirror) (Holien 1974:170–71). These fragments are among the very few tangible bits of evidence that even marginally support suggestions that Mesoamerican traders may ever have visited Chaco Canyon (Reyman 1978).

The mosaiclike effect achieved with a linear "formline" was also used in paintings that are certainly Anasazi in their origin. Most often, as in paintings on wood and stone, wall paintings, and some rock art, the mosaic effect was gained by directly applying paint to make a broad contour line which isolated flatly painted color areas. At Chaco Canyon, for example, virtually all of the painted wooden objects from Pueblo Bonito and Chetro Ketl have colored areas outlined in a manner that clearly suggests the pseudo-cloisonné fragments that were found there (Reyman 1978:253). Similar painted objects were also recovered from contemporary small and architecturally informal villages at Chaco. Among them are flat wooden effigies of a human face, bird wings, and an insect painted in four colors outlined in black which was found at the small site of Tseh-So (Hibben 1937:96–97).

Many of the painted wooden fragments have been found grouped together as constructions suggestive of birds, bird tails, and puppetlike forms, all of which support the idea that they were used in public dramatic rituals (Vivian et al. 1978:62) (Plate 8). That Great Kivas were the locus for dramatic spectacles seems certain; at the Great Kiva of Casa Rinconada in Chaco Canyon there is even a tunnel providing a hidden entrance to the kiva floor, serving the same purpose as a trapdoor in a modern theatrical stage. The variety of locations from which theatrical ritual paraphernalia has been recovered suggests a relatively widespread and widely practiced activity rather than one controlled by an elite priestly class.

Painted wooden constructions generically similar to those recovered from Chaco have been found in dry caves in southern New Mexico and eastern Arizona and are generally associated with Mogollon or Salado traditions that were contemporary with or somewhat later than the Chacoan specimens (Cosgrove 1947; Ellis and Hammack 1968; Lambert and Ambler 1961) (Fig. 35). That such theatrical constructions were not limited to wood is evidenced by the recovery of leather effigies of sunflowers and of tantalizing fragments of feather mosaic in various parts of the San Juan Basin (Kidder and Guernsey 1919; personal communication, Fred Blackburn 1984).

Cloisonné-style painting was also used on wood and stone carved sculptures such as the painted snake and bird carvings reported from Pueblo Bonito (Judd 1954:278) and from Sunflower Cave in northeastern Arizona (Kidder and Guernsey 1919) (Fig. 36). It is also used on wooden and stone human effigies found in Mogollon country and in the mountainous border regions between Mogollon and Anasazi territories (DiPeso 1950). With rare exception, these effigies are virtually undocumented, undated, and undatable. Some are certainly not Anasazi, but may be Mogollon or Salado and, despite their visual appeal, most are of questionable historical value (Fig. 37).

Painted Pottery

In the period from A.D. 900 to 1300 Anasazi pottery painting is characterized by elaboration and refinement of earlier style trends. Regional variations became increasingly differentiated, and a much higher proportion of pottery was painted than in earlier periods. Pottery painting had become a dynamic and highly

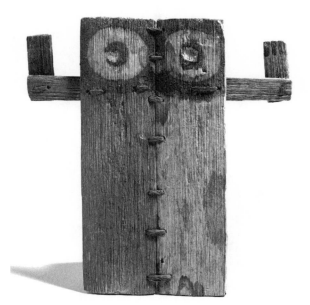

Figure 35. Painted figurine, U-Bar Cave, southwestern New Mexico, Mogollon, Animas Phase, thirteenth century. Flattened slabs of yucca stalk are sewn together with vegetable fibers. Similar construction methods for painted ritual objects in yucca, agave, or wood have been used throughout the Southwest for at least fifteen hundred years. Note a similar use of nucleated circles in the small pseudo-cloisonné fragment, Figure 34. (Laboratory of Anthropology, Museum of New Mexico, cat. no. 26554/11, height 5½ inches, photograph by Roderick Hook.)

creative activity even while its forms and subjects were still controlled by utilitarian needs and by local norms and expectations with regard to craft standards and judgments about appropriate forms, designs, and painting styles.

Except for the occasional use of isolated animals, most pottery paintings are of nonrepresentational linear motifs such as terraced figures, curvilinear or angular scrolls, and interlocking triangles (Fig. 38). Most are in black paint on white-slipped surfaces, and the outlined design units are filled, as in earlier times, with solid masses of black or fine-hachured gray lines. In some places red or orange slips were used with black paint, and other color variations occurred, especially

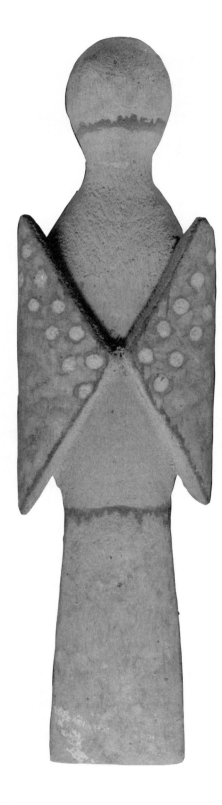

Figure 36. Painted wood sculpture, Sunflower Cave, northeastern Arizona, thirteenth century. Descriptive and representational details were ordinarily painted on Anasazi sculpted forms, whether these were planar constructions or carved in the round. This carved bird was found in a corrugated pottery vessel with an assortment of painted wooden and leather flowers. (Peabody Museum, Harvard University, photo no. NA32100, length 9⅜ inches, photograph by Hillel Burger.)

Figure 37. Painted sandstone figurines, Kayenta district, northeastern Arizona, Pueblo III. Traces of paint are still visible within the hollowed-out spaces of these planar carvings. Similar carvings are reputed to have been recovered in the vicinity of Zuni and Isleta Pueblos. (Museum of New Mexico, Laboratory of Anthropology, cat. no. 43622, no. 43623, height 4 inches, photograph by Roderick Hook.)

toward the end of the period (Plate 9). Linear quality seems to have been highly valued in all regions, and tight control over the application of paint characterizes most Anasazi pottery of the period.

Most often, motifs were placed in rhythmic and symmetrical arrangements on vessel walls. Methods for organizing and patterning designs, for subdividing design spaces, and for controlling the size, scale, and complexity of paintings varied from place to place, but in most regions the vessel form provided the essential basis for pictorial organization. Rather than being decorative overlays, pottery paintings were structurally integrated markers designed to enhance the form of a vessel by use of lines, shapes, colors, and motifs, pictorial elements that were expressively independent of the surface on which they were placed. The art of Anasazi pottery painting involved two kinds of creative expression: imagery and structure. Almost certainly, but perhaps less easily demonstrated than with architecture, the metaphoric value of Anasazi decorative art was expressed by its organizational principles as well as by its motifs.

The occasional figurative subject painted on pottery was usually isolated from the pictorial field and tended to be more loosely drawn than were more common nonfigurative motifs. In both pictorial treatment and iconography, most representational paintings on pottery resemble contemporary rock art, but, as in earlier times, there are significant visual differences also, especially those related to the structure of pictorial space. Figures on pottery were usually painted within framed borders and more tightly integrated within their picture space than was usual for paintings or engravings made at rock-art sites (Fig. 39).

There is significant comparability between Anasazi pottery painting and the comprehensively planned architecture of this period, especially in the Chaco Canyon region and the areas served by the widespread network of Chacoan roads. In most places, strong emphasis was given to sharply articulated geometric shapes: cubes, cylinders, rectangles, arcs, and, where buildings were higher than one story, evenly stepped terraces (Fig. 28). At open sites, light and shadow define the thickness and texture of massive walls and the openings made in them by the varied size and shape of windows and doorways. Light and shade also visually dominate the architecture constructed within the protection of rock shelters. The natural arch of a shelter, which so sharply defines and isolates communities

Figure 38. Pottery bowl, Mesa Verde black on white, Pueblo III, thirteenth century. Bold, negative forms were emphasized in the mature carbon-painted pottery traditions of the northern and western Anasazi. Deep blacks which sometimes fade to gray, soft, and fuzzy-edged lines, and polished white slips that may crackle or have a pearly glow are distinctive. Mesa Verde wares generally have wide and flat rims decorated by dots or ticks. (Laboratory of Anthropology, Museum of New Mexico, cat. no. 35744/11, diameter 6½ inches, photograph by Roderick Hook.)

from the surrounding landscape, is manifested by shadows that also give scale and pattern to the man-made cubes, cones and spheres within (Fig. 40). This architectural aesthetic is radically different in scale but not at all in kind from the aesthetic which shaped pottery painting, basketry, and the other Anasazi decorative arts. And as in those other arts, in architecture also there was a strong tendency to frame space. Those villages built within the protection of large rock overhangs rarely extended beyond the framed space of their natural shelter. Those built in the open were strings of rooms with contiguous outer walls that generally enclosed all of the space of a village or town.

Recognition of the practical, social, and aesthetic values of Anasazi architecture, including its efficient use of solar energy and its organizational forms expressing both social equality and visual rationality,

Figure 39. Pottery bowl, Wetherill black on white, Mesa Verde district, northwestern Colorado, Pueblo III, thirteenth century. Representational images in painted pottery are rare in all Anasazi areas before Pueblo IV, but they are more common in the Mesa Verde district than elsewhere. The imagery is often identical with that used in rock art. (Laboratory of Anthropology, Museum of New Mexico, cat. no. 19841/11, diameter 7¾ inches, photograph by Roderick Hook.)

should not disguise its metaphorical value as artistic expression. The south-facing terraces of multistory buildings were solar collectors that also created useful outdoor work spaces. But the stately rhythms of their geometrical shapes are both aesthetically stimulating and formally identical to the terraced altars of Anasazi ritual and to the ubiquitous terraced images of Anasazi paintings which may be interpreted as stylized clouds. The architectural terraces are utilitarian, but they are also visual metaphors for well-being, constant reminders of the supernatural realm and of ancestors who have become cloud people. Similarly, all kivas, whether built underground or in upper story buildings, were symbolic openings to the underworld; to enter one was always to be reminded of the emergence

of humans to the present plane. The metaphorical character of Anasazi architecture is, of course, the quality that makes it an expressive art related to painting and other art forms.

Elsewhere, in the non-Anasazi Southwest, Hohokam pictorial arts of the tenth through the fourteenth centuries were hardly more elaborate than those of the past. Pottery painting became more highly structured, and motifs were often confined within rectilinear panels as in Anasazi pottery painting styles. During the Sedentary period (circa A.D. 900–1100), design panels were often set at right angles to each other in apparently overlapping, expanding, and dynamic patterns that resemble twill-weave basketry (Fig. 41). Similar patterns have been found on rare painted textiles of a somewhat later date, which were recovered from caves in the northern periphery of Hohokam territory (Haury 1945b; Kent 1983) (Fig. 42).

During the Classic period of the Hohokam, the flamboyant spontaneity of earlier Hohokam pottery painting was replaced by Anasazilike, tightly controlled linear patterns that were kept within framed bands, and the more dynamic compositional structures of the previous period were seldom used. Few new motifs of any sort appear, and there is little indication in surviving Hohokam paintings of any particularly new or strong influences from the south.

Among the most interesting innovations in pottery painting during this era was one developed in southwestern New Mexico within the Mimbres branch of the Mogollon culture in the eleventh and twelfth centuries. Initially stimulated by Hohokam-painted pottery of the Colonial period, Mimbres artists invented a highly organized black-on-white painting system whose dynamic tensions depended on the tight balance of opposing visual forces within the framed concave spaces of small pottery bowls (Brody 1977; Brody et al. 1983). Most of their motifs were nonrepresentational and overlapped almost universally (as did their compositional schemes) with the design inventory of contemporary Hohokam and Anasazi potters. In addition, a significant minority of Mimbres paintings are representations of real and mythical animals and humans, sometimes shown in narrative scenes that appear to depict events in either the real world or in mythology (Fig. 43). A number of Mimbres narrative paintings show activities within spatially illusionistic environments, and the representational sophistication of these pieces is of a very high order. Well over seven thousand Mim-

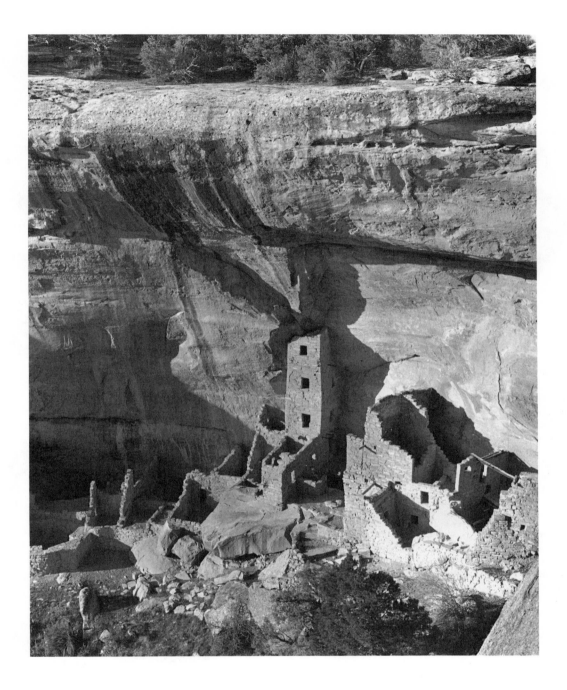

Figure 40. Square Tower House, Mesa Verde, Colorado, Pueblo III, thirteenth century. Mesa Verde Pueblo III architecture is made dramatic by the play of light and shadow which is a by-product of the use of sharply defined geometric forms within south-facing rock shelters. The architectural aesthetic parallels that of other domestic arts. (Photograph by David Noble.)

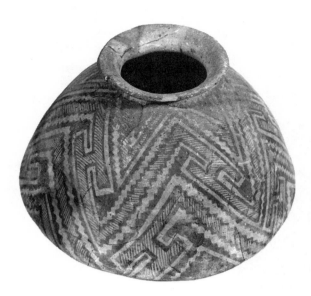

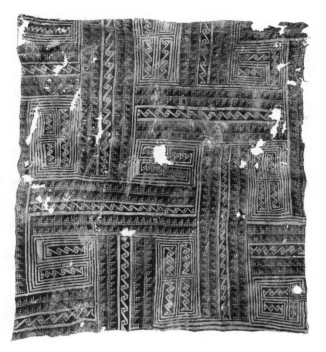

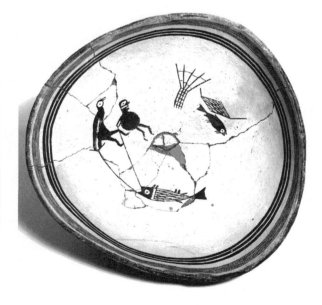

Figure 41. Pottery jar, Sacaton red on buff, Sedentary Period Hohokam, eleventh–thirteenth centuries. Jars with a low center of gravity characterize Sedentary-era pottery. Their upper shoulders were generally painted with a complex of interwoven panels using design patterns and motifs also seen on contemporaneous textiles of central Arizona, western Anasazi pottery, and southeastern Anasazi ritual objects (see Figures 2, 30, 31, 42). (Arizona State Museum, University of Arizona, cat. no. GP47845, diameter 13 inches, photograph by Helga Teiwes.)

Figure 42. Painted cotton textile, Hidden House, Sinagua region, Verde Valley, central Arizona, twelfth–thirteenth centuries. Parallels to contemporaneous Hohokam and western Anasazi pottery designs are clear, both in compositional layout and decorative motifs. (Arizona State Museum, University of Arizona, 56 inches by 64 inches, photograph by Helga Teiwes.)

Figure 43. Painted pottery, Mimbres black on white, Mimbres Mogollon, southwestern New Mexico, ca. 1100. Mimbres artists of the eleventh and twelfth centuries used the interior surfaces of ceramic food bowls for narrative paintings that might simultaneously refer to mundane activities (fishing) and to myth (bird-faced humans). (Laboratory of Anthropology, Museum of New Mexico, cat. no. 19971/11, diameter 10 inches, photograph by Roderick Hook.)

bres pottery paintings are known, and the vast majority have been recovered from mortuary contexts.

Some images in Mimbres art are identified with manifestations of Mesoamerican deities, including Tlaloc and Quetzalcoatl, and may suggest episodes illustrative of Mesoamerican rituals and narrative traditions (Fig. 44). Many similar subjects appear later in Anasazi and Pueblo art and in the art of other Mogollon regions. As well as iconographically, Mimbres paintings seem to prefigure in both technical and conceptual ways the elaborate mural art and some pottery-painting styles of the Anasazi that did not come into use until almost two centuries after the end of the Mimbres pottery-painting tradition. The conceptual similarities are both general, as when compositional emphasis organizes action within closed pictorial spaces, and specific, as in the studied use of voids to suggest real-world environments.

Pottery painting also became an important art at Casas Grandes in northern Chihuahua during the eleventh century. Its influence in southwestern New Mexico overlapped with that of the Mimbres, and became quite important throughout the Southwest toward the end of the Pueblo III and the beginning of the Pueblo IV eras. As it evolved, the Casas Grandes tradition came to be characterized by production of highly polished polychrome wares precisely painted with stylized macaw heads, snakes, feathered serpents, and a variety of feather and corn motifs. Animal and human effigy vessels were also made there.

The history of painting in the non-Anasazi Southwest from about A.D. 900 to 1300 is considerably more complex than it had been in earlier periods. Radical innovations in both style and subject matter of pottery painting and related changes in rock art occurred in many places in that vast region. In some areas, as at Casas Grandes and in Mimbres and Jornada Mogollon territories, it appears that iconographic novelists were introduced from further south. In other regions, especially along the northern peripheries of Mogollon and Hohokam territories, painting styles evolved that evidently were adaptations of ideas that had originated with or been developed by the San Juan Anasazi.

Mural Painting

The earliest known Anasazi mural or wall paintings date from this time and are linked stylistically and iconographically to both contemporary rock art and

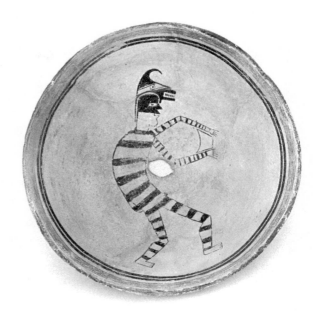

Figure 44. Painted pottery, Mimbres black on white, Mimbres Mogollon, southwestern New Mexico, ca. 1100. Some imagery related to the ritual art of central and western Mexico, which came into use by the Anasazi after 1300, first appear in Mimbres pottery paintings. The horned serpent headdress with snoutlike mouth resembles a Mexican ehactl mask—Quetzalcoatl in his manifestation as the Wind God. (Taylor Museum, cat. no. 4589, diameter 9¼ inches, Colorado Springs Fine Art Center, photograph by Fred Stimson.)

decorative art, especially pottery painting. Excluding rock pictures that may at one time have been associated with architectural features that since have been destroyed, the known distribution of wall paintings made between about 950 and 1100 is limited to a few sites in the Chaco and Mesa Verde districts. Many more examples distributed over the entire San Juan Basin are known which were made between about 1100 and 1300, but even at that time mural painting was not yet a highly developed art form. No murals of this historical period are known from Anasazi sites in the Rio Grande drainage.

The anomalous and problematic quality of the history of early Anasazi mural paintings may be epito-

Figure 45. Pictographs, Turkey Pen Ruin, Grand Gulch, southeastern Utah, Pueblo III, thirteenth century. The rock shelters of the San Juan region were used extensively, both as habitation sites and as rock art sites, during Basketmaker times and again in the Pueblo III period. Though stylistically identical to Basketmaker art, these birdlike images were painted on the smoke-covered wall of a Pueblo III room and appear to be copies of nearby Basketmaker III paintings. (Photograph by J. J. Brody.)

mized by one room at a large rock shelter in Grand Gulch, southeastern Utah, which protected the Pueblo III cliff houses that we call Turkey Pen Ruin. First excavated at about the turn of the century, that shelter once had protected a Basketmaker III village, and its back wall is decorated by a large number of paintings in the style of the earlier period. Among these are two large, birdlike images in white with black outlines painted immediately above the remains of a rectangular stone and adobe Pueblo III room that butts against the cliff wall. Similar images, though very faint indeed, can be made out painted on the heavily blackened plaster of the back wall of a Pueblo III room which had been raw cliff during Basketmaker times (Fig. 45). We cannot tell directly if the pictures are contemporaneous, but all fit well into a style category that we associate with Basketmaker III. However, one painting unquestionably was made on a plastered and blackened

surface on the back wall of a room whose architectural style is characteristic of a much later Pueblo period. We know there is a wall painting, and we know that it looks like nearby rock-art images, but the wall appears to be of one era and the painting of another. There are other examples of similar anomalies elsewhere in the San Juan Basin, and comparison with less anomalous wall paintings of the region seems not to be very clarifying.

Early murals in the Mesa Verde area are reported from a circular kiva at Alkali Ridge, Utah (Brew 1946:141, fig. 87b, d; Smith 1952:55–56), from another kiva and from a room near Cortez, Colorado (Prudden 1914:48–49; Morris 1919:170, Plates 34c, 35; Smith 1952:56), and from a nearby ruin in the vicinity of Mancos Canyon (Jackson 1876:373, Plate 3; Smith 1952:56). All of the paintings are nonfigurative; motifs are bands of horizontal or diagonal lines, triangles, and stepped forms (Plate 10). The relationship to pottery painting is obvious in the motifs and even more so in the organization of pictorial space.

As in painted pottery, the mural designs were placed in bands that circled the interior space enclosed by a structure or, alternatively, were in bordered units marking distinctive architectural features. In one instance, eight-inch-wide bands are described as "running around the floor, sides and ceiling" of a room (Jackson 1876:173). In two others, decorative bands were confined to the face of a shallow bench or banquette jutting from the wall of a room. Few technical details concerning the paint or means of application are available. Colors used included white, red, brown, yellow, green, black, and "clay-colored." With the possible exception of black, we may assume all to have been mineral colors.

Kiva 3 at the small site of Tseh So in Chaco Canyon, which may have been built as early as A.D. 922, had traces of black and white paint on its plastered interior walls. Seven different groups of designs were also incised through the wall plaster there (Fig. 46). Most of this graffiti is cryptic, but one set of images included "a fish and possible vegetable or tree design" (Hibben 1937:79). The distribution of these motifs, the drawing techniques, and the mixing of media all strongly resemble the rock art of open-air sites.

Two kivas at the small eleventh-century village now called Bc 51 at Chaco also had fragmentary paintings on their walls. One, on the east wall of Kiva 5, is described as a "crude, unrealistic representation of a human, possibly wearing a headdress, and with details of eyes and hands incised rather than painted" (Kluckholm 1939:38). The picture was painted in white gypsum and had traces of blue and red as well. It was placed on the second and third layers of thirteen layers of plaster that had been applied at various times to the kiva walls.

There were thirty-one layers of plaster on the walls of Kiva 6 at the same site. On the fifth of these, a picture was painted in white in which ten ten-inch-high human figures with bows and arrows appeared to be hunting several bighorn sheep and deer (Fig. 47). This was also crudely executed and was similar in both style and subject to hunting scenes found in contemporary rock art as well as in some thought to be dated earlier that were found all around Chaco Canyon (Fig. 48).

Perhaps the most complex of these early murals was found within a large circular kiva at a site called LA 17360 excavated near Chaco Canyon. Built in about A.D. 1190, the interior wall of the kiva was carefully coated with whitish adobe plaster above a dark brown dado. Four sets of roughly triangular figures, which jut up from the dado in configurations to suggest mountains on the horizon, are painted in the same brown color. Floating above that horizon, and also in brown paint, are a humpbacked flute player and a large crescent (Doyel et al. 1989; McAnany 1982; Silver 1982) (Fig. 49). The mountainlike forms suggest the four sacred mountains which define the home territory of so many contemporary southwestern native peoples, and the flute player could be a hunting deity, especially if the crescent is interpreted as a rabbit-hunting throwing stick (Beaglehole 1936; Brill 1984).

The style as well as the iconography of both the humpbacked figure and the crescent resemble images sometimes found in contemporary Anasazi painted pottery and often in Anasazi rock art at many places in the San Juan Basin (Brill 1984) (Fig. 50). The mountainlike forms resemble those on a Mesa Verde mural painted about a half-century later at the Salmon Ruin, a large Chaco outlier with a later Mesa Verde occupation not too distant from LA 17360 (Fig. 51). This kiva mural thus appears to link early mural painting with both pottery-painting and rock-art traditions. Further importance is given to it by the apparent intent of its artist to create the illusion of a comprehensive landscape within which supernatural beings are shown. That illusion, which depends on the relative placement of figures, "mountains," and ground line, predicts visual devices that characterize the far more complex mural paintings of a much later time. It also resembles those

Figure 46. Incised plaster wall, room interior, village of Tseh So (Bc 50), Chaco Canyon, northwestern New Mexico, eleventh century. The drawing on the left looks almost like a plan view of a Basketmaker pithouse with an entry ramp pointing downward. (Courtesy of Maxwell Museum of Anthropology and National Park Service, neg. no. 30678.)

0 5 10 Inches

contemporary hunting scenes at open-air rock-art sites which also imply landscape environments by the combination of draftsmanship and figural relationships.

Murals dating from about 1100 to 1300 are comparatively more complex and refined than earlier ones. There even may have been more of them distributed over a wider area, but at best, the mural painting tradition was not very well developed. The largest number are reported from the Mesa Verde region, but even there, comments by early archaeologists emphasize their "paucity" and describe them as "crudely drawn" and "without any very elaborate development of design" (Smith 1952:59).

Several kivas of this period in the Mesa Verde region were decorated with dark red dados along their lower walls or banquettes on which a number of sets of small isosceles triangles were painted in groups of three along their upper edge (Smith 1952:62). Most have only a generic resemblance to the painted kiva at LA 17360, but at least one, a twelfth- or thirteenth-century kiva at Spruce Tree House, seems to represent a landscape with mountains and several bighorn sheep on the horizon (Nordenskiöld 1893:fig. 77). Borders of dots that surround the mountainlike forms are similar also to dots used around the mountain shapes in the roughly contemporaneous Salmon Ruin mural.

Dots and rectangles were painted on a wall at Cliff Palace (Chapin 1892:143; Fewkes 1911:32, fig. 13a), borders of white dots were used at New Fire House (Fewkes 1916:106, fig. 2, Plate 7), and white painted dados and triangles were used at another kiva in Spruce Tree House (Fewkes 1909:20). In the same general region but west of Mesa Verde, a kiva at the Lowry Ruin

Figure 47. Incised plaster wall, Kiva 6, village of Bc 51, Chaco Canyon, northwestern New Mexico, eleventh century. Stylistically, this mural of a hunting scene is identical to contemporaneously engraved or painted pictures at outdoor sites (see Figure 48). (Katrina Lasko drawing, after Kluckhohn 1939:38–39.)

is painted in white with a continuous terraced pattern (Martin 1936:42, fig. 6, Plates 48, 51, 58–64) (Fig. 52). A more complex meandering fret design was found in a room at nearby Montezuma Creek, Utah (Smith 1952:58, fig. 7h). Throughout the region, a variety of other painted patterns have been found on the walls of kivas and residential rooms. These include straight and wavy parallel-line patterns and more elaborate designs and motifs such as rectangles divided into symmetrical figures filled with hachures, frets, "Tau" figures, and connected diamonds (Smith 1952:62). In at least one example, at Cliff Palace, a filled rectangle suggests the representation of a painted textile (Nordenskiöld 1893:fig. 78).

Similarities to the kind of patterning used on contemporary basketry and pottery of the Mesa Verde region are quite specific. The extensive use of dots on the borders of painted dados and murals echoes the use of dotted and ticked rims to frame-painted pottery bowls that is characteristic of the Mesa Verde style. Equally characteristic of Mesa Verde painted pottery are small triangular elements evenly distributed along a bordering line and meandering frets and connected diamonds. As with some earlier wall paintings, the parallel

Figure 48. Pictograph, Mockingbird Canyon, Chaco Canyon, northwestern New Mexico, tenth–thirteenth centuries. Though cryptic, these lively little drawings are of realistic animals who interact within a spatial environment that is defined by their actions. Compare to Figure 47, where the kiva walls provided a limiting frame around the picture space. (Photograph by Dudley King.)

decorative treatment given to pottery bowl interiors and the hollow cylinders of circular kivas is worth noting (compare Figs. 38 and 52).

Figurative motifs were used in Mesa Verde wall paintings for the first time during this period. As was the case earlier at Chaco, they resembled contemporary rock art in both style and subject. Birds were the subjects of paintings at Mug House and at a cave site near McElmo Canyon (Smith 1952:58–59, 63, fig. 7d, g), and a plumed serpent, perhaps the first to be used at an Anasazi site, was reported on a wall of a ruin in the same general area (Ferdon 1955:11–12). A small image of a human flute player that may have had a humped back was reported at Sandal Cliff House (Chapin 1892:122), and several small humpbacked phallic humans with bows and arrows were painted on a wall at New Fire House (Fewkes 1921:88; Schaafsma 1980:fig. 101; Smith 1952:62–63, fig. 7f).

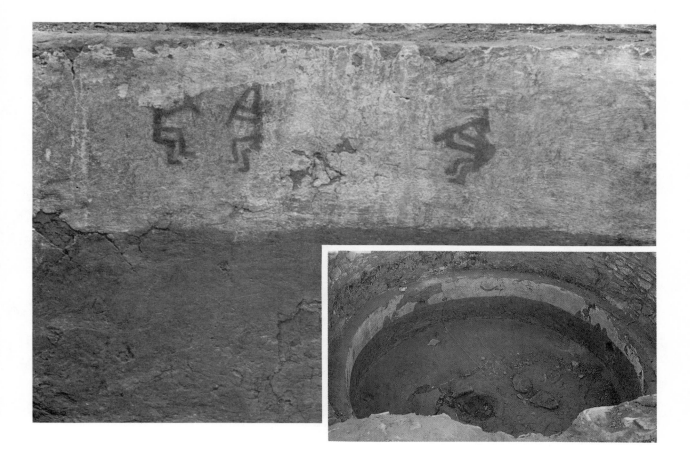

Like the flute player on the kiva wall at LA 17360, those at New Fire House were roughly painted monochromatic silhouettes. One appears to have the face and horns of a bighorn sheep, and another has a featherlike projection on its head. Crudely drawn animals that vaguely resemble bighorn sheep and triangular forms fringed with dots are associated with the humanoid figures. The dotted triangles are somewhat like those found at Spruce Tree House and described above, and there may have been some iconographically meaningful associations of dotted triangles with mountain landscapes, bighorn sheep, and supernatural hunters.

Considering the very great number of domestic rooms and kivas excavated at Chaco Canyon, the paucity of mural paintings from that area is remarkable. Only a few have been reported that postdate 1100, and none are described in detail (Cassidy 1936:52; Smith

Figure 49. Wall painting, kiva, site LA 17360, Chaco district, northwestern New Mexico, eleventh century. The flute players in this monochromatic painting appear to float above the ground line as though they were in the sky above the earth. Irregularly shaped triangles (inset) jut upward like mountain peaks from the dark-colored dado, adding to the illusion that the entire round kiva wall is a single landscape. (Photograph by Connie Silver.)

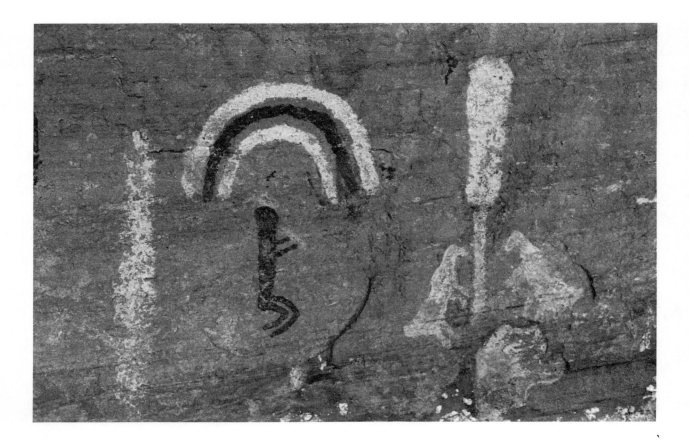

Figure 50. Pictograph, Pictograph Cave, Cañon de Chelly, northeastern Arizona, ninth–eleventh centuries. The multicolored arc above the flute player suggests a rainbow, but the association of sky and fluteplayer is more ideographic than pictorial. Unlike the kiva wall of Figure 49, which is treated as a unified picture space—a single sky in which several figures interact—the pictorial space at this rock-art site is characteristically fragmented. (Photograph by David Noble.)

1952:64). Unlike contemporary murals from Mesa Verde, which are uniformly monochromatic, the few from Chaco, such as one from the site of Kin Kletso, and another from Chetro Ketl are multicolored. Kin Kletso is an early twelfth-century community with architecture that is distinctly Mesa Verdean in style. Nonetheless, the mural there is quite different from any reported from the Mesa Verde district. It is a totally abstract series of painted horizontal stripes in red, white, and yellow. The painting from the small, rectangular Room 106 at Chetro Ketl consists of a precisely drawn stepped pattern of dark blue and faint, red-brown rectangles (Plate 11).

Elsewhere, monochromatic paintings with a limited inventory of motifs similar to those found on contemporary rock surfaces seems to have been the rule. To the south, at the Village of the Great Kivas, a Chaco outlier near Zuni Pueblo, vertical and horizontal pan-

els with triangular and striped motifs were crudely incised into the walls of a circular kiva and then colored with a light pigment (Roberts 1932:78–80, Plates 13b, 14a). The painting from the Salmon Ruin with mountainlike forms, which was discussed earlier, is in dark red on white plaster and, though more boldly painted, is clearly related to similar pictures at Mesa Verde. At the nearby Aztec Ruin, another Chaco outlier which has a twelfth- or thirteenth-century Mesa Verde component, dados with white dotted borders were reported in residential rooms as well as kivas (Smith 1952:64). There, too, graffitilike "pictographs" that were later covered by a coat of colored plaster were incised into the white plastered wall of a room (Morris 1928:fig. 13).

Frets were reported on the face of a bench in a kiva at Cañon de Chelly, and a circular kiva there had a white painted dado capped by triangular serrations in sets of four (Mindeleff 1897:181, 178–79, fig. 72). Also at Cañon de Chelly, geometric bands were painted on the inside wall of a circular kiva at Three Turkey House (Colton 1939:27–28, fig. 7). More complex horizontal bands of terraces, frets, and other motifs culled from the inventory of decorations applied to utilitarian objects were painted on the walls of two kivas at the Kayenta site of Betatakin in northeastern Arizona (Judd 1930:figs. 1, 2).

More complicated paintings of the period are reported from the Gallina district of north-central New Mexico. These occur at several small village sites that probably should be considered as provincial Anasazi; they were once thought of in terms of a separate "Gallina Culture" (Hibben 1938, 1949). Because Gallina material culture, especially painted pottery, is generally less than elegant and provides some justification for categorizing the region as "provincial," mural paintings there appear to be surprisingly complex and well developed. All that have been reported are monochromatic. The best known is a series of framed panels in a band on the face of an adobe bench along one wall of a rectangular pithouse which may have been a kiva. Each panel is different. In one, a series of triangles are appended to a vertical line rather like pennants on a flag staff; another has sunflowers, and another a spruce-like evergreen tree. At another place, the cliff wall near a set of rooms in a rock shelter is painted with a spectacular mural of realistic ducks or geese in flight (Gallencamp 1950; Smith 1952:65–66, fig. 7a, b, c, e) (Fig. 53).

Figure 51. Wall painting, Salmon Ruin, northwestern New Mexico, eleventh–thirteenth centuries. Triangles on line which are ubiquitous and presumably nonrepresentational in Anasazi decorative art can, with minor modifications and in the right context, suggest mountains. See Figures 20, 49. (Salmon Ruin, San Juan County Archaeological Research Center, New Mexico.)

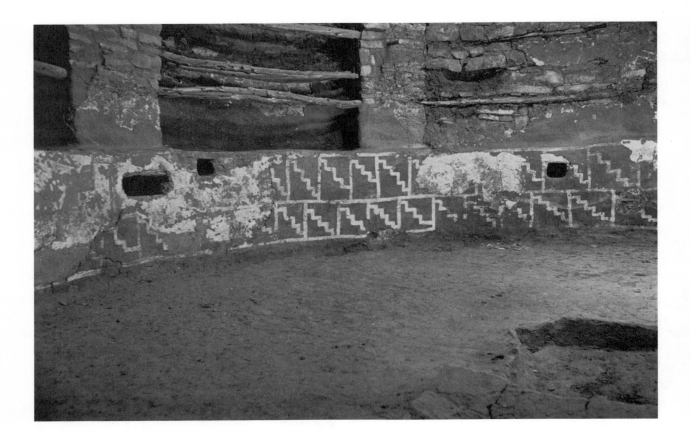

Figure 52. Wall painting, kiva, Lowry Pueblo, Mesa Verde district, southwestern Colorado, Pueblo III, twelfth century. In every respect—color, spatial organization, motif, positive–negative patterning—the painting here is like that on contemporaneous Mesa Verde decorated pottery. Mural painting in ritual buildings of the Pueblo II–III era could be as closely related to nonfigurative, domestic art made by women as it was to representational rock art made by men. (Photograph by Dudley King.)

The most elaborate Anasazi mural we know that may have been painted before 1300 is from the site of Atsinna located about midway between modern Acoma and Zuni pueblos. Atsinna is one of several ruins considered ancestral to Zuni. The mural there was probably painted between about 1250 and 1300 (personal communication, Steven LeBlanc 1982) and was so fragmentary when excavated that it could not be preserved (personal communication, Gordon Vivian 1957). The Atsinna painting is so much more closely related to the rich mural painting tradition of the following centuries than to any of earlier times that it could well be considered an early Pueblo IV painting.

This transitional mural included a series of rectangular panels, each subdivided into two or more sets of symmetrical designs painted in black, red, yellow, and white on the white plastered wall of a kiva (Plate 12). The panels may once have covered all or most of the

wall in a repeat pattern. In its complex geometric patterning as much as in its use of individual motifs, it resembles polychrome pottery and textile designs of the region that date from the thirteenth, fourteenth, and fifteenth centuries. Motifs included stepped figures, interlocking triangles, arcs, ticked lines, and other geometric elements.

With the exception of the Atsinna mural, none of the known Anasazi wall paintings that predate 1300 are particularly elaborate. Most are monochromatic in red, white, black, or gray paint on tan, white, or light gray plastered walls. Other colors were used occasionally and, since color technology was well developed in the widespread rock-art painting tradition, the slow adoption of color to mural painting must be interpreted as a matter of choice rather than of limited knowledge. With rare exceptions, the better organized murals are on the walls of circular kivas and mimic the banded

Figure 53. Pictograph, Nogales rock shelter, Gallina district, northwestern New Mexico, eleventh–thirteenth centuries. This flight of monochromatic flying birds is within the domestic space of a cliff dwelling. Compare to Figure 20. (United States Department of Agriculture, Forest Service, Santa Fe National Forest.)

patterns which encircled the interior walls of pottery bowls. Most other wall paintings bear the same sort of uncertain relationship to their picture spaces that characterizes most Anasazi rock art.

The interaction with rock art and pottery painting are also seen when mural subject matter is examined. Figurative pictures usually use imagery and styles that are clearly derived from the rock-art traditions. Nonfigurative paintings use motifs identical with those that usually decorated painted pottery, basketry, and textiles. Thus, two well-established and well-developed but largely independent painting traditions seem to have been separately used as models for these early wall paintings. One was decorative, nonobjective, and highly structured; the other was figurative, expressive, and loosely structured. The two modes might coexist on a single wall, but only as separate images.

Toward the end of the period, a more complex and highly integrated kind of mural painting made its appearance as though predicting the future. By 1300, the technology for a complex mural painting tradition was in place, as was the accumulation of experiences that could make the creative pictorial explosion of the following centuries comprehensible in terms of Anasazi artistic evolution.

Rock Art

There was a proliferation of rock art in all Anasazi areas during this time. Cliff faces and the boulders of talus slopes near and within village sites were commonly used surfaces for both rock paintings and petroglyphs, and both media are also found near springs and in isolated locations (Schaafsma 1980:135). The mural painting tradition which seems to have begun during these centuries was related to rock art and, to some degree, derived from it. At times, it appears as though the two traditions are indivisible. As noted, some pictures within rock shelters were made on the back walls of rooms that have since been destroyed, leaving only the cliff and its art visible. There are examples also of older art within a rock shelter being incorporated within the walls of a much later room.

In certain parts of the Four Corners, other kinds of artistic interactions between early and later peoples are still visible. In the Grand Gulch drainage, for example, virtually all pictographs found at occupation sites, whether of Archaic, Basketmaker, or Pueblo II or III age, were bombarded with mud balls by later people

(Plate 4). The colorful residue adds an attractive and harmonizing patina to the rock surface, which curiously suggests deliberate modification of the ancient images.

Among the most common rock-art representations are humans, human hands, lizards, birds, and game animals, especially deer and bighorn sheep. Images of corn occur, but other plants were rarely represented. Common nonfigurative motifs include spirals, concentric circles, stepped figures, frets, and sets of triangles often arranged in designs similar to those used on pottery and baskets (Fig. 54).

Other than representations of phallic, humpbacked flute players, pictures that obviously refer to deities, supernaturals, culture heroes, or ritual are rare. More common and problematic are stiff, front-facing human figures, lizards that are easily anthropomorphized, and masklike heads which, like images of hands and such geometric forms as stepped triangles or pyramids, arcs, trapezoids in rows, large, isolated circles, and spirals, are all subject to a variety of interpretations. Associations and contexts are usually essential for evaluating the plausibility of any interpretation; the impossibility of directly dating any of the images compounds the problem.

Many spirals, concentric circles, and fringed circles may well have been sun symbols. When these are located in contexts that clearly relate to solstice, equinoctial, and other kinds of celestial observations, such interpretation seems warranted. Other images, including serpents, starlike forms, and hands that appear to be associated with possible sun symbols, may be presumed to have a related iconographic value. There is always a dynamic symbolic potential for images in open-air sites which can be seen to interact with light, shadows, and natural and man-made structures. If the interactions were deliberately structured, these become components of a complex art form that might have practical utility. That dynamic may be dramatically seen today by observing beams of sunlight as they move across certain rock images, penetrating shadows or casting them at the time of a solstice. As the sun advances in the sky, a dagger-shaped beam of light may move slowly across the face of a spiral engraved on a boulder or a cliff wall, or in snakelike patterns across a panel of images on a rock surface (Sofaer et al. 1979; Williamson 1984:92–103). Shadows cast by buildings also may have been incorporated within an expressive complex wherein pictures, ritual, calendric systems,

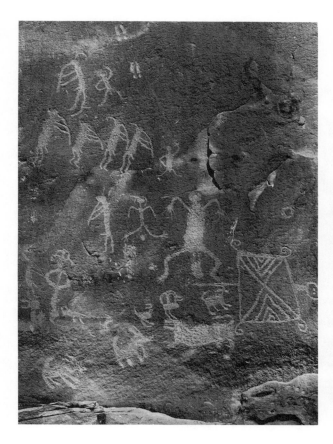

economics, and the social order were all integrated (Williamson 1984:124–29).

The so-called Supernova painting at Chaco is thought by some to record a spectacular stellar event that took place on July 4, 1054. It is located on the walls of a sandstone cliff a few hundred yards distant from the large, mesa-top Chacoan town called Peñasco Blanco and is among the most complex paintings at Chaco. Its images include a hand, a starlike form, and a crescent on the plane of the "ceiling" of the naturally fractured cliff and several concentric rings on its back wall (Fig. 55). Similar motifs are also found engraved at a sun-watchers shrine near Zuni, and other, more recent configurations of the same sort are known from other places (Cushing 1967:40–41; Williamson 1984:77–78). The mesa-top immediately above the painting is an ideal location for solar observations, especially at dawn, and we may reasonably assume that the painting, sun-watching, and daily life at Peñasco Blanco all interacted

Figure 54. Petroglyph, Chaco Canyon, northwestern New Mexico, tenth–twelfth centuries. A typical Pueblo II–III panel of graphic images. Animals, fluteplayers, active little humans, rabbit tracks, and a geometric design that becomes a lizardlike animal form a bewildering array of images in a single space. Some, such as the line of fluteplayers, appear to be in a narrative configuration, but most seem to be visually and ideationally independent of each other. (Photograph by David Noble.)

Figure 55. Pictograph, Chaco Canyon, northwestern New Mexico, eleventh century (?). This painting has been interpreted as depicting an extraordinarily bright supernova that was visible in the eleventh century. If so, it is a rare example of an Anasazi artist recording a memorable natural event. (Photograph by David Noble.)

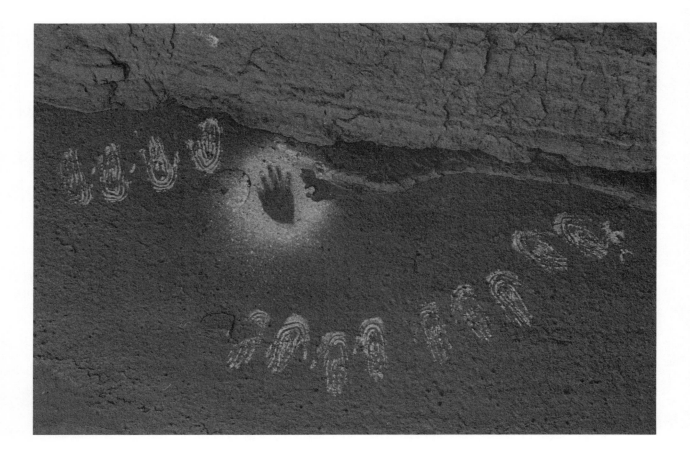

Figure 56. Pictograph, Cañon de Chelly. Handprints made in every conceivable way are painted, stenciled, stamped, drawn, and engraved at many Anasazi and modern Pueblo rock-art sites. In the Anasazi heartland from Basketmaker times through Pueblo III, sets of handprints were often patterned in elegant compositions. In at least some cases they seem to be signatures—marks left by ritualists at a sacred place. (Photograph by David Noble.)

(Williamson 1984:180–89). The question of whether the painting recorded an observed stellar event is likely to remain unanswered, but it is abundantly clear that its pictorial references are celestial and that it served somehow to support ritual.

Many individual rock pictures were carefully made and composed with regard for naturally occurring shapes, frames, and imperfections of the stone. Sets of images, such as painted handprints, often seem to have been made at one time and are patterned with compositional unity (Fig. 56). Humans and animals were often organized to imply narrative interactions in real world environments in which landscapes are suggested by the relationships between figures despite the absence of background details. Scale differences between figures, as well as draftsmanship, contributed to these interactive and spatial illusions (Plate 13).

Even where superpositioning or differential pati-
nation occurs, it appears at times as though later art-
ists placed their pictures with compositional regard
to preexisting ones on the same surface (Schaafsma
1980:136) (Fig. 57). Similarly, a desire to pattern rock
surfaces is evidenced in work areas where, for exam-
ple, randomly placed abrasion marks made by shaping
bone awls on a sandstone wall could be converted into
a pattern by applying the same method to make a few
nonrandom lines (Fig. 58). Sometimes, large individ-
ual images, including great circular motifs and enor-
mous animals, were placed in compositionally domi-
nating positions on a rock wall (Fig. 59).

The patterning of marks, images, and designs on
rock surfaces could be anything from entirely random
to entirely structured, and, because so much of it was
additive, artistic intent and style changed from time to

Figure 57. Petroglyphs, Tapia Wash, central New Mexico, Ar-
chaic or Basketmaker II superimposed by eighteenth- or
nineteenth-century Navajo. There is a tendency for art at
outdoor sites to generate new art that may even be super-
imposed over the old. The ancient, larger than life-size,
heavily patinated reclining figure that appears to be giving
birth underlies a more visible and far more recent standing
figure. (Photograph by J. J. Brody.)

Figure 58. Patterned abrasions, Grand Gulch, southeastern Utah, Pueblo III, thirteenth century. Bone tools were formed and sharpened by abrasion against the friable sandstone wall at the back of a rock shelter used as a Pueblo III habitation site. At some point, a toolmaker began to pattern out the otherwise randomly made marks to make a vertical zig-zag line. (Photograph by J. J. Brody.)

time. As in earlier times, most rock-art panels were dynamic, unframed pictorial surfaces that seem to have been worked on over time by an unknown number of artists who sometimes showed concern for earlier pictures made on the same or nearby surfaces and often did not. As with most other Anasazi rock art, there is usually no direct evidence for dating any of it or even assigning it a place within a cultural sequence.

Colors used in pictographs appear to have been made from local clays and other mineral sources and include a wide range of reds, browns, yellows, and ochers as well as blue, green, white, and black. Paintings which combine several colors are not uncommon, and colors are sometimes separated from each other by white or dark contour lines. Paintings made on the varicolored sandstone walls of canyons in the San Juan Basin are pictorially and texturally quite rich, as had

been the case in that region since Archaic times. The wealth of rock paintings in that area may be taken as evidence that the artists were eager to explore the aesthetic qualities of the natural world that surrounded them.

Many paintings are directly associated with villages placed in south-facing rock shelters along narrow canyon walls. However, cultural affiliation and dating are both made difficult by the fact that many of these shelters were occupied at different times by different peoples. Later artists were certainly aware of the work of earlier ones, as witnessed by arrays of mud daubs, and may well have been influenced by them. Therefore, stylistic and iconographic anachronisms should be expected.

Rock paintings are generally found along the back wall of the rock shelters which formed a natural frame

Figure 59. Pictographs, Jailhouse Ruin, Bullet Canyon, Grand Gulch, southeastern Utah, Pueblo III, thirteenth century. Large-scale, billboardlike pictures, which are visible from a considerable distance, were sometimes made at Anasazi habitation sites. Each of the three shieldlike discs painted above the highest building at this village is about six feet in diameter and visible from about a quarter-mile away. (Photograph by Dudley King.)

Figure 60. Pictographs, River House, San Juan River, southeast Utah, Pueblo III, thirteenth century. Small- and large-scale pictures are overlayed and intermixed here as though one pictorial message were superseded by another. There seems to have been no great passage of time between any of the paintings. (Photograph by Dudley King.)

for a village. Large paintings or patterned groups of small ones were sometimes placed prominently at either end of a rock shelter as though marking the boundaries of the community that was built within it (Plate 7). Other very visible images are found more centrally located within a village (Figs. 59, 60). While all of these suggest some sort of sign-posting, we are left to speculate about the specific meanings that may have been placed on any of these emblems. No matter their precise significance, it seems clear that rock painting in the San Juan Basin during this period was an activity quite closely related to architecture and to the daily life of a community. This interpretation stresses the integration of art, religion, ritual, and very many other aspects of Anasazi life.

During these centuries, innovations occurred in the rock-art as well as the pottery-painting traditions of

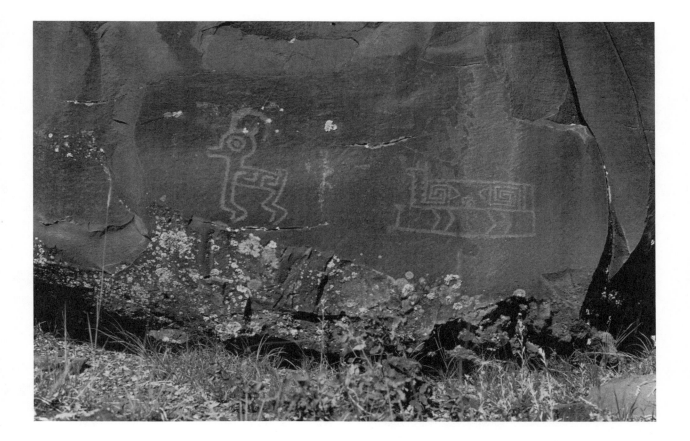

some Mogollon groups that had important effects, then and later, on Anasazi painting. Pictographs and petroglyphs in and near the Mimbres region may resemble the representational images of Mimbres pottery. Similar rock art is abundant in Jornada Mogollon territory far to the east of the Mimbres Valley; and a few examples are also known from the area around Reserve, New Mexico, along the upper reaches of the San Francisco River and its tributaries (Fig. 61). The dating of all of these is uncertain; some may be as early as the eleventh century, but much of it, especially in the Jornada, seems to date from the fourteenth century.

Mimbreslike imagery in the rock art of the Jornada area is elaborate and includes animal and human figures as well as some nonrepresentational motifs. Among the many petroglyphs and pictographs in the area are some with iconographic features that suggest

Figure 61. Petroglyphs, Cibola Mogollon, near Reserve, western New Mexico, eleventh–twelfth centuries. Both isolated animals are like pictures sometimes found as framed central images on Mimbres pottery. The drawing style and content may be the same, but the structural rationality of pottery paintings is entirely absent. (Photograph by Dudley King.)

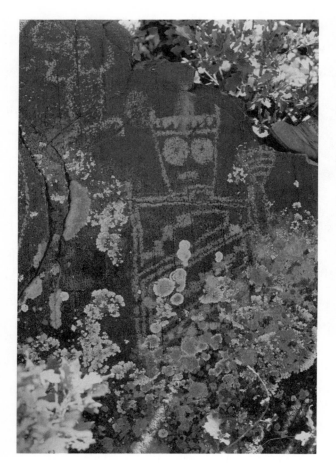

the Mexican deities Tlaloc, Tezcatlipoca and Quetzal-coatl. Images of masks, masked figures, serpents, and a variety of other motifs are reminiscent of both Meso-america and Anasazi art of the following period (Fig. 62). Schaafsma theorizes that these are evidence for the introduction of Mesoamerican deities and associated ritual organizations to the Southwest by way of the Jornada Mogollon (Schaafsma and Schaafsma 1974; Schaafsma 1980:199ff).

In that scheme, it is proposed that Mesoamerican iconography and associated ideology came by way of Casas Grandes in northern Chihuahua, Mexico, begin-ning shortly after A.D. 1050 (Schaafsma 1980:235–37). Casas Grandes has been thought of as a Mesoamerican trade center, which became active after about A.D. 1050 (DiPeso et al. 1974). However, there is little direct evidence that the imagery of the Mimbres or Jornada Mogollon was inspired by that of Casas Grandes, and despite similarities, there are significant iconographic and style differences between the Jornada pictures and somewhat similar rock engravings found in the vicinity of Casas Grandes and to its west, in Sonora. More serious, perhaps, is the lack of direct evidence to sup-port an eleventh-century date for either the Jornada rock-art pictures or those of northern Mexico. The Jornada Mogollon communities, which are nearest to the largest and most elaborate of the Jornada rock-art sites such as the one at Three Rivers, consistently date from the fourteenth century, two hundred years later than the Mimbres communities that are thought to have made similar rock art in southwestern New Mex-ico. It is conceivable that the rock art bridges two eras, but since none of it can be dated with precision, the primacy of the Jornada Mogollon over the Mimbres in introducing these iconographic themes to the rest of the Southwest as well as the role of Casas Grandes must remain moot issues. Nevertheless, it is clear from both the iconography and the drawing style of the Jornada rock art that it somehow related both to Classic period Mimbres pottery paintings and to the Anasazi mural paintings and rock art of the following era.

Mogollon rock art of other regions is generally not well described, and most seems little different from contemporary Anasazi work. There was a rich rock-art tradition in the Reserve area that seems to evidence a fairly complex history. Some of its imagery resembles that found on Mimbres pottery and some that of pottery in the local Tularosa black-on-white pottery-painting tradition. Tularosa-style pottery dates from the late

Figure 62. Petroglyph, Jornada Mogollon, southern New Mexico, ca. 1300–1350. Limbless beings with bulging eyes, horns or horned headdresses, and blankets occur in fourteenth-century Jornada Mogollon art along with many water-associated animals. Though they generally lack details such as fangs that are diagnostic of the Mexican water deity Tlaloc, they are often called by that name. In some contexts their "eyes" may be read as owl eyes or as breasts. See Fig-ure 35. (Photograph by Dudley King.)

twelfth to the fourteenth century and seems to represent an amalgamation of Anasazi and Mimbres painting modes adopted by a northern Mogollon people. Other motifs in the rock art of the Reserve area include flute players, small animals, lines of humans, and geometric forms that suggest a strong Anasazi input. There are many rambling, meandering patterns that are representationally incomprehensible. They may be read as maps, as aimless meanders, or as idiosyncratic but meaningful abstractions. Most of these petroglyphs are on basalt cap rocks, and many are near springs. Regardless of their iconographic variety, many make studied use of the varicolored stone and appear to be composed within the boundaries of controlled if uncertain borders (Plate 14). Their sensitive use of color, texture, and natural forms anticipate qualities of succeeding Anasazi rock-art traditions.

Forms of Anasazi Painting: A Comparison

Of the surviving Anasazi arts that predate A.D. 1300, the stone-built architecture of the San Juan Basin made from the tenth to the thirteenth centuries is by far the most impressive. Regional and intraregional architectural variations reflect differences in local environments, access to materials, community size, and building functions, as well as aesthetic preferences, but the overall similarities from place to place are very great. Buildings were, for the most part, compact and blocky, with their aesthetic character dependent on the play of light and shadow over wall surfaces. It is probable that many more architectural surfaces were embellished by paintings than have survived, but even so, the visual quality of Anasazi architecture was largely independent of any applied decoration. Basic similarities in formal organization between Anasazi architecture and decorative arts argue for their being aspects of a single, unified aesthetic system.

Most known Anasazi paintings dating from about A.D. 900 to 1300 that are not on cliff walls or in other outdoor locations are small in scale and found on domestic artifacts such as textiles, basketry, and pottery. Other than pottery, which generally only used black paint on a white surface, surviving specimens of domestic paintings are rare.

Except for specimens decorated with simple stripes, most known textiles and baskets that were decorated with color are patterned in the manner of the contemporary pottery painting styles of northeastern Arizona. These stressed the use of darkly painted overall designs, negative motifs, and integration of vessel shape and painted surface by means of scale changes (see Fig. 31). A common compositional device was the use of offset rectangular blocks in diagonal twill-weave patterns that circulated about a central point (see Fig. 41). Similarities to Hohokam pottery and textile designs are specific and testify to the many social interactions that took place during those centuries among neighboring southwestern peoples.

The painted textiles found at Anasazi sites of this period tend to be brightly colored in discrete, bordered, and rectangular blocks. Green, yellow, red, white, and black are common colors that were usually separated from each other by contour lines. As in many other kinds of Anasazi painting, line was used as the primary descriptive and integrative element.

Such use of line is particularly noticeable on the very rare and often fragmentary objects of painted wood that have been recovered from Anasazi sites (see Fig. 5). Many of these objects are evidently components of ritual equipment: pieces of altars, headdresses, or other articles of special costumes. In most instances the similarity to textile, basketry, or pottery design is quite obvious, reinforcing a sense that no important or necessary ideological distinction was made between domestic and ritual classes of Anasazi decoration at this time.

At this time and earlier, painting methods using lines simultaneously to separate flatly applied color areas from each other while integrating the blocks of color into cohesive motifs and patterns were widely distributed in Mesoamerica and northern and western Mexico. They were used in various decorative techniques on domestic and ritual objects and were characteristic procedures in painting codices and murals (Villagra Caleti 1971). Hohokam and Anasazi familiarity with portable Mexican paintings in the technique called "pseudo-cloisonné" that used this pictorial method can be demonstrated. However, it is difficult to evaluate the significance of that familiarity to the history of Anasazi painting, for such linear devices were ancient in the Southwest also.

Anasazi pottery painting stressed linearity and integration of the applied design with the three-dimensional form of a vessel. A painting on a bowl, for example, might be placed in its interior and composed in patterns designed to distinguish between the vessel

wall and its bottom. A painting on a jar would be on the exterior and structured so that the neck, handle, upper wall, and other parts of the vessel form would be differentiated. Design elements, motifs, and patterns were usually geometric, symmetrical, and arithmetically predictable.

Regional styles evolved that were controlled by these regularities; they were also cross-cut by shared, pan-regional variants as, for example, preference for the use of positive or negative designs or for use of hachure as opposed to solidly painted fillers (see Plate 9, Figs. 14, 31, 38). Widespread trade in painted pottery suggests an extensive interest in all of these variations. Further emphasis on the social and aesthetic values of pottery painting is implied by the very great increase in quantity, quality, and variety that characterized the art during these centuries.

Mural paintings made on prepared surfaces in domestic or ritual rooms occurred with increasing frequency and complexity in this era. Most are monochromatic and nonfigurative, and relate in both form and subject to the domestic painting tradition (see Fig. 52). A significant number are also of figural images similar to those found in rock art which, like rock art, are less clearly organized on their pictorial surfaces (see Fig. 49). Thus, early wall paintings seem to derive from aspects of both of the major painting traditions which predated them. Toward the end of the period, some highly structured, colorful paintings were made that represent a significant maturation of this slow-growing tradition (see Plate 12). It must be stressed that the technology for mural painting, as well as important elements of its basic aesthetic, were in place long before A.D. 1300.

Outlining was used in southwestern rock art as early as the Archaic period, and the procedure continued in the rock art of the San Juan Basin at least until A.D. 1300. During the time from 900 to 1300, rock art, especially painting, became particularly well developed in the sandstone canyon country that drains into the San Juan and Colorado rivers. Communities built within rock shelters in that region were often surrounded by paintings placed on nearby cliff walls. In some cases, the paintings may be interpreted as marking village boundaries (see Plate 7). Plastered outer walls of buildings were sometimes painted, suggesting a fusion of sorts between painting and architecture (see Plate 10). A variety of subjects were used, including many small-scale images of humans, human hands, game animals,

and hunting themes. Except for images of a hump-backed figure sometimes carrying a bow and arrow, sometimes playing a flute, sometimes horned, and sometimes phallic, representations that are certainly of anthropomorphic supernaturals are uncommon. While many rock pictures appear to be composed with respect to each other as well as to some designated pictorial surface, boundaries are rarely clear, and pictorial structure, as in the past, is usually uncertain and left to the imagination of the viewer.

When compared to the highly developed architectural arts of the time, Anasazi painting seems a relatively minor art form. The structural logic of the domestic painting tradition is like that which shaped the architectural aesthetic, but the scale and impact of each are of entirely different orders. Nonfigurative mural paintings also conform to the same structural logic and add a decorative touch to architectural forms that is consistent with them. In contrast, most figurative wall paintings are more like graffiti and the kind of pictures that were made at open-air art sites. These murals used architectural surfaces with little regard for spatial relationships.

And yet both figurative and nonfigurative rock art could, on occasion, be surprisingly integrative with architecture. This is especially notable at places where rock shelters, the communities that were built within them, and the paintings on the rock walls all combined to define and even frame a single space. The implication is that open-air art sites directly associated with habitations should be distinguished from those that are not.

Interactions among Anasazi, Hohokam, Mogollon, and other southwestern people are reflected by aspects of their respective painting styles. However, the powerful painting traditions of the Mimbres branch of the Mogollon, the innovative rock art of the Jornada Mogollon (which may well be of a later era), and the elaborate polychrome pottery of Casas Grandes seemingly had little visual impact on Anasazi art before A.D. 1300. Thus, the richest pictorial traditions of the Southwest as well as a potential wealth of Mexican-inspired iconography had virtually no effect on the burgeoning Anasazi cultures. Other than some vague similarities in pictorial concepts, there is not much in Anasazi painting to suggest any important Mexican influence to this time.

As in earlier periods, there is little that is integral to either the subject matter or the organization of Anasazi paintings that seems to identify any particular purpose

that a painting may have been intended to serve. The motifs and organization of pictures made on domestic artifacts could be identical to those that were on the walls of kivas, and ritual themes could be painted on utilitarian objects. Rock walls that were covered with paintings and engravings could, and did, share every sort of subject and demonstrate familiarity with every kind of pictorial mode of organization. This blurring of genres makes it difficult to argue for any kind of artistic specialization other than that which was presumably gender-related. Every man and every woman could have practiced painting, and we must assume that many did; as in the past, it was an egalitarian way to make art. Two major pictorial traditions coexisted that were, on occasion, used within identical spatial and social contexts. The forms of Anasazi painting are far more easily understood than their functions.

FOUR ■ The Florescence of Painting: A.D. 1300–1700

The era from about A.D. 1300 to 1700, called "Pueblo IV" by the Pecos Conference in 1927, was also called by many culture historians of the second quarter of this century the "Regressive Pueblo Period." That name was based, in part, on contemporary aesthetic judgments about changes in Anasazi architectural and pottery-painting traditions during the years from about 1300 to 1600. In that time, the San Juan Basin was largely abandoned and new Anasazi centers were established around the eastern, southern, and western borders of the ancient Anasazi homeland. Because many of the new communities were relatively large and may have included people of diverse origins, the era is some-times referred to today as the "Coalition Period." It was an era marked by some radical changes in artistic styles and aesthetic values.

Painting was the art most obviously and positively affected by these changes. Color gained new impor-tance in pottery painting, which also saw innovations in pictorial concepts, subject matter, and technology. Sim-ilar changes occurred in other decorative arts, espe-cially in textiles. Representational mural painting on kiva walls became an important expressive form which introduced new pictorial concepts and a wealth of new subjects (Fig. 63). In rock art, there was a decline in the number of pictographs as well as changes in their style and subject matter similar to those in mural painting. Petroglyphs underwent a creative explosion of sorts, especially in the Rio Grande and Pecos drainages, with changes that paralleled those in the other pictorial arts.

Regional variations in both the style and subject mat-ter of all pictorial arts became increasingly obvious and significant. These distinctions were stimulated and re-inforced by the absorption within Anasazi communi-ties of many Mogollon and some Hohokam groups and of other southwestern peoples such as the Salado and the Sinagua, who formerly had lived on the frontiers of the Anasazi world.

The period, of course, bridges history and prehis-tory. The invasion by Europeans obviously had great impact, but it was only one of several critical events that marked what seems in retrospect to have been a tur-bulent era; and the sixteenth-century Spanish *entrada* was by no means as important to the history of Anasazi painting as earlier undocumented historical events, es-pecially those which resulted in the abandonment of the San Juan Basin and the resettlement of the Anasazi in their new homeland. Of almost equal importance is the obscure history of relationships between the Ana-sazi and their near neighbors and the debatable nature and history of what appears to have been an infusion of novel ritual and cultural ideas from Mexico.

The Greater Southwest, Dispersal and Relocation: 1300–1500

Abandonment of one or another long-settled and formerly fruitful valley or watershed was a frequent event throughout the prehistoric Southwest. In Anasazi times as today, the country was semiarid and subject to locally severe droughts, arroyo cutting, and other envi-ronmental stresses that can quickly degrade land which was once agriculturally productive. Not so quickly per-haps, but ultimately, relatively minor climatic changes

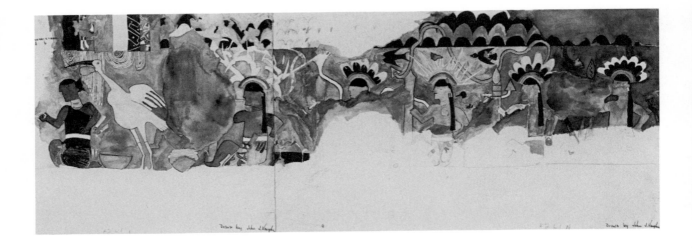

can reverse the process, thus establishing conditions to support the periodic resettlement of once-abandoned areas. The San Juan Basin is studded with canyons and mesas such as Tsegi Canyon, Cañon de Chelly, Grand Gulch, and Black Mesa, all of which were periodically occupied, abandoned, reoccupied, and then abandoned once more by Anasazi people (Cordell 1979; 1984; Plog 1979; Plog 1980; Plog and Powell 1984). Each occupation and each abandonment might last for several generations or even several centuries as different people invested their hopes and their energies in a location that might provide them with resources sufficient for a good life. Always, in the end, they were turned away by a chancy and marginal environment.

After the first failure of a settlement in a canyon oasis, all future prospective settlers would know of it, if not by oral tradition, then by the evidence of abandoned villages and their rock art. Nonetheless, reoccupation was a regular occurrence until the fourteenth century began. Therefore, it was not the abandonment of sites that distinguishes the Pueblo IV period from all earlier Anasazi eras, but the scale and utter finality of the migrations preceding it. Most of their ancient homeland was abandoned, possibly forever, by the Anasazi who, knowingly or not, were participants in a vast reorganization of the people of the entire Southwest.

The Anasazi dispersed eastward toward the Rio Grande and Upper Pecos River watersheds, southward to the wooded plateaus above the Mogollon Rim, and west and south toward the barren lands of the Hopi country (Fig. 64). The process took several centuries,

Figure 63. Wall painting (field drawing), Kiva 2, layer 1, north wall, Pottery Mound, New Mexico, early fifteenth century. Men wearing elaborate headdresses sit in rows on a ground line which seems to represent the floor of a room. Semicircular white-painted clouds above their heads indicate the sky, so that the men are simultaneously indoors and outside. This layer of painting was continuous around the four walls of the kiva. Compare to Plate 1. (Maxwell Museum of Anthropology, cat. nos. 76.70.664 and 76.70.665, watercolor by John Vaughan [1955], photograph by Roderick Hook.)

beginning as early as the middle of the twelfth century when many people left the Chaco Canyon area, continuing into the 1300s when the Mesa Verde and Kayenta districts were depopulated, and still may have been in progress at the time of first contact with Europeans. During those centuries there were many smaller movements within the larger ones. Some groups may have migrated several times from canyon to canyon within the San Juan Basin, while others shifted more certainly toward its periphery. The process was gradual and piecemeal, and there must be doubt that it was perceived at the time as radically different from the smaller-scale traumas of periodic abandonment that had characterized the earlier history of most Anasazi people.

Coincident with the Anasazi movements to the south and east, more southerly peoples, especially subgroups of the Mogollon, moved northward, apparently

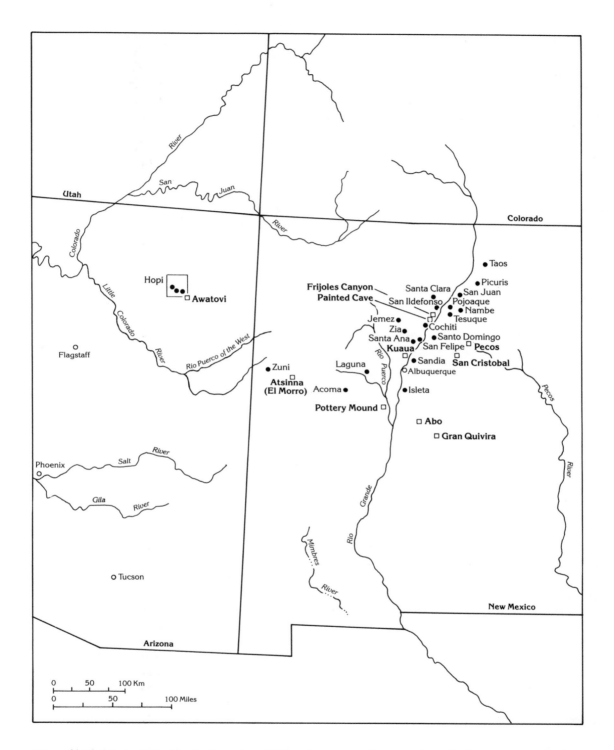

Figure 64. The Anasazi–Pueblo Southwest, ca. 1250 to the present. Sites mentioned in the text are marked with a hollow square; Pueblos still occupied are marked with a black dot.

with the same sort of steady but unfocused inertia that moved the Anasazi. At about the time that Chaco was abandoned, Mogollon people of the Mimbres Valley also moved and then, or shortly afterward, stopped making their distinctive painted pottery. By that act, they effectively erased themselves from the archaeological record. To the east, in the deserts and highlands of the Jornada Mogollon region, Anasazi-style villages were built during the 1200s and early 1300s, and abandoned by the mid-fourteenth century with many of the occupants moving northward. Further west, the high mountain valleys of the San Francisco and Upper Gila River drainages supported hundreds of fair-sized Mogollon and Salado villages. All were abandoned by about 1400, by which time the enormous, well-watered but mountainous territory of southeastern Arizona and southwestern New Mexico was as empty of people as the San Juan Basin. It is virtually impossible today to identify any particular group of the Mogollon with any Anasazi or later Pueblo community, just as it is difficult or impossible to identify most Anasazi ruins of the San Juan Basin with any modern pueblo or even any Pueblo-language group. We can only be sure, on the one hand, that there was amalgamation of Mogollon and Anasazi people, and, on the other, that the San Juan Anasazi became Pueblo people.

Elsewhere, the Hohokam of the low deserts of southern Arizona apparently dispersed to small ranchos, while those who had earlier migrated northward seemingly merged with the Mogollon–Anasazi. Other agriculturalists such as the Hakataya, Sinagua, and Fremont peoples, who had built distinctive communities on either side of the Grand Canyon, also moved during these centuries, modifying their material culture and life-styles either to integrate themselves with the new Anasazi or, like the desert Hohokam people, to change their life-style radically in some other manner.

Further south, Casas Grandes began to decline during the thirteenth century and was finally overrun and abandoned in about 1350. It is one of the very few southwestern cases where there is clear evidence for a community being destroyed by violence (DiPeso et al. 1974). Its decline as a trading center and its later destruction have been explained in terms of political struggles in the far distant Valley of Mexico which resulted in the loss of power by the Toltecs during the thirteenth century (DiPeso et al. 1974; Kelley and Kelley 1974:210–13). If, as theorized, Casas Grandes owed its size and complexity to its position within a wide-spread Mesoamerican trade network, it follows that disruption of the network center in the Valley of Mexico would have cut it off from the support base on which it depended. Supposition that several rival trading systems had long operated on the northern frontiers of Mesoamerica strengthens the case for explaining the rise and fall of Casas Grandes in terms of distant economic and political events that were of far greater magnitude (Kelley 1974b:23–24).

Warfare or fear of violence seems also to have affected the Mogollon even in their isolated and rugged mountain valleys. Many Mogollon villages of the twelfth to fourteenth centuries are walled and defensively situated; however, more tangible evidence of violence is generally lacking both in Mogollon territory and in that of the far more vulnerable desert Hohokam. Among the Anasazi as well, there is small direct evidence for higher incidences of violence and raiding than was usual in earlier times. As with the Mogollon, however, some late Pueblo III villages in the San Juan Basin, and many larger Anasazi Pueblo IV communities, had a decidedly defensive character even when built in open locations.

The centuries immediately preceding the arrival of Europeans seem to have been turbulent ones in the Southwest. They were marked by wholesale population movements apparently involving both the relocation of communities and the realignment of peoples. Resettlement of entire communities had happened among the Anasazi with fair frequency in earlier times, but the creation of new settlements made up of peoples thought to be of different cultures amalgamating themselves into new political and social alliances was, indeed, a novelty.

The Greater Southwest: 1500–1700

The Spanish intrusions were initially exploratory and exploitive. Francisco de Coronado, who led the first large expedition to the region in 1540, was largely disappointed in his expectations of finding great wealth and great cities. In 1541 he left the Pueblo country with most of his forces, leaving behind several Christianized Mexican Indian auxiliaries and a few priests intent on missionizing the Pueblos (Schroeder 1972:49). Perhaps Tlaxtaltecans from the Valley of Mexico, some of these Mexican Indians were still at Zuni Pueblo in 1583 (Hammond and Rey 1966:184; Riley 1971). Despite the residency of the Mexicans and missionaries, neither

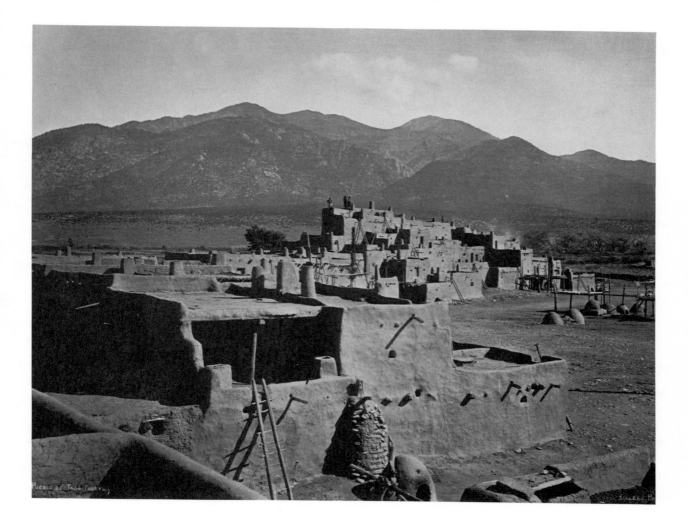

Coronado's expedition nor the few small and generally badly supported ones of the next half-century seem to have had a measurable effect on the Pueblos, their religion, or their art (Hammond and Rey 1966; Schroeder 1972:49). It is possible, however, that the documented abandonment of several middle Rio Grande Pueblos late in the sixteenth century resulted from social and political upheavals or from epidemic diseases triggered by the European intrusions.

Many Pueblos named in the sixteenth-century Spanish reports were long established in their new locations; among those mentioned in the earliest chronicles are Pecos, Taos, and Acoma, all founded between about 1250 and 1400 (Fig. 65). The largest had popula-

Figure 65. Taos Pueblo, North House, 1880. Though built of adobe, Taos Pueblo, which dates from the fourteenth century, resembles Pueblo III communities in its basic plan. It is multistoried, terraced, and surrounded by a wall; and its main buildings enclose a large plaza used for ritual, economic, and social activities. (Photo Archives, Museum of New Mexico, neg. no. 16096, photograph by John K. Hillers, Ben Wittick copy.)

tions ranging from about one thousand to perhaps three thousand (Schroeder 1979). For missionizing purposes, the Spanish grouped villages whose people spoke the same language as though they were politically allied "provinces." For administrative purposes, however, the term "province" was more likely to be based on geographical rather than linguistic factors, so the word as used in early Spanish records is confusing (Hayes 1981a:5, 6). In any case, except for the many hamlets that had satellite relationships to larger villages or towns, political alliances among Pueblo communities were loose at best. Similarities to earlier Anasazi art styles, technology, and religious, economic, and social organizations do suggest that social, ritual, and economic networks among Pueblo IV people resembled those which characterized the previous era in the San Juan Basin.

Fundamental similarities to earlier Anasazi modes are also apparent in architecture and town planning. Perhaps only because the geological conditions were so different in their new territory, Pueblo IV Anasazi people built few communities within narrow canyons or framed by the natural walls of rock shelters. Most of the larger pueblos were now built near streams in open country or on mesa-top defensive sites. In the region of the Jemez Plateau, villages were sometimes strung out along canyon walls and built partially within caves excavated from the soft volcanic ash that characterizes the area, but adobe, cobbles, and small boulders were now the more usual wall-building materials. Easily worked laminar sandstones which had been so important to Anasazi architecture of the Four Corners were a rarity in most of their new territory, but where stone suitable for neat masonry construction was available, it was used. Large pueblos on mesa-top and other open-site locations had by no means been uncommon in earlier periods, and even where adobe replaced stone as the basic building material, the forms and aesthetic character of Pueblo IV communities closely resembled those of earlier times in the San Juan Basin.

Large pueblos were usually inward-facing, enclosed by the exterior walls of building blocks that were often two or three stories high with no outward-facing doors or windows. These terraced residences were arranged about open plazas which often had large kivas within them (Fig. 66). The defensive potential of such structures was great, and Spanish accounts of warfare with the Pueblos describe their defensive use (Hammond and Rey 1940, 1966). Conflicts with the Spanish, in-

ferences in the early chronicles about Pueblo war societies that may have resembled those described in nineteenth- and twentieth-century ethnologies, and pictures of warriors in murals and rock art all confirm that warfare was a fact of Pueblo life. Nonetheless, the earliest Spanish chronicles also stress the peaceful and nonaggressive qualities of Pueblo societies, and there is little to indicate that defense was a more dominating consideration in architectural planning than in earlier eras. As in the past, as well as having practical defensive applications, the well-defined, closed spaces of Pueblo communities provided form and focus for the tightly integrated and highly structured pueblo societies.

Tradition and the social role of architecture seem to have been the critical factors in architectural planning, and the differences between Pueblo III and Pueblo IV solutions to community planning and construction problems have more to do with materials than design. Descriptions, recorded by archaeologists and historians during the nineteenth and twentieth centuries, of startling architectural differences between the two eras can almost always be reduced to distinctions between the texture and color of fine sandstone veneers and that of relatively coarse stone or adobe walls, and are reflections of the simple fact that abandoned adobe buildings melt into mud. Continuity with the past rather than innovation is the dominant theme of Pueblo IV architecture.

As in the past, both interior and exterior walls of many pueblos were painted. There is confusion in sixteenth-century accounts about the nature of wall paintings on building exteriors. Baltasar Obregón, who saw Pecos Pueblo in 1583, wrote that the houses there were "whitewashed and painted with very bright colors and paints [or paintings]" (Kessell 1979:42). The Castaña de Sosa expedition which reached Pecos in 1591 only noted whitewashed walls (Kessell 1979:54–55). No exterior wall paintings of the period are known to have survived.

The first Spanish settlements in Pueblo Indian territory were established after 1598. They were small, poor, and isolated from Spanish Mexico by terrible roads and great distances. Most of the settlers were farmers, largely left to their own resources and intent on carving out a new life in the new land. While they were potential competitors with the Pueblos for the same resources, the land was vast and overpopulation was not a problem. That aspect of competition was largely theoretical.

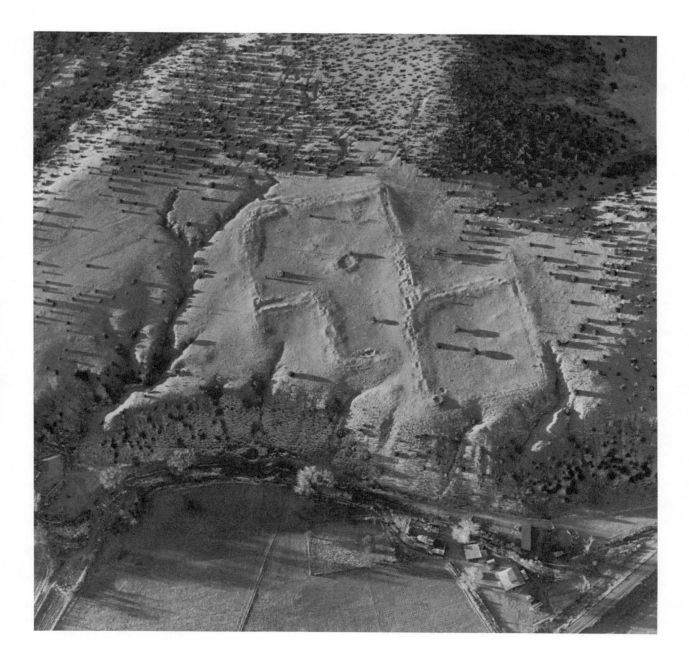

Figure 66. Aerial view of Poshu, Chama Valley, north-central
New Mexico, Pueblo IV, fourteenth–sixteenth centuries.
The basic town plan is similar to that of the self-contained
Pueblo II and Pueblo III communities of the San Juan
Basin. Multiple plazas and defensive locations on mesa tops
are characteristic of the larger Pueblo IV towns. (Photo-
graph by Tom Baker, Baker Aero Works.)

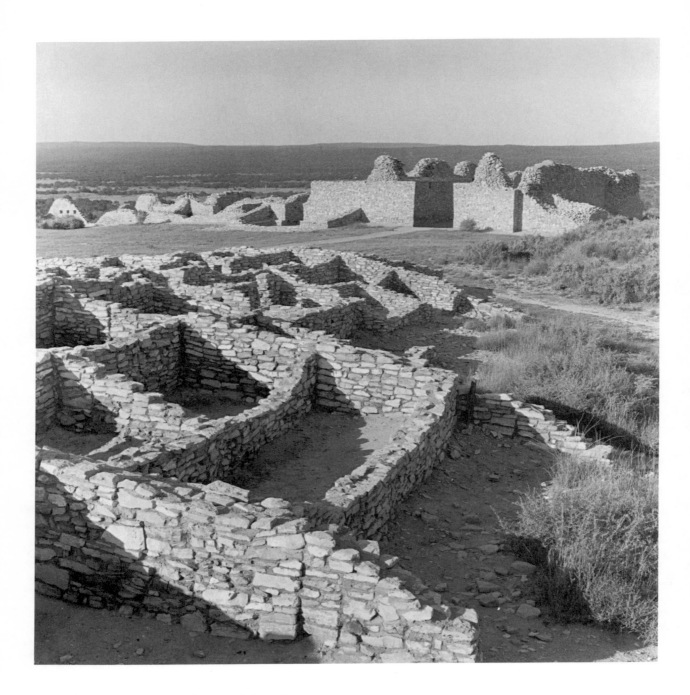

Figure 67. Las Humanas (Gran Quivira), Salinas district,
New Mexico, fifteenth–seventeenth centuries. Ruins of the
Spanish mission are seen from Mound 7, which predates
the Spanish arrival and was occupied during the Spanish
period. The mission was built with local materials, local la-
bor, and building methods that were essentially native.
(Photograph by David Noble.)

Metalworking and carpentry with metal tools were virtually the only novel craft techniques brought to the Southwest by the first Spanish settlers. There were, in fact, so few craft specialists among them that they seem to have depended on Pueblo artisans for such important utilitarian products as pottery containers and textiles. Nonetheless, the political and economic effects of Spanish settlement were wide-ranging.

A greater impact on the material culture and arts of the Pueblos came from the relatively few Franciscan missionaries who, during the first decades of the seventeenth century, established *conventos* in or adjacent to many Pueblo villages. The ruins of their structures that remain today are massive stone buildings which dominate the native settlements. They were built by Pueblo labor with local materials and according to plans supplied by the missionaries. Even so, except for learning the use of metal tools and perhaps some innovations in engineering, the technological impact of mission construction was minimal, and the general style of mission architecture was visually and formally compatible with existing Pueblo stylistic traditions. Based on Mexican prototypes, the missions were dominated by a massive, blank-walled church. A walled compound of associated buildings was connected to the church and merged visually with the domestic parts of the pueblo that they dominated (Kubler 1972) (Fig. 67).

With the exception of a few portable artifacts, including most of the absolutely essential tools of their trade which they brought with them, the Franciscans were also greatly dependent on Pueblo craftsmen and artists for objects ranging from the utilitarian to the decorative. Religious pictures on cured animal hides may have been made locally by relatively unskilled priests. The more decorative paintings in the churches, even those using motifs that were European in origin, were generally painted by Indian artists, often women, directed by the missionaries (Montgomery et al. 1949:293–303) (Fig. 68). Thus, despite all novelties of form and function, most seventeenth-century paintings and artifacts associated with Catholic ritual that were used in the pueblos were either made by Pueblo craftsmen or were relatively crude products made by unskilled European priests.

Resentment of efforts to suppress native religions led to a number of violent episodes and generally unsuccessful Catholic proselytization. Several of the massive missions built during the 1620s, such as Guisewa

Figure 68. Wall painting (copy), Franciscan Mission at the Hopi town of Awatovi, northeastern Arizona, seventeenth century. The painting imitates Mexican majolica-glazed ceramic tiles and was probably done by Hopi artists using native paints. (Peabody Museum, Harvard University, no. N20986.)

Figure 69 (both pages). Kiva wall painting, Room 788, right wall, design 4, Hopi town of Awatovi, northeastern Arizona, first half of the sixteenth century. Fragments of a baseband, which served as both a frame and ground line, and vertical framing panels are on the left-hand page. The circular face, headdress, and staff held by the figure on the right-hand page identifies him as the Ahul kachina who appears at the Powamu ceremony to symbolize the coming of the sun. (Peabody Museum, Harvard University, photo no. N20239.)

near Jemez Pueblo, were abandoned within a few years of their construction, and others were destroyed by the Pueblos both before and during the 1680 Revolt. Even where missionaries appeared to have been most successful, as among the Salinas Pueblos, their success was superficial and events conspired to defeat them (Hayes 1981a:1–10). Destructive raids by the Apaches, economically ruinous demands of Spanish mission and civil authorities, and smallpox combined by 1672 to force the Salinas people to abandon both their older villages and their newly built missions. Pecos Pueblo, once the largest of them all, began a long decline at about the same time for similar reasons, also coordinate with moderately successful proselytization (Kessell 1979).

The end of the initial period of European coloniza-

tion came with the successful Pueblo Revolt of 1680. Renewal of Spanish colonization signified by de Vargas's reconquest of 1692 provides a convenient end to the Pueblo IV period and opens an era when more fundamental effects of the European intrusion were felt. Painting in the Anasazi world, however, had become a radically altered art form long before the first Europeans came to the Southwest, and the initial European impact on Anasazi painting traditions seems to have been minimal.

Painted Objects

As in earlier periods, most preserved paintings are in the media of pottery, rock art, and murals. However, these media, and especially the mural paintings of the fourteenth through the seventeenth centuries, indirectly provide a novel wealth of evidence of other kinds of painting. The murals show hundreds of woven, dyed, and painted textiles, costumes, and masks, many instances of body painting, and a variety of other painted objects on wood and leather, as well as what seem to be decorative and representational pictures made with feathers (Figs. 69, 70).

A great variety of textile designs are shown in many forms ranging from square blankets or mantas to kilts, shirts, belts, hats, and stockings (Fig. 71, Plate 15). The range in pattern runs the gamut from geometric designs that appear to be virtually identical with those sandal, tumpline, basketry, and pottery designs familiar to us from the very beginning of Anasazi times to highly stylized representations of birds and their wings, tails,

Figure 70. Kiva wall painting, Test 5, Room 2, left wall design 2, Hopi town of Kawaika-a, northeastern Arizona, fifteenth century. This personage wears a white netted or open-work woven shirt, an elaborate headdress, and streamers with feathers. His collar is green and he holds a parrot in his hand. (Peabody Museum, Harvard University, photo no. N20267, photograph by Fogg Museum.)

and feathers. The integration of woven, embroidered, and painted textile design with other decorative and pictorial forms is quite clear, as is, despite all innovations, the unbroken continuity with past Anasazi traditions.

Body and facial painting appears to have been symbolic and representational. Some images represent constellations, the sun, stars, or planets, and animal parts such as paws and claws (Fig. 72). Others appear related to kachina masks and to contemporary kachina imagery (see Fig. 69, Plate 1). In some instances, it is not clear if a design shown on the body of a figure in a mural or rock-art picture represents body paint or an item of costume. Aside from textiles, other kinds of costume and paraphernalia include painted masks and headdresses, some of which are quite elaborate and

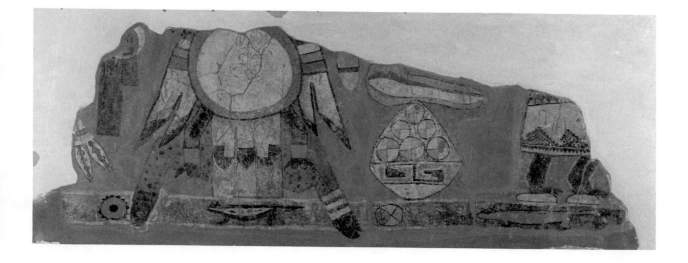

many of which include stylized feathers as important elements. Many headdresses shown in the paintings are similar to modern-day Pueblo dance tablitas, including both the relatively simple, terrace-shaped, slat-type forms and the far more elaborate arc-shaped ones that are sometimes made of many pieces of wood tied or nailed together (Plates 16, 17).

Perhaps related to the tablita forms are some structures painted within murals and the frames around them which are shaped like modern Pueblo altars. Other paintings may represent background scenery used historically in theatrical performances of a religious nature. Many of these paintings are dominated by cloud forms, sunflower images and other rosettes, and a variety of other iconographic elements that are still in use in modern Pueblos as emblematic of rain and fruition. In most cases, the style of presentation, as in modern Pueblo ritual art, is direct and descriptive (Plate 18).

Also direct and descriptive are the paintings found on a very few small stone carvings associated with this period which resemble painted sculptures of the Pueblo III period, some of which have been found in Mogollon contexts (see Fig. 37). The carvings tend to be flat and cursive, and the paintings on them appear to be descriptive of details that are intrinsic to the beings that they represent. Some suggest pseudo-cloisonné objects that have lost their thick, colored paints.

Clearly, this was a period when the pictorial arts and

Figure 71. Kiva wall painting, Room 788, left wall, design 5, Hopi town of Awatovi, northeastern Arizona, first half of the fifteenth century. This original painting is among the most recent Awatovi murals. The composition is symmetrical with a large eagle flanked by men wearing painted or embroidered kilts. A similar painting was on the opposite wall of the room. Basebands enclosing animals and rosettes were common framing devices at Awatovi. (Museum of Northern Arizona, neg. no. 89.178, photograph by Gene Balzer.)

painting of all sorts were made to inspire and instruct the Anasazi people as well as to decorate their everyday furnishings. Yet, if not for the kiva murals we would know very little about the daily arts of the time, and it is appropriate to speculate whether the costumes and the other ephemeral arts of earlier Anasazi people were any less inspiring, instructive, or decorative.

Painted Pottery

The great changes that occurred in Anasazi pottery painting styles after about A.D. 1250 seem to have followed directly from the thirteenth- and fourteenth-century population displacements that affected most parts of the region. During the thirteenth century, the border area between Anasazi and Mogollon territories

Figure 72. Wall painting, Kiva 8, south wall, center, layer 15 or 16, Pottery Mound, New Mexico, early fifteenth century. The four-pointed star painted on the chest of this frontally posed, hieratic figure may represent the planet Venus, associated with warfare and warfare societies by historic-era Pueblos. The upper part of the adobe plastered wall had collapsed centuries ago and is stabilized here by white plaster. (Maxwell Museum of Anthropology, photograph by Dennis Tedlock.)

became a major center for important and long-lasting innovations in pottery-painting styles and technology. Among the creative transformations of visual ideas from all over the Southwest which occurred in that region were the invention of polychrome and glaze painting techniques and of pictorial systems that spread widely in the following centuries (Dittert and Plog 1980).

Pottery painting was not an important art form in most Mogollon regions until relatively late, and Mogollon pottery-painting styles tended to be short-lived, diverse, and less a set of traditions closely related to each other than they were variations and inventions stimulated by pottery-painting systems associated with other southwestern peoples. The paintings on Classic Mimbres pottery are more like those of eleventh- and twelfth-century Chaco and Mesa Verde Anasazi

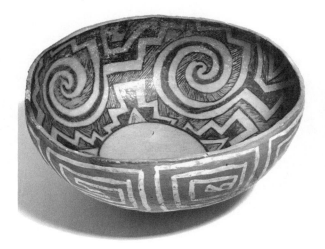

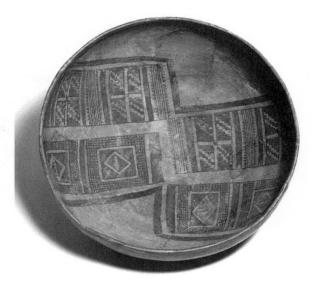

Figure 73. Pottery bowl, St. John's Polychrome, ca. 1175–1300. Polychrome wares using red slip, white paint, and black mineral paint were made in the Mogollon–Anasazi border region from about the twelfth to the fifteenth centuries. The paintings often combine fine-line hachures with solidly filled areas, as in the Chaco Anasazi style, with novel designs, including terraces which first appear in the Jornada Mogollon region at about this time. (Museum of New Mexico, Laboratory of Anthropology, cat. no. 19674/11, diameter 12½ inches, photograph by Roderick Hook.)

Figure 74. Pottery bowl, Heshotauthla Polychrome, fourteenth century. Glaze paints became established in the Zuni area in about 1300 and spread from there to the Rio Grande region. Colored slips and bold, large-scale, iconic motifs also characterize late Anasazi painted pottery. (Museum of New Mexico, Laboratory of Anthropology, cat. no. 35749/11, diameter 13 inches, photograph by Roderick Hook.)

than they are like any contemporary Mogollon group. Fourteenth-century Mogollon ceramic forms and their coloring and patterning systems are more adaptations of Hohokam, Anasazi, Salado, and Casas Grandes pottery-painting traditions than they are of any earlier Mogollon styles. But unlike the Mimbres paintings which were relatively uninfluential outside of Mimbres territory, the later Mogollon pottery inventions had far-reaching effects.

Beginning in the 1200s, a variety of alien traditions were creatively and almost simultaneously modified and transformed by different groups of Mogollon potters, perhaps most vigorously in the White Mountains of east-central Arizona and west-central New Mexico (Carlson 1970) (Fig. 73, Plate 19). There, many of the technical, iconographic, structural, and pictorial innovations that came to characterize Pueblo IV pottery

were first developed. By the fifteenth century, many Anasazi pottery-painting styles had become transformed and were more like those of the White Mountain Mogollon than of any earlier Anasazi people (Fig. 74).

Anasazi pottery painting of the late prehistoric era is characterized by considerable regional diversity, but within this diversity the nature of the changes from earlier periods was much the same all over. Compositional structures tended to be less rigid than in the past, and the imagery became more iconic. Though the art still depended on linearity, lines now tended to be thicker, more fluid, less angular, and at times so casual as to be downright sloppy. Fields of color made with clay slips added another pictorial dimension that sometimes replaced and sometimes supplemented the white slips, hachured lines, and blocks of dark paint

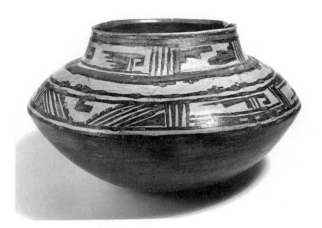

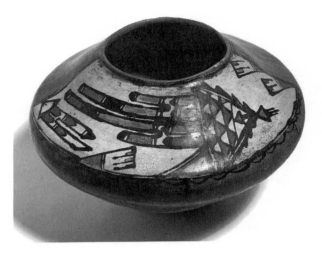

Figure 75. Pottery jar, Rio Grande Glaze Polychrome, early seventeenth century. Large and squat jars were made in all Anasazi regions during the Pueblo IV era. Design zones on these vessels are generally defined by framing bands on the upper shoulder and neck areas that were often subdivided into panels, each with a discrete pattern. Stylized birds, feathers, clouds, rain, and rainbows are common motifs. (Museum of New Mexico, Laboratory of Anthropology, cat. no. 8586/11, height 9½ inches, photograph by Roderick Hook.)

Figure 76. Pottery jar, Hawikuh Glaze Polychrome, Zuni–Cibola region, northwestern New Mexico, seventeenth century. Large, iconic painted motifs isolated within framed panels are typical of both domestic and ritual pottery of the Pueblo IV period. Late glaze paints shine, bubble, and run. (School of American Research, Indian Arts Fund, cat. no. 2155, diameter 16 inches, photograph by Roderick Hook.)

which had earlier provided the colors and textures of Anasazi painted wares. When the newly introduced glaze paints vitrified, their luminous and reflective quality changed the texture of Anasazi pottery painting. Vitrified paints also ran at times, adding yet another and perhaps unwanted quality of uncontrolled accident when lines of liquefied glaze paint flowed over and interfered with the careful draftsmanship that still dominated Anasazi painting (Fig. 75). In many areas the new polychrome tradition replaced the white-slipped wares of earlier times with much darker red slips, and the carbon- or mineral-based matte black paints were replaced by colored glazes which appeared to be black when painted on dark grounds (Plate 20).

The middle Rio Grande and upper Pecos drainage regions and the Zuni-Acoma area became centers of production for a number of related glaze-polychrome styles between about A.D. 1300 and 1700. These used

red, orange, yellow, or white slips and a variety of new paint colors including white, orange, and red slip and black, green, and purple glaze paints (Fig. 76, Plate 21). The color of the translucent glazes was usually apparent only when painted on white or light-colored slips (Plate 22).

Grayish, carbon-based matte paint wares on soft gray or creamy slipped surfaces continued to be made in the Jemez Mountain, Pajarito Plateau region of the northern Rio Grande drainage. Even there, however, vessel forms, designs, and design systems were more like contemporaneous glaze-polychrome wares than any older Anasazi tradition (Fig. 77). The Hopi in northeastern Arizona made unslipped yellow wares of highly polished, hard-fired kaolin clay. The distinctive Hopi yellow wares were copied in other places, especially the middle Rio Grande Valley, where orange or yellow slips were sometimes used on red or gray paste wares.

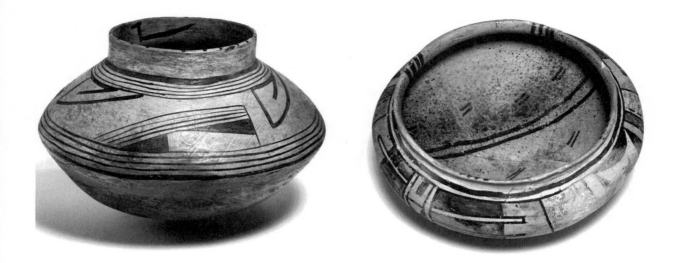

Figure 77. Pottery jar, Bandelier black on gray, Pajarito Plateau, fifteenth–sixteenth centuries. Pueblo IV pottery of the Pajarito Plateau in northern New Mexico was unique in using a soft, crumbly paste, dull creamy or gray slips, and flat, black carbon paint. Vessel forms, design structures, and pictorial motifs parallel the artistic traditions of all other Pueblo IV Anasazi regions. (Museum of New Mexico, Laboratory of Anthropology, cat. no. 21211/11, diameter 15 inches, photograph by Roderick Hook.)

Figure 78. Pottery bowl, Sikyatki Polychrome, Hopi, northeastern Arizona, sixteenth century. Pueblo IV Hopi potters exploited local kaolin clay deposits that gave their wares unique color and textural qualities. These qualities as well as designs and design concepts were often imitated by potters in other regions, and there were close conceptual and iconic similarities between Hopi pottery and mural painting traditions. (Museum of New Mexico, no. 21110/11, diameter 9¾ inches, photograph by Roderick Hook.)

The black, mineral-based paint used in the Hopi region often fired to a brownish color with a shiny, glazelike texture. Matte red and white paints were also used by Hopi potters, sometimes to draw lines but most often to fill in delineated areas with blocks of color. A unique variety of textures, including spatter, drybrush, incising, and engraving, was used by some Hopi artists to enliven picture surfaces, and many of their paintings are strongly related in every way to the contemporaneous kiva-mural tradition (Fig. 78, Plates 23, 24, 25).

Vessel forms were much the same in most Anasazi-style regions and were novel when compared with those of the past. Bowls tended to be larger and more shallow than in earlier days and were painted on both visible surfaces; as time passed, exterior designs became increasingly prominent (see Fig. 78, Plate 25). The dominant new jar form was a wide-mouthed, low vessel with a prominent neck and a sloping shoulder, a shape that may have derived from the squat jars that characterized eleventh- and twelfth-century Hohokam pottery. The neck and upper body were usually the focus for zoned design panels on these vessels. The squatness of both jars and bowls led to the invention of vessel shapes that were neither bowl nor jar but rather a fusion of the two forms (see Fig. 78).

Paintings were usually organized within panels that conformed, as in earlier Anasazi styles, to the architecture of a vessel. Most painted vessels were probably made for secular purposes, but their painted designs suggest sacred themes far more obviously than in the past. Traditional geometric motifs such as stepped figures or interlocking spirals were often recombined to become feathers, birds, sun symbols, horned serpents, or other emblems of Pueblo sacred iconography that give many ordinary painted vessels a ritual character (see Figs. 75, 76). Very often, such iconic motifs are

shown isolated within a panel or other well-defined design field, a kind of pictorial emphasis that sharply contrasts with the integration that characterized most earlier Anasazi painted pottery (see Fig. 76, Plate 23). Use of such designs was especially common and creative at the western pueblos of Zuni and Hopi, but the iconic themes were ubiquitous in all Anasazi regions from about 1350 onward. Less common but even more obviously representational were realistically drawn birds, humans, other animals, and masks, any of which might be seen in a narrative context (see Plates 24, 25).

From the fifteenth through the seventeenth centuries many Hopi pottery artists worked in a style called Sikyatki Polychrome (or one of its variants), named for a once important but long-abandoned Hopi town on First Mesa on the eastern edge of the Hopi country. Their richly textured paintings are related both stylistically and iconographically to the sacred mural-painting tradition that burgeoned contemporaneously at several Hopi towns in the general vicinity of Sikyatki. As with the much older Mimbres pottery tradition, some Sikyatki-style paintings are composed as narratives within the circular hemispherical space of the portable picture surface. As with Mimbres paintings also, the line between representationalism and abstraction is blurred and many nonfigurative pictures suggest animals and their parts, especially bird feathers, bird tails, bird wings, and bird beaks.

Both the narrative and the abstract paintings in the Sikyatki style may be composed in spirals around the center of a vessel; may be quadrilaterally symmetrical; may be in rough bilateral symmetry that assumes a vertical orientation for a picture; or may even be asymmetrical (see Fig. 78, Plates 23, 24, 25). Some are extraordinarily complex and dynamic. The paintings are usually framed with a heavy line around the rim of the vessel, but the framing line is often left open with apparent deliberation. This line break may have had the same sort of metaphoric value as similar "spirit breaks" do in some modern Pueblo painted pottery and Navajo weaving, to ensure a flow of harmony between the picture and the outside world. In some of the ancient pictures the line break is used as a narrative device through which a connection is made between the imaginary world of the painting and the real world outside it (see Plate 24). Such complex pictorial nuances provide yet another link between these pottery paintings and the contemporary art of the kiva murals.

The combinations of color and texture in these pictures can give them a painterly quality that is virtually unique in prehistoric southwestern painting; it is otherwise found only in the related tradition of contemporary kiva murals and in some pottery-painting styles that were derivative from the Sikyatki tradition. The only regional precedents for that tactile quality seem to be in the unrelated pictographic rock art of the San Juan region. As in earlier times, pottery painting was on a continuum with other kinds of pictorial art, but in the Pueblo IV period its position seemed to shift from the domestic and mundane toward the esoteric and the sacred.

Mural Painting: Early Accounts and Recent Discoveries

It has only been during the last half-century that many examples have come to light of the vigorous representational mural-painting tradition of the Rio Grande pueblos that had been described by sixteenth-century Spanish chroniclers. A few fragmentary Pueblo IV paintings were excavated earlier, but until the 1935 discoveries at the site of Kuaua on the west bank of the Rio Grande north of Albuquerque there was scant evidence to support the accounts of the Spanish explorers (Dutton 1963; Hewett 1938b; Sinclair 1951; Smith 1952; Vivian 1935).

Those accounts are, for the most part, frustratingly vague. For example, Hernan Gallegos, who was a member of the 1581 Chamuscado–Rodriguez expedition, wrote of "monsters and other animals and human figures" that he saw painted on the walls of Rio Grande Pueblo houses. But he did not say how large or small they were or give any other indication of what they may have looked like, nor did he say if they were on interior or exterior walls; and he did not discuss their purpose or who may have painted them. Gallegos was one of the few chroniclers to describe gender division of labor in the arts among the Pueblos, but with regard to painting, his words confuse: "women are the ones who spin, weave, decorate and paint. Some do it as well as the men" (Hammond and Rey 1966:82–86). In the end, it is uncertain whether the paintings were done by men, women, priests, lay people, or professional artists.

Juan de Oñate, who led the Spanish colonists to the Rio Grande Valley in 1598, is supposed to have seen "portraits" of the leaders of earlier Spanish expeditions painted on the walls of Pueblo buildings (Dutton

1963:12). One of his officers, Geronimo Márquez, reported seeing paintings of Mexican Indians whom he identified by their costumes on the walls of a kiva at Acoma Pueblo (Zarate 1962:165; *in* Brown n.d.:17). Although few known Pueblo IV paintings support the idea that the artists had any interest in painting portraits, or any other pictures of foreigners for that matter, those sixteenth-century interpretations of Pueblo murals cannot be lightly dismissed. Precedents for Native American portraiture were as close as Mexico, and both Oñate and Márquez may have been familiar with the tradition recorded by Bernal Diaz in the 1560s (but not published until 1632) that Aztec artists in 1519 had painted portraits of Cortez for Montezuma (Diaz 1979:72–74). If, on the one hand, knowledge of portraiture in Mexican art may have influenced Oñate and Márquez to misinterpret Pueblo pictures, on the other hand it could have sensitized them to recognize portraits even when they were done in an exotic art style.

The casual ethnocentricity and application of alien values that sixteenth-century Spanish explorers commonly applied to the interpretation of the Pueblo art that they saw may best be demonstrated in the descriptions written by Perez de Villagra, another of Oñate's officers. He was quick to classify as demonology the painted images of Pueblo ritual that he saw at a Piro Pueblo near San Marcial on the Rio Grande: "On the walls of the rooms where we were quartered were many paintings of the demons they worship as gods. Fierce and terrible were their features. It was easy to understand the meaning of these, for the god of the mountains was near the mountains and in like manner all those deities they adore, their gods of the hunt, crops and other things they have" (Villagra 1933:140).

Equally assured and almost certainly mistaken was his interpretation of a painting seen in a kiva at the still-unidentified Rio Grande pueblo called Puaray located somewhere north of modern Albuquerque. A Spanish priest had been killed near Puaray in 1582, and two others who elected to remain there as missionaries were also thought to have been martyred. The kiva walls seen by Villagra in 1598 had recently been whitewashed, and "we were able to see, through the whitewash, paintings of scenes which made our blood run cold.... There, pictured upon the wall, we saw the details of the martyrdom of those saintly men, Fray Agustin, Fray Juan, and Fray Francisco. The paintings showed us exactly how they had met their death, stoned and beaten by the savage Indians" (Villagra 1933:132).

However, the single incident that he thought was pictured never occurred, for the priests were killed at different times in different locations (Dutton 1963:13). And of the many hundreds of Pueblo murals recovered since 1935, only a rare few can reasonably be interpreted to support the idea that martyred priests, or portraits, or Mexican visitors were ever painted on kiva walls. Instead, those surfaces appear to have been generally reserved for pictures of mythic events or for images of a ritual nature (Dutton 1963:13).

In earlier years, before the mural discoveries at Kuaua, no Pueblo wall paintings that were unequivocally narrative were known and the descriptions by Villagra and his countrymen of a representational and narrative pictorial art could reasonably be discounted or even dismissed as fabrications. Kuaua (now Coronado State Monument) had been identified by some prehistorians as Villagra's Puaray, which added interest to the 1935 discovery of kiva murals there (Dutton 1963:19). But even though the Kuaua paintings verified the Spanish descriptions of a Pueblo narrative tradition, they did little to support Villagra's interpretation of what he had seen. It was now known that Fray Juan had met his death not at Puaray in 1582 but at the Pueblo of Paako on the eastern slopes of the Sandia Mountains in 1581 where, coincidentally, fragmentary wall paintings were discovered earlier in the 1930s (Dutton 1963:13; Tichy 1938:78). Most importantly, it was abundantly obvious that, rather than representing sixteenth-century events, the subject matter of the Kuaua paintings referred to mythological and ceremonial narrative traditions comparable to those still known and practiced among the modern Pueblos (Dutton 1963:13) (see Plate 1).

The Kuaua discoveries meant that we could now believe that Villagra saw what he said he had seen but still doubt his interpretation of it. A further effect of the discoveries was to remind prehistorians of the many fragmentary paintings that had been found in earlier days and whose importance could now be reevaluated. One of the earliest reports of a Pueblo IV mural painting concerned one found in 1915 on a wall of a square kiva at the site of Otowi. Otowi (also known as Potsuwi'i) is on the Rio Grande near the eastern edge of the Pajarito Plateau, the northeastern portion of the Jemez Mountains (Tichy 1938:78; Wilson 1917:87; 1918b:290–94; Wilson 1918a:317).

Otowi is among several Pajarito Plateau Pueblo IV sites considered to be ancestral to nearby modern

Figure 79. Wall painting, Otowi Pueblo, Pajarito Plateau, fifteenth–sixteenth century. This painting of a black-outlined yellow animal clearly falls within the contemporaneous wall-painting tradition, but is much less elaborate than murals later uncovered at Kuaua, Pottery Mound, and Hopi. Similar painted animals are usually identified as mountain lions, and some are known from cave sites near the Salinas Pueblos. (Photo Archives, Museum of New Mexico, neg. no. 82917, photograph by Lucy W. W. Wilson [1915].)

Tewa-speaking pueblos. Others in the vicinity and elsewhere in the Jemez Mountains are ancestral to modern Keresan-speaking pueblos and to the Towa-speaking community of Jemez Pueblo. The region had become an important Anasazi population center during the Pueblo IV period, with emigrants coming to it from the Mesa Verde, Gallina, and Chaco Canyon areas from the twelfth to fourteenth centuries (Cordell 1984; Ellis 1967; Ford et al 1972). A great variety of Pueblo IV pictorial art is found there.

The Otowi mural appeared to be more realistic and compositionally better controlled than any earlier Anasazi wall paintings that were then known (Fig. 79). It represented a single large and crouching animal thought to be a stylized mountain lion in a static pose,

with no hint of interaction with other figures or of a narrative story. Similar subjects which are stylistically quite different were known from other Pueblo IV pictures in that region, and others, more like the Otowi painting, are now known from more southerly sites in the Rio Grande region.

Most Pueblo IV pictures in the Jemez area are engraved or painted on plastered room walls of cliff-side villages, engraved on the blackened soft volcanic ash of cavate room interiors, or appear on cliff walls and other rock surfaces (Baumann 1939; Chapman 1916:3, 1938:143; Hewett 1938a:97–98; Steen 1977). Other murals had been reported in the region but were fragmentary and had not been described in much detail (Chapman 1916; Smith 1952:68). Of these, the ones most similar to the Otowi wall painting were "remnants of mural paintings in many colors" that had been found in a "few of the larger caves, once used as kivas" (Chapman 1938:147–48). We now know that some of these very fragmentary paintings belong to the Pueblo IV mural-painting tradition, but their quality could not be fully realized until after the Kuaua discoveries.

Regardless of style or medium, the subject matter of most Pueblo IV pictures in the Jemez region differs significantly from that of earlier Anasazi pictorial art. In general, the iconography throughout the area is dominated by images of horned and feathered serpents, masks and masked beings, and many anthropomorphic and zoomorphic creatures that could be made to fit Villagrá's descriptions of "the demons they worship as gods." In many instances, interactions shown between and among these many personages had mythic narrative implications. Unlike the Otowi painting and in contrast to the realism implied by Villagrá's descriptions, however, most of the Jemez region narrative pictures are rather crudely engraved and arbitrarily composed on rock surfaces (Fig. 80). The more elaborate paintings and rock engravings of the region tend to be in the form of unframed, isolated images or are groups of images whose narrative relationships are uncertain at best.

More recently, a fragmentary mural which combines some of the narrative complexity of the Kuaua murals with the compositional control of the Otowi painting was recorded from the Pueblo del Encierro site on the Rio Grande upstream from modern Cochiti Pueblo and only a few miles downstream from Otowi (Schaafsma 1965) (Fig. 81). Dating from the late fifteenth or early sixteenth century and found in a round kiva, its subject matter included large circular forms thought to be sun shields which were flanked by a pair of unidentified animals (Schaafsma 1965:8–11). As does the Otowi mural and the mural fragments from the caves and rock shelters of the Jemez, the Pueblo del Encierro painting confirms the Pueblo IV mural tradition along the upper Rio Grande as well as the fact that the Pueblo IV residents of the Jemez Plateau nurtured a complex of pictorial traditions.

A few other fragmentary Pueblo IV mural paintings, which might have elucidated the Spanish descriptions had they been more complete, were reported earlier in the twentieth century from the Chama River Valley in New Mexico (Nelson 1923:12, 17) and from a few sites in Arizona (Haury 1934:14–42). Much of the rock art from several other regions of the Rio Grande Valley was visually and iconographically complex enough to give credibility to Spanish accounts of the mural-painting tradition.

Especially interesting are engravings and paintings found on boulders, rock shelters, and volcanic outcrops in the area east of Santa Fe and in the Piro and Tompiro regions to the south (Fig. 82). As in the Jemez area, the subject matter of this Pueblo IV rock art is vastly different from that of earlier Anasazi periods, and there are many iconographic resemblances both to Pueblo IV murals and to modern Pueblo ritual art. Similar imagery, including kachina masks, horned and feathered serpents, stars and anthropomorphized stars, and terraces were also among many motifs noted in the Pueblo IV rock art of the Zuni and Hopi regions. However, none of these pictures had been comprehensively described at the time of the Kuaua discoveries, and even the most complex of them was as ambiguous in composition and unclear in narrative intent as any earlier rock art.

In short, nothing comparable to the pictures described by the Spanish chroniclers was familiar to investigators until the mural discovery at Kuaua. Those paintings, recovered from different layers of plaster found in two kivas there, dated from the fifteenth and sixteenth centuries and provided a context within which the other pictorial arts of the Pueblo IV period could be interpreted (Dutton 1963:201–5). Rock art, pottery painting, woven, embroidered, and painted textiles, dance costumes, wooden and stone altars, and many other forms and media could now be understood as elements of a visual tradition that included a complex iconography and a stylistic spectrum ranging

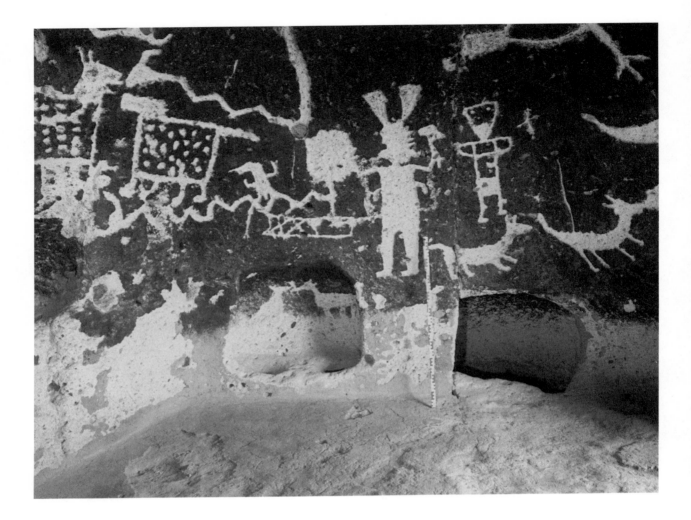

Figure 80. Cavate pictures, Cave Kiva, Pajarito Plateau, near Los Alamos, New Mexico, ca. sixteenth century. Many rooms excavated into the volcanic ash cliffs of the Pajarito Plateau were smoke-blackened to create a contrasting background for drawings that were made by scratching deeply through the black surface. While figures do interact, the pictorial organization is more like that of Anasazi open-air rock art sites than of wall paintings. (Los Alamos National Laboratory, photograph by Charles Steen.)

from the most abstract to the most narrative kinds of representation.

In 1936, hundreds more Pueblo IV wall paintings that were stylistically and iconographically distinct, although obviously similar to the Kuaua murals, were recovered from twenty-two kivas at the sites of two abandoned Hopi pueblos, Awatovi and Kawaika-a, near Sikyatki on Antelope Mesa in northeastern Arizona (Smith 1952). From 1954 to 1961, more than eight hundred paintings of the same period were recorded from sixteen kivas at the site of Pottery Mound south of Albuquerque, New Mexico (Hibben 1975). Other Pueblo IV murals from rooms and kivas have since been recorded (as discussed above) at Pueblo del Enciero near Cochiti Pueblo (Schaafsma 1965), at Picuris

Pueblo (Dick 1965), at Gran Quivira (Las Humanas) (Peckham 1981), at Homolobi near Winslow, Arizona (Pond 1966), and elsewhere, but nowhere in such profusion or in such comparatively good condition as at Kuaua, Awatovi, Kawaika-a, and Pottery Mound.

Figure 81. Wall painting, Pueblo del Encierro, near Cochiti Pueblo, New Mexico, ca. sixteenth century. Barely visible here are fragments of a shield and what appears to be the muzzle of a deer with a dark line leading to its heart. (Museum of New Mexico, Laboratory of Anthropology, drawing by Nick Evangelos.)

Visual Analysis of Pueblo IV Murals

The Pueblo IV narrative wall paintings from all sites share many similarities. With a few exceptions, for example, a single round kiva at Pottery Mound and other circular ones at Las Humanas and Pueblo del Enciero, they were painted on the walls of square or rectangular kivas, an architectural form associated with the western pueblos and possibly derived from Mogollon pro-

Figure 82. Pictographs, near Tenebo Pueblo, Salinas district, central New Mexico, fifteenth–seventeenth centuries. Masks, masked human figures, and a star-faced personage are among tiny paintings that seem randomly distributed across the back wall of this small rock shelter. Compare to Plates 34 and 35. (Photograph by Dudley King.)

totypes (Dutton 1963:190–206; Hibben 1975). Mural paintings of the San Juan Basin Anasazi in the previous era had usually been on the walls of circular kivas, but the exceptions, as at Atsinna near Zuni, were the most colorful and elaborate.

By far the most complex of the earlier known murals are those from Atsinna, which are transitional in time between the Pueblo III and Pueblo IV periods (Woodbury 1956). The Atsinna paintings were on the walls of a rectangular kiva in a location bordering on Mogollon territory, and a Mogollon association of some sort seems plausible not only because of proximity to Mogollon territory, but also by identification of the site as among those ancestral to modern Zuni (Woodbury 1979). Zuni is thought to have been created by Anasazi people migrating from the north who were joined at the beginning of the Pueblo IV era by Mogollon people from the west and south (Ferguson and Hart 1985:20–27; Stevenson 1904:444).

Except for the two with paintings, the kivas at Kuaua are circular, as is usual for the eastern pueblos of that period. Pottery Mound is also in the Rio Grande drainage, but most of its kivas are square or rectangular. Its relationships to any modern pueblo are unknown, and, like Atsinna, it is located in a Mogollon–Anasazi border region. Though the case is by no means clear, some sort of Mogollon and Western Pueblo stimulation for the emerging Anasazi mural-painting tradition may be postulated by the common association of murals with rectangular kivas. The logic of the argument is confounded by the late prehistoric–early historic site of Las Humanas located in the home territory of Jornada branch Mogollon people. Kivas there, including those with murals, are round.

Pueblo IV kiva murals often show interactions among animals, humans, animals and humans who appear to wear masks, anthropomorphic animals such as snakes with human legs, other fantastic creatures including stars with legs and faces, and inanimate motifs such as water and plants. These subjects are generally organized into planar compositions wherein background spaces are characterized by voids and few visual clues are given to define particular spatial or temporal relationships between and among images. Some compositions are symmetrical, often along a vertical axis, but those that are most obviously narrative are generally organized in a linear fashion and may extend continually across two or more walls (Fig. 83, see Plate 1). In some instances, all four walls of a room were painted with a continuous scene surrounding the interior space as though the walls were a window looking out on another world (Brody 1969). Framing of the picture space is common, if only along the bottom margin. The upper parts of many pictures are missing, but upper framing lines are usual where evidence for them is possible, and side frames also occur (Smith 1952:106–19).

Figures were overlapped and scale differences between them were used to create consistent if shallow illusions of spatial depth. There is considerable variation in detail from site to site in both iconography and compositional preferences, but basic pictorial techniques and methodology were much the same in all places. Human and animal images were usually painted in a frontal or profile view and are very often shown in active and interactive poses. Some frontal anthropomorphic figures are quite static, symmetrical along a vertical axis, and hieratic in posture with hands held

Figure 83. Wall painting (copy), Kiva 2, level 14 (or Kiva 8, level 6), Pottery Mound, New Mexico, fifteenth century. This seems to be the rarest of all kiva wall-painting subjects, a representational narrative of an actual world event. (Maxwell Museum of Anthropology, copy by Tom Bahti.)

upward and arms bent at the elbows (see Plates 1, 18). The legs of such figures are most often shown in profile, both turned in the same direction. Facial features are usually stylized and lack distinctive character, but masks, facial painting, costumes, and other paraphernalia are often depicted in precise detail and seem to establish the unique identity of each individual.

As in earlier Anasazi pseudo-cloissonné–style paintings of the San Juan Basin, figures were generally flatly painted in different colors and each color area was separated from all others by contour lines. As well as separating color areas, these bounding lines, usually either black or white, served to integrate the blocks of various colors into visually legible motifs, organisms, and individual beings (Fig. 84, Plate 26).

Colors were descriptive, and unlike earlier Anasazi paintings, color selection, especially when prey animals were isolated on a wall, seems to have been more systematically coded symbolically, as in modern Pueblo ritual art. Though color values were close, the color range was wide (Plates 1, 26). Most colors were made with mineral pigments probably held in some sort of organic binder such as plant juices or egg in a water-based medium (Smith 1952:22–32). The wall surfaces were generally well prepared of fine-grained,

Figure 84. Wall painting, Kiva 7, layer 7, Pottery Mound, New Mexico, fifteenth century. Humans, birds, and serpents may all have star faces. Some star images are surely to be identified with the planet Venus and warfare, but their variety of associations suggests multiple meanings. (Maxwell Museum of Anthropology, photograph by Dennis Tedlock.)

smooth mud plaster, sometimes with a white gypsum or pinkish clay coating to serve as a unifying background color. Both the pigments and the prepared wall surface tended to be nonreflective. There is little evidence concerning paint application tools; brushes made of plant fibers and perhaps feathers were almost certainly used, but often no tool finer than a human finger was needed. Late in the nineteenth century, similar lines in mural paintings done at Hopi were drawn with strips of corn husk bent over a finger and dipped in paint (Fewkes and Stephen 1892:224). Except that more colors were used, the painting technology seems to have been virtually identical to both earlier Anasazi mural-painting traditions and those of the nineteenth-century Pueblos (Fewkes and Stephen 1892; Silver 1982; Stephen 1936).

Variations from site to site in iconography, narrative subject matter, and styles of presentation have been briefly noted and discussed (Brody 1969, 1974; Cole

1984; Crotty 1979; Dutton 1963; Hibben 1975; Peckham 1981:32–38; Smith 1952:148–51). In general, the figures at the four major sites dominate the walls on which they are painted. Because the upper parts of the rooms were rarely preserved, wall height is generally unknown, but it probably ranged from about seven to nine feet; most painted kivas were about twelve to fourteen feet on a side. A dark-colored dado about two feet high, with a framing line at its top to delineate the picture space, was usually painted below the mural. The dado often appears to be an upward extension of the dark earthen or flagstoned room floor. The framing line above it is made generally of several narrow stripes of color and resembles the modern Pueblo pictorial convention for a rainbow. In some instances, a band of stylized clouds framed the upper part of a painting, which may even have been extended to the room ceiling (Brody 1969:105–7).

To summarize, paintings were usually confined within a framed band that was about four to six feet high, within which human figures were shown somewhat less than life-size and birds and most other animals about life-size. The upper and lower frames often used images of rainbows below and clouds above a painted extension of the mundane floor of the kiva whose walls were painted. The pictorial context then can be interpreted as an explicit representation of an ethereal and sky-related space within which painted figures act and interact.

At some sites, for example Las Humanas, the painted figures on a wall were considerably smaller than at the major mural sites; they are less dominating and their placement is more suggestive of rock-art compositions at open-air sites than of the more formal, framed kiva paintings (Figs. 85, 86). In a noteworthy reversal that dramatizes the continuity between mural-painting and rock-art traditions, contemporary paintings at rock-art sites in the vicinity of Las Humanas, although much weathered, once seem to have been as monumental and dominating as the most impressive and tightly controlled kiva mural from any of the major sites (see Fig. 82, Plate 27).

The figures in the Kuaua paintings tend to be stiffer, more angular, less variable, somewhat less elaborately costumed and masked, perhaps more human in scale, than figures from the Hopi sites or Pottery Mound. They are long-waisted and tend to have vertical headdresses, and in those respects and their stiffness they suggest the sixteenth- and seventeenth-century paint-ings at Las Humanas and the open-air art sites in that region (see Figs. 82, 85, Plate 15). The painted background details at Kuaua, including lightning, plants, and rainfall, are sometimes quite specifically represented. Compositions there are bordered only by a bottom line in the form of a multicolored rainbow, which acts as a ground or horizon line and serves as a point of reference that combines with the background contextual details to suggest a specific environment. Vertical framing lines used to create paneled picture spaces are absent, and most pictorial compositions at Kuaua were continuous around the four sides of the room (see Plate 1).

There seem to be more fantastic beings, such as composite figures with human and animal attributes, at Pottery Mound than at any of the other major sites. Costumes, headdresses, and masks are elaborate and varied, and there are many more pictures of decorated textiles than at the other sites. Pictorial compositions are more varied and complex than elsewhere, and there are examples of virtually all compositional systems that have been recorded from any mural site. Subject matter also seems to have the greatest variety at Pottery Mound. Many pictures there are static and hieratic, but some appear to record secular activities; others seem to depict ritual events taking place within a kiva, and many show incidents that seem to occur in the world of the supernaturals (Plate 28, see Figs. 6, 63, 71). Several paintings that appear to be of warriors and prisoners come closest to validating Villagra's historical interpretation of the paintings that he saw at Puaray as well as Oñate's report of portraiture (see Fig. 83).

Compositional formality and complexity is best developed at Awatovi and Kawaika-a, where masks and masked figures also appear to be most common and elaborate. At Hopi, paintings are most likely to be limited to only one wall of a room, to be organized symmetrically, and confined to a panel by vertical framing lines. Mural compositions that are complex abstract patterns, also found on some murals and many paintings of textiles at Pottery Mound, are most highly developed at Hopi (Plate 26). These resemble and may derive from the Hopi pottery painting style called Sikyatki Polychrome, and it is appropriate to call these Sikyatki Style paintings (Fig. 87). The Hopi murals are the most stylized and the least likely to suggest events taking place in a naturalistic, real-world environment, though some suggest theatrical enactments of battles (Plate 29, see Figs. 69, 71).

Figure 85. Wall painting, Room 12, layer 15, west wall, Mound 7, Las Humanas (Gran Quivira), Salinas district, New Mexico, mid-seventeenth century. Though similar in size and scale, this mural is markedly more spontaneous and casual in its execution than were many local pictographs of this period (see Figure 82). It differs even more radically from the somewhat earlier wall paintings at Pottery Mound, Kuaua, and the Hopi mesas. See Figure 86. (Western Archaeological Center, National Park Service.)

Chronology and Iconography

There is some overlap in the iconography of the images painted at the different kiva-mural locations, but for the most part each site has a different inventory of masks, masked figures, fantastic beings, animals, and narrative contexts. Obviously, our understanding of the mural-painting tradition and its history would be greatly improved if we could accurately describe these variations and organize, analyze, and evaluate them with some degree of confidence. But knowledge of both the relative and the absolute chronologies of the paintings within each site and among them all is critical to the analytical process; almost as important, a comprehensive descriptive iconography is needed so that the painted images may be correctly identified in all of their variety. At present, neither requisite is very well met.

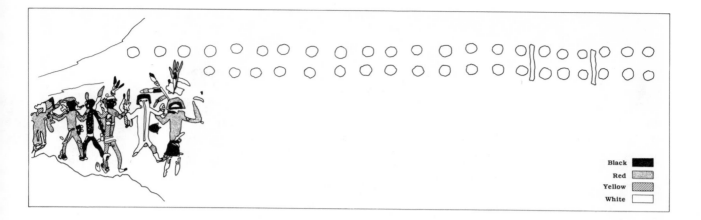

Black ▮
Red ▨
Yellow ▨
White ▯

In many instances, the painted subjects can be directly identified with the imagery, ritual, and traditional literature of modern Pueblos, especially in relationship to aspects of the kachina societies and Zuni and Hopi ritual (Dutton 1963) (see Plate 29). However, most often these identities are generic rather than specific, and even the surest resemblances must be treated with caution. Iconographic details in the murals are elusive, and the pictorial methods that were used often avoid precise background contexts which appear to be essential for the identification of particular personages, narratives, or rituals.

Further complicating the situation is the complexity of kachina iconography as it is known today. The inventory of kachina masks is enormous. New ones are constantly but irregularly added and old ones retired; each community has its own kachinas, and where the same ones appear in several places they may not look alike. Diagnostic characteristics that identify particular kachinas are not always obvious and may not be constant in any case; furthermore, there is no way of knowing what changes occurred during the last, dynamic four or five hundred years of the history of the various kachina societies (Anderson 1955; Colton 1959; Dockstader 1954; Hayes 1981a:89; Smith 1952:292–313; Wright 1973). At Hopi one hundred years ago, Alexander Stephen noted that "it is the rule for the personator to decorate his own mask and . . . he is allowed considerable latitude" (Stephen 1936:523; Smith 1952:293).

That "rule" may be very old and may also have been held at all of the pueblos that supported kachina societies; if so, the Pueblos and the Anasazi before them

Figure 86. Wall painting (copy), Room 12, layer 15, west wall, Mound 7, Las Humanas (Gran Quivira), Salinas district, New Mexico, mid-seventeenth century, reconstruction; see Figure 85. (Drawing by Katrina Lasko after Hayes 1981b:figure 66.)

had a mechanism to ensure that both formal and iconographic changes would occur in kachina art. Therefore, while there can be little doubt that the vast majority of the many hundreds of masks and masked personages painted on kiva walls or drawn at open-air art sites during the Pueblo IV period are representations of kachinas and kachina rituals comparable to those of modern Pueblos, it is not likely that any but the smallest fraction of the personages depicted or the activities shown will ever be identified with certainty.

Equal or greater uncertainty surrounds attempts to date precisely any murals thus far excavated. In all known cases, dating is contextual rather than direct; it is not presently possible to assign a date to a painting, but a range of dates may be established for the room where it was made. The year that a room was built may be estimated if enough structural wood found within it can be dated; the approximate time of its abandonment may be determined by dating burned earth within it or organic material or pottery found in the trash that filled it when it was no longer occupied. At best, usually, a range of time that is two, three, or four generations long can be assigned to the paintings that were found in any room.

In all known cases, kivas with murals had their walls replastered on many occasions; in several instances, more than one hundred layers of plaster have been counted on a single wall, and most were replastered dozens of times. Usually, several layers of plaster had pictures painted on them and a single wall might have as many as forty or fifty paintings. As a rule, if there is one layer of painting others can be expected. In theory, such obvious seriations should make it relatively simple to establish internal sequences in each painted room. However, several factors may obscure the potential clarity. Periodic renovations were often made during the life of any one structure. Walls were torn out when rooms were enlarged, or others were built if a kiva was reduced in size. Reroofing might damage all upper surfaces; niches and other wall openings were built or filled; walls would slump and require buttressing; plaster would spall and peel, and paintings might be deliberately defaced or partially erased. Add to these factors the damage caused by time, scavengers, and neglect after rooms and villages were abandoned, and the difficulties in understanding a sequence of paintings are multiplied (Bliss 1936; Dutton 1963:27–32; Silver 1982).

Very often, wall paintings were too fragmentary when first discovered for the relationships between their layers to be clear even on a single wall or for investigators to be sure that they were observing or recording only a single layer (Dutton 1963:26–32; Hibben 1975; Peckham 1981:15–18; Smith 1952:33–38)

Figure 87. Wall painting, Test 14, Room 3, front wall B design 11 and right wall design 18, Hopi town of Awatovi, northeastern Arizona, early fifteenth century. Details differ in each half of this bilaterally symmetrical composition. Motifs such as stylized feathers and hooking curves derive from the Sikyatki Polychrome pottery painting style (see Plate 21). The animals on each side of the central medallion have bird, quadruped, and human aspects. (Peabody Museum, Harvard University, cat. no. 39-97-10/23060d, photo no. N20305a, b, photographer unknown.)

(Fig. 88). Confusion could be compounded when more than one wall in a room had paintings on it.

Preservation of paintings is both difficult and costly. The layered pictures can only be seen and preserved by peeling each from its original plaster surface and remounting it on another backing (see Fig. 71, Plate 15). Since each painting overlies all others, exposure is from the outside in, with only the most recent picture visible. Field workers, therefore, generally have little idea of what lies beneath any one picture. And yet to preserve an upper layer without removing it from lower ones perpetually hides everything that is below it. Meanwhile, the risk of damaging earlier layers when trying to preserve a painting is always high. Field condi-

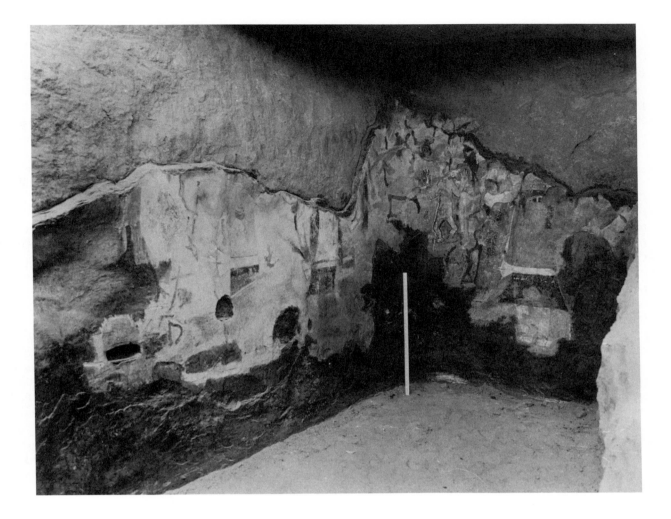

tions compound the difficulties, but the only preservation alternative is to remove entire walls, which itself must damage paintings and involve new risks.

Thus, few paintings can be dated with precision, few have been preserved, and most have been recorded by drawings and photographs and then scraped away to expose the underlying plaster layers and, perhaps, other paintings hidden below the topmost layer. Those that have been preserved are modified to some extent by the preservation process as well as by the effects of time; and both iconographic and stylistic analyses of all of them must rely on the not always consistent observations and recording methods used by archaeologists under difficult field conditions.

Figure 88. Wall painting, Kiva III, layer A-8, west and north walls, Kuaua, New Mexico, early sixteenth century. The generally poor quality of preservation of Pueblo IV wall paintings is graphically shown here. (Photo Archives, Museum of New Mexico neg. no. 87281, photographer unknown [1936 or 1937].)

Mural Painting Style

While many hundreds of paintings have been recorded, the number that can be fully analyzed in clear sequential order is quite limited. Therefore, it is hardly possible to describe in detail and with confidence the stylistic development of this most important Anasazi art. The best that can be done is to suggest a developmental sequence based on impressions which can provide direction for future research.

The technology of kiva mural painting was certainly developed locally by the Anasazi over many centuries, but the colorful Pueblo IV tradition of complex narrative painting seems to have little visual or iconographic relationship to earlier southwestern art (Brody 1969; Crotty 1979). Instead, it appears to have evolved over the course of only a generation or two, beginning perhaps about A.D. 1350, possibly at the Hopi pueblos where the tradition seems to have continued ever since (Smith 1952:95–103; 315–23). The impetus for its subject matter and narrative content clearly relates to the ritualism of the kachina societies, which seems to be a concomitant tradition. The rich and novel iconography of presumably contemporary rock art at open-air sites, especially in the Rio Grande Valley, seems also to be related.

Kachina societies, Rio Grande style rock art, and kiva murals form so interconnected a triad as to appear to be all parts of a single phenomenon. It is therefore reasonable to expect that if kachina societies were introduced to the Anasazi from the south by way of the Rio Grande Valley, then so also were kiva murals and Rio Grande style rock art (Schaafsma and Schaafsma 1974). But the issue is fatally confused by uncertainty over the dating of both the kiva murals and the Jornada Mogollon rock art, whose iconography provides the foundation for belief in a southern manifestation if not a southern origin for kachina societies. Meanwhile, both southern and western origins for the elaborate mural-painting tradition are suggested by the apparent correlations of mural paintings with rectangular kivas and the proximity of early kiva mural sites such as Atsinna to central and western Mogollon territories.

Regardless of its origin, the Pueblo IV mural-painting tradition burgeoned during the fifteenth century at Hopi, along with the invention there of the Sikyatki style of painted pottery (see Fig. 87). The wealth of murals recovered from Awatovi and Kawaika-a, the stylistic evolution of those paintings described by Watson Smith (1952:106–62), the fourteenth-century dates for some of them, and their association with rectangular kivas that are typically Hopi in virtually every detail all support the idea of a Hopi focus for the elaboration of the art.

Pottery Mound, near the Rio Grande, has the greatest variety of kiva murals and is the single most productive site of the art thus far discovered. Paintings done there, including those on pottery, are notable for their many iconographic relationships to Hopi ritual, ritual art, and pottery designs (Plate 26). A relatively large number of Hopi ceramics are documented from that site, and there is some ethnographic support for the suggestion that migrants from Hopi may have played a role there (Brody 1964). Though dating of the Pottery Mound paintings is rough, they all appear to have been done over the relatively short period of perhaps two generations, beginning about 1400. In any event, many of the murals at Awatovi and Kawaika-a appear to be older than any from Pottery Mound, and the latter site seems to have been abandoned by about A.D. 1450 (Voll 1961; Brody 1964). The quantity and variety of paintings at Pottery Mound may best be interpreted as a local specialization, stimulated by Hopi stylistic ideas and serving elaborate ritual activities that were, likewise, local in character but related to Hopi traditions (Hibben 1966, 1967, 1975).

The paintings at Kuaua, while surely a part of the same regional tradition, appear to be more recent and to represent a Rio Grande or Eastern Pueblo variation of a Western Pueblo and perhaps Hopi-inspired art. Later prehistoric and early historic mural paintings at other eastern pueblos are more tentative and less exuberant than those of Pottery Mound, Kuaua, and the two Hopi sites (compare Figs. 81 and 85 to Plate 1, Figs. 61 and 69). There are fewer of them at the sites where they are found, and the iconographic and pictorial variety that characterized the paintings at the major sites is lacking. In that context, it may be significant that the pictorial art at open-air sites near many Rio Grande pueblos of this period is enormously varied both formally and iconographically. It is tempting to conceive of at least some of that rock art as paralleling or even substituting for mural paintings.

To be an alternative tradition, the rock art would have had to serve purposes similar to those of the murals, an issue that cannot be pursued without examining the possible uses made of each kind of art and of the art sites. In the absence of direct information about

how either kind of art or art site was used, analogies with historically recorded Pueblo practices must be substituted. Evaluating these analogies depends to a great degree on judgments made by investigators of the meanings that have been applied to the visual and iconographic similarities and differences recognized among the pictures found at each kind of site.

Among the most persistent meanings given by investigators to both Pueblo IV murals and rock art is that both were made for related ritual purposes and at ritual locations. Yet despite considerable iconographic and some stylistic overlaps between both kinds of art, the formal distinctions between them are very great. How, then, can they have served similar ritual purposes? These formal differences must be explained if we are to assume shared ritual associations. If it is given that the form of any art is a response to a particular set of ideological and aesthetic values that are integral to both its location and its anticipated use, then, in this case, the place where ritual occurs establishes both the artistic context and the formal framework for the art.

Artistic form as well as artistic images communicate the symbolic and social values of the ritual; the two work together and they must be analyzed together. Great differences in either the form or the imagery of art at different kinds of locations must be satisfactorily explained if we are to believe that similar ritual purposes were served at two kinds of sites.

As well as understanding imagery, understanding the formal interactions between Pueblo IV art and the locations where it was made is a precondition for evaluating any analogies with historically documented practices that may be used to explain the art. The question of parallelism between the functions of Pueblo IV indoor and outdoor art sites requires close analysis and comparison of the formal characteristics of both rock pictures and mural paintings. Implicit in that analysis are questions concerning the very basic assumptions that, for the most part, both kinds of art were made in association with ritual activities, and that at least some of those activities were similar at the different kinds of art locations.

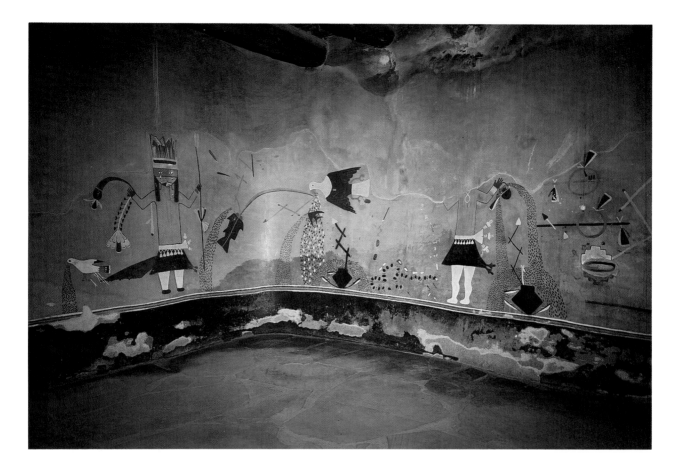

Plate 1. Wall painting (replica), Kiva III, southwest corner, layer G-26. Kuaua, New Mexico, late fifteenth–early sixteenth century. This replica at the original site of Kiva III is thought to depict the Universe (Dutton 1962:Plate XVI). People on a rainbow stand in a space where the ordinary laws of nature are suspended. Fish as well as birds spit seeds and water in the sky, and lightning flashes from water jars. Compare to Plate 15. (Museum of New Mexico, Monuments Division, photograph by Roderick Hook.)

Plate 2. Painted, clay-lined, coiled basket in a pottery bowl, northeastern Arizona, Pueblo III. The design painted on the thick, unfired, and smoothly polished clay is in the tradition of Kayenta Polychrome pottery. The utility of this unusual painted container is unknown. (Museum of Northern Arizona, cat. no. A1597/1337, photograph by Gene Balzer.)

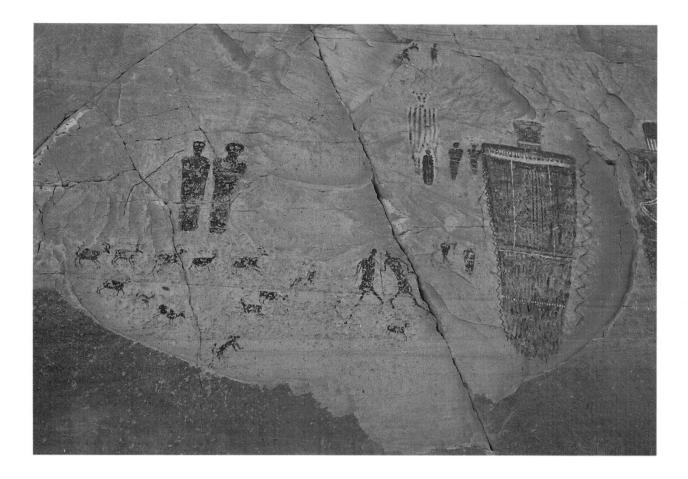

Plate 3. Pictographs, Great Gallery, Horseshoe Canyon, Utah, Archaic era. The small, lively, and realistic pictures of animals and men who appear to be in conflict seem to be as old as the armless, spectral images. The paint strokes at the bottom of the largest figures are feathered to create the illusion that the figures merge with the rock. (Photograph by Dudley King.)

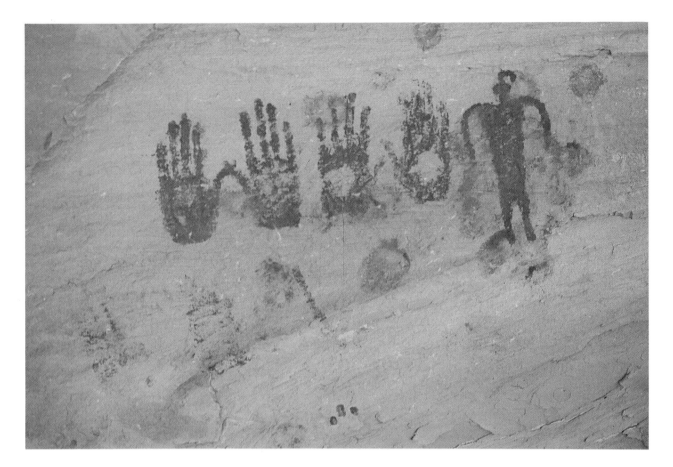

Plate 4. Pictographs, Grand Gulch, southeastern Utah. Bas-
ketmaker III period. These monochromatic paintings are
high on the ceiling of a rock shelter occupied during Bas-
ketmaker III and again in Pueblo III times. The carefully
composed handprints and Basketmaker III-style human fig-
ure appear to be contemporaneous. Also visible are traces
of other handprints and of mudballs that had been thrown
at the painting in the distant past. (Photograph by J. J.
Brody.)

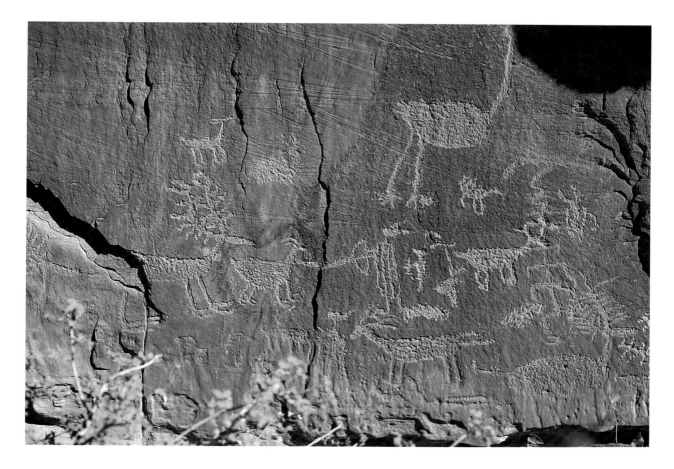

Plate 5. Petroglyphs, near Moab, southeastern Utah, Pueblo
II. Small representations of animals and humans in narra-
tive relationships are typical of Pueblo II rock art. (Photo-
graph by Dudley King.)

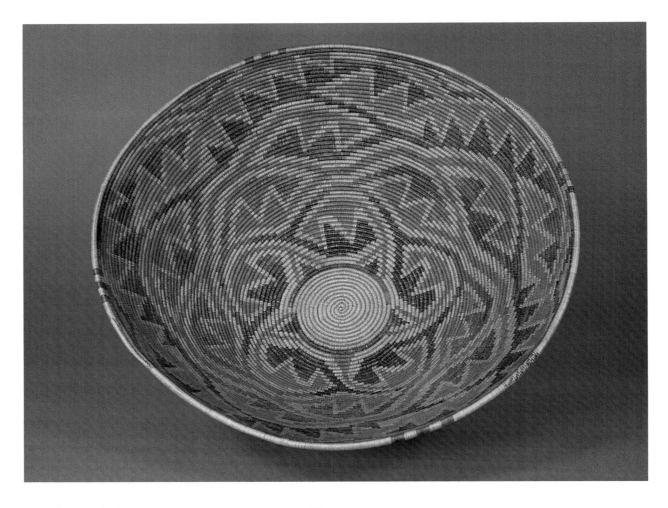

Plate 6. Coiled basket, near Grants, New Mexico, Pueblo III.
This extraordinarily well-preserved basketry bowl demon-
strates the continuity of Anasazi basketmaking skills. The
flowing rhythm of the undulating and interlocking red and
black motifs is unusual, but more angular versions of the
same basic design are common in other media. See Figures
5 and 30. (Grants Chamber of Commerce, photograph by
Deborah Flynn.)

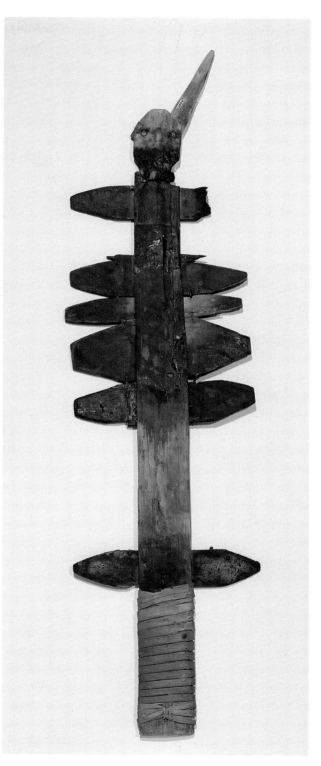

Plate 7. Pictograph, Betatakin, Tsegi Canyon, northeastern Arizona, last quarter, thirteenth century. The size of these paintings can be judged by comparison with the white human handprints to the left and above the shieldlike medallion. They are above a set of rooms on the northern edge of the great rock shelter that contains the Betatakin site and are visible from a considerable distance. (Photograph by J. J. Brody.)

Plate 8. Wand, painted wood, Chetro Ketl, Room 93, Chaco Canyon, northwestern New Mexico, mid-eleventh century. Only one of two long triangular hornlike elements remains at the top of the wand. Eyes are the only features painted on the snakelike head of the 23-inch-long construction. The cross-pieces are sewn to the main wooden slat with sinew. (National Park Service, photograph by Roderick Hook.)

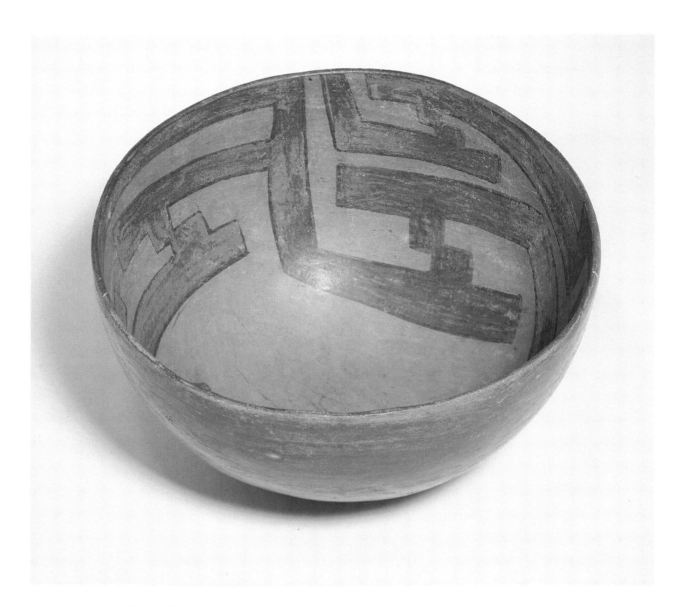

Plate 9. Pottery bowl, Citadel Polychrome, northeastern Arizona, twelfth century. Four-part patterning systems and interpenetrating positive–negative forms were well-developed attributes of western Anasazi decorative art. Deep bowl shapes are characteristic of the Kayenta region, which produced some of the earliest Anasazi polychrome wares. (Museum of New Mexico, Laboratory of Anthropology, cat. no. 43328/11, photograph by Roderick Hook.)

Plate 10. Wall painting, Moon House rock shelter, San Juan region, southeastern Utah, thirteenth century. In Pueblo III times bold, monochromatic paintings were sometimes placed on interior and exterior house walls, especially in the Mesa Verde area. The horizontal white stripe here continues behind the wall of a later room that juts into the plaza. The dots above the stripe and the triangles below it are typical of Mesa Verde wall paintings. (Photograph by Dudley King.)

Plate 11. Wall painting, Chetro Ketl, Room 106, Chaco Canyon, northwestern New Mexico, eleventh century. The ground for this painting is a carefully prepared, thick layer of very smooth gypsum. Each square in the precisely regulated composition was laid out with lines engraved in the plaster. There is a thickly painted pattern of interlocking brown and blue terraces in the bottom rectangle. Small, unpainted, and unrelated stick figures are also engraved in the plaster. (Photograph by J. J. Brody.)

Plate 12. Wall painting (copy), Atsinna Pueblo, El Morro, northwestern New Mexico, thirteenth century. Fragments of an elaborately painted, polychromed dado about 30 inches high were recovered from one kiva at this ancestral Zuni town atop the sandstone mesa known as Inscription Rock near Zuni. There are obvious similarities to pottery, textile, and basketry designs as in Plate 6. (Painting by Don Page, photograph courtesy of Gordon Vivian.)

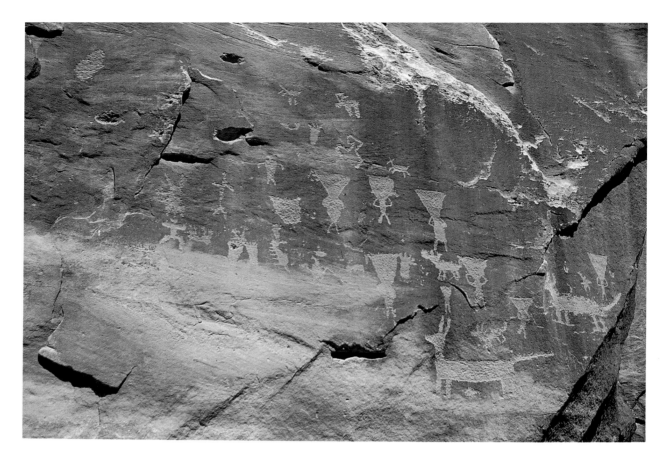

Plate 13. Petroglyph, Tapia Canyon, northwestern New Mexico, ninth–twelfth centuries. The many small figures carrying large, conical burden baskets are positioned as though seen by a viewer who is in front of and above them. Figures in the upper register are then perceived as more distant than those below, and the large animals become a kind of visual static that interferes with the spatial illusion. (Photograph by Dudley King.)

Plate 14. Petroglyph, Apache Creek, western New Mexico, Mogollon or Anasazi, ninth–thirteenth centuries. The basalt cap rock of this mesa in the Anasazi–Mogollon border region is naturally colorful and seamed with a variety of textures. Its very large and complex meandering engraving both incorporates and imitates the natural qualities of the material. (Photograph by J. J. Brody.)

Plate 15. Wall painting, Kiva III, south wall, layer G-26, Kuaua New Mexico, late fifteenth–early sixteenth century. In the 1930s, murals at Kuaua, Awatovi, and Kawaika-a were peeled from the mud walls and transferred to hardboard surfaces. Despite some degradation, many of the pictures are still well preserved. This painting of a personage called "Lightning Man" (Dutton 1962:136–37) should be compared with its reproduction in Plate 1. (Museum of New Mexico, Laboratory of Anthropology, photograph by Roderick Hook.)

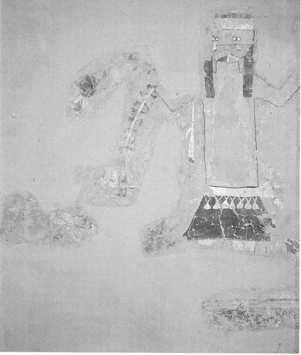

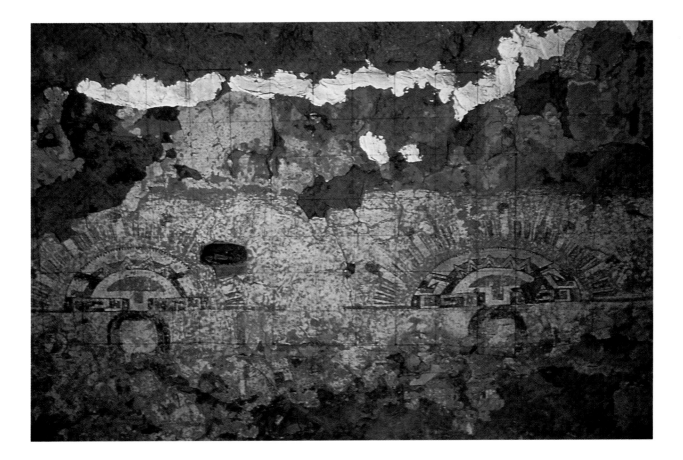

Plate 16. Wall painting, Kiva 8, west wall, layer 20, Pottery Mound, New Mexico, fifteenth century. This in-situ photograph is of a painting that no longer exists. The elaborate headdresses are similar to those worn today at Hopi by ritualists representing several different kachina and corn maidens. Compare to Plates 17 and 26. (Maxwell Museum of Anthropology, photograph by Dennis Tedlock, 1961.)

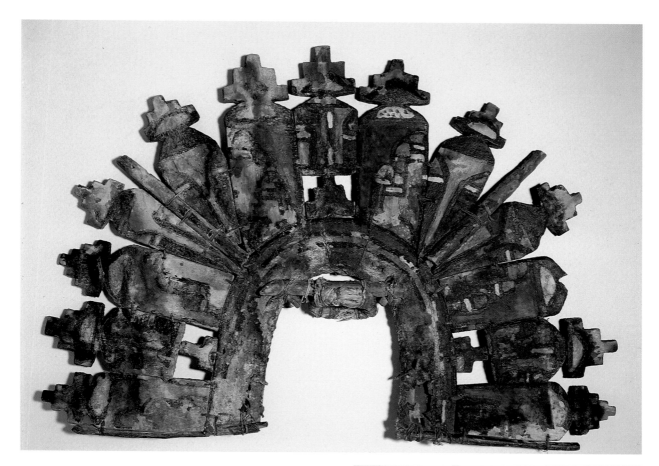

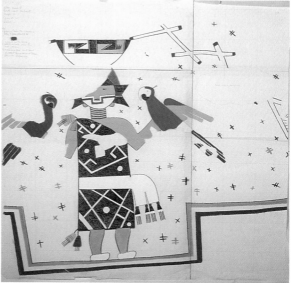

Plate 17. Shalako headdress, Oraibi Pueblo, Hopi, nineteenth century. The construction is of painted cottonwood carvings tied together with sinew and fiber, but each element is also an independent symbolic and visual statement. This was one of the several tablitas used by Hopi artist Fred Kabotie in the 1920s, when he researched the revival of the Hopi Shalako ritual. (School of American Research, Indian Arts Fund, cat. no. C.173, photograph by Roderick Hook.)

Plate 18. Wall painting (field drawing), Kiva 9, Pottery Mound, New Mexico. The standing figure wears an off-the-shoulder dress in the style still used as traditional, ritual costume by Pueblo women. She stands framed by a terraced rainbow and has a macaw in her right hand and a painted bowl on her head. Dragonflies in the background, which symbolize water, suggest an outdoor environment. (Maxwell Museum of Anthropology, cat. no. 76.70.744, painting by Paul Kay, photograph by Roderick Hook.)

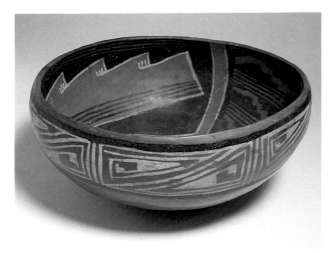

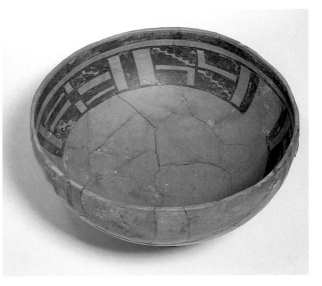

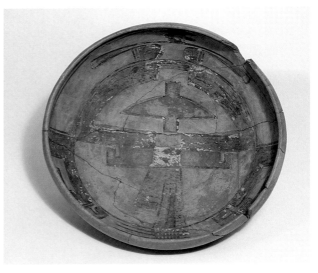

Plate 19. Pottery bowl, Four Mile Polychrome, White Mountains, eastern Arizona, fourteenth century. The Mogollon–Anasazi western border areas were important centers of innovative pottery painting during the transition from Pueblo III to Pueblo IV. Red-slipped wares painted in black, white, and red on jar exteriors or both surfaces of bowls, glaze paints, and large-scale, iconic designs all came into use. (School of American Research, Indian Arts Fund, cat. no. 118, diameter 10 inches, photograph by Roderick Hook.)

Plate 20. Pottery bowl, Agua Fria Glaze on red, middle Rio Grande, New Mexico, 1350–1425. Glaze paint on red, yellow, or orange slip characterizes Pueblo IV pottery from Santa Fe southward. Early glazes differ in many respects from older Anasazi wares, but are also similar in many ways. Line quality remained important, and many ancient organizational features and motifs were still commonly used. (Museum of New Mexico, Laboratory of Anthropology, cat. no. 42937/11, photograph by Roderick Hook.)

Plate 21. Pottery bowl, Pottery Mound Glaze Polychrome, New Mexico, late fifteenth century. Elaborate curvilinear bird and bird feather abstractions of the Hopi Sikyatki-style pottery paintings were also used on textile and wall paintings at Hopi and at Pottery Mound in the Rio Grande district. They also had great impact on glaze-painted pottery at Pottery Mound. (Maxwell Museum of Anthropology, cat. no. 87.50.16, diameter 11½ inches, photograph by Roderick Hook.)

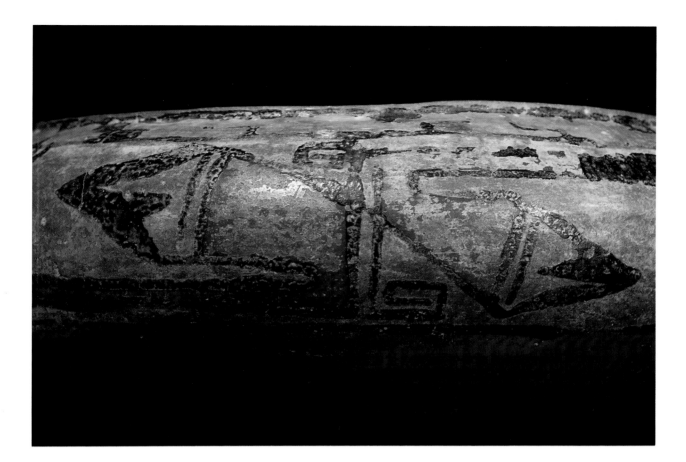

Plate 22. Pottery bowl, detail, Hawikuh Polychrome, Acoma–Zuni region, northwestern New Mexico, seventeenth century. Green, purple, and yellow–brown glaze colors show best on white-slipped surfaces, which were most commonly used by potters in the Acoma–Zuni (Cibola) area. This bowl was still in use at Acoma Pueblo when it was collected early in the twentieth century. (School of American Research, Indian Arts Fund, cat. no. 935, diameter 12½ inches, photograph by Roderick Hook.)

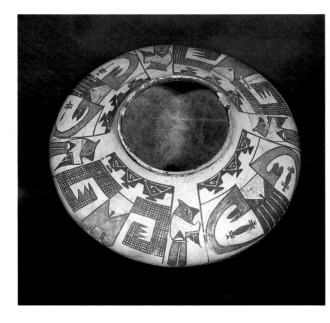

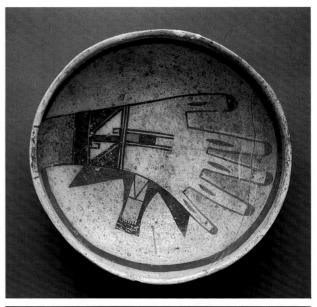

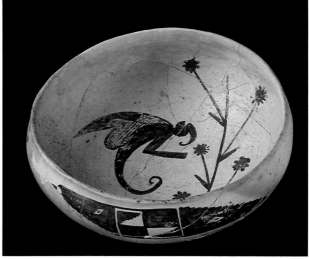

Plate 23. Pottery jar, Sikyatki Polychrome, Hopi, northeastern Arizona, fifteenth–seventeenth centuries. Vertical, stylized birds separate the four main panels, each dominated by an elaborately abstracted bird's tail. The terraced pattern above each panel is identical to ancient and modern textile designs used on ritual costumes. Compare to kiva murals at Awatovi, Kawaika-a, and Pottery Mound. (University Museum, University of Pennsylvania, cat. no. 29-77-73, diameter 16 inches, photograph by J. J. Brody.)

Plate 24. Pottery bowl, Sikyatki Polychrome, Kawaika-a, Hopi, northeastern Arizona, fifteenth–seventeenth centuries. Bowl interiors were sometimes used for narrative scenes by Sikyatki artists as though they were framed picture spaces equivalent to kiva walls. Here, an elaborate hand thrusts into the bowl from outside, breaking through the wide and painted frame. It partially obscures a flying bird that seems to be well below it in a sky made by spattered paint. (University Museum, University of Pennsylvania, cat. no. 39051, diameter 10½ inches.)

Plate 25. Pottery Bowl, Sikyatki Polychrome, Awatovi, Hopi, northeastern Arizona, sixteenth century. The insect approaching a sunflower is very much like figures in narrative paintings on kiva walls found at Awatovi and at Pottery Mound in New Mexico. The expressive qualities of Sikyatki-style paintings are reinforced by richly varied textures and colors. (Peabody Museum, Harvard University, cat. no. 36-131-10/7230, neg. no. T1083, photograph by Hillel Burger.)

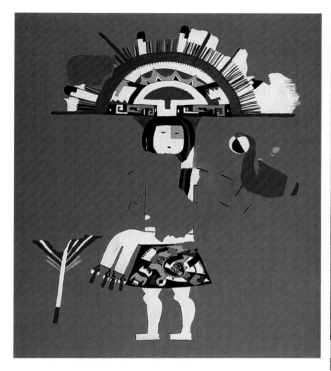

Plate 26. Wall painting (copy), Kiva 8, layer 20, Pottery Mound, New Mexico. The dancer's kilt decorated in the Sikyatki style was probably painted or embroidered. (Maxwell Museum of Anthropology, cat. no. 76.70.840, photograph by Roderick Hook.)

Plate 27. Pictographs, Abo rock shelter, Salinas district, New Mexico, fifteenth–seventeenth centuries. The headdress, head, and upper torso of an almost life-sized, ochre-colored human partially outlined in blue-green are centered here. Just above the figure is the head of a similar figure that was largely covered by the more visible painting. Fragments of other faces and figures are also visible. Many small paintings are isolated on the vertical faces of the lowest rocks (see Plate 33). (Photograph by Dudley King.)

Plate 28. Wall painting (field drawing), Kiva 9, Pottery Mound, New Mexico, fifteenth century. A human seems to be under attack by a feathered serpent. The scene suggests dramatic enactments between humans and water serpents at modern Hopi and Zuni pueblos, but the snout and headdress of the serpent resemble those worn by modern-day Zuni Shalako–bird impersonators. (Maxwell Museum of Anthropology, cat. nos. 76.70.776 and 76.70.777, drawing by Paul Kay, photograph by Roderick Hook.)

Plate 29. Wall painting (copy), Test 14, Room 2, right wall, design 6, Awatovi, Hopi, northeastern Arizona, 1375–1425. The diving figure with the conical cap is tentatively identified by Smith as one of the Hopi War Twins who make dramatic appearances at the Winter Solstice ceremonies (1952:302–3). (Museum of Northern Arizona collections, 65C.59; photographer unknown.)

Plate 30. Overview, Abo rock shelter, Salinas district, New
Mexico. There is no evidence of habitation at this shelter
whose ceiling and back wall are covered with Pueblo IV
paintings. (Photograph by Dudley King.)

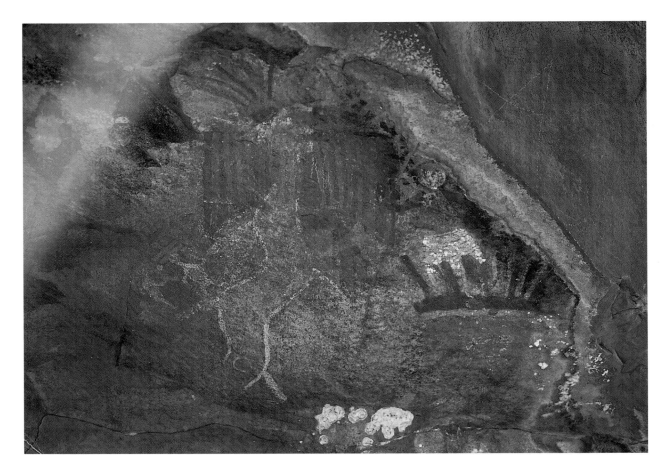

Plate 31. Pictographs, Abo rock shelter, Salinas district, New Mexico, fifteenth–seventeenth centuries. The most visible paintings here include (from the left) a four-pointed star, the spread wings of a bird with a feathered headdress above it and a green feathered serpent outlined in white below it, and a life-sized head and feather headdress at the lower right. Fragments of other overpainted images may also be seen. (Photograph by Dudley King.)

Plate 32. Pictographs, Abo rock shelter, Salinas district, New Mexico, fifteenth–seventeenth centuries. The color and texture of the rocks as well as the superpositioning of one painting over another helps to obscure the imagery. A realistic pair of bent, human-sized legs wearing white-fringed leggings are cleanly painted in the lower right, but the entire upper body of the figure is lost in a jumble of color and textures. (Photograph by Dudley King.)

Plate 33. Pictographs, Abo rock shelter, Salinas district, New Mexico, fifteenth–seventeenth centuries. These small, inter-active figures are near the base of the rock shelter. The heavy white line on the lower left is a portion of a modern whitewashed road sign. (Photograph by Dudley King.)

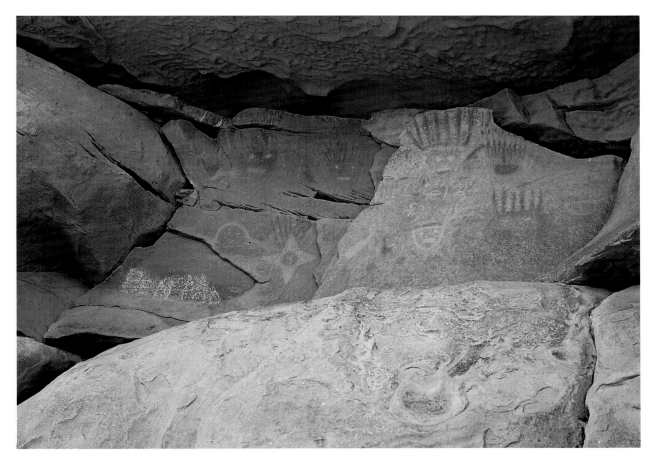

Plate 34. Pictographs, San Cristóbal, northern New Mexico, fifteenth–seventeenth centuries. These paintings are about life-size and similar to some pictures at Abo and at other Tompiro and Piro sites. Unlike the Abo paintings, these are easily perceived (barring the fading effects of time) and isolated on the walls of the small rock shelter. (Photograph by Dudley King.)

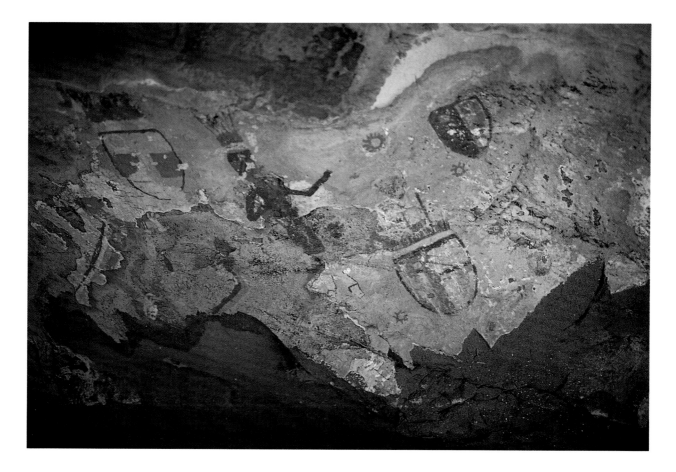

Plate 35. Wall painting, cave interior, Cerro de los Indios, Rio Grande Valley, fifteenth–seventeenth centuries. Human figures no more than about 6 inches high, tiny masks, stars, and a rainbow-backed mountain lion are painted on the naturally smooth white surface of a small cave. The cave is under the caprock of a steep mesa, on top of which are the ruins of a large Pueblo IV Piro town. The precisely drawn pictures are similar to some found near other Piro and Tompiro pueblos (see Figure 82). (Photograph by Dudley King.)

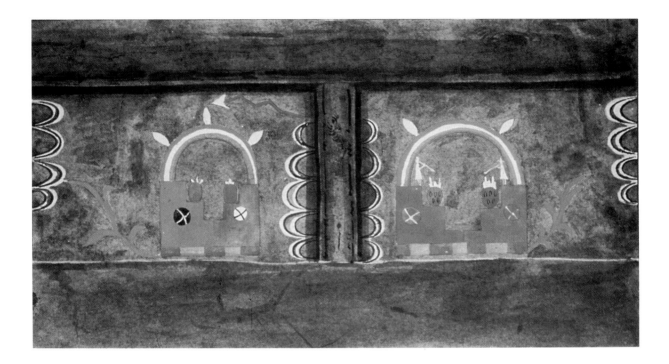

Plate 36. Wall painting (copy), kiva at Jemez Pueblo, New Mexico, 1849. The closed forms that incorporate facing terraces connected by rainbow arcs have a masklike character. Small white, flute-playing figures identified as "Montezuma's helpers" are under the rainbow atop the terraces on the right-hand side. Containers holding corn are on steps in each enclosure. (Library, Academy of Natural Sciences, Philadelphia, watercolor by Richard H. Kern, Jr.)

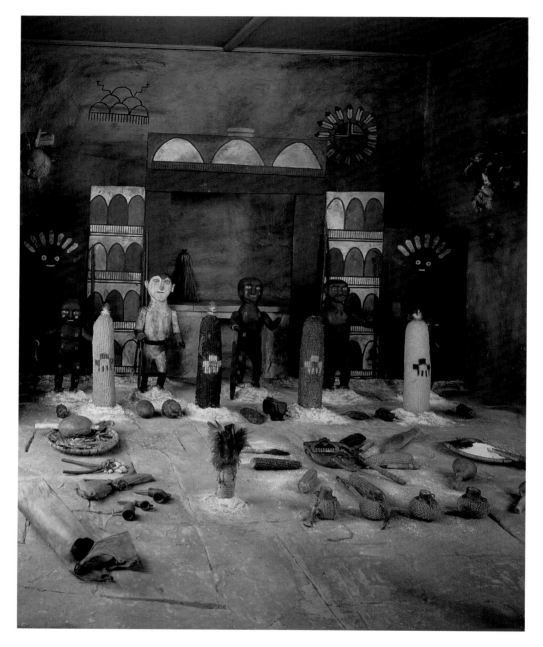

Plate 37. Altar (replica), Niman ritual, Shongopavi, Second
Mesa, Hopi, northeastern Arizona, ca. 1900. The Niman is
an annual nine-day ceremonial honoring the midsummer
departure of the kachinas to their home in the San Fran-
cisco Mountains. Paintings of Tungwup kachinas who flog
initiates at winter kachina rituals are on either side of the
altar. This was the simplest of three Niman altars seen by
Fewkes in 1891 (1892:88–89). (Field Museum of Natural
History, Chicago, neg. no. A11358c.)

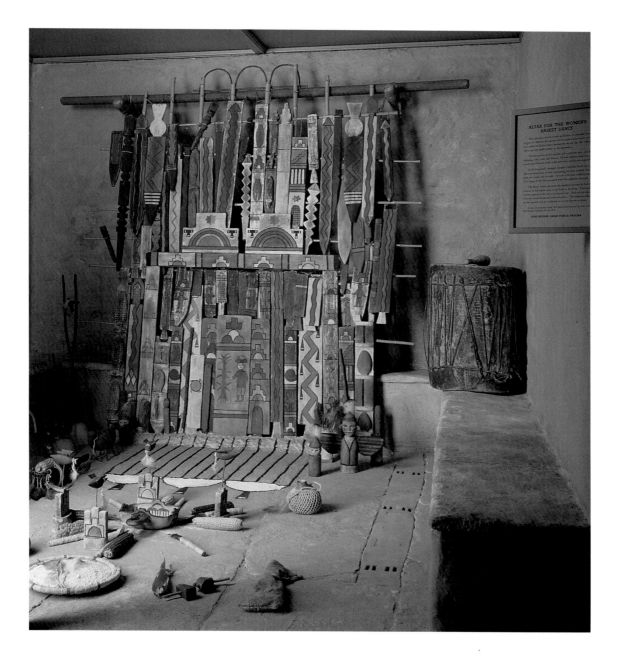

Plate 38. Altar (replica), Oa'qol (Women's Society), Oraibi, Third Mesa, Hopi, northeastern Arizona. This altar, like that of the Mamzrautu (Figure 7), is said to have been brought from Awatovi by the women survivors of that unfortunate town (Fewkes 1903:60). The original may date from Pueblo IV times. It includes eighty-three discrete painted slabs and sticks tied to a reed frame. A painting of the germination deity is its centerpiece. (Field Museum of Natural History, Chicago, neg. no. A11359c.)

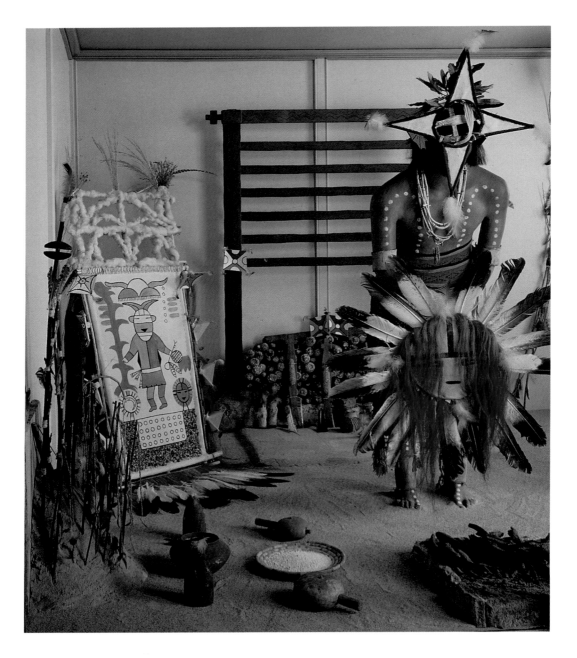

Plate 39. Diorama, Soyal ritual, Oraibi, Third Mesa, Hopi, northeastern Arizona, ca. 1900. The ritualist wearing a star-shaped mask/headdress in this winter solstice ritual carries a sun shield. A simple slat altar is behind him, and an elaborate painting of the two-horned germination deity is to his right. Cotton-covered cloud images form the upper frame of the painting. (Field Museum of Natural History, Chicago, neg. no. A11357c.)

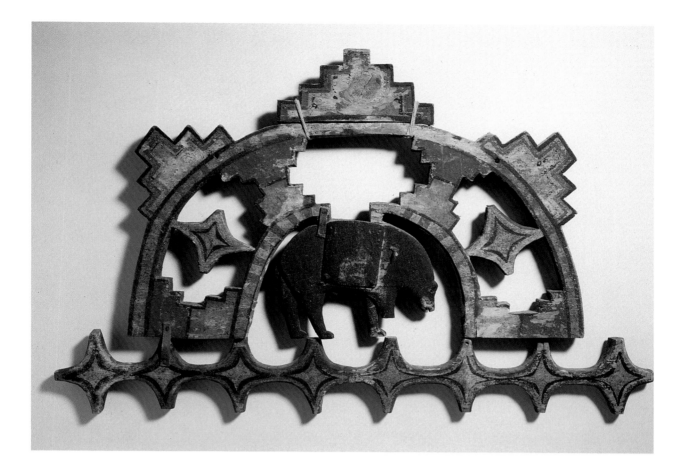

Plate 40. Painted wood, suspended altar, Zuni Pueblo, New Mexico, ca. 1900. A line of stars supports a bear who stands under a rainbow arc of this altar which is part of an elaborate room construction (see Figure 1). Other stars and terraces are attached to the rainbow. Most of the motifs used are also design units normally found as decorations on objects of everyday use. (School of American Research, Indian Arts Fund, cat. no. C.248, width 29 inches, photograph by Roderick Hook.)

Plate 41. Dance wands, painted cottonwood, Hopi, north-
eastern Arizona, ca. 1900. These are carried by participants
at certain line dances. Similar paintings on board are also
seen in altar setups, and somewhat larger ones may be
used atop a kiva to inform the community of activities tak-
ing place below. (School of American Research, Indian Arts
Fund, cat. no. C.191a, b, each about 23 inches high, photo-
graph by Roderick Hook.)

FIVE ▌ Art in the Open Air: 1300–1700

Most Pueblo IV murals are composed within framed spaces on one or more walls of a specialized room once reserved for ritual purposes. The subject matter of the paintings very often suggests that the pictures themselves also served ritual functions. They are dominated by images of animals and anthropomorphs who appear to be deities and by symbols and paraphernalia associated with the sacred domain. The beings depicted are often shown in narrative relationships suggesting mythological events, or alternatively they assume static, hieratic poses implying power authority. Many of the images and themes can be related confidently to Pueblo ritual institutions of the historic period, especially those associated with kachina societies.

Most rock art of this period is found clustered together in open-air sites, but, in contrast with wall-painting sites, there is great variety in the types of locations where it was made. Rock-art sites may be near villages, water sources, or animal trails, or they may possess some other obvious physical attraction or association. Unlike kivas and most other wall-painting locations which can be identified with a limited range of ritual activities, it seems clear that all rock-art sites are not the same and that it may be a taxonomic error to classify them as though they were. However, as will be seen, there are few obvious clues about the way art was made or used at open-air sites to suggest an alternative to classifying these places as though they all basically belonged to the same category.

Some of these problems will be examined more fully here, primarily through close examination of the imagery and formal characteristics of pictures that we call rock art, which were made at two important outdoor sites that are considered to be more or less contemporaneous with Pueblo IV mural-painting locations. The physical characteristics of these outdoor art spaces also will be examined, in terms of both their potential utility as ritual areas and the ways in which their physical configurations may have affected art production.

Place and Placement: Form and Imagery

As with kiva murals, Pueblo IV rock-art imagery is dominated by pictures of animals and anthropomorphs that appear to be deities and by symbols and paraphernalia associated with the sacred. But there are also animals and other subjects such as abstract or nonrepresentational forms which have no clear connection to ritual, while deity images are seldom shown in obvious narrative contexts and are only occasionally posed in dominating, hieratic fashion. Most pictures at open-air sites are less formally organized than kiva murals, and their ritual associations are less easily established. For both of these reasons, explanations of rock-art pictures as ceremonial art objects are necessarily more generalized than are kiva murals. The same subjects are likely to occur at any kind of location, so subject matter does not seem to provide a systematic basis for a typology of rock-art sites. Even when the subject matter is similar, stylistic differences between wall paintings and rock pictures can be very great.

The range of subjects used in Pueblo IV rock art is much broader than those in kiva murals of the period, a

fact which, in part, may be attributed to sheer numbers: There are many more known examples of rock art than of kiva paintings. But other factors must be taken into account. For example, rock art is far more widely distributed than kiva murals, and it was probably made by people from many more communities of diverse linguistic, cultural, and historical backgrounds. Further, because dating rock art is so difficult and uncertain it seems probable that the inventory of its images covers a much longer time span than the period represented by the known kiva murals. Therefore, rock-art iconography may represent a far greater diversity of meanings, purposes, ritual traditions, and activities than the kiva murals. It also seems likely that differences in imagery and style between these two kinds of pictorial art reflect functional differences between the two types of art sites.

In that regard, it may be useful to compare closely styles of presentation and classes of subject matter that were characteristic of the pictures made at open-air sites with apparently similar pictures made on the walls of kivas of about the same age. The assumption that a relationship existed between differing functions of the two different kinds of art site and the forms of art found at each may then be tested. Generalizations about the formal attributes of mural art have been made; it is now necessary to discuss the formal attributes of Pueblo IV pictures that are comparable to murals but which were made at open-air sites.

For purposes of comparison, it is important to know that the sites and the associated art that will be analyzed are contemporaneous and that they more or less represent the ordinary range of variation. Formal distinctions that may relate to differences in media, as between pictographs and petroglyphs, and to variations in the morphology of the art-site location, as between a rock shelter and a boulder field, must also be taken into account. Of a great number of open-air sites that could be used for analytical purposes, two seem to be particularly well suited for a broad, synoptic analysis: the Abo Painted Rocks site and the San Cristóbal petroglyph site (Fig. 89, Plate 30).

These two sites are among the best documented of the many Pueblo IV open-air sites that possess pictures comparable to kiva murals. Abo Painted Rocks is a rock shelter near the ruins of the Tompiro-speaking community of Abo, one of the Salinas Pueblos east of the Rio Grande and south of Albuquerque. The San Cristóbal petroglyphs are on basalt outcrops and boulders scattered on a hillside above the ruins of the southern Tewa- (Tano-) speaking village of the same name east of Santa Fe. Most pictures at both places can be attributed with reasonable certainty as the work of people from the nearby communities which were occupied from about the thirteenth through the seventeenth centuries.

In both cases, the surrounding countryside became heavily populated by incoming peoples after about A.D. 1250 and was abandoned by about 1680. In about 1672 the people of the Abo area moved to the Rio Grande Valley near Socorro, New Mexico, and they dispersed after the Pueblo Revolt of 1680, some among them joining the ancient Tiwa-speaking pueblo of Sandia near Albuquerque (Cole 1984:13–14; Schroeder 1979:241). San Cristóbal was abandoned between 1680 and 1692, with many of its people moving first to northern Tewa territory and then to First Mesa Hopi by 1716. They are identified today as among the Hopi–Tewa of Hano Pueblo (Dozier 1954, 1970; Schroeder 1979:247–48; Sims 1963:215–16; Stanislawski 1979:600). The two open-air art sites, therefore, almost certainly overlap in time with the major Pueblo IV mural-art sites.

No kiva murals are known from the village sites nearest these two rock-art locations, but they have been reported from nearby communities including Las Humanas, the largest of the Salinas Pueblos. Seventeenth-century murals were also found in rooms at Las Humanas that had no kiva features (Peckham 1981:15–38). Less is known about the murals reported from several rooms at sites in the Galisteo Basin not far from San Cristóbal (Nelson 1914; Tichy 1938). Other impressive rock-art sites with many similarities and some differences to the two described below are located within a few miles of each. There are many indications that the art at all of these open-air sites is related to kiva murals both iconographically and stylistically.

Abo Painted Rocks: Form and Subject

The Abo Painted Rocks site is in a shallow rock shelter less than a mile from the Pueblo of Abo, but hidden from it. It is in the Manzano Mountains near a major pass between the Rio Grande Valley and the salt lakes that give the Salinas pueblos their name. Many pictures in the rock shelter resemble figures in kiva murals (Cole 1984) (Fig. 90, Plate 31). There are also scattered engravings on nearby boulders, some of which, lightly patinated, share imagery with the paint-

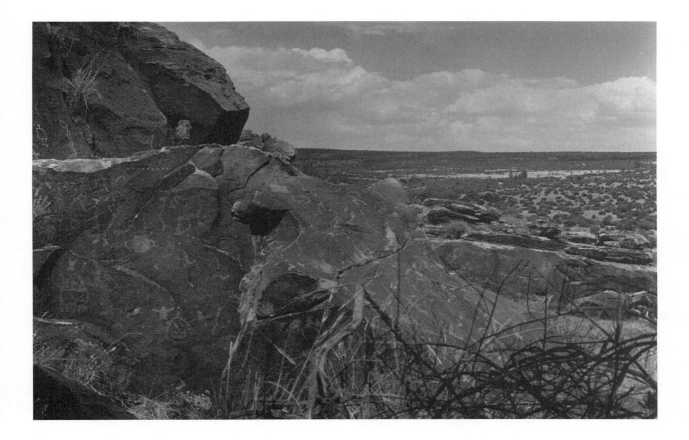

ings. However, the majority of rock engravings at this site are heavily patinated and seem unrelated to the painted images. Conversely, some of the paintings are distinctly different from the majority and may be related more closely to the heavily patinated petroglyphs.

Except that they were made directly on the sandstone walls of the shelter rather than on a plastered surface, the technology of the Abo paintings, including their color range and the possible use of brushes for paint application, appears to be identical with that of contemporary kiva murals (Cole 1984:21–23). Much of the imagery is also similar in style and detail to that of kiva wall paintings.

At Abo, large-scale anthropomorphic figures are shown full face or in profile and most wear elaborate headdresses, masks or facial paint, body paint, kilts, belts, and other costume elements typical of kiva mural figures. They are flatly painted and may be outlined by

Figure 89. Petroglyphs near San Cristóbal Pueblo, northern New Mexico, fifteenth–seventeenth centuries. The ruins of San Cristóbal, which was abandoned in about 1700, are at the far right. (Photograph by Dudley King.)

Figure 90. Pictographs, Abo rock shelter, Salinas district, central New Mexico, Pueblo IV, fifteenth–seventeenth centuries. The large figure with snake on the upper left is about four feet high. The rock shelter was not occupied in Pueblo IV times, and the nearest pueblo, Abo, which was abandoned in about 1670, is about one mile away. (Photograph by Dudley King.)

Figure 91. Pictographs, the Abo rock shelter, Salinas district, central New Mexico, Pueblo IV, fifteenth–seventeenth centuries. Extensive superpositioning—the overpainting of one image upon another—is characteristic of this site. Note the handprints which continue an iconic tradition that is at least as old as the Basketmaker period. Note also the small, active paintings at the base of the panel. (Photograph by Dudley King.)

contour lines which also separate the different blocks of colors within each figure that are descriptive of its body parts, costume, and paraphernalia. As in many kiva murals, forward-facing figures tend to be in static poses with upper bodies bilaterally symmetrical, arms raised and bent upward at the elbows, and legs bent at the knees either facing forward or both facing in the same direction (Plates 27, 32). The more active of the large figures are usually shown in a side view, heads in profile, and each gesturing hand gripping an object. Unlike the figures painted in kiva murals, which are invariably at about eye level on a vertical wall, the largest, most elaborate, and most dominant of the Abo painted figures are well above eye level, suspended over the head of a viewer on the overhanging, arched ceiling of the rock shelter (Fig. 91, Plate 32). The con-

figuration of the stone walls and ceiling of the shelter adds another spatial dimension to the paintings; they bulge and flow with the disconformities of the stone. The painting surface gives them a dimensional quality absent from the smoothed, vertical walls of a Pueblo room.

Cole (1984:27–38) identifies some of the masked figures painted at Abo with historically documented kachinas and the rituals associated with them at some Pueblos today; she also identifies some with masks that are pictured at kiva mural sites, especially Kuaua. In addition, shield figures painted at Abo resemble some from Pottery Mound, and there are feathered and horned serpents and four-pointed stars, some with painted faces and legs, which are like those on the walls of all major kiva-mural sites. One prominent figure with striped arms and legs resembles the ritual clown called *Koshare* at many Eastern pueblos; a feathered serpent similar to a Pueblo Water Serpent, and variously called Awanyu (Tewa), Palulukonti (Hopi), and Kolowitsi (Zuni), is adjacent to it (Cole 1984:cover, 29–31) (Figs. 90, 92, 93). Images similar to the ritual clown figure are known in the prehistoric and historic rock art of the Pajarito Plateau and Galisteo Basin regions and in twentieth-century ritual murals, including some at Hopi and at Acoma Pueblo (Cole 1984:31, Fig. 2; White 1932a:Plate 11a, b) (Fig. 94). Horned and feathered serpent figures are almost ubiquitous in the late Pueblo IV and Historic period art of the Southwest, varying somewhat from place to place both visually and in their mythic character.

Other painted images at Abo seem to refer to more ancient practices and imagery. Painted hands made in negative outline by stencil techniques suggest much older Anasazi rock art of the Four Corners and Mogollon imagery found to the south and west (Ellis and Hammack 1968) (see Plate 32). But they also resemble some Pueblo IV Sikyatki-style pottery paintings as well as paintings from other late prehistoric and Historic period open-air art sites, including some nearby, some from the Galisteo Basin, and others more distant such as at Painted Cave on the Pajarito Plateau (Fig. 95). Similar painted hands are said to be made today by certain Pueblo priests and other ritualists when depositing prayer offerings at shrines to remind the supernaturals of who made the offering (Ellis and Hammack 1968:35). Thus, painted hands are useless for chronological or stylistic purposes and seem to have only the most general interpretive value.

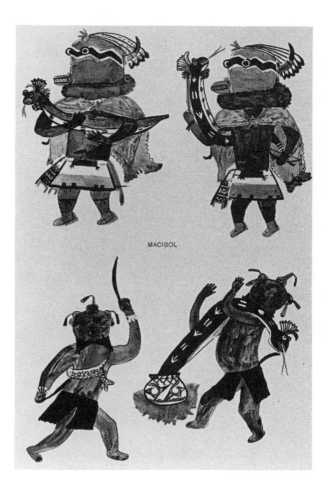

MACIBOL

Figure 92. Paintings of events in a Hopi Palulukonti ritual, 1900. Note the generic similarities to Pueblo IV paintings in posture and proportion as well as in the use of blank background spaces. Note also differences, especially in the use of dynamic gestures. (From a lithographic copy of watercolors done by an unknown Hopi artist and published in Fewkes 1903:Plate 26.)

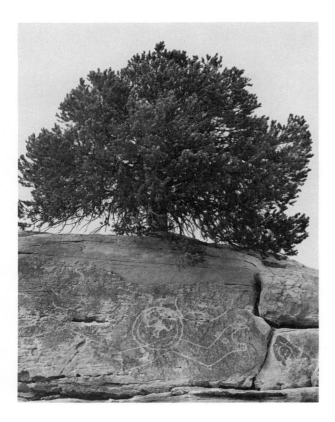

Figure 93. Petroglyph, near Pueblo Blanco, Galisteo Basin, northern New Mexico, Pueblo IV, fifteenth–seventeenth centuries. This is one of several very large horned serpents engraved in sandstone near Pueblo Blanco. As here, they are associated with shields and feathers. Compare especially to Figures 44, 89, 90. (Photograph by David Noble.)

Small monochromatic and red-painted stick figures at the Abo rock shelter are also stylistically indeterminate, but bear a general resemblance to Mogollon Red Style rock paintings of an earlier day (Schaafsma 1980:183) (Figs. 96, 97). Suspicion that these may be much older and culturally unrelated to the other paintings at the site is supported by the heavily patinated nearby rock engravings, which resemble thirteenth-century or even older Mogollon rock pictures from western New Mexico. The possibility of Mogollon art being at this site is supported by the presence of Mogollon pithouse villages in the general vicinity (Caperton 1981). The red stick figures and other, equally small polychromatic images, which more closely resemble kiva paintings, are the only ones here that obviously group themselves into potential narrative relationships (Plate 33).

Many of the small polychrome figures are masked, wear costumes, and carry paraphernalia that clearly identifies them with kachina images. Others carry shields, bows, and other equipment that may identify them with hunting, curing, and warrior societies. They tend to be long-waisted but are otherwise quite realistic in proportion, and their naturalism is emphasized by active postures and the draftsmanship of a lineal pictorial technique. Unlike the larger but generally similar paintings on the ceiling of the shelter, many of the smaller paintings are less than prominent and some seem to have been placed deliberately in locations that are virtually inaccessible and invisible.

Erosion and vandalism have taken their toll at this site, making iconographic identification difficult and disguising pictorial relationships. However, it appears that all of the human and humanoid figures, from the largest, most elaborate and hieratic single image to the smallest, simplest, most narrative and interactive image, were subject to superimposition. Several figures may have been covered with white paint before new images were made over them (Cole 1984:24). None are contained by clearly defined borders, and the nearest that any come to being composed within framed picture spaces are those groups of small figures on horizontal boulders near the base of the rock shelter, which are isolated from its mass by physical position as well as by their small scale.

Several distinct styles of painting are present at this one site: large polychromed figures that are hieratic and prominent; small polychromed ones that occasionally interact with each other and are often natu-

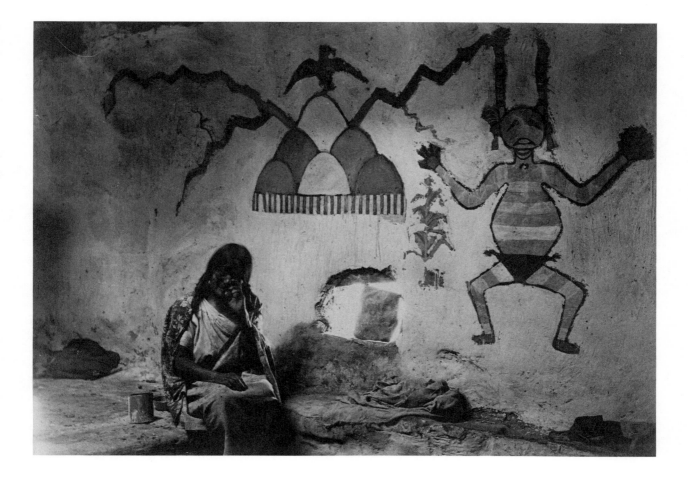

ralistic; and monochromatic, linear stick figures which seem unrelated to the other two styles. The two polychromed styles combine to provide complex visual effects which may or may not have been intended. The large dominant images are immediately attractive by scale and position, while the combination of superpositioning with the naturally rich colors and textures of the rock walls gives them an almost surreal character. They merge with and emerge from the living rock as though it all were a single organism. In visual counterpoint to this powerful illusion, the small paintings are almost invisible and, when found, they tend to emerge from rather than merge with the picture surface. They must be searched for, and the very process of discovery adds to their kinetic and interactive qualities. The combination of visual, pictorial, tactile, and narrative qualities, the natural and man-made effects, and

Figure 94. Wall painting, Lallaconte Kiva at the First Mesa Hopi town of Walpi, 1901. The composition is less highly structured and the major figure more active than was usual in Pueblo IV paintings, but similarities are nonetheless very strong. Compare the striped ritual clown with the figure next to the large serpent at Abo rock shelter (Figure 90). (National Anthropological Archives, Smithsonian Institution, photo no. 42189-D, photographer unknown.)

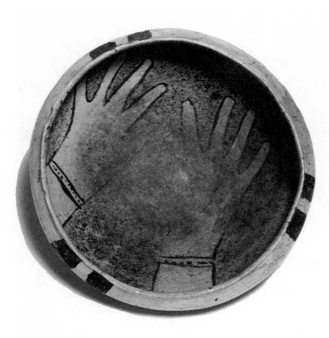

Figure 95. Pottery bowl, Sikyatki Polychrome, Hopi, north-eastern Arizona, Pueblo IV, sixteenth century. Human hands were sometimes used as stencils in Sikyatki pottery, with paint spattered around them. The hands here are reinforced with a painted outline after spattering. (Museum of New Mexico, cat. no. 21194/11, diameter 9¼ inches, photograph by Roderick Hook.)

the very necessary participation of the viewer make the entire rock shelter a powerful work of art with a very contemporary character. It almost could be an elaborate environmental construction made by some postmodern artist.

San Cristóbal Petroglyphs: Form and Subject

Unlike the Abo rock shelter, which is a well-defined, naturally framed space, the San Cristóbal open-air art site is large, rambling, and poorly defined, including many large boulders scattered over the talus slope of a mesa as well as the steep basalt walls of its caprock. San Cristóbal Pueblo is only a few hundred yards to the northeast and easily seen from the rock-art site. Most pictures there are pecked and engraved on the basalt,

but a few, in sheltered locations, are painted and share iconographic and technical features with the Abo paintings (Plate 34). It is worth noting that even though the Abo site is framed by its rock shelter, the images placed within that frame seem to have been no more deliberately organized into a unified composition than were those scattered over the landscape at San Cristóbal. In both instances, groups of images may have been intended to interact, but in neither case was the whole ever treated as a single composition.

There is enormous variety of subject matter at San Cristóbal, including humans, anthropomorphic figures, humanoid animals, other animals, masks, masked figures, stars, meanders, circles, and other abstract or nonrepresentational motifs (Fig. 98). They range in style from naturalistic to conventional. Some are massed in inchoate groupings, while others are interacting and narrative (Fig. 99); some are ritualistic and obviously ideational, while others are prosaic, genre, almost trivial. As well as space, they share age and technology. Except for some which are more deeply patinated and possibly quite older than the majority, patination is generally about the same quality and most of the pictures appear to be contemporaneous. Almost all were made by pecking and abrading, and the quality and style of workmanship is both fairly uniform and of a high order.

The medium generally forbids precision and lacks color, thus preventing detailed comparisons of masks, costume, and paraphernalia either with kiva murals or with painted rock art. Nonetheless, a list of images corresponding to those in kiva murals is quite long and includes feathered serpents, horned serpents (see Fig. 98), four-pointed stars with faces (see Plate 34), parrots and other birds, shield figures, and kachina masks (Fig. 100), some of which are identified with several pictured at Kuaua and are also thought to be identical to some modern Kachina personages (Sims 1949, 1963:214–20). In addition, at least one engraved panel at San Cristóbal is a narrative composition, with both subject matter and formal qualities appearing related to several Kuaua paintings (Dutton 1963:146–47; Fig. 14) (Fig. 101).

The two rock-art sites differ from each other in many respects, but individual pictures and groups of pictures at each site are organized in much the same way. Groups of images that may or may not be related to each other are clustered in various parts of each site in no very obvious kind of visual or narrative relationship.

Though no geologic feature at San Cristóbal is equivalent to the high-ceiling rock shelter of Abo, many San Cristóbal pictures are high on the walls of the caprock and have an equivalent dominating effect (Fig. 102). Other compositions that begin low on the cliff walls rise upward in a complex and equally powerful visual mass made up, apparently, of separate images drawn by different artists at different times (Fig. 103).

Far more than at Abo, which can be perceived and appreciated as a single, very large picture space, San Cristóbal is an agglomeration of many pictorial clusters. That some of these may have expanded to join with others testifies to the dynamic process which created the art there. There appears to be a greater uniformity in image size at San Cristóbal, and no style distinctions appear to correlate with size differences. The

Figure 96. Pictographs, the Abo rock shelter, Salinas district, central New Mexico, fifteenth–seventeenth centuries. Small-scale as well as large-scale figures are found at the Abo site. The stick figures in red are reminiscent of a much earlier Mogollon pictograph style, as in Figure 97. (Photograph by Dudley King.)

Figure 97. Pictograph, Lake Roberts, Upper Gila district, southwest New Mexico, Mogollon, ninth–twelfth centuries. Compare this monochromatic red–brown stick figure to the stick figure in Figure 96. (Photograph by Dudley King.)

Figure 98. Petroglyphs, near San Cristóbal Pueblo, northern New Mexico, fifteenth–seventeenth centuries. Though the site has thousands of individual drawings scattered with apparent randomness across boulder surfaces, superpositioning is rare. The bear is about 6 feet in length. (Photograph by David Noble.)

range in size from smallest to largest image is similar at the two locations.

Perhaps only because of media differences, the evocative quality and rich textures of the Abo paintings have no equivalent at San Cristóbal, which is characterized by clarity of image. Superpositioning, which at Abo could create sensually rich abstract colors and textures, at San Cristóbal usually only has the effect of obscuring a drawn image, and there is not much of it. However, there is at San Cristóbal an almost sculptural concern for the aesthetic and expressive values that are potential in the interplay of line with volume. Many figures are simply linear engravings on more or less flat planes of the hard stone, but many others are patterned to shift planes with the stone and are textured by a variety of pecking techniques. These textures combine with the flowing lines to integrate the imposed images with the planes and massive volume of the boulders on which they are placed (see Figs. 98, 103).

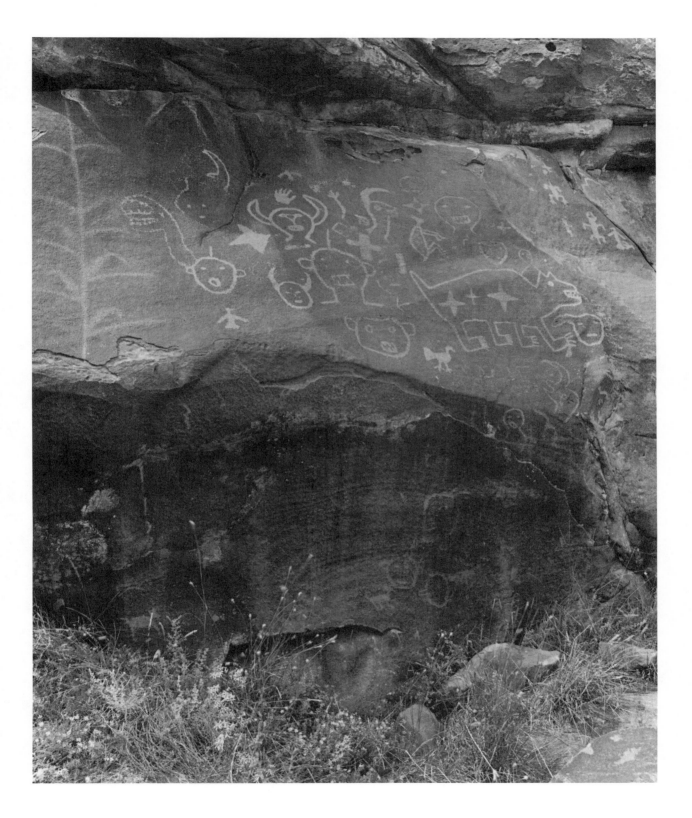

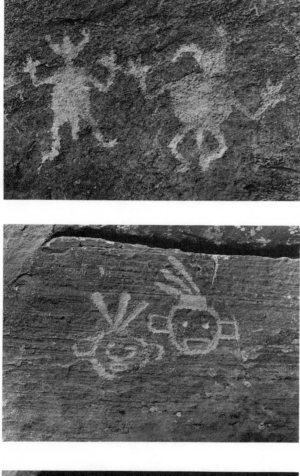

Figure 99 (upper left). Petroglyphs, near San Cristóbal Pueblo, northern New Mexico, fifteenth–seventeenth centuries. While most images made at San Cristóbal appear to have been conceived as independent and isolated from all others, some do interact. These two small and active creatures are not only similar in appearance, but their hands touch as though they are engaged together in some activity. (Photograph by David Noble.)

Figure 100 (middle left). Petroglyphs, near San Cristóbal Pueblo, northern New Mexico, fifteenth–seventeenth centuries. Kachina faces or masks are the single most common subject at many Pueblo IV rock-art sites. (Photograph by David Noble.)

Figure 101 (lower left). Petroglyphs, near San Cristóbal Pueblo, northern New Mexico, fifteenth–seventeenth centuries. The bird or bat flying upward on a lightninglike line is also a subject in kiva mural art at Kuaua. Compare to Figure 104. (Photograph by Dudley King.)

Figure 102 (right). Petroglyphs, near San Cristóbal Pueblo, northern New Mexico, fifteenth–seventeenth centuries. Lacking a facial outline, the eyes and mouth of a masklike face merges with the caprock near the top of the mesa above San Cristóbal. (Photograph by David Noble.)

Synthesis: Rock Art and Wall Paintings

The almost random and anarchic lack of pictorial organization at Pueblo IV open-air art sites, so comparable with older Anasazi pictorial treatment at similar locations, exists in strong contrast to the compositional rationality of most kiva murals, which seem always to be guided by a single intelligence. The pictorial surfaces at both Abo and San Cristóbal were patterned as their images accumulated: Many of their compositions are additive, progressive, accretional, and, in the end, the product of the last artist who happened to work on a panel, boulder, or section of a picture. These very distinct classes of composition are site-related; different kinds of sites have different kinds of art.

Yet exceptions to the rule must be noted. A great concave boulder at San Cristóbal was organized as though it were a single framed picture space. As subtle and delicate as a painting, the engraved drawing is centered on an upward flying birdlike creature whose body overlies a zigzag line that suggests lightning (see Fig. 101). Dutton identifies similar subjects at Kuaua as bats on lightning and associates them with rain-making ceremonies (1963:148–50; figs. 14, 69a, b) (Fig. 104). The San Cristóbal picture can also reasonably be interpreted as illustrating an incident in a widely shared Pueblo emergence myth in which a bird attempts to find a route from the Underworld to an upper level (Benedict 1931; Nequatewa 1947:7–23; Courlander 1982:3–10).

However it is identified, the artist who engraved the compelling image centered it on its panel in order to create a bilaterally symmetrical planar composition made energetic by its precision and linear quality. Its conceptual similarity to the controlled compositions of kiva murals is emphasized by the similarity in size and proportions of the boulder to the walls of a kiva and by placement of the picture at eye level, as with most wall paintings. Other images on the boulder—one of which is less deeply patinated and therefore considerably later—distort the visual relationships, and the tense, balanced composition was modified and diminished by accretion.

Perhaps less obvious as intellectually controlled compositions but equally impressive because of the way they define their surrounding picture spaces are several mask or face drawings located high on the caprocks at San Cristóbal (see Figs. 102, 103). These can be identified as belonging to the class of Ogre or Natashka

Figure 103. Petroglyphs, near San Cristóbal Pueblo, northern New Mexico, fifteenth–seventeenth centuries. Compositions here are accretional and seem to build from the bottom upward as images are added over time. (Photograph by David Noble.)

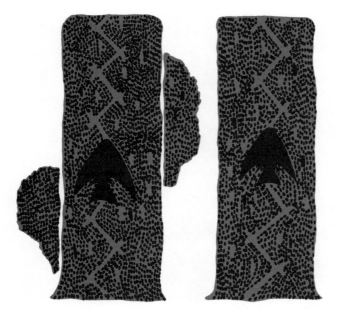

Figure 104. Wall painting, Kiva III, altar, layer F-23, Kuaua, New Mexico, Pueblo IV, fifteenth–sixteenth centuries. Dutton (1963:147) identifies these as "bats, lightning, moisture." See Figure 101. (Drawing by Katrina Lasko after Dutton 1963:Figure 14.)

ment and the draftsmanship of significant detail. They dominate the boulders on which they were made, and few are impinged upon by later drawings. Although similar minimalist images are found at other rock-art locations in the Rio Grande and Jornada Mogollon regions, none are more impressive than those at San Cristóbal.

Other boulders at San Cristóbal and some panels at Abo confirm the impression that at least some of the open-site artists were as self-conscious about composition as the kiva muralists. Conversely, a few Pueblo IV mural paintings have the appearance of being as imbalanced and randomly composed on their walls as most rock-art pictures, and some were subject to superimposition. Instances were recorded at both Awatovi and Pottery Mound, where extraneous graffiti were placed over well-organized kiva mural compositions (Smith 1952:Fig. 92; Hibben 1975). Further south, many of the wall paintings recorded in rooms and in one kiva at Las Humanas were unframed, asymmetrical, and quite casually organized (Hayes 1981a:46–53; Peckham 1981:15–38). The similarities in size, scale, proportion, and iconographic detail between the Las Humanas murals and many of the pictures at Abo and other Tompiro open-air sites argue for a regional pictorial style that blurred distinctions between wall paintings and rock art (Plate 35, see Figs. 85, 96).

But few kiva murals were organized as though they were rock-art pictures, and unframed pictures at open-air sites were rarely as highly structured as framed kiva murals. These site-related distinctions remained dynamic even after pictures were completed. The most tightly organized picture at an open-air site was far more vulnerable than any wall painting to accidental or deliberate modifications. Over time, compositions might be altered so as to disguise the intent of the artist and destroy their original quality. In rare instances, most commonly in the Tompiro area, a picture at an open-air site was covered over and the surface prepared before a new picture was made on that spot (Cole 1984; personal observations). Such was the rule rather than the exception for kiva murals, which, rather than being gradually overburned with new images, were almost always whitewashed away and then repainted in their entirety. A kiva mural might be erased, but it was rarely disfigured. Nonetheless, superimposition and erasure are both acts of completion, unambiguous and graphic evidence that a picture has become obsolete, used up, finished.

kachinas who appear annually at the Powamu ceremonies at Hopi (Fewkes 1903:31–38; Kealiinohomoku 1980:37–69). They also belong to a class of image thought to resemble representations of the Mexican rain deity Tlaloc (Ellis and Hammack 1968; Schaafsma 1980:199ff.). They have large, round eyes that appear to be protruding and rectangular, muzzlelike mouths with large serrated teeth resembling horizontal lightning lines and identical to one of the more ubiquitous Anasazi and Pueblo basketry and pottery painting motifs (see Figs. 14, 15, 29, 31). Each is shown staring straight ahead and several have no facial outlines but are defined only by eyes, mouths, and, sometimes, ears engraved on the rock. These rather startling and minimal images are given great presence by their place-

Therefore, accretion of images was to a rock-art site what overpainting with white plaster was to kiva murals. Each procedure had the same purpose, to replace one picture with another; but each expressed a different value that was given to the art, both the old picture to be replaced and the new one to be made in its stead. Similar kinds of subject matter look very much the same on room walls or in the open, but the differences in replacement procedure correlate very nicely with the two fundamentally different compositional principles characteristic of each class of site. Rather than emphasizing subject matter, it appears that the way pictures were composed and how they were treated when they were to be replaced identified them, the surfaces on which they were made, and the sites where they were located as having differing ideological as well as aesthetic values.

A muralist would know that one day his painting was to be whitewashed and replaced by another picture. His painting would still be made with care and according to the appropriate aesthetic and iconographic rules. The artist could be equally certain that his picture would not be vandalized or radically altered without his participation; it would keep its integrity until it was replaced. The knowledge that art made at an open-air site was likely to be modified by accretion or even partially destroyed by some later artist was everywhere visible at rock-art locations. The care with which so many rock-art pictures were made, despite this knowledge, suggests that future pictorial integrity was not important; the process of making a picture and the knowledge that it had been made well, and to the best of the artist's ability, may have had greater value than the end product. Each case argues for a utilitarian art, ephemeral but made with pride and with different purposes at the different classes of location; a picture had to be in the right place and it had to "look right" in order to be successful.

A utilitarian explanation for making either kind of art applies, whatever the purpose was. Whether the art was primarily made to communicate to supernaturals or to other humans, whether for sensory enjoyment or in the context of ritual formalism, for purposes of some kind of affective magic or for any other imaginable utility, it still had to follow rules. In Pueblo IV pictorial art, the rules can be adduced by examining the finished works in their physical contexts. More clearly than with almost any other kind of art, Pueblo IV murals and rock art can be seen to have their forms and social values integrated with their physical contexts. But in neither case does the content of the art—its subject matter—seem to explain the purpose for which it was made. To take the next step and hope to understand the particular purposes for which any of the art was made requires us to know something about the uses that may have been intended for any of the art sites.

Open-Air Sites: Their Interpretation

"What they did they left for us to classify according to our standards and then worry as to how and why they did it" (Baumann 1939). Thus did the Santa Fe artist Gustave Baumann, who admired ancient and modern Pueblo art, summarize the interpretive problems surrounding Pueblo IV rock art of the Pajarito Plateau. Consistent with this view, his brief published study of Frijoles Canyon pictographs is more graphic than verbal, a format used also by Agnes Sims, another Santa Fe artist with similar interests who recorded the art at several places in the Galisteo Basin including the San Cristóbal open-air site (Baumann 1939; Sims 1949).

The problem recognized by Baumann, Sims, and many others is that an ancient art has survived without documentation and therefore may be explained only through a filter of experiences that are historically and perhaps culturally far removed from those of its makers. The art was patently social and utilitarian; to gain insights into it requires knowledge of the purposes for which it was made, but those purposes were not recorded by either the makers or the original users.

In the case at hand, knowledge of purpose depends on our knowing how the places where the art was made were used and what meanings were applied to these places by the people for whom the art was made. Since we have no direct way of learning these things, we depend on analogies with Pueblo Indian social and artistic practices as these have been recorded in historical and ethnographic documents. The use of analogy validates Baumann's concern that we will "classify according to our standards." The concern is magnified by the uneven quality of information from which the analogies must be drawn. As a cautionary measure, we are required continually to refer back to the original work of art.

Explanations of the motivations for making Anasazi rock art and the uses to which Anasazi open-air art sites were originally put range from the fantastic to the merely mundane. Leaving aside the more incredible of

these—that the art or the sites are evidence of visits by earthly or extraterrestrial aliens, that they mark the location of buried treasure, or that they are systematically written languages—only a few seem both reasonable and potentially testable. Among these few are suggestions that the motifs carried information about historical events, including migrations and migration legends; that they were clan emblems, individual signatures, icons or other sacred emblems, visual manifestations of prayers, or had other social, ceremonial, or ritual value; or that they were doodles or other forms of individual and idiosyncratic expression. An open-air art site in each of these cases can be construed as a historically important place, a boundary marker, a shrine, a ceremonial site such as an "outdoor kiva," or a shelter for bored hunters or sheepherders. None of these suggestions are mutually exclusive, some may overlap, and virtually the only means for testing any of them would be by comparison with kiva murals and other kinds of Pueblo and Anasazi pictorial art, by analogy with historically documented practices, and by discussion with knowledgeable modern Pueblo people.

Sixteenth-century Spanish accounts provide limited descriptions of Pueblo paintings and say little about why any of them were made, less about how they were used, and nothing whatever about art that was made at open-air sites. Spanish documents of later times are even less informative about Pueblo painting, and there is a gap of almost 250 years in the written record, ending with Lt. James Simpson's observations of the paintings that he saw in two kivas at Jemez Pueblo and of ancient rock art that he described in several locations, all in 1849 (Simpson 1852:21–22).

At least as important as Simpson's eyewitness accounts were pictures made of the Jemez murals and some of the rock engravings by his companion, Richard Kern (Simpson 1852:Plates 7, 8, 9, 10, 11; Weber 1985) (Plate 36, see Fig. 3). During the next seventy-five years, many more drawings, photographs, descriptions, and discussions of nineteenth- and twentieth-century Pueblo wall painting were added to the record. The oldest descriptions and analyses of how paintings were used in the pueblos date from this time, and it was now that Pueblo people first began to participate, either freely, unwillingly, or unwittingly, with non-Indian scholars in the descriptive and explanatory processes. With rare exception, however, as in earlier times there was precious little said about either ancient

or contemporary rock art, or open-air art sites, or how these were used or may have been used in the past.

At best, the few sources that exist for any analogies that can be used to interpret Pueblo IV art are at least 250 years later than its production, and some may be as much as 650 years removed. Worse, barring assurance of a clear, direct, accurate, and, above all, unmodified oral transmission of information from past to present, discussion of any Pueblo IV art or art site by modern Pueblo people, no matter how well informed or well intentioned, is also based on analogy with modern practices. The Pueblo people, like all others, must interpret their own past according to modern standards (Young 1985, 1988).

While we cannot know if ancient unrecorded and modern recorded uses of pictorial art were substantially the same, we do know that the art of the past may look different from that of the present. The pictorial integration, iconographic variety, and narrative character of Pueblo IV murals is generally absent from most of the eighteenth-, nineteenth-, and twentieth-century wall paintings that have been documented. Rock art production, which had been so active and creative during Pueblo IV times, was much reduced by the nineteenth century, and known examples that surely postdate 1800 also look substantially different from those of earlier times (Schaafsma 1972, 1975, 1980; Young 1985, 1988; Young and Bartman 1981) (Fig. 105). Thus, in both cases, but most especially with regard to art made at open-air sites, changes in the visual character of pictorial art, the frequency with which it was made at different kinds of locations, and the uses that were made of the art sites all support the view that extreme caution must be exercised in evaluating any interpretations of Pueblo IV art—even when these are based on documented Pueblo Indian practices or on explanations given by living Pueblo persons.

The situation is further complicated by the famous hesitancy of Eastern Pueblo people to discuss their ritual practices with outsiders. For that reason, although art at open-air sites was considerably more diverse and richer in Pueblo IV times among the Eastern Pueblos, we must rely more on Western Pueblo than Eastern Pueblo sources for its interpretations. In light of all this, we should not be surprised to learn that open-air art sites of the Historic period in the Rio Grande region have had a very narrow range of known uses, most of which can be glossed by the generic term *shrine*.

Open-Air Art Sites: Function and Use

Today, some old open-air art sites in the Jemez Mountains mark shrines that are visited on ritual occasions by members of esoteric hunting and medicine societies (Hill 1982:343–45; Ferguson and Hart 1985:125). In like manner, offerings are made at other open-air art locations on the western slopes of the Sandia Mountains and at many other places by members of esoteric societies concerned with other activities as well as hunting. There is little or no evidence that modern ritualists either made the art at these places, or know why it was made, or when, or who the makers were. In at least one case, the members of the society report ignorance about all of those matters (personal interview 1986). Furthermore, it is not at all unusual for user groups to come from Pueblos several hundred miles away, suggesting that propinquity to an open-air site may give no clue as to who made the art, or when, or why.

A hunting association for some open-air art sites in the Galisteo Basin east of Santa Fe is implied by their location near animal trails. At the Pueblo IV rock-art site of Comanche Gap, for example, some clusters of rock engravings on the south face of high cliffs are on either side of animal trails that were narrowed by stone walls as though to control the progress of game animals such as antelope. It must be noted that neither the forms nor the images of the art at Comanche Gap appear to differ significantly from that at other nearby open-air art locations such as the San Cristóbal site which are so close to large villages as to make unlikely a direct connection between the art site and an animal-hunting location.

More particular information about the associations of art at open-air sites with hunting activities comes from Zuni Pueblo. In recent times there, images of both prey animals and predators are used both in formal hunting rituals and in less formal circumstances also associated with hunting. In the former case, it is not clear that rituals are actually performed at the open-air art site locations that contain animal pictures, even those of the sacred "Beast Gods," the predatory "animals of the six directions" whose images are also carried as hunting fetishes (Bunzel 1932a:489–92; Kirk 1943; Young 1985, 1988:129–34). In the case of prey animals, older images of them are sometimes shown as though pierced with arrows. Both ancient and modern drawings and paintings of them, some of which were reported to have been shot at with arrows in about

Figure 105. Pictograph, Village of the Great Kivas near Zuni Pueblo, northwestern New Mexico, ca. 1930. The bear mask is one of the original paintings made by Zuni workmen employed by Frank H. H. Roberts, excavator of the Village of the Great Kivas (Roberts 1932). The bullet holes are later and have been interpreted both as vandalism and as an aspect of hunting ritual (Young 1988:168). (Photograph by David Noble.)

1900, still serve sometimes as targets for guns (Stevenson 1904:439; Young 1988:167–69) (see Fig. 105).

The eighth- or ninth-century Mogollon shrine at Feather Cave in southern New Mexico was found to have full-sized and miniature arrows shot into crevices in the cave wall. This practice is thought to be consistent with nineteenth- and twentieth-century hunting rituals described at some pueblos (Ellis and Hammack 1968). Many pictures of prey animals shown with spears or arrows in them are found at open-air art sites throughout the Southwest, and date from various pre-

historic periods; these can obviously be interpreted in terms of hunting rituals and hunting magic. Even so, it is quite clear that such an interpretation for the real or metaphorical shooting of animal images need not imply generally accepted practices and may, in fact, evidence ignorance concerning correct ritual or social behavior. For example, Young notes that some Zuni people today disapprove of the practice of shooting at rock-art images of animals as "a shame," done by "young kids who don't know any better" (1988:168). It is not known whether rituals accompany the modern-day shooting of animal images at Zuni, although this would seem unlikely if the criticism is just. Nor is it known why any of the prey images, even those made in recent years, were drawn at one place rather than another.

Springs or other water sources are often noted as favored locations for shrines (Ortiz 1973; Adams et al. 1961; Schaafsma 1980; Stevenson 1904:232–33). While many Pueblo IV open-air art sites are located near streams or arroyos, relatively few appear to be directly associated with springs or other water sources and the association with water seems to be both casual and generic. After all, if a rock-art site is near a habitation site water will be nearby. One set of engravings at San Cristóbal is above a depression in the rocks where water collects after storms, and there is a stream bed below the site. The Abo painted rock shelter and several other painting sites in much smaller shelters near neighboring large pueblos that are contemporaneous with Abo are also near streams or springs (Caperton 1981:10).

Periodic visits to widely dispersed ancestral shrines, some of which are recognized by the presence of nearby rock art, are still made by Hopi priests (Page and Page 1982:606–12). There are many other active associations of shrines, rock art, ancestors, and esoteric societies either documented or suspected among all Pueblo groups (Ellis and Hammack 1968; Stevenson 1904:232–33). For example, prominent lava flows and several small volcanic cones on the West Mesa above Albuquerque are associated with the spirits of their dead by people of at least one nearby Pueblo (personal communication 1985).

Mile upon mile of that escarpment is engraved with a variety of images including many kachina masks; the association that kachinas have with ancestors and identification of that location as the home of the dead may partially explain the function of that open-air art site in Pueblo IV and modern times. But not all of the subjects there relate to the kachinas and some of the imagery dates from the Archaic period, long before there were kachinas. The present sacred meaning given to the escarpment as a location for rock art can date only from Pueblo IV times, and the place and its art had a different significance before then; even Pueblo people can give new meaning to old art. Of course, other Pueblos may give different meanings to the site and its art.

The recycling of art is an intellectual activity by no means limited to modern, urban-industrial people; it appears to be a common and universal human practice. In recent years at Zuni Pueblo, Anasazi rock-art images that are specifically not claimed to have been made by any direct ancestors of the Zuni are nonetheless interpreted in terms of events specific to Zuni mythic history or even to Anglo-American notions of ancient significance (Young 1988:195–230). In the more distant Anasazi past, mud balls were sometimes thrown at pictographs of different eras painted in rock shelters in the San Juan Basin, especially at Grand Gulch (see Plate 4). This may only have been a species of vandalism or sport, but it fits better with our knowledge of the Pueblos to interpret the mud daubs as a kind of offering or signature, not too different from the prayer plumes or handprints that are traditionally placed at outdoor shrines by Pueblo men. The paintings were made over a period of at least half a millennium in locations that were periodically occupied and abandoned during that same time span. We have no way of knowing when the mud was thrown, but it is at least reasonable to interpret the practice as evidencing the conversion of art sites whose original purposes had been lost into ancestral shrines by later occupants of the rock shelters, or even by their descendants on pilgrimage to the ancestral home.

Further confusion regarding the relationships between imagery and site use comes with the knowledge that sacred imagery may well be found at rock-art locations that are primarily associated with secular economic activities. For example, near the junction of the Jemez River with the Rio Grande are stone-walled sheep corrals apparently built in the seventeenth or eighteenth centuries. The stone walls as well as nearby boulders are covered with hundreds if not thousands of petroglyphs, including many kachina masks that are virtually identical with those of Albuquerque's West Mesa, which is only a few miles downstream. Many of these drawings were obviously done after the walls

were built, thus demonstrating the continuity of iconographic and stylistic traditions from prehistoric to historic times while proving as well the universality of sacred themes in all Pueblo art (Fig. 106). Imagery alone can never tell us why art is made or what uses are made of an art site.

New art is occasionally made at some known open-air art sites but not, apparently, at most; nor do many of them appear to be used for any purposes by modern Pueblo people. In fact, many of the most spectacular Pueblo IV outdoor art locations in the Rio Grande drainage that are not on Pueblo-occupied land seem to be unfamiliar to modern Rio Grande Pueblo people (personal observation). Furthermore, it is not always clear that those places where art is still made, or where ancient art is in any kind of use today, continue in their original purpose. In modern practice, it is customary for individuals or groups visiting a shrine to make tangible offerings at that location, including such durables as pottery and stone objects as well as wood and feather prayer sticks and food. There is little or no evidence that such offerings were ever made at most open-air sites in the Rio Grande drainage, leaving open the questions whether any of these were shrines to begin with or whether they are or ever were used as shrines of any sort.

In any event, we can often be certain that an art site is used differently today than it was in the past and the present use gives no clue as to why the art was originally made at its location. For example, the painted shield at the Kayenta Anasazi site of Betatakin, which is among ancestral shrines visited by Hopi priests today, could hardly have been intended by its makers, assuming it to be contemporaneous with the buildings there, to fill its present purpose of marking a place from which ancestors came (see Plate 7). And association of open-air art sites with water when those sites are located near villages may always be coincidental. Regardless of any later use, the identification of any of these as having been made to serve as a water-related shrine requires evidence other than simple proximity to a water source.

Some open-air art sites commemorated particular events. Ute and Apache shields were engraved on boulders to mark the locations of late eighteenth- and early nineteenth-century skirmishes between the Hopi and those enemy tribes (Stephen 1936:130–33). In one instance, the engravings are a form of picture writing, mnemonics that were still an aid to memory late in the

Figure 106. Petroglyphs, near Bernalillo, New Mexico, Rio Grande Valley, historic era. Some of the boulders used here to make the walls of a sheep or horse corral were engraved after placement in their current position. (Photograph by J. J. Brody.)

nineteenth century (Stephen 1936:fig. 83). In another, tallies are clearly indicated, which were still understood in the 1890s as counts of Apache dead (Stephen 1936:fig. 4). It is not known if these locations are still recognized as battle sites, if the rock-art messages can still be read without the aid of Alexander Stephen's journal, or if they have any modern use as shrines. Apparently, an equivalent historicism of another sort was represented by engravings on a large boulder near Zuni that was removed by Matilda Cox Stevenson to the United States National Museum late in the nineteenth

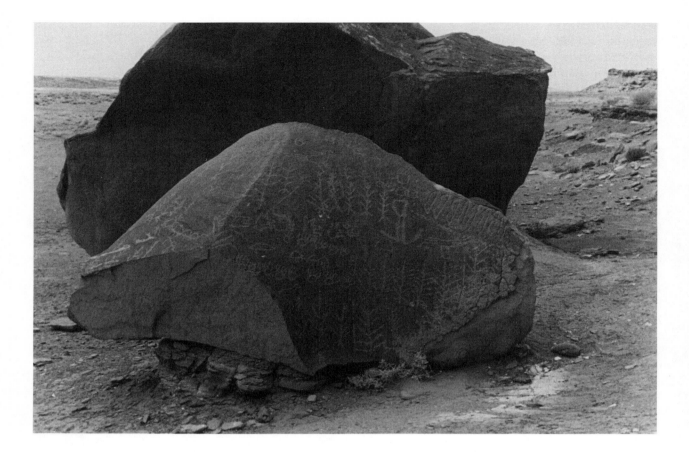

Figure 107. Petroglyphs, Hopi, Willow Springs, northeastern Arizona, historic era. These are clan signs made by initiates on pilgrimage. Note the unusually formal linear arrangements of the drawn elements. (Photograph by Donald E. Weaver, Jr.)

century. The meandering lines on it were interpreted at the time by members of the Zuni Sword Swallowers religious fraternity as a map tracing the migration route of their ancestors (Stevenson 1904:444, Plate 107).

Among the best documented of all active open-air art sites which are shrines are the engraved boulders on the Hopi Salt Trail at Willow Springs, Arizona (Colton 1946a; Michaelis 1981; Schaafsma 1980:289; Titiev 1937; Talayesva 1942) (Fig. 107). The place is visited periodically by men on pilgrimage, each of whom engraves a picture that seems to fuse a clan symbol with a personal emblem. Kachina masks, clouds, and many other motifs characteristic of Pueblo IV and modern Pueblo ritual and decorative iconography are engraved sequentially in rows. Their very orderly and linear placement is unusual in Pueblo rock art and may have no parallel among the Eastern Pueblos. Collectively, these images closely resemble signatory pictures made in pe-

titions by Hopi elders and in ledger books to acknowledge receipt of wages by Hopi workers late in the nineteenth century (Fewkes 1919; Schaafsma 1980:figs. 247, 248; Yava 1978:figs. between pp. 68–69, pp. 165ff).

The iconography at Willow Springs certainly supports the possibility that similar images at other locations may also have been clan emblems or personal signatures. In other contexts, such pictures have sometimes been identified as territorial markers (Forde 1931:368; Voth 1905:23; Wellmann 1979:9–10; Young 1985). However, there seems to be no possibility of visually distinguishing clan emblems from other meanings that may have been given to similar or identical images. While the kachina masks at Willow Springs are clan emblems that evoke ancestors in several different ways, they do not seem to signify the same sort of resting place or home for the dead as do the volcanoes and lava flows of Albuquerque's West Mesa, which have many thousands of similar pictures.

A painted engraving of "a maid" on the side of a stairway leading down from First Mesa Hopi was thought to be "very old" by Alexander Stephen in the 1880s, but he did not know of any special meanings that either the picture or its location may have had (Stephen 1936:1012, fig. 497). The drawing appears to date from the historic period or late Pueblo IV times, and it was occasionally refreshed. Stephen lived at Keams Canyon only a few miles east of Hopi First Mesa from 1881 until his death in 1894. He was a devoted student of Hopi life, especially in its ceremonial aspects, and he kept detailed notebooks of his observations which he illustrated with his own drawings (Stephen 1936). Considering his interests and demonstrated talent as an encyclopedic ethnographer, his inability to find out more about "the maid," as well as the limited mention of open-air art sites in his notebooks, must be taken to mean that Hopi traditions of making and using rock art were very weak by the late nineteenth century. Neither "the maid" nor the site where she was located seems to have had any special ritual significance at that time.

The rock shelter at Abo is among a number of open-air art locations that are sometimes interpreted as having served kivalike functions (Cole 1984:26–42). Kivas are enclosed spaces that conceptualize metaphysical space; they are usually entered from above and often have a hole in the floor to symbolize passage to (or from) an Underworld. They are oriented to the cardinal or intercardinal directions, and their highly structured spaces may be thought of as architectural cosmic

maps (Stirling 1942). They are sometimes made more complex and modified for particular ritual use by the placement of special altars and paintings on their walls, floors, or ceilings, which, characteristically, are as systematically structured as the kivas themselves. Rituals that take place in them generally leave material evidence of the events.

Iconographic similarities of kachina paintings at the Abo shelter with some kachina images found on Pueblo IV kiva murals seemingly support the suggestion of a kivalike function for that particular art site. That support would be more compelling if kachina imagery were not so ubiquitous and if it could be demonstrated that the Abo art postdates Spanish occupation of the nearby town and the consequent religious persecutions that presumably made it necessary to relocate kiva functions. The kivas at the largest Pueblo community of the region, Las Humanas, were closed by missionaries early in the seventeenth century, and their ritual functions were apparently served by other, hidden rooms located within the main living structure of the town (Hayes 1981a:8–10). It is not known if similar arrangements were made at Abo, where Franciscan missionaries also restricted native ritual practices.

However tempting it is to postulate the Abo rock shelter as a kiva substitute used to frustrate Catholic missionary activities, the paintings there are undated, some are almost certainly pre-Hispanic, and there is no material evidence reported, other than the paintings themselves, to suggest ritual (or any other use) for the site. Regardless of their iconographic similarities to kiva murals, the pictorial organization of the Abo paintings is quite different from that of any known pueblo wall paintings. Conversely, the Abo paintings are quite similar to those at several different and considerably smaller Piro and Tompiro locations that could not, because of their size and the terrain, possibly have accommodated kivalike functions for more than a very few individuals (see Plate 35). Consequently, rather than consider these outdoor art sites as the functional equivalents of kivas, it would seem more useful to consider them, perhaps, as another kind of specialized ritual space, possibly dating from the early historic period, which may have been peculiar to the Piro and Salinas Pueblos.

Despite the elusiveness of correlations among imagery, style, and known site functions, the persistence of kachina imagery at Pueblo IV open-air art sites seems to encourage the belief that these art sites were made for

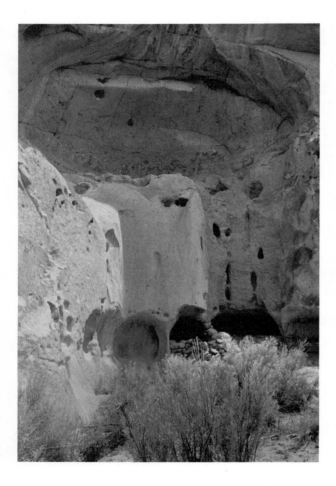

Figure 108. Pictographs, Painted Cave, Pajarito Plateau, historic era. A great variety of images, including some that resemble early twentieth-century pottery paintings, are arranged in a waist-high frieze on the plastered wall of the shelter. (See Figure 109, photograph by Dudley King.)

special ritual and religious uses that were somehow related to the kachina societies. Kachinas are thought to live in mountains, springs, or lakes, and their images at open-air sites are often in the vicinity of those landscape features. They are generally benevolent, and their blessings include rain and good crops, but they can be dangerous, cannibalistic, and carriers of disease. Ritual offerings of cornmeal and other food, prayer sticks, and feathers are regularly made to them along with verbal prayers. Their characters are often assimilated with those of other supernaturals including Cloud Spirits and the Chiefs of the Directions, as well as with ancestors and other human dead (Anderson 1955:404–7). As noted, the association of kachinas with ancestors may be symbolized by clan signatures as well as by kachina imagery at locations associated with the spirits of the dead.

Where kachina societies exist among modern Pueblos, membership is the minimum religious requirement for all men, and the societies are integrated with other social and ceremonial structures of each town including clans, moieties, kiva groups, and medicine societies (Anderson 1955:405). Where they exist, the kachinas are both critically important and all-pervasive; all boys are initiated into their societies, and all men have special knowledge of them. Thus the kachinas become ubiquitous, and instead of marking special ritual locations, pictures of them may only mark the places where men of kachina societies happened to make pictures. Rather than identify sites used for religious ritual, kachina imagery may merely symbolize locations where art was made by initiated men—which could mean virtually all men of any given place—for its own sake.

Documentation that at least some art at open-air sites was done for its own sake, or recreationally, comes from Zuni Pueblo. In about 1930, several young men from Zuni worked as laborers at the nearby archaeological site known as the Village of the Great Kivas. In their spare time and apparently for their own amusement, they painted elaborate kachina masks in a shallow rock shelter above the ancient community (Roberts 1932). Other, similar pictures were made there during the ensuing decades (Young 1988; Young and Bartman 1981:15–16; personal communication 1986) (see Fig. 105). There is a considerable amount of other rock art nearby, mostly in the form of engravings that were made any time between about the twelfth and the

twentieth centuries. The use of kachina imagery in a rock shelter suggests Pueblo IV practices; nonetheless, these paintings had no apparent ritual purpose. Furthermore, they are in the style of the modern Zuni easel-painting tradition whose invention was stimulated by Anglo school teachers, curio dealers, and anthropologists (Brody 1971:112–14; Bunzel 1932b; Gonzales n.d.). Interestingly enough, once the process of making art at the site began, it continued as a dynamic activity with new pictures being added every so often by the same or other artists. Once made, the paintings were cared for even to the point of occasionally being refreshed (Young 1988).

Zuni is not the only modern Pueblo where kachina images were painted or drawn for pleasure at open-air art sites. Before 1910, Hopi artist Fred Kabotie and his childhood playmates routinely drew pictures of kachina masks, "scratching them on rocks" and drawing them "with charcoal on walls in abandoned houses." "That was just play . . ." (Kabotie 1977:8). Less well documented, but equally suggestive of recreational painting that utilized sacred images at an open-air site, is the Painted Cave rock shelter on the Pajarito Plateau only a few miles from Cochiti Pueblo.

Though little is known about the site, most, if not all, of the pictures there were apparently done between about 1700 and 1880 (Lange and Riley 1966:172, 206–7) (Fig. 108). It is a large and well-protected place, difficult of access, and high above a valley where sheep could graze. Ruins of a Pueblo IV or early historic period village are carved out of the cliff walls immediately below the rock shelter, and a permanent stream flows nearby. By tradition, the shelter was used periodically by sheepherders from Cochiti Pueblo who are reputed to have painted the pictures in it. Most of these are linear and monochromatic, done with broad strokes of pinkish, black, or white paint.

The pictures form an impressive horizontal band at about eye level above the cave floor, dividing the concave picture surface into upper and lower segments (Figs. 108, 109). A variety of subjects, most of which have little obvious narrative relationship to each other, are painted there. Among them are kachina masks; stylized animals, including horned serpents and others resembling the abstracted birds sometimes drawn on nineteenth- and twentieth-century Cochiti pottery; realistic animals; a ritual clown similar to the one painted at the Abo rock shelter; decorative designs; and inani-

mate objects. Among the latter are large, terraced pyramids identical to Anasazi cloud terraces, except that they are topped by crosses which cause them to look like facades of eighteenth- or nineteenth-century rural New Mexico churches—and somewhat like the registered cattle brand of Cochiti Pueblo (Lange 1985).

There is little about the art at Painted Cave other than its iconography to support the notion that it had some ritual function or sacred purpose. Even though the predominant subjects appear to be both sacred and syncretic, at least one "sacred" image, the cattle brand, is in fact secular. Assuming the art here to have been made by Cochiti sheepherders for pleasure and to relieve boredom (as was done by Zuni, Navajo, and Hispanic sheepherders as well), the motivation for many of the paintings would have been personal and recreational. From the evidence, it seems reasonable to generalize that sacred subjects were and are considered appropriate for both ritual and nonritual Pueblo art made by men and boys at open-air sites.

The idea that the Pueblo worldview does not distinguish between the sacred and the profane is certainly not novel and may even be considered a truism (Ortiz 1973, 1972b, 1979). It should, therefore, be no surprise to discover and document the fusion of the sacred and nonsacred domains in some traditional Pueblo pictorial art of the historic period. So far as pictorial subject matter is concerned, we can be virtually certain that what was true in the recent past was true also prehistorically: Subject matter alone is not likely to provide enlightenment concerning the function of any Anasazi open-air art site.

With rare exceptions, as at Willow Springs, form also seems to be relatively noninformative about the particular functions that the art at an open-air site may have been intended to serve. As well as subject matter, the compositional ideas, distribution of images, and virtually all other visual characteristics subject to analysis seem to have followed, or broken, much the same set of rules. It appears that in the absence of some special evidence such as tangible offerings, uncommon subjects, or modifications of the landscape, the particular ritual or corporate function or use of a Pueblo or Anasazi open-air art site is not likely ever to be known, nor will we learn why it came to be. Indeed, it seems probable that many of these locations were places where individual Pueblo people, most likely men, routinely made art for their personal pleasure. Art was a

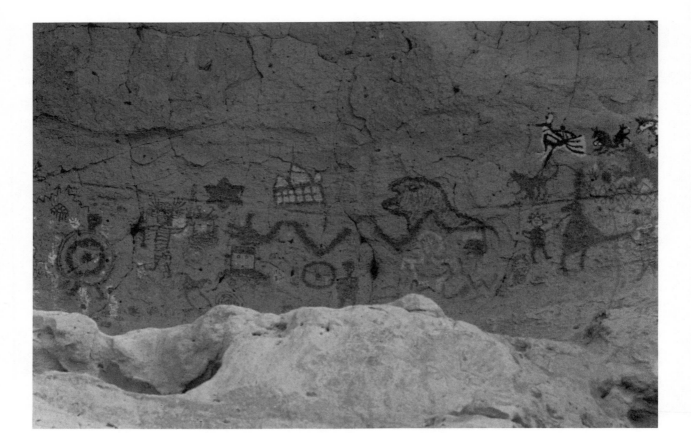

Figure 109. Pictographs, Painted Cave, Pajarito Plateau, northern Rio Grande Valley, historic era. Detail of Figure 108. Compare the striped figure on the left with Figure 90 from Abo, and Figure 94 from Hopi. (Photograph by Dudley King.)

thing to do, a pleasure to make, and a pleasure to see. Art engendered art, and if the art process and the end products helped people to focus on social concepts that were about harmony, regeneration, the natural and the supernatural world, and such ideal states or attitudes as "being of good heart"—which is to say virtuous—so much the better (Ladd 1983b:27).

SIX ▌ Mural and Ritual Art to 1900

Pueblo IV mural paintings are usually much more highly structured than the pictures made at open-air sites. Comparison with documented Pueblo wall paintings and related art of the historic period suggests that those paintings and the architectural spaces where they were made served more tightly structured and precisely defined ritual objectives than we know may have been involved in either rock art or rock-art sites. Wall paintings and their architectural spaces appear to be more comprehensible to us than the art and the ill-defined spaces of open-air sites.

Most Pueblo IV murals are found in rectangular rooms considerably smaller than the Great Kivas thought to have been used for large-scale community rituals during Pueblo III times. These rooms, however, are about the same size and proportions as the kivas and society houses of historic period Pueblos, where wall painting and other pictorial art was made in support of rituals sponsored by many different esoteric and religious societies. Considering these close physical similarities as well as the unbroken continuity with the past that is evident at so many modern Pueblos, it seems at least reasonable to interpret Pueblo IV ritual architectural spaces and associated art in terms of recorded history and the customary activities of the recent past.

Despite their relatively small size when compared to ancient Great Kivas or even modern circular ones, the rectangular kivas and the less stylized society houses of the Pueblo IV period and today can and often still do accommodate dozens of spectators and ritualists. In modern usage, most such structures are considered to be either the property of, or the locus for, an esoteric group which may be as generally inclusive as, for example, those kachina societies that all men are expected to join, or as exclusive as many priesthoods and some medicine societies. They are used, or owned, by men's and women's societies, and in some cases they have no exclusionary rules based on gender. In all cases, members are selected according to some set of rules; then, after they are indoctrinated, trained, and initiated, they may consider that they belong to the kiva or society house rather than it belonging to them.

As well as being used as ritual spaces, many of these rooms are available much of the time for more casual social use by members and their relations. Aside from secret rituals and those performed during times of need, most of the spaces are also used for more public rites, which are often theatrical in nature. Many of these are given periodically, at set times, and are considered to be essential for the well-being of the entire community or even of the entire world. Pictorial art is integral to many rituals, and very often, ephemeral and portable three-dimensional art is integrated with wall paintings to create an appropriate ritual environment. Wall paintings in these spaces may also be ancillary or even thematically unrelated to a particular ritual, whether public or esoteric, and to any ephemeral, portable, or performance-oriented art made for the ritual.

Each esoteric group contributes a necessary piece to a mosaic of rituals performed for the good of all; their special knowledge, their rituals, their art, and the spaces within which they do their work are patterned to be part of an entity, a unit of a much larger whole.

The complexity of the system was, and in many places still is, designed to integrate all adults as necessary participants in the past, present, and future life of their community. Further complexity arises when the same or closely similar esoteric societies occur in more than one pueblo. Then, rituals may be shared by different communities, and initiates have ceremonial links that serve to integrate more closely the various pueblos.

The intrusion of the Catholic church into this system is pertinent to the history of Pueblo painting. The church introduced some novel pictorial and iconographic themes, but of greater interest perhaps is the ample evidence that art made by Pueblo people in Catholic spaces served Pueblo ritual and social concerns as well as those of the church. A consideration of the symbolic and formal relationships of portable, ephemeral, and theatrical art to wall paintings and of all these to the ritual architectural spaces of the pueblos, including kivas, society houses, and Catholic churches, may provide additional insight into mural art and other ritual art traditions of the Pueblo IV period.

The More Permanent Wall Paintings

The ritual system of the Pueblos and some of the art supporting it is described and analyzed by a considerable body of literature and many photographs, drawings, and paintings made from about 1880 to 1940. These describe kiva murals from both Eastern and Western Pueblos and other decorative, ritual, and theatrical art made for use in kivas and society houses. There are also descriptions, photographs, and drawings of paintings that were sometimes made on the interior and exterior walls of Catholic missions and churches built and used at the Pueblos. Some of these are informative, directly or obliquely, about the more traditional and esoteric forms of Pueblo ritual and ceremonial paintings, especially those which are less ephemeral. Taken together, the documents provide the bases for interpreting the paintings of an earlier day that were made in ritual architectural spaces.

Wall paintings and large, murallike portable paintings serving as screens were and are used by the Pueblos in at least two distinct ways. In one, they remain on the walls and are maintained and periodically refreshed as though they were considered a permanent part of the architectural space. In the other, they are temporary, made for use or in association with a par-

ticular event, and then covered over, destroyed, or removed and stored until needed again. The more permanent pictures, regardless of their original inspiration, meaning, or any special use that may be made of them, also provide an ambient background to all other activities that may take place within the walls of the room containing them. The other kind of painting is more clearly limited in function, utilitarian in more particular and specific ways, and very often more obviously a part of some other kind of ritual, expressive event.

Perhaps the best known kiva wall paintings that seem to have been made for permanent use are those from the two kivas at Jemez Pueblo that were first described by James Simpson and illustrated by Richard Kern in 1849 (Fig. 110; see also Fig. 3, Plate 36). They were seen again in 1884 by Captain John G. Bourke, who made no pictures of them; were seen and drawn by Albert B. Reagan in 1900; and were pictured again by an anonymous eyewitness in about 1940 (Bloom 1938:228; Reagan 1914:Plate 6, 1917:62, 1922, 1926; Simpson 1852:21–23, Plates 7, 8, 9, 10, 11; Smith 1952:84–87; personal interview 1984). A comparison of all the drawings and the descriptions of them, which do vary, nonetheless confirms the impression first recorded by Bourke that the same pictures, of indeterminate age, were periodically repainted and renovated and were among the regular and permanent features of those kivas.

All are composed within horizontal rectangular panels framed along the base and sometimes the top by a horizontal line; their organization is, therefore, somewhat like the style of the kiva murals excavated at Awatovi and Kawaika-a, which Watson Smith classified as Layout Group I (Smith 1952:25, 107–10, 117–19). Their vertical divisions are not as explicit as the horizontal ones, and they are made with stacked "C"-shaped cloud symbols or vertical plant forms or formed by the corners of a room (see Fig. 110, Plate 36). The compositions are roughly symmetrical, and each has a different subject. In one, alert, naturalistic deer dominate the picture space (see Fig. 3); in another, the primary subject is a sinuous, horizontal vine full of large, ripe gourds or watermelons. Another is dominated by a pair of masklike terraced forms, each capped with a rainbow arc to which feathers are attached (see Plate 36). Vessels filled with corn and a pair of flute-playing humans are on the steps of the terraces. Other subjects include men hunting turkeys with bows and arrows, other birds, snakes and other animals,

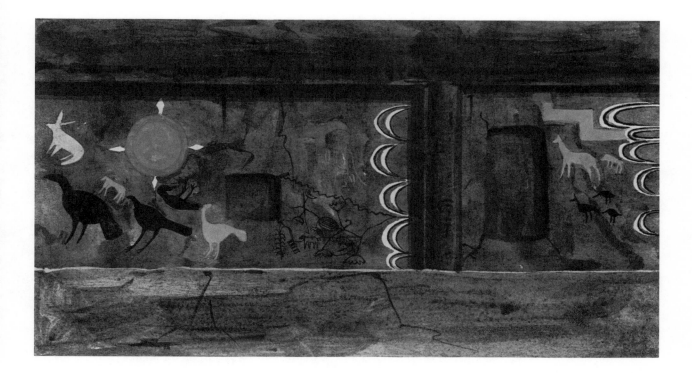

lightning bolts, stars, the sun, the moon, clouds, falling rain, and feathered circles.

Several rooms at both Zuni and Hopi, with murals on their walls that were more or less permanent, were also reported in the late nineteenth century. Bourke mentions a large painting of an antelope that he saw in a domestic room at Zuni in 1881 (*in* Bloom 1938:192); and Stevenson described paintings in a chamber used by a hunting society there, which were said "to be permanent" and served initiation functions (Smith 1952:93–94; Stevenson 1904:438). An 1899 photograph in Smith (1952:Fig. 36a) may depict that room; it shows more than a dozen animals drawn in profile in a continuous frieze on at least three walls of a large, high-ceiling room (Fig. 111). They are life-size or slightly smaller, natural in proportion and posture, and each stands flush with the picture plane on or just above a ground line placed about two feet above the floor. The background is a featureless void. Both prey and predatory animals are represented, but unlike the six "Beast Gods" of the Zuni hunting and medicine societies, each of which is symbolically associated with a special color and one of the six directions (the cardinal points, ze-

Figure 110. Wall painting, kiva, Jemez Pueblo, watercolor copy by Richard H. Kern, 1849. The framing system used here is consistent with Pueblo IV kiva murals, but the spatial and pictorial organizations are different, as is the suggestion of realism in many of the animal images. (Library, Academy of Natural Sciences of Philadelphia.)

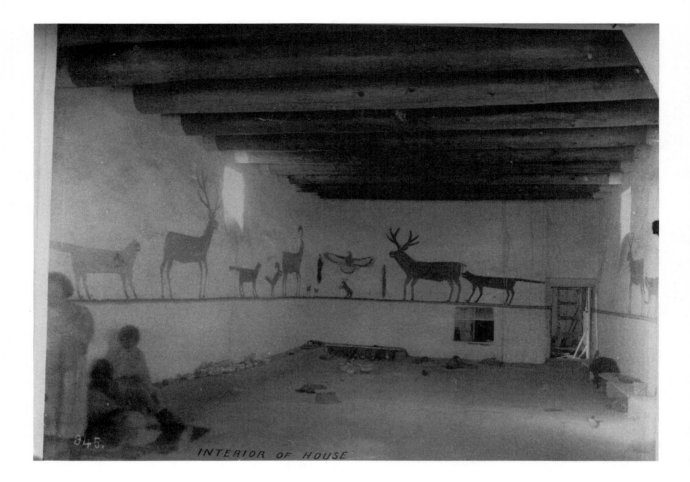

INTERIOR OF HOUSE

Figure 111. Wall painting, Zuni Pueblo, Ritual Society Room, 1899. As in Anasazi murals, a bottom framing line acts as ground line and also defines the picture space which, in this instance, is very shallow. The realistically drawn animals seem to fit a description of "permanent" paintings on the walls of a Hunters Society initiation room described by Stevenson (1904:438). (Peabody Museum, Harvard University, neg. no. N22591, photographer unknown.)

nith, and nadir), the predators here are not given special, isolated values, but instead they interact naturally—if peacefully—with the other animals.

Higher up on the wall of another ceremonial room at Zuni, a painting associated with the Macaw Clan, which was photographed by A. C. Vroman in 1899, may also have been in place for a long period of time (Webb and Weinstein 1973:100) (Fig. 112). This, too, was organized as a continuous frieze extending over at least three walls, but here the picture space was subdivided into two equal horizontal registers. A series of evenly spaced, stepped terraces divided the narrow registers into panels, and several kinds of birds naturalistically drawn in profile were painted between or on the steps of the terraces. The whole has the kind of neat regularity characteristic of Anasazi and Pueblo painted pottery.

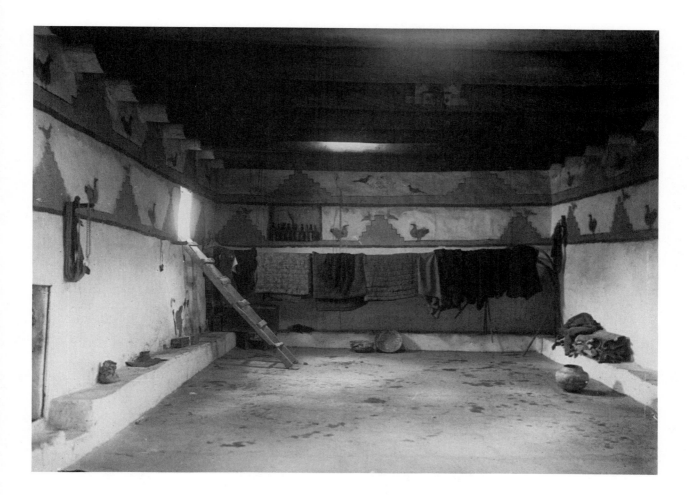

These two sets of Zuni paintings are organized rather like the continuous narrative pictures of Kuaua and Pottery Mound. Quite different, but identical to a third major compositional system used in Pueblo IV kiva murals at Otowi, Pottery Mound, and elsewhere, were large paintings of animals recorded at several Hopi towns, each isolated on the wall of a room (Fig. 113). One house at Walpi, on First Mesa, had a sealed room used by a warrior society and reported by several observers over the course of two decades to have predatory animals painted on each of its four walls (Fewkes 1902:485–86; Mindeleff 1891:131; Smith 1952:97–98). They included mountain lion to the north, bear to the west, wildcat with a five-pointed star above him to the south, and wolf with a sun above him to the east. These are, of course, four of the six "Beast Gods" that at Zuni and elsewhere are also important to medicine and

Figure 112. Wall painting, Zuni Pueblo, Ritual Society Room with Macaw Clan emblems, 1899. The terraces and birds are organized in two registers and composed with the regularity ordinarily associated with decorative patterning on pottery and other domestic objects. (Seaver Center for Western History Research, Natural History Museum of Los Angeles County, photo no. V869, photograph by Adam Clark Vroman.)

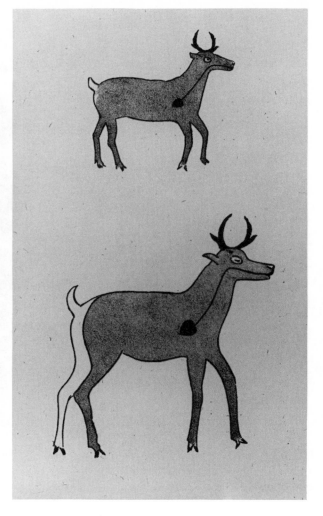

Figure 113. Room interior with wall painting, First Mesa Hopi town of Sichomovi, 1902. Though the painted deer on the left is in a domestic house, the home is that of the governor of the town and the room may have had some special uses. Note the matted pictures of Hopi ritual dancers on the walls. (Southwest Museum, no. 30481, photograph by Adam Clark Vroman.)

Figure 114. Wall paintings, Oak Clan Kiva of the First Mesa Hopi town of Sichomovi, copied in 1881. Smith (1952:96) suggests that use of the heart line came from the Rio Grande by way of Zuni. See Figure 81 for what may be a much earlier heart line in a Rio Grande Pueblo mural painting. (Etchings made after drawings by A. F. Harmer, originally published in Bourke 1884:Plate 25.)

hunting societies (Fewkes 1903:25). These predators are sometimes referred to as "the pets" of the gods; for example, the mountain lion is the pet of the Twin War Gods. Since these animals may also cause as well as cure diseases, they are of fundamental importance to medicine societies (Parsons 1936:xl, xli).

Apparently similar in style but less easily interpreted were large and rather naturalistic antelope painted on the walls of kivas at several Hopi towns including Sichovami (Bourke 1884:131–32, Plate 25, 26) and Walpi (Fewkes and Stephen 1892:244, Plate 3, 5) (Fig. 114). The chief priestess of the Women's Society, which is also a curing society and used the Walpi kiva, is reported to have scraped a cavity in the heart of each antelope on the kiva wall and attached a small prayer feather "to invoke" the antelope kachina for rain (Fewkes and Stephen 1892:223–24). The painting bears no similarity to images of the antelope kachina or to antelope-kachina masks. An apparently similar painting was photographed in 1899 by Vroman, who identifies the room as a house interior rather than a kiva (see Fig. 113). We are reminded of the antelope painting that Bourke reported from a Zuni house almost two decades earlier, with the impression that the antelope paintings were not made for any particular ritual event (Bloom 1938:192; Smith 1952:96; Webb and Weinstein 1973:Plate 32). Some of the dozens of other wall paintings reported from these and other pueblos also may have been permanent, but none seem to have been organized much differently than those described above.

What did any of these paintings mean? Why were they done? Simpson had been told by Francisco Hosta, the governor of Jemez Pueblo and his guide, that the paintings he saw there "were *por bonito* [for ornament]," and Hosta identified the flute players as "Montezuma's adjutants" calling to him for rain (1852:21–22) (see Plate 36). Simpson interpreted the word *bonito* to mean merely ornamental and assumed the paintings to be essentially decorative. Had he known more about Pueblo beliefs and considered *bonito* to mean "beauty," "visual harmony," or something on the order of a visual prayer, he would have understood the murals to be more than trivial decorations. Furthermore, the association of the flute players with the Aztec ruler Montezuma was neither anomalous nor a careless mistake, but carried, instead, great significance.

Montezuma, by then, had come to be identified by Pueblo people with Poseyuma, the universal culture hero of the Pueblos, who, in some places, was also identified with the Christian deity Jesus (Parmentier 1979:609–22). Hosta, therefore, correctly informed Simpson that the painting referred to an important mythological personage of the Pueblos who was the son of the Sun, and the bringer of fertility, prosperity, ritual knowledge, hunting knowledge, physical protection, and much else to each of them. Of special interest here is that Poseyuma "taught the people to paint their houses and edifices of worship in representative figures of the gods" (Reagan 1917:48–49). Simpson apparently did not ask if Montezuma himself (Poseyuma) was also depicted in the mural.

As well as having specific narrative and symbolic meaning, the Jemez kiva murals and perhaps many others were also painted as general acts of worship that acknowledged supernatural sanctions. A variation of another Jemez painting with some of the same elements in it, which Reagan saw in 1900, was entitled "The Universe" by Edgar Lee Hewett on the basis of a fuller understanding of Pueblo mythology and history (Fig. 115). Its symbolism as a cosmic map was by then assumed to be "common knowledge among all the Pueblo villages" (Hewett 1938a:126, fig. 17; Smith 1952:87).

The Jemez paintings were certainly of subjects appropriately chosen to serve a variety of generic and ambient ritual purposes. But these pictures were not limited to a general utility; universality of theme could also be put to very particular ceremonial use. In the summer of 1900, Reagan witnessed thirteen members of an esoteric society being "presented" in ritual sequence to the paintings on all four walls of one kiva (1917:62). These people were in religious retreat, preparing themselves to perform a sacred dance which was the public part of their ceremony. Other emblems that Reagan noted on other Jemez wall paintings seemed to be identical with paintings he saw on some sacred masks, and in 1911, similar pictures were painted "eight times enlarged" for use in a most solemn "Ghost Dance" (Reagan 1917:62). The masklike images painted by Kern in 1849 and drawn by Reagan a half-century later were visual metaphors subject to several parallel kinds of use and meaning.

The potential for a similar mix of generic and specific meanings and utility seems to characterize the other permanent paintings that we know of. A Zuni hunting society kept pictures of both game animals and predators on its walls; a Hopi warrior society used images of four predatory animals associated with the

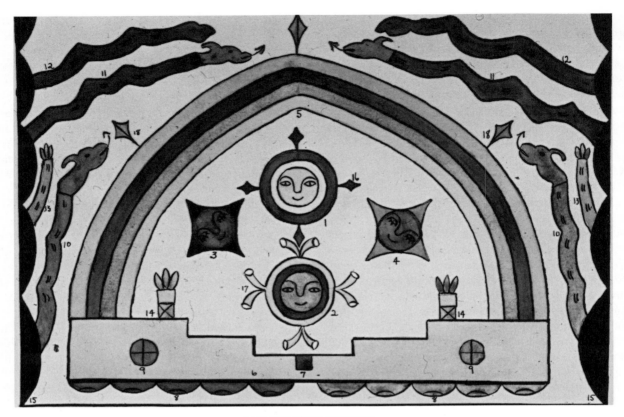

KIVA PAINTING AT JEMEZ

Key—Universe

1	Sun	10	Water Serpent
2	Moon	11	Aranyu—Plumed Serpent
3	Morning Star—Warrior Star	12	Lightning—Forked
4	Evening Star—Maiden with Yellow Hair	13	Sheet or Cloud Lightning
5	Rainbow	14	Heat Lightning
6	Earth	15	Rain Clouds—Black
7	Center of Earth—Where *Their* Pueblo is Located.	16	Sun Rays
8	Clouds of Underworld	17	Feathers—Meaning Birds or Life of Sky
9	Hearts of World	18	Rays of Sun Band

Plumed Serpent Combines Deific Power of Earth and Sky

Figure 115. Wall painting, Kiva at Jemez Pueblo, from a drawing by Albert B. Reagan, ca. 1900. Hewett (1938:126) described this design as a "picture of the universe" said to be "very ancient" and "of common knowledge among all the Pueblo villages." (School of American Research, Indian Arts Fund, cat. no. C.302.)

cardinal directions. Those animals are of great importance to hunting and medicine societies, as well as to warrior organizations, and each was isolated and painted in its appropriate symbolic colors on a symbolically appropriate wall. In one case, the pictures are naturalistic and anchored to a ground line close to the viewer; in the other, the animals float in the uncertain space of a void. In both, pictorial spatial conventions and symbolic values seem to reinforce each other. Hunting, even with its sacred aspect, is mundane and necessary; warfare may sometimes be necessary also, but it is a most dangerous and disharmonic activity whose sacred rituals can touch upon almost any other kind of esoteric force.

But game animals, the preyed upon, which have no special relationship to the kiva where they were painted or to its esoteric functions, may also be placed in ambiguous spatial voids and may even be painted that way in domestic contexts. In contrast, birds that are almost surely special to a particular society and to the architectural space where they were painted may be pinned to a ground line, bounded by stylized cloud and mountain terraces, and kept within a pictorial structure commonly associated with the most abstract and generic kinds of imagery and meaning. Among the more permanent mural paintings of the historic period, there seem to be no easily perceived consistencies between pictorial means and subject matter and between form and symbolism. These paintings could be used both for particular rituals and for ambient "background" purposes, and the same kinds of pictures could be made in different kinds of spaces.

A similar range of relationships between form and subject and between the functions of architectural spaces and the meanings that may be attached to paintings in those spaces is seen in paintings made for long-term use on the walls of Catholic churches by Pueblo people from the seventeenth century onward. The oldest of these paintings that have been recovered are nonfigurative decorations which, though based on Hispanic or Mexican prototypes, were almost certainly painted by Pueblo artists (Kubler 1972:135; Montgomery, Smith, and Brew 1949) (see Fig. 68). Pueblo subjects in Pueblo style were painted in Catholic church contexts as early as 1696 (Kubler 1972:109). However, the oldest surviving representations of Catholic saints and other Christian holy images known from Pueblo churches are the work of seventeenth- and eighteenth-century Franciscans and itinerant Mexican or New Mex-

ican Hispanic artists of the late eighteenth and early nineteenth centuries (Bol 1980; Wroth 1982). Until recent times, the subjects used by Pueblo artists in Catholic space were taken from Pueblo iconographic traditions or from European decorative ones, or they were otherwise secular in character when viewed from a Catholic perspective.

Perhaps the most common form of Pueblo wall paintings in Catholic churches are friezes of rainbow arcs, cloud forms, terraces, featherlike triangles, birds, stylized corn plants, stars, sun, moon, and similar motifs taken from the vocabulary of traditional Pueblo decorative and stylized ritual art (Kubler 1972; Prince 1915; Smith 1952) (Fig. 116, see Fig. 8). Many of these can also be interpreted as symbolically or metaphorically appropriate for a Christian-church context. Generally, they are painted along both sides of a single-naved, high-walled church interior, either above a dado, as in Pueblo IV painted kivas, or on a ground line placed two or three feet above the floor, as in one of the Zuni society chambers discussed above.

The visual elements in these friezes are generally clustered into discrete design units repeated in a steady and predictable rhythm as in Anasazi and Pueblo pottery, textiles, and other decorative arts. Compositional similarity to the paintings of the Macaw Clan room at Zuni are also obvious. In keeping with this ancient decorative logic, the paintings flow around architectural intrusions such as doors or sconces, creating frames around them which sometimes take the form of cloud terraces. The cloister of the San Esteban Mission at Acoma Pueblo was decorated early in the nineteenth century with a complex series of paintings that are prototypical of this compositional method. Some motifs are remarkably similar to the masklike terraces of the "Universe" painting at Jemez Pueblo (Marshall 1977:Illus. 40–45).

At both Acoma and Laguna, the same or similar pictures on the church walls have been recorded in place for more than a century. Similarities of both compositional procedures and imagery to the more abstract and decorative paintings in kivas and society houses is quite specific and, to some degree, probably deliberate and symbolically meaningful. Bourke was told by an Acoma man in 1881 that the paintings in the Acoma church were *"por agua"*; being "for water," they had precisely the same symbolic meaning as though they had been made in a non-Catholic context (*in* Bloom 1937:369). Even the sanctuary and apse areas of Pueblo

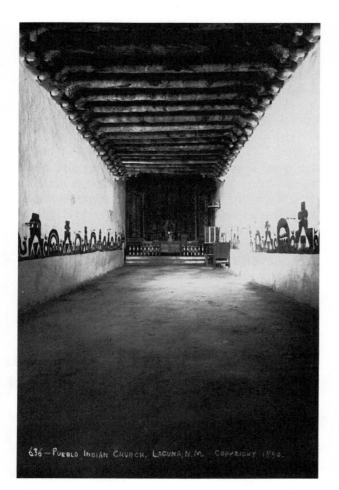

Figure 116. Wall paintings, Laguna Pueblo, Church of San José de García, 1890. The murals on either side of the nave were probably painted by women of the town and use motifs drawn from the vocabulary of pottery painting. They were in place as early as 1846, and since then, they have been refreshed or entirely overpainted periodically. (Southwest Museum, photo. no. 636, photograph by Charles F. Lummis.)

churches usually preempted by more traditional Catholic imagery may be infiltrated with terraces, corn plants, game animals, and other Pueblo decorative and ritual subjects (Fig. 117).

This distribution on church walls of Pueblo decorative art that has a generic kind of symbolic value supports the use of church spaces for native rituals. When church interiors are used for Pueblo ritual dances, the nave areas are generally the focal point. The native dancers are surrounded by paintings that quietly suggest an orderly, structured universe decorated with visual prayers for water and other blessings that relate to fertility and general well-being. The sanctuary or apse, dominated by Christian imagery, is generally used when dancers and other ritualists are blessed by a Catholic priest prior to a performance that will take place in the nave or outside the church.

Large, isolated, more naturalistic representations of animals are also painted on church walls. Life-size realistic horses above the west entrance of the church at Santo Domingo Pueblo were first recorded early in the twentieth century and are repainted occasionally. Similar animals were photographed flanking the main entrance to the San Felipe Pueblo church in 1919, and on a nave wall at Zia Pueblo in 1938 (Kessell 1980:fig. 3; Kubler 1972:fig. 143). The proportions, posture, and three-dimensional quality of some of these suggest twentieth-century-style commercial Indian easel paintings, but their scale and the entire absence of horizon, ground line, or any other spatial referent is consistent with animal paintings on the walls of kivas and society houses.

Much earlier, and even more striking in their resemblance to native styles of animal representation are fragments of large wall paintings recorded from the cloister of the mission church at Acoma Pueblo. A series of isolated images thought to have been painted early in the nineteenth century formed a frieze along one, and perhaps several of the adjoining walls there (Marshall 1977; Marshall and Silver 1983; Mauldin 1988). Subjects included horses with Hispanic riders, some of whom were clergymen; deer; antelope; and other animals remarkably similar in style to those recorded late in the nineteenth century at Zuni and Hopi by Vroman, Bourke, and others (Marshall 1977:Illus. 33, 38) (Fig. 118, see Fig. 117). The particular significance of these paintings is not known, but they may commemorate a December 26 feast day honoring St. Stephen the Protomartyr, the original patron saint of

Acoma Pueblo (Mauldin 1988). The coincidental correlation of that day with the winter solstice, the start of the winter cycle of the Pueblo religion, and the importance given by the Pueblos at that time of year to hunting and hunting ritual conveniently and economically explains the otherwise puzzling emphasis given to animal subjects.

The visual and symbolic content as well as the styles of paintings made by Pueblo artists in Catholic ritual spaces are compatible with the art made in native ritual spaces. Further fusion of Catholic art into the Pueblo ideological system can be demonstrated. Stylistically distinctive Hispanic and Catholic art in Pueblo churches could be reinterpreted, metamorphosed so that their symbolic content was fused into the Pueblo belief system. Gowned images of St. John the Baptist and Jesus painted by an Hispanic artist in the apse at the Santa Ana Pueblo church came to have "nothing to do with the Catholic religion" (White 1942:62–63). Instead, both were transformed iconographically. The larger painting, St. John, became Nautsiti, the mythic Elder Sister, and the smaller one, Jesus, became Utetsiti, the mythic Younger Sister. These two, respectively, were the Creator Mothers of Indian and non-Indian peoples and their transformation within an alien space imposed upon Pueblo space is an obvious one. As with some of the other important Pueblo mythic person-

Figure 117. Wall painting, Acoma Pueblo, cloister of the Mission Church of San Esteban Rey, early nineteenth century. As well as horsemen, paintings in the cloister included animals, rainbows, terraces, and other more traditional Pueblo subjects. Compare this antelope to late nineteenth-century Hopi paintings in Figures 113 and 114. (Drawing by Katrina Lasko after a field drawing by Michael P. Marshall.)

Figure 118. Wall painting, Acoma Pueblo, cloister of the Mission Church of San Esteban Rey, early nineteenth century. Several large pictures of mounted men including priests and Spanish soldiers are among fragmentary paintings uncovered at the Acoma Pueblo church. They may commemorate an early nineteenth-century visit by church dignitaries. Similar paintings were noted at the Cochiti Pueblo church interior later in the nineteenth century. (Drawing by Katrina Lasko after a field drawing by Michael P. Marshall.)

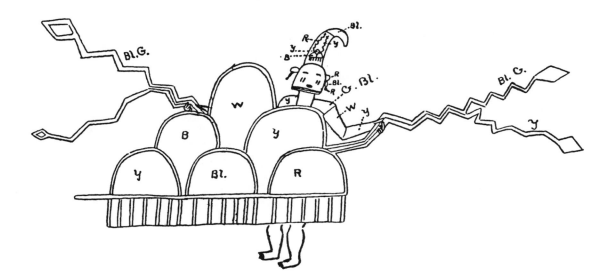

ages, they also have an association with the art of painting for they once fought bitterly over a picture that Elder Sister would not let Younger Sister see (Stevenson 1894:31).

The phenomenon that St. John and Jesus came to explain through their transformation into the two Creator Mothers is, of course, post-Hispanic, for there were no non-Indian people known to the Pueblos before that time. In the context of that transformation, it becomes reasonable for Catholic churches to become another kind of Pueblo ritual architectural space on the order of kivas or society houses. Aspects of this conversion include the use of church walls as surfaces for Pueblo ritual art and of church interiors as the ceremonial locus for sacred dances as well as shrinelike interiors for other sacred rituals.

The Less Permanent Wall Paintings

The more ephemeral wall and ceiling paintings associated with ritual and esoteric societies are important also, but they generally play a less specific and interactive role than do the more permanent pictures. Kivas and society rooms are usually cleaned before a ritual so that the appropriate art can be made on fresh surfaces, and at that time older and more permanent paintings may be refurbished. For example, at Walpi on the second day of the nine-day Mamzrau Women's Society ritual, young women who are to be initiates whitewash the walls of the kiva all the way up to the roof. On one

Figure 119. Wall painting, Young corn-mound kiva, First Mesa Hopi, ca. 1892. (From Stephen 1936:Figure 188, drawing by Alexander Stephen, modified by Elsie Clews Parsons.)

occasion late in the nineteenth century, it was during this whitewashing that they "restored" the two antelope figures painted on the kiva walls using strips of cornhusk bent over their fingers as brushes to draw the lines and define the margins (Fewkes and Stephen 1892:223–24).

Much more customary at this point, at least at Hopi, is the making of new paintings on walls and ceilings when appropriate for a scheduled ritual event. Unlike the altar or theatrical arrangements that are likely to be the public focus of rituals which generally follow a set form, these paintings may be quite variable and even ancillary to the ritual activity. The Hopi Powamu or Bean Dance, for example, is held in the late winter to celebrate the return of the kachinas and to mark the beginning of the new planting and growing season with rituals designed for the purification and renovation of the earth. Powamu festivals differ considerably at all Hopi towns, but masked and unmasked dances are likely to take place in all kivas for a period of three or four weeks. Impersonators of most major deities and of many different kachinas make their appearance, some in set theatrical dramas; and traveling groups of kachinas perform rehearsed and impromptu sketches.

Just before Powamu, kiva renovations take place all over the mesas with "much frolicking fun and joking . . ." (Stephen 1936:210). A century ago, young men helped the young women, did the heavy work, and made wall paintings in the kivas in a setting combining play, courtship, gift exchanges, and the most sacred rituals. The young women also made paintings.

On several occasions, Alexander Stephen observed groups of four or five young women, assisted by young men, washing and renewing kiva walls with fresh mud plaster. The young women decorated the roof beams with mud-plaster paintings of clouds, lightning and other rain emblems, as well as with handprints. They referred to these paintings as "prayers," and in the "old usage," the pictures expressed a desire to grasp clouds and to bring rain (Stephen 1936:195–96, 202). Meanwhile, the young men sometimes made pictures on the kiva walls, but clearly these were not always considered necessary (Stephen 1936: 195–96, fig. 118). On one occasion at Walpi, Stephen asked why the kiva walls were not decorated and was told that everybody was "too busy" preparing figurines and making moccasins and other gifts for Powamu; they would paint the walls "when they have leisure" (Stephen 1936:210–11).

Nonetheless, the wall paintings, like those on the ceiling, were more than ornament. "It is not entirely decoration, they say the clouds and other symbols are as much prayers for rain and other blessings as the altar itself" (Stephen 1936:210–11). The subject matter, pictorial organization, and painting procedures are telling. In one painting, stylized clouds, rain, and lightning are superimposed over a realistically drawn masked deity (Fig. 119). In another, there are a crescent moon and constellations of four-pointed stars (Stephen 1936:fig. 143); and yet another has clouds, rain, lightning, a bird, and sunflowers (Stephen 1936:fig. 144) (Figs. 120, 121). In every case, Stephen's drawings show the paintings to be unframed and with compositions that tend to be potentially expandable rather than self-contained. There is compositional and iconographic similarity to Pueblo IV rock art, but these also resemble elements of painted cloth screens within which ritual dramas are staged. These casual wall paintings are like fragments of the theatrical scenery that may well be set up in the same rooms later on.

The paintings would be made by "two or three young men of the kiva, but the appropriate colours and emblems are suggested by the elder men, chiefs, etc."

Figure 120. Wall painting, Chief Kiva, First Mesa Hopi, ca. 1892. (From Stephen 1936:Figure 143, drawing by Alexander Stephen, modified by Elsie Clews Parsons.)

(Stephen 1936:209–10). On other occasions, the artists might have more freedom. For Powamu at Walpi in 1893, three "youths" painted some "elaborate wall frescoes." "As usual . . . elders prompt with regard to colors etc. . . . but the young men seem to choose their own subject" (Stephen 1936:224, 233–35, figs. 143, 144). There is no mention of how any of these were used in ritual, but they sustained use: kiva wall paintings made on February 6, 1893, were almost obliterated by February 8. The paintings also had meaning. Elaborate pictures that were little different from those described above were called "cloud altars" and had "the same intent and virtue as any other altar made on the kiva floor as elsewhere, during any ceremony." When it rained during a ritual, it meant that the prayers were answered and a painting "having served its purpose should be effaced" (Stephen 1936:237–38, figs. 145, 146).

Other ephemeral wall paintings could be more elaborate, more tightly organized, and more specifically useful in an esoteric ritual. A symmetrically balanced composition that extended around all four walls of the ritual chamber of the powerful Laguna Fathers Medi-

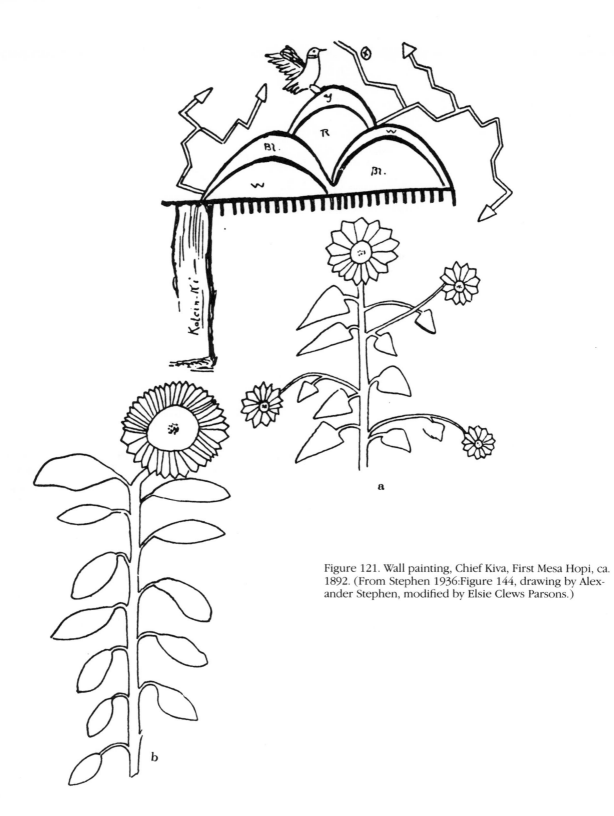

Figure 121. Wall painting, Chief Kiva, First Mesa Hopi, ca. 1892. (From Stephen 1936:Figure 144, drawing by Alexander Stephen, modified by Elsie Clews Parsons.)

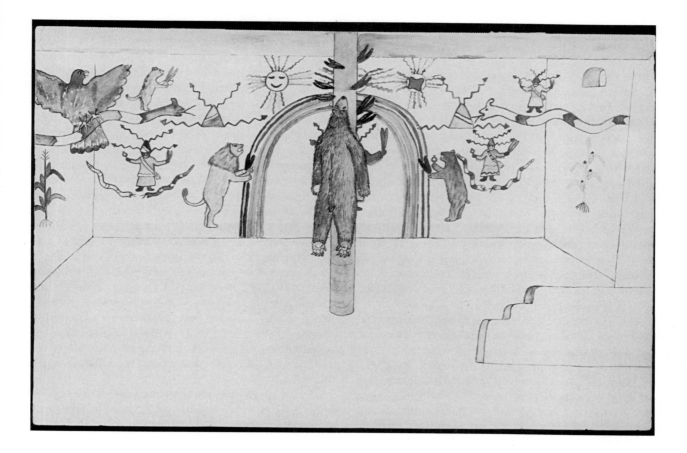

cine Society of Isleta Pueblo suggests narrative coherence on the order of some Pueblo IV kiva murals at Pottery Mound and Kuaua (Parsons 1932:Plate 17) (Fig. 122, see Fig. 63, Plate 1). Also reminiscent of Pueblo IV murals are paintings associated with Pamurti Society rituals which came to Hopi from Zuni. Among these are pictures of ceremonial kilts painted on the four walls of a clan house that suggest some murals from Pottery Mound (Fewkes 1903:26–29). More theatrical by far are wall paintings at Zuni, such as those used by the Sword Swallower Society (see Fig. 1), or the great painting of horned serpents in the kiva where Kolowotsi puppets, the Zuni version of the Hopi Palulukonti, perform (Stevenson 1887:549). Other ephemeral wall paintings at Zuni include images of deities, and deity wall paintings made for the use of esoteric societies in ritual are also cited at the more easterly Pueblos (Cushing 1882–83:30; Reagan 1917:70–71; Stirling 1942; White 1932).

Figure 122. Wall painting, Laguna Fathers, Isleta Pueblo, June 1940. A painting on paper of a medicine society kiva rich with murals. Despite the obvious modern elements, the ties to the past are evident. Many motifs are traceable to Anasazi origins, and the bilaterally symmetrical composition which depends from a rainbow arc is as ancient as the Pueblos themselves. (American Philosophical Society Library, original painting by "The Artist of Isleta," see Goldfrank 1962:Plate 63.)

Ephemeral Art, Esoteric Societies, and Ritual Structures

The more permanent Pueblo wall paintings in kivas, society houses, and Catholic churches seem to provide general background imagery in support of ritual. Some apparently function primarily to establish an ambience appropriate to any kind of Pueblo ceremony that may take place within the space of a given structure; and these have a close identity with the formal and symbolic vocabulary of the Pueblo decorative arts found on utilitarian objects. Others are more narrative, more naturalistic, or more particularly esoteric in subject matter; and these may better define a special purpose for the architectural space where they are made. Even so, these pictures are usually general enough to be familiar and important to several different esoteric societies, and for that reason, they may play only a marginal role in the ritual of any particular group.

A similar generic and ambient quality characterizes those ephemeral paintings that are incidental to ritual, but those made by ritualists seem to serve a more specialized ceremonial role. Rather than being the focal point for ritual, however, most wall paintings that we know are only one element, and sometimes only a minor one, of a complex, three-dimensional artistic assemblage made for esoteric use in special spaces on very special occasions. Ephemeral and complex artistic structures including wall paintings particular to certain rituals are known from most, if not all, of the pueblos. Pictures of them have been made at many pueblos, and are most extensively documented from the westernmost Pueblos of Zuni and Hopi. These wall paintings are best discussed in the context of the ritual structures of which they are a part.

A composite description of one of these ritual artistic structures begins by noting that each of the six surfaces of a rectangular room may hold a portion of it. Its most important visual and symbolic element is a free-standing altar constructed of painted wood and many other materials located on the floor in front of the north wall (Fig. 123). Dry paintings made of sand, flowers, ash, and other powdered colors, and painted and unpainted carvings and sculptural constructions of wood, stone, feathers, and so forth are usually located on the floor in front of the altar and are integrated visually and symbolically with it. Other constructions, including small altars, may be suspended from the ceiling or attached to or leaned against walls, and there

may be cryptic paintings on the roof beams. A visually and symbolically important painting often is seen on the north wall or hung in front of it, and other paintings or hangings may decorate the other walls (Plate 37).

The more theatrical rituals have painted cloth or tanned hide screens in place of or in back of the main altar, behind which actors and puppeteers may hide. The primary purpose of the screens may be to establish an environment suggestive of supernatural forces and personages that may be invoked directly or indirectly by the dramatic performance which is only one portion of a lengthy ritual (Fig. 124). Free-standing paintings on either side of a screen or altar, or wall painting, and a painted proscenium may reinforce the effect of a framed stage space designed to make the drama convincing (Fig. 125). In some instances, all four walls have dramatic and important wall paintings. At the end of a ritual, all of the pictorial and visual components are usually removed, covered over, or destroyed and the whole environment is re-created for any later performance. Screens and other painted constructions or scenic elements generally have their paint refreshed before each use, and wall paintings are made new each time.

The rituals of an esoteric society may last from one to nine days. Many are regularly scheduled to take place annually; some are held in alternate years; and others are scheduled at four-year intervals. Some rituals, such as kachina society dances, occur often but irregularly during the appropriate seasons, while initiation ceremonies that are also held irregularly occur but seldom. Child-naming ceremonies, mourning and other death-related rituals, as well as those that have to do with witchcraft or hunting, may all come under the authority of esoteric societies, and, along with curing and purification rituals of medicine and warrior societies, are held only when needed (Parsons 1932, 1962; Reagan 1917; Stevenson 1894, 1904; White 1932a, 1932b, 1935, 1942, 1962; Stirling 1942).

At the end of the nineteenth century, the annual calendar of regularly scheduled ceremonial events at one typical Hopi town included no fewer than seven nine-day, three five-day, and eight one-day rituals performed by various esoteric societies. Two other one-day and two nine-day rituals were regularly held in alternate years, and one nine-day ritual took place every fourth year (Fewkes 1903:20–23). At a minimum, ninety-six days of each year in that community were given over to scheduled rites that required ritual art.

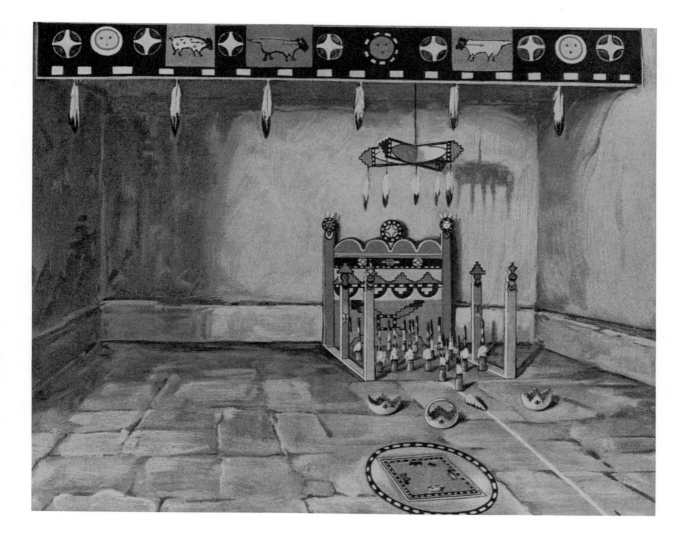

There have been changes since then, with some esoteric societies dying out and others adjusting their calendars to accommodate work schedules imposed by the economic requirements of the non-Pueblo world. But Pueblo social mechanisms such as the clan and moiety systems which regulate marriage and membership in social and religious organizations are dynamic and encourage the continual recreation, revival, or invention of interconnected ceremonial organizations. The overall complexity of the Hopi ceremonial calendar today is hardly different from that of a century ago, and complexity is probably no less a factor at most other Pueblos.

Figure 123. Altar of the Pe' sha't silo'kwe (Cimex Fraternity), Zuni Pueblo, late nineteenth century. Flickering light and shadows cast by suspended feathers and mobile structures reinforce the dynamic qualities of Pueblo ritual art. Time as well as space are integral to the complex assemblages. (Smithsonian Institution, no. 2359-A-1, after Stevenson 1904:Plate 126.)

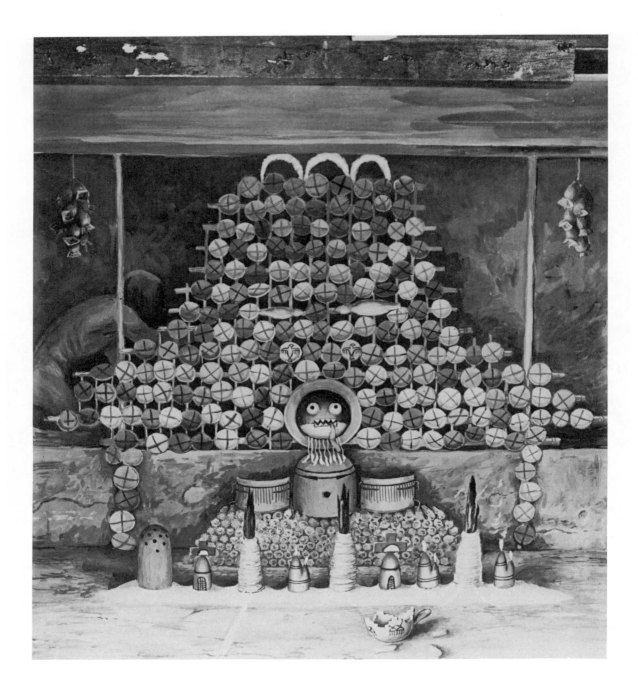

Figure 124. Altar, Winter Solstice Ceremony, Walpi, First
Mesa Hopi, ca. 1897. The background screen is made up of
dozens of small, painted discs (called "corn flowers" by
Fewkes) sewn to a framework of tied wooden slats. (Na-
tional Anthropological Archives, Smithsonian Institution,
no. 1812, original drawing by Mary M. Leighter, from
Fewkes 1898:Plate 1.)

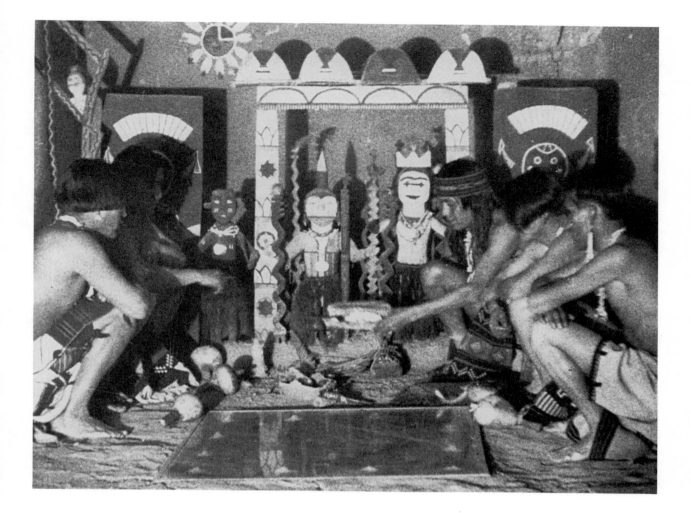

Each ritual of each society has its own set of artistic forms made in architecturally defined spaces. These need not be kivas; less specialized society houses and even domestic rooms may be used for esoteric rituals. Nonetheless, kivas are the most sacred and symbolically complex architectural spaces. Their physical structures may be considered quite specific representations of elements of an emergence myth that, with variations, is shared by all of the Pueblos. At Acoma, for example, the mythic first kiva was round like the sky; its roof was supported by four beams, each made from a different tree that had been planted in the Underworld so that the people could climb up to the present level. Turquoise of different colors was placed under the foundation to mark the cardinal directions; the walls

Figure 125. Antelope Society Altar, unidentified Hopi kiva, northeastern Arizona, ca. 1920. Carved and painted deity figures are framed by a painted cloth proscenium in this elaborate construction. (National Anthropological Archives, Smithsonian Institution, photo. no. 57419, frame from a motion-picture film by Paul Vanderbilt.)

represented the sky, the ceiling was the milky way, and entrance through the roof was by a ladder representing a rainbow (Stirling 1942:19).

Similar metaphors provide the logic for the form, special features, and structural details of kivas of all sizes and shapes at other pueblos. At another level of specialized symbolism, a mythology unique to each esoteric society may inform the complex artistic structures that are made in kivas and society houses by those organizations for their rituals. Each society has its own history, its own ritual functions, its own ritual and artistic forms, and its own supernatural sanctions.

There also are formal variations in the ritual art made by the same or related societies that may be located at different villages, for each branch has its own history (Fewkes 1897b, 1927). The history of the Hopi Women's Society called Oa'qol (Owakulti) is particularly instructive about the mechanisms by which esoteric societies may spread from place to place and how history may impact on the character of ritual art. When the town of Awatovi was destroyed by other Hopi in 1700 or 1701, the women and children were taken to live at other Hopi communities. One Awatovi refugee who settled at Mishongnovi brought with her the original altar and major fetish of the Oa'qol society and introduced it to her new community. About a century later, an Oraibi woman was initiated into the society after her marriage to a Mishongnovi man; when she moved back to Oraibi, she organized an Oa'qol Society there and became its first chief priestess (Voth 1903a:3). A new altar was made for the Oraibi Oa'qol Society, which also acquired other unique ritual paraphernalia (Plate 38). All of these objects which, by the end of the nineteenth century, were considered very old and very sacred, differ in unspecified ways from the original sacred objects (Voth 1903:3–5, 10).

Since the altar and other sacred paraphernalia which form the core of Oa'qol Society ritual art are different at each branch of the society, it follows that each branch will have evolved a somewhat different artistic tradition. The aesthetic character of the unique objects may control the total character of the artistic construction, but great symbolic importance that far transcends any aesthetic values sometimes accrues to heirlooms. Then, the symbolic value given to old objects, rather than aesthetics, rationalizes artistic decisions. For example, large stone-animal images, carved and painted wooden images, and some altars with components that date from Pueblo IV times or even earlier may sanction

the power and importance of an esoteric society. That sanction, rather than the intrinsic visual character of any one of those objects, explains why visual attention is focused on it.

In some instances, these ancient objects have "indescribable sanctity and in them rests the welfare of the people" (Bunzel 1932a:490). Such objects may also serve as tangible evidence of connection between a group and real or putative ancestors from a remote but historically known past. At the very least, these and less ancient but perhaps equally sacred and powerful objects provide the visual focal points or the narrative axes for the complex artistic constructions composed as ritual environments within architectural spaces.

To cite only a few of a multitude of examples, some rites of the important women's curing society called Mamzrau or Marau came to the Hopi town of Walpi through the agency of yet another priestess who survived the destruction of Awatovi. The central focal elements of the Mamzrau altar set up in 1891 were five large painted wooden slabs made with stone tools "long ago" (Stephen 1936:882–84, 912). These may have originated at Awatovi in the sixteenth century or earlier (Fewkes and Stephen 1892:217–19; Stephen 1936:882–84, 912; Voth 1912) (see Fig. 7). Painted carvings from Awatovi were also supremely important to at least one other esoteric group at Mishongnovi (Stephen 1936:147, fig. 90), while similar visual importance was given to stone carvings of the Little War God of the Firewood Clan that came to Walpi following the destruction of Sikyatki late in Pueblo IV times (Fewkes 1898b:73). Elsewhere, the most powerful and valued of the large animal fetishes that sanction the medicine societies of Zuni and dominate their altar constructions are "either found in ancient ancestral sites or inherited over generations" (Cushing 1883:12). The same is true also at Zia and at other Keresan Pueblos. Ancient carvings can structure floor layouts and provide the focal point for linear arrangements drawn on the kiva or society-house floor with cornmeal. These are metaphorical roads connecting the altar, the fetishes, and the supernaturals who sanction the special powers of the esoteric society (Stevenson 1894:72, 101; White 1932a:44–45, 1942:334, 336, 1962:146) (see Figs. 1, 126).

Most free-standing altars are rectangular and bilaterally symmetrical along the vertical axis. At Zuni they are usually made as hollow cubes, but many Keresan altars are flat, fencelike constructions (Figs. 127, 128).

Most Hopi altar structures are shallow, formed by three-sided, post-and-lintel frames to create a theatrical stage space within which three-dimensional objects are arranged (Fig. 129). The horizontal crosspiece or lintel of older Hopi altars was often native handspun cotton cloth stretched over a reed or wooden frame. The upright sidepieces of older altars are generally painted in flat, chalky colors with stylized images of corn, clouds, feathers, and rainbows. Some altar frames, especially at Zuni, incorporate many images of deities, most often the animals of the six directions, as well as large numbers of generic symbolic evocations of fertility and well-being. Unlike most others, modern Zuni altars are painted with shiny, crisp, and intense enamel colors.

An elaborate arrangement of carvings, painted wooden or stone slabs or tiles, deity images, fetishes, feather constructions, and pottery, stone, and basketry containers covers the floor in front of, contained within, or framed by an altar structure (Fig. 130). These and other sacred objects are emblematic or unique to a society; some are the personal property of its members; and many are essential for performance of a particular ritual. On each side of the altar structure—either on the wall behind it or on free-standing cotton cloth or animal hide surfaces stretched over frames—other deity images may be painted in the form of masks or as full frontal figures (Plate 39). These paintings may become a focal point for ritual attention. For example, a painting of the Germination Deity that had been made on a buckskin screen in another kiva on the previous day was brought ceremoniously into the Soyal kiva on the ninth day of the theatrical Soyal winter ritual at Oraibi just "preliminary to the principal act of the whole ceremony" (Dorsey and Voth 1901:53–54, Plate 28) (see Plate 39).

An altar may thus be dynamic, both visually and ritually, and it can extend in all directions. The objects arranged within its frame may be placed well forward of it, and an elaborate dry painting that is made during the course of a lengthy ceremony can become yet another of its frontal extensions (Fig. 131). Paintings of deities, clouds, lightning, corn plants, evergreens, and almost any kind of imagery may project out on either side of it along the back wall; and constructions suspended from rafters may extend it upward to the ceiling. These suspended altars vary in form: Some are mobile cosmic maps; others contain small carvings of deities; and still others are remarkably like the more

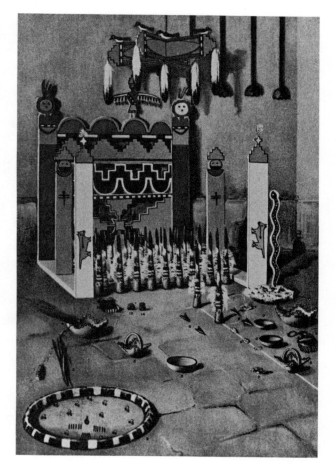

Figure 126. Altar Ma'ke 'Sannakwe (Little Fire Fraternity), Zuni Pueblo, late nineteenth century. A cornmeal path on the floor leads to the elaborately painted wooden altar. (Stevenson 1904:Plate 127.)

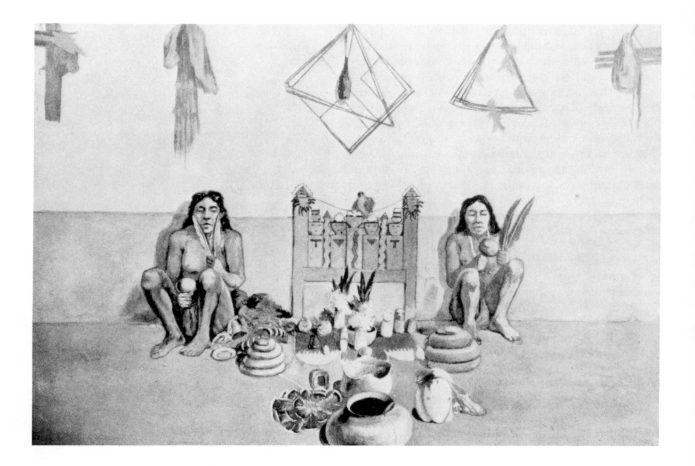

Figure 127. Altar of the Snake Society, Zia Pueblo, late nine-teenth century. The two priests and the large bowl in front are positioned as the points of an equilateral triangle that structures the assemblage. The objects on the wall are stored paraphernalia rather than an integral part of the al-tar. Compare to Figure 128. (National Anthropological Ar-chives, Smithsonian Institution, no. 2194, from Stevenson 1894:Plate 15, after a photograph by Matilda Cox Steven-son.)

elaborate headdresses sometimes worn in kachina dances and pictured in Pueblo IV kiva murals (Plate 40).

The essential formal feature of the whole construct is bilateral symmetry keyed to the long north–south axis of the room. This symmetry rationalizes the juxtaposi-tions of the many visually dissimilar three-dimensional objects with the few large-scale, painted images that are on either side behind them and with the narrow, rec-tangular horizontal and vertical panels of the altar. These painted panels, filled with a multitude of care-fully balanced, small-scale, repeated elements of geo-metrical decorative symbols, frame the three-dimen-sional objects which ordinarily provide the symbolic focus of the whole structural assemblage.

The focal sculptural elements may be organized ca-sually and without regard for artistic unity other than

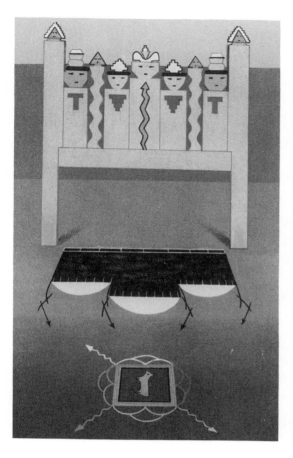

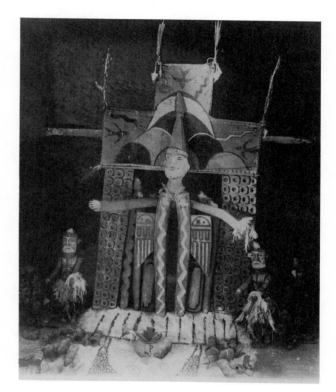

that which comes from nominal adherence to bilateral symmetry and a tendency to mass objects in roughly pyramidal configurations, often with the smallest elements in front (Stevenson 1894:Plate 19; Stephen 1936: Fig. 313) (see Fig. 127, Plate 37). Conversely, the sculptural objects may be organized artistically, as though without regard for symbolic meaning (see Plate 38). Most often, a combination of these two notions seems to be evident, and in some cases the arrangements are quite dynamic and may even be kinetic. For example, painted slabs used with a Hopi Flute Society altar which represent the Flute People are moved from point to point during a ritual (Stephen 1936:791, 9; figs. 425, 426, Plate 22).

Bilateral symmetry and sculptural massing supply the aesthetic logic for balancing large sculptural figures close to and on either side of an altar or its wings. When

Figure 128. Altar of the Snake Society, Zia Pueblo, late nineteenth century. A stylized drawing of the same altar as in Figure 127, but with all of the three dimensional objects removed. The static qualities of the planar, slat altar, and the two dry paintings in front of it are now dominant. (National Anthropological Archives, Smithsonian Institution, photo. no. 86-2635, after Stevenson 1894:Plate 14.)

Figure 129. Flute Altar, Oraibi Pueblo, Hopi, northeastern Arizona, 1899. The dominant, gesturing, and cruciform central figure is dramatically framed by a proscenium that establishes a cloud-filled sky above his head. (National Anthropological Archives, Smithsonian Institution, photo. no. 1820E, photograph by Sumner W. Matteson.)

Figure 130. Painted stone slabs, Walpi Pueblo, Hopi, north-eastern Arizona, Pueblo IV (?). Identified by Fewkes as "altar slabs," these ten- by fourteen-inch paintings are used in a kiva ritual at Walpi. Each is painted in a directional color, and all are composed of cloud and rain motifs in facial configurations. Similar painted stone slabs have been collected at a number of Pueblo III and Pueblo IV sites, including Sikyatki and the Puerco Ruins near Petrified Forest, Arizona. (Fewkes 1900:Plate 65.)

these figures are deities such as the Twin War Gods or male and female culture heroes, they have a compelling ideological importance that makes the sculptural arrangement symbolically appropriate (Fewkes 1897b:140, 142; Fewkes 1927) (see Figs. 125, 129). Large slabs of stone or wood painted with bilaterally symmetrical images of clouds, rain, or butterflies may also be placed on the floor beneath an altar and on either side of it. These provide both iconographic and visual links between the altar and the other three-dimensional objects assembled on the floor in front of it (Fewkes and Stephen 1892:226, 234; Fewkes 1892: 112, 113, Plate 65; 1904:Plate 46; Stephen 1936:figs. 426, 433; Webb and Weinstein 1973:fig. 45) (see Fig. 131).

More certainly aesthetic are arrangements that result when iconographic or symbolic meaning has been lost.

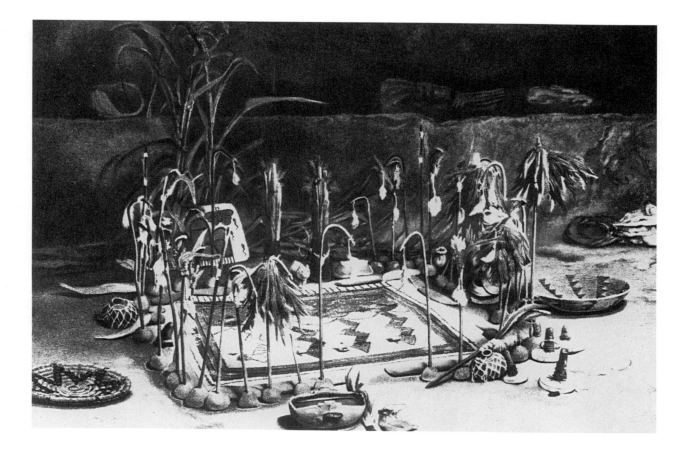

Figure 131. Dry painting, Antelope Altar, Walpi Pueblo, Hopi, northeastern Arizona. The horizontal dry painting which is the centerpiece of the altar would be appropriate as a vertical picture. Its stylized snake-lightning forms stand on clouds from which rain falls. The painted stone slab in the background is similar to those in Figure 130. (National Anthropological Archives, Smithsonian Institution, photo. no. 1816A, after a photograph by George Wharton James, 1896.)

One of the most elaborate and visually compelling Hopi altars is that of the Oraibi Oa'qol Women's Society, whose nine-day autumn ritual is climaxed by a basket dance. Late in the nineteenth century, H. R. Voth saw that altar erected during several different years by elderly men who were priests of the society. Early in this century, he had an accurate copy made of it, perhaps by one of those men, for a diorama exhibition of Hopi ritual art at the then-new Field Museum of Natural History in Chicago (Voth 1903) (see Plate 38). The oldest elements of the Oraibi altar were a suite of eighty-three flat wooden slabs suspended from the lintel to create a background screen within its structural frame. Each was painted with a different abstract, geometrical pattern, and, except for one wide panel called a "sun slab" which was always placed in the central position, there was little obvious pictorial or icono-

graphic logic in any of it. By 1900, only three or four generations had passed since its original creation, but no one could remember precisely how it was to be arranged: "a good deal of advising and arguing generally takes place"; "put it anywhere"; "it is immaterial where you tie it"; "that way is all right . . ." (Voth 1903:10). The uncertainty was not unique, and it could be that there never had been a single correct arrangement. In 1892 at Walpi, Alexander Stephen had noticed changes from the previous year in the Mamzrau Society altar arrangement and was told that "this way is also well . . ." (Stephen 1936:911, Figs. 470, 471). Clearly, though, in both cases aesthetic judgments controlled the iconography, and a mechanism is seen by which style change could occur within the strict constraints of ritual necessity.

Dry Paintings and Ritual Theater

By contrast with the sculptural assemblages, dry paintings that are made on the floor during the course of a multiday ritual are highly controlled both iconographically and visually. They are almost always bilaterally symmetrical along the north–south axis, have precise and sharply delineated frames, are consistently crisp in execution, are about the same size, shape, and proportions as the focal, three-dimensional altar, and are oriented to it so that the two units are often positioned base to base. Even though they are at right angles to each other and may be separated by a sculptural assemblage, the visual effect of the dry paintings is to close off and balance the altar construction; together, the two frame off two ends of that part of the total ritual structure that is on the floor of a room (see Figs. 123, 125, 128, 129, Plate 38).

The imagery in dry paintings is generally large in scale and may be quite iconic, as for example the pictures made to support Antelope Society rituals at Hopi that are associated with summer Snake Dances (Bourke 1884:Plates 18, 19; Fewkes 1900:Plate 53) (Fig. 131). However, there may be a tendency for the more iconic and esoteric subjects such as cosmic maps, and animal and other deity images to be used most often in association with the irregularly held ceremonies that have to do with naming, mourning, curing, warfare, and witchcraft rather than with those that are regularly scheduled (Stevenson 1894:Plate 14; White 1932b:Plate 16; 1942:30, 80–81) (Fig. 132). Motifs in dry paintings may also resemble those used on the rectangular posts or lintels of altar structures, pictures on painted stone

Figure 132. Dry painting, Acoma Pueblo, New Mexico, ca. 1930. The characteristics of strict formality, rigid symmetry, and interpenetration of shape, line, and color are found in certain kinds of ritual art at Acoma, Laguna, and Isleta Pueblos. Here, a painting used in a child-naming ceremony has a turtle appear to float through different colored triangles which become a rectangle. Similar effects are typical of tablitas worn by women in summer dances. (From White 1932:Plate 16.)

and wood slabs or tiles placed on the floor near an altar, designs painted on wooden slabs and wands carried by ritualists, or those used as emblems by esoteric societies (Plates 38, 41).

But even when dominated by such images as clouds, rain, lightning, and other generic symbols of water, fertility, and well-being, the dry paintings are intensely specialized. Each is appropriate only at a particular time, place, and ceremony, and decorative details such as color selection may be prescribed by tradition and have symbolic value. Some dry paintings may even substitute for a three-dimensional altar construction (Fewkes 1892a:96; White 1942:330–32).

They are made usually by members of an esoteric society under the general direction of an older priest, and materials for them are gathered at special places by other members of the group (Voth 1901:89; Plate 47). Women may make dry paintings, even the most esoteric (Fewkes and Owens 1892:112–13), and a young man with special artistic skill may be asked to make them and be thanked afterwards, even if he must be "repeatedly prompted in his work by others..." (Fewkes 1894:53). They are usually drawn from the inside out in an orderly, ceremonial sequence, and great care is taken to draw the images with clean precision.

The dry painting made for an Antelope Society kiva on the first day of a Hopi Snake Dance ritual takes about two hours to complete. It functions as an altar, and after completion it is blessed with corn pollen and then surrounded by an assemblage of sacred objects (Fewkes 1894:19, 20, 21–24; 1900:Plate 53) (see Fig. 130). It may be freshened on about the fifth day of the nine-day ceremony, and it is destroyed ritually on the last day when the cloud symbols drawn along its base are carefully removed and deposited in agricultural fields (Fewkes 1894:46, 95–96). On the same day, in the Snake Kiva, another painting may be destroyed ritually by putting snakes used in the ceremony on it since "it is their home." The remnants of the pictures are then carefully deposited in special locations (Fewkes 1894:84–87).

Because dry paintings can acquire supernatural power, the care and ritual that often surrounds their destruction may be considered an integral part of their making and their use (Mallery 1893:211; Voth 1901:76, 93). Particulars of destructive rituals vary considerably: the colors from an image of a mountain lion in a dry painting used in Zia Snake Society rainmaking and curing rituals were rubbed on his own body by the head priest of the society "for mental and physical purification." The remainder of the painting was given to a woman to take home and rub over the bodies of her children (Stevenson 1894:85) (see Fig. 128).

With Pueblo dry paintings the interactions between two- and three-dimensional art media and between art and sacred forces become quite specific, while humans and the pictures they make are transformed and acquire physical and psychic unity when people apply the pictures to their own bodies. Transformations that may be quite theatrical may also intrude upon sculptural assemblages, as, for example, when painted images of Flute People are moved about, or when male and female culture heroes who are ordinarily represented by painted carvings placed near an altar are impersonated by actual people. Boy and girl participants in Antelope Society Snake Dance rituals are painted and dressed as a deity pair and stand in the appropriate places, almost motionless as though they themselves were the deity images (Fewkes 1897c:142). The chief priest of the Oa'qol Women's Society and a woman initiate are costumed and painted to represent male and female germination, growth, and seed deities whose images may also be seen near the altar on the night of the fifth day of the Basket Dance ceremony (Voth 1903:22–23). Personations, three-dimensional representations, and paintings on kachina society altars are all the same thing ideologically and can be interchangeable (Fewkes 1897b:134; 1927:476–77). Body paint also serves similar functions. It transforms Zia Snake Society initiates into deities, and body paint may serve a similar transformational role when the bodies of honored dead are painted before burial (Parsons 1932:216; Stevenson 1894:89, Plate 90; Stirling 1942:55).

More obvious and public theatricality is integral to many scheduled rituals. The Palulukonti at Hopi is one of a number of regular kachina society ceremonies of the early spring that feature dramatic performances held in kivas for audiences of uninitiated people. Several presentations on the same theme, but with each using a different script, may be held simultaneously by different kiva groups in the same town. Fewkes describes the Palulukonti as a "mystery play" which illustrates the growth of corn and is held for the purpose of producing rain (1903:24). The performance begins with actors setting up the stage by bringing in and hanging a large painted cloth screen from wall to wall and floor to rafters across one end of the kiva. A variety

Figure 133. Painted cloth curtain, First Mesa Hopi, 1893. This screen is hung from wall to wall and rafters to floor in the kiva where the Palulukonti ritual is held in late winter to signal the return of the sun. It serves as theatrical curtain, screen and scenery. Horned serpents emerge from the sun discs in the lower register to threaten a miniature field of corn set up in front of the curtain. See Figure 90. (From Stephen 1936:Plate 10, field sketch by Alexander Stephen modified by Elsie Clews Parsons.)

of designs may be used. In one, the screen is divided into two horizontal registers of equal size that are bordered on top and bottom by narrow frames of curvilinear stylized clouds and on each side by snake-like lightning symbols (Stephen 1936:Plate 10) (Fig. 133). The heads and shoulders of two male and two female humans or deities are painted in the upper register, each confined within a large, arced frame. Circular, masklike sun symbols are topped by stylized clouds or feathers, and several birds are painted within three square panels and one rectangular one in the lower register. Another screen was capped by a long, horizontal proscenium with a frieze of arced clouds, lightning, and birds (Fig. 134). Each of five vertical panels suspended from that screen had a large frontal image of a deity painted within it. Three of these panels stand above stylized clouds arranged as a terraced altar with a bird sitting to one side; the others are flanked by cloud, lightning, and rain symbols. Other deity images were placed in spaces left between the hanging panels (Stephen 1936:Plate 11).

For the performance, the first screen described above had a miniature field of corn set up in front of it. Each of the six circular sun discs or masks was a door that swung open so that black and white horned serpent puppets could emerge. These are the Palulukonti after which the ritual is named—a Hopi version of the horned and feathered serpents shown in Pueblo IV kiva murals and rock art and known by other names at other Pueblos. Here, each was about four to five feet long, with goggle-eyes, a fanlike crest, toothed mouth, and red tongue. Men behind the screen roared through empty gourds, and there were a series of action-filled sequences as the serpents attempted to destroy the corn plants in front of them and fought with each other and with human actors, many of whom personated kachinas (Fewkes 1893; 1900:Plates 32, 33; 1903:40–57) (see Fig. 92).

Each screen, the other paraphernalia, and presumably each variant script is owned by one of the kachina societies. The screens are repainted on the day of the dramatization by the performers, who are usually initi-

Figure 134. Painted cloth curtain, First Mesa Hopi, 1892. More a background screen than a curtain, this large cloth scenic unit is completed when two large Sha'lako Mana puppets are placed in the vacant spaces. The screens are repainted annually by the performers. (From Stephen 1936:Plate 11, field sketch by Alexander Stephen modified by Elsie Clews Parsons.)

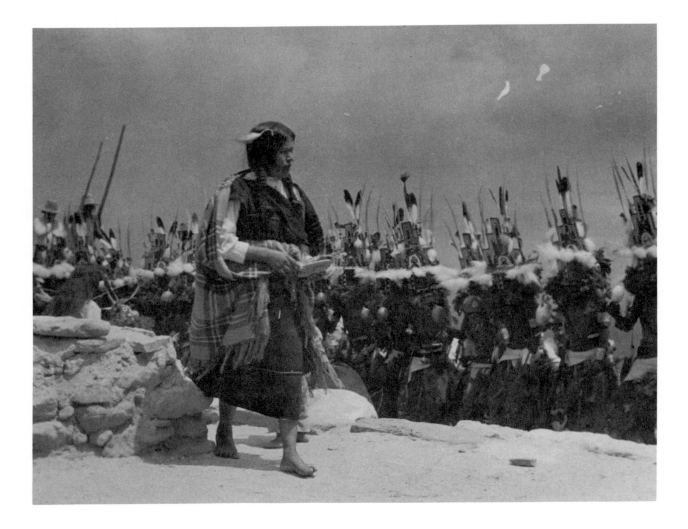

Figure 135. Niman Kachina Dance, Oraibi, Third Mesa Hopi, July 1923. Each kachina figure wears a high, terrace-shaped tablita that summarizes the ideographic and visual essence of Anasazi and Pueblo ritual painting of the last six or seven hundred years. Every painted tablita is topped by vertical feathers reaching upward from the unifying, cloud-like horizontal base made by white downy feathers worn by each participant. (Photograph by Emry Kopta, courtesy Maxwell Museum of Anthropology.)

ated members of that society. The repainting is surrounded by ritual, with the artists fasting beforehand and purging themselves afterward. All former outlines are carefully followed except for the bird designs, which each artist could finish "according to his own fancy" (Stephen 1936:308–9).

Many variations of similar theatricality are documented. The Niman ritual in late summer marks the end of the kachina cycle at Hopi as the kachinas "go home" to the San Francisco peaks. The Niman altar is dominated by cloud symbols stacked into terraces which look very much like the headdress or tablita of the Hemis Kachinas, who traditionally dance at this time (Fig. 135). The similarity of the Niman altar paint-

ing and tablita to the masklike murals of the painted kiva at Jemez Pueblo is worth noting (Plate 36). A theatrical stage is created for Niman rituals by having a "considerable part of the wall of the kiva . . . occupied by a screen formed by two upright cloth curtains connected by a cross-piece." Large, frontal images of other deities are painted on these side screens which flank the performance space (Fewkes 1892a:103–6).

The Soyal ritual of late winter dramatizes the return of the sun with great theatricality (Fewkes 1903:24–25). Artificial flowers made up of discs called "corn flowers" are stacked high on a frame behind the altar and piles of corn form a mound below (Fewkes 1898b:76–77, Plate 1) (see Fig. 124). Together, these provide a backdrop for a complex series of dramatic events which feature mock battles between deity impersonators and a solemn display of elaborately feathered sun shields as well as several portable paintings of Alosaka, the Germ Deity, shown in a corn field (see Plate 39). At the conclusion, the corn-flower structure is disassembled and individual flowers are deposited in agricultural fields (Fewkes 1898b:78). Some Pueblo IV kiva mural subjects may well be of similar performances (see Fig. 69, Plates 28, 29).

It is of interest that no known permanent or ephemeral wall paintings of the historic period seem to be so specifically narrational and theatrical. Rather, the more permanent wall paintings made in architectural settings tend to be generalized in their iconography and seem to have as their primary purpose the establishment of an ambience that is appropriate for many different kinds of ritual performance. They are usually formal in structure, framed, balanced, rhythmically predictable, and architectonic. They help to reinforce the visual and structural qualities of the space enclosing them and thereby parallel the organizational logic of traditional Pueblo decorative art. While pictorial themes are dominated by representational images and water and fertility-related emblems and forms, there are ideological relationships to decorative art in the use of motifs drawn from the vocabulary of decorative and symbolic designs applied to utilitarian objects, especially containers.

Most ephemeral wall paintings made during the last century in association with particular esoteric rituals also appear to be generalized and ambient, but some may have particular formal and iconographic associations with other art forms that are specific to those rituals (see Fig. 1). The organizational character of ephemeral wall paintings tends to be fragmented, and rather than rationalizing architectural space, many are likely to be unframed, isolated on a wall, and structurally unrelated to the architecture that contains them (see Figs. 119–21). They also often refer to specific compositional and pictorial elements that are visible in the more highly structured religious and theatrical art objects which are the focal points of the rituals. They are less like decorative paintings, and to a much greater apparent degree than with more permanent paintings, the ephemeral ones are likely to be thought of as ritually efficacious. Their formal and iconographical relationships to the more impressive Pueblo IV murals are minimal. The modern ephemeral murals generally do not have the compositional unity or the narrative or iconic intensity of those earlier paintings. Above all, both kinds of modern wall painting generally lack the dominating visual and ideographic character that made the paintings of Pottery Mound, Awatovi, Kawaika-a, and Kuaua so impressive.

Visual and ideographic dominance seems to have shifted in the intervening centuries from the walls to the floor of the ritual spaces, and from static, two-dimensional to dynamic, three-dimensional media. In modern usage, the wall paintings rarely control the ritual space either visually or iconographically, as they once seem to have done. Instead, most have become ancillary elements of extraordinarily rich and complex, multimedia assemblages. At Hopi, certainly, in the nineteenth century ephemeral wall paintings were the most spontaneous of all religious ritual paintings.

As well as their ritual role, at least some of the modern wall paintings have had a social role that may be pictorially invisible. Joy as well as solemnity are characteristic of many regularly scheduled Pueblo rituals, which are festive as well as religious events. Wall paintings made in preparation for even the most solemn of them a century ago at Hopi were the focus for social interactions, including courtship. Both men and women could make ritual pictures, and in at least some instances where gender was important to the making of art, the art had social ramifications comprehensible to even the most alien understanding. That the subject matter of art made a century ago spontaneously and to impress young friends was entirely religious and may have been suggested by elders and priests who were witness to the social interactions merely confirms that art was a multifaceted integrative force that bespoke the unity of Pueblo life of an earlier day.

SEVEN ▌ More than Ornament, Ever Impermanent

Anasazi Painting, Form and Content

The original Anasazi homeland, the San Juan Basin of what is now the southwestern United States, has a distinctive visual character dominated by enormously high skies, dynamic cloud formations, almost unimaginably distant horizons, and geological formations that are sculpturally impressive, sometimes bizarre, and always colorful. The colors and the shapes of nature here are so varied, intense, and exaggerated as to approach cliché; the landscape can be almost a caricature of itself.

It is a commonplace for visitors to that country to remark on the consistency with which the Anasazi people selected village locations surrounded by a compelling natural beauty. In truth, it would have been more remarkable had the Anasazi chosen otherwise, for they would have had to look hard for home sites in their original homeland which were not dominated by dramatic natural features. When they moved out of the San Juan Basin, their new lands had a new character; the sky was much the same but mountains were generally greener, higher, and nearer, and horizons correspondingly closer. While geological formations were often as dramatic, they were less saturated by color. Problems of site selection may have been different, but the results were similar: villages were almost always sited in places of great natural beauty.

Characteristically, in both areas Anasazi villages were confined, restricted, and inward-looking in their limitless landscape. They were often built with high walls around a central plaza or within the confines of a rock shelter which sometimes limited visual access to only a few hundred yards up or down a narrow, steep-cliffed canyon. Natural space and domestic space differed from each other; the former was endless, while the latter had distinct boundaries. Still, natural space was accessible even if outside the walls; and domestic space partook of natural space, not only because each was made of the same materials, but because light, shade, and geometry were manipulated by the builders to create architectural forms that fused nature and culture. In more modern times, the interpretation of nature and culture is made specific by Pueblo people in many ways: Trash piles within domestic space are locations where nature is understood to reclaim its own; shrines and sacred mountains that are far removed from settlements mark places where culture impinges on the domain of nature (Ortiz 1973).

Among the remains of the Anasazi world in the San Juan, the visual effects of this fusion can be deceptively natural; if not commonplace, it is not unusual either for modern visitors to ancient Anasazi sites to find them virtually invisible. Sites in the open may have disintegrated into mounds of rubble that look like rounded hills. Yet even where stone walls stand, their silhouettes may take on the crenelated appearance of a basalt dike, the jagged character of a volcanic plug, or any of the pseudoarchitectural forms that wind and water give to sandstone. Buildings in rock shelters that are almost pristine seven hundred years after their abandonment can appear so natural as to be perfectly camouflaged, and large and visually powerful paintings on the cliff walls that frame them may become incorporated into

their environment. It may not be so absurd, after all, to look on these works as though they were the products of nature rather than of culture. But they are, of course, a part of history, which is culture—a fact that was not lost on the Anasazi people or their Pueblo descendants.

Anasazi painting was invented and evolved in that environmental and social setting, and its forms restated the nature–culture dichotomy while its content was concerned with the relationships between society and the supernatural, a relationship often stated as one between humans and their mythic past. The most domestic paintings, drawings, and two-dimensional images in all media were made on utilitarian containers, on costumes, and on other useful objects of all sorts. These are almost invariably confined, restricted, and inward-looking. They are rational, symmetrical, arithmetical, geometrical, composed of segmented masses or blocks of color. Their most constant feature is an almost painfully taut linearity. Abstraction and geometry rule their imagery, which refers obliquely, if at all, to natural forms. The less domestic pictorial art, which is generally found outside of or on the edges of the constructed environment and is not directly associated with mundane utility, tends to be unconfined, unrestricted, and expansive. It may be unsymmetrical; its linear quality is variable, and within it masses or blocks of color may be segmented or may merge with line. Both visual and ideational relationships among drawn images are uncertain, confusing, and not easily interpreted. The images themselves very often are of real or imaginary organisms.

Scale and medium usually directed the character of Anasazi pictorial art. The smaller-scaled and most domestic media—pottery and basketry containers, clothing and other textiles—generally carry the most rational and most abstract pictorial images. The largest-scaled and least domestic media—paintings and engravings on otherwise unmodified boulders, cave walls, and rock outcrops—are the least rationally structured and among the most representational Anasazi pictures. But each may partake of some of the quality of the other, and between the two is the large-scale domestic medium of architectural space.

It is within architecture that nature and culture, abstraction and representation, are most certainly joined by Anasazi painting, as though the art mediated between the two realms and the two kinds of reality. Within architecture, the organizational principles of domestic art and many of its aesthetic processes were applied to the subject matter and the endless spaces that characterized nondomestic art. Some mural paintings in room interiors, especially those from before the fourteenth century, have the appearance of large-scale renderings of the most domestic kinds of art, as though a room were nothing more than a very large container. However, in other Anasazi wall paintings, especially the kiva murals of the Pueblo IV period, we have controlled and deliberate artistic illusions of boundless space. In these paintings, pictorial spaces are created within which the personages painted on a wall act and interact in created environments that somehow penetrate through and beyond the real-world surface of the constructed environment.

The illusion that a painted personage is a performer in an artistically created environment is, of course, the essence of theater. Anasazi murals of the illusionary type are theatrical, or the next thing to it, but, except for the certainty that dramatic performances were a feature of Anasazi sacred ritual, we know very little about the forms, the art, or the artistic paraphernalia of Anasazi theater. Neither the visual character nor the imagery of most modern Pueblo wall paintings that we know of which are directly associated with dramatic rituals seem to bear a very close connection to the more illusionary and theatrical of ancient Anasazi wall paintings. Conversely, the most obviously theatrical of Anasazi architectural spaces, the Great Kivas of the Pueblo III era, have no wall paintings associated with them at all; we know only of fragments of painted constructions that are thought to be related to the sacred theater of those places. Theatrical illusionism as a device for mediating between nature and culture, on the one hand, and between the world of humans and that of the supernaturals, on the other, may have been important to the Anasazi and remains important to modern Pueblo people. But the pictorial methods used by the Anasazi and the Pueblos to support that mediation appear to be significantly different, and we can only guess how those methods may have overlapped.

In that regard, the three-dimensional altar assemblages and the framed stage spaces of Pueblo theatrical rituals described almost a century ago are especially provocative. These mixed media and ephemeral constructions were usually made within the confines of a large, rectangular room and were the visual as well as the ideological focal point for sacred theatrical performances. Ephemeral wall paintings, though made for the same rituals, were not generally important to the

theatrical illusion; they were ambient, had social functions, could be spiritually efficacious, and referred visually and iconographically to the altar and stage paintings, but they were peripheral to the performances. The tantalizing and fragmentary bits and pieces of sacred and theatrical paraphernalia of the Pueblo III era which survive to our day suggest a continuity with the recent past; they look as though they could be parts of altar assemblages, stage settings, or costumes. That suggestion of continuity is confirmed in the most positive way possible by the images and interactions shown in the Pueblo IV wall paintings. But those paintings themselves remain a puzzle in the sequence, for they seem to belong to a pictorial tradition that did not exist before the Pueblo IV era and then changed considerably during the course of the most recent three or four hundred years.

In all eras, Anasazi pictures on domestic objects were usually made as internally consistent statements and iterations about the form and the character of domestic space; these were about the quality of culture. Pictures that were made in locations clearly outside the constructed environment were usually made as internally consistent statements about the form and character of undomesticated space; these were about the quality of nature. Architectural paintings and those done in architectural contexts could be composed as either of the other two forms, or could combine aspects of both in novel structural and narrative arrangements. It is as though the constructed environment partook of both nature and culture and, by its nature, it nurtured ambivalence. The kiva mural tradition grew out of that ambivalence.

Each of these pictorial forms had a distinctive aesthetic tradition and a distinctive history. Each responded to the unique requirements of a particular medium and a multitude of other unique factors, not least of which was the utility to be made of the object or of the site on which the art was made. These pictorial traditions overlapped, of course, for each ultimately served the same, unifying social purpose, and each was made by the same individuals or their near relatives. The Anasazi world was large geographically but small socially and demographically.

It is almost certain that there were no full-time art professionals among the Anasazi; their communities were too small, their means of livelihood too close to the subsistence level to support art specialists on either the social or the economic level. But their artists were certainly trained, and they and their audiences knew the rules and evaluated the products of the various pictorial traditions. While picture-making opportunities might be accessible to all, we can be sure that not every person painted, that some made more art than others, and that certain kinds of pictures were made by certain kinds of people. The domestic arts, especially, required a high degree of training and skill that not every individual could or might want to acquire.

Among modern Pueblos in the recent past, often if not always, opportunities to learn the skills of picture-making on domestic objects were regulated by the social system, especially as it pertained to marriage and other family relationships. We must assume that a similar arrangement held true in the Anasazi past. Among modern Pueblos, some forms of paint and painting are sanctioned supernaturally and have mythic histories, and the art of painting may be sacred, dangerous, and only done by authorized individuals (Stirling 1942:43). But kiva muralists today may also be selected for their skill as school-trained artists (personal interview 1968). Some and perhaps all of the ritual art of the Anasazi almost certainly was conceived of as sacred and dangerous, and akin to a form of ritual property and ritual responsibility; and as with domestic painting, access that an individual might have to that art was likely regulated by the social system. Nonetheless, individual artistic skill, interest, and training also would have been selective factors in the making of ritual art.

Individual and personal innovative expression, among the Anasazi as with all people at all times, was channeled by training and social requirements. Even the most rigid ritual arts allowed for innovation as, for example, when dancers were permitted to repaint their masks as they wished. The rules for making rock art are not easily adduced, but they often seem to have allowed for more inventive placement of images and a greater degree of idiosyncrasy in choice of subject than did other pictorial forms. The consistency and high quality of draftsmanship at so many open-air art sites argues for some degree of technical training, even if informal, on the part of the artists making those pictures. Of course, the Pueblo IV kiva murals suggest a tradition dependent upon skilled and trained artists.

In the Anasazi world, the most rigorous pictorial training seems to have been applied to the utilitarian domestic arts, and the most rigorous social requirements were applied to the ritual arts made for use in well-defined ritual spaces. While the former was more

likely to be a female and the latter a male domain, observations of Pueblo painting practices recorded from the sixteenth century onward support the view that gender divisions may not always have been rigid. As with so much else in Anasazi life, the order, control, and stability imposed on an artist were modified by access to a socially acceptable alternative.

The values given by Anasazi people to the products of their various pictorial traditions seem to have been much the same regardless of any kind of diversity. Anasazi pictures, for the most part, were made for use and discard. "Pueblo wall designs are ever impermanent," wrote Alexander Stephen in 1887, but he could well have extended the statement to cover virtually all Anasazi and Pueblo pictorial media (Stephen 1936:87). Large painted wooden carvings and multitudes of carefully fabricated feathered and painted prayer sticks were, and are, made to be placed at shrines; among other things, these objects are tangible prayers, offerings that are not fulfilled until they have finally, by decomposition, returned to nature (Eriacho and Ferguson 1979; Ladd 1983a:26–32). The most permanent pictures are the rock-art images at open-air sites which were almost always added to, modified, and superimposed over each other as though they also were ephemeral. When painted domestic objects were broken or became obsolete, they were placed on the trash heaps where nature reclaims culture. Masks and other ritual paraphernalia are almost always repainted before they are reused, and when they cannot be used anymore, they are deposited forever in caves or in other natural locations.

Regardless of medium, form, quality, utility, or content, few Anasazi or Pueblo paintings seem ever to have been valued for themselves. Old painted objects might be preserved, honored, and respected, but the paintings on them were, and are, remade rather than reused. Repainting rather than conservation is, and may always have been, the operative curatorial principle of Pueblo and Anasazi art. Because paint and the act of painting may be sacred, the paintings must be differentiated from the objects on which they are placed; the two may have entirely different purposes and values. Prayer plumes and the pigments used to color dry paintings are given to nature to complete the ritual for which they are made; a similar process may have operated for all forms of Anasazi pictorial art. It is as though the Anasazi in full understanding of the impossibility of resisting nature and natural decay, incorporated principles of destruction and temporal limitation to all of their paintings.

History and Iconography

The apparent coherence and integration of Anasazi painting with other aspects of Anasazi life and its world-view argues against the validity of the notion that any important innovation in Anasazi art could have occurred simply as the consequence of stimulation from outside the Anasazi world. Instead, a close look at the history of Anasazi painting must place great emphasis on the development of regional traditions within that world. Each of these traditions tells both a positive and a negative story; a preference for certain forms is also a rejection of others. In painted pottery, the Mesa Verde people liked dark paintings, Chaco people preferred fine-line pictures, Pueblo IV Hopi artists used matte paint, and their contemporaries in the Zuni area used shiny glazes. These preferences cut across time and media; Zuni artists today prefer to use shiny paint on their altars, while Hopi artists use a matte paint on theirs. The invention and persistence of regional traditions, with each one depending on the consistent application of refined principles of selection, is yet another aspect of the history of Anasazi painting that requires us to evaluate outside influences very carefully indeed.

Culture and nature; the social order and the universal one; the world of humans and the world of the supernaturals; mediation between realms through prayer and ritual—these, apparently, were the prime subjects, content, and motivation for Anasazi pictorial art. Anasazi art was about religion, but it was also about history and for society. Many kachinas are ancestors—they had once been live people; many deities are also culture heroes, and they personify mythic history while validating the social order. If Pueblo beliefs can be projected backwards, the Anasazi world of the supernaturals was populated by more than yesterday's people, for the unborn were there too (Bunzel 1932b). Anasazi art did more than simply tell of and mediate between the past and present—it also connected with the future. The tenuous quality of pictorial space in Anasazi art, whether in the background voids of framed kiva murals or the ambiguous margins of rock art, are consistent with this temporal theme.

The imagery of domestic art also makes constant reference to these unifying connections. Abstractions

of feathers, clouds, lightning, water, and corn are ubiquitous in domestic painting, but the particular meaning that any of these may have is largely irrelevant. Whether these were visual prayers for general or specific kinds of well-being carried to the sky by feathers or their images, conscious marks of respect offered to supernaturals, or automatic, unthinking, thoughtless, and purposeless motifs, they are all about the same thing. Their objective point of reference is the supernatural realm.

These abstractions appear alongside and even permeate the more obviously iconic, symbolic, representational images of kachinas and supernaturals used in ritual or which illustrated ritual events, or are found in other, less easily understood contexts such as rock art. Pueblo ritual art in any of its forms almost always makes some reference to mythic history, and, if we assume the same for the Anasazi, we must then read the content of Anasazi painting as not only intensely religious, but also intensely social and historical for myth is a species of history that has social meaning.

Anasazi painting functioned as a system of interconnecting parts: form, content, media, utility—each drew upon all of the others. It was a system that could transform an entirely alien image of Jesus into that of Younger Sister, Utctsiti, the mythic Creator Mother of the Indian people, or, alternatively, transform the personality of the same Jesus into that of the Aztec ruler Montezuma who had become one with the culture hero Poseyuma. If the iconography of Catholicism could be so altered in the face of military invasion, political and economic domination, well-planned and practiced proselytization, and terrible epidemics of smallpox, what problems might the Anasazi have had in transforming other alien iconographies introduced in earlier times under circumstances that appear to have been considerably less trying?

There can be little doubt that the mythic Utctsiti and Poseyuma were there before Jesus came to the Pueblos, and their original personalities, histories, and social and ritual roles were at least similar to, if not identical with, those they have today. In times before history was recorded, Quetzalcoatl, Tlaloc, Tezcatlipoca, the kachinas, and other deities are thought to have come north from Mexico. How these presumed emigrant Mexican gods were absorbed into the Anasazi system and what mergers and transformations took place with perhaps even more ancient Anasazi deities are important historical questions that may never be

answered. Quetzalcoatl today may be identified with Sotuqnang-u, the Hopi one-horned Sky God. He is also, and perhaps not surprisingly, absorbed by the Poseyuma of the Eastern Pueblos. Tlaloc may identify with Pautiwa, the leader of the Gods and head of the Zuni Kachina Village, Tezcatlipoca with the Mountain Lion of the North, the kachinas with the Tlalaco rain spirits, and other valid identifications with Mexican deities can surely be made (Ellis and Hammack 1968; Parsons 1933). With the possible exception of Quetzalcoatl–Montezuma–Poseyuma, we do not know how any of these transformed Mexican deities relate to more ancient Anasazi mythic beings and events; the systematic integration of these and so many other alien personages into Anasazi art and life suggests that the puzzle, interesting as it may be, was of little consequence to the Anasazi.

We know Tlaloc and the others by their Mexican names, and our understanding of their personalities, rituals, and social and religious roles are deeply colored by their very elaborate Mexican histories. But Mexico and the Southwest were both parts of a very large and ancient American system, and many of these deities were widely dispersed throughout Middle America and other parts of North America. Therefore, it may be an error to accept any one regional version of them, or the concepts that they embodied, or their rituals as more primary or more authentic than any other. Authenticity of any variant can only be judged by the quality and degree of its integration with the social and artistic systems of the group that used it. And integration and elaboration are both entirely independent of antiquity. The Mexican Tlaloc, spectacular, elaborate, and dramatic as he was, was no more authentic than the Anasazi version of a similar being; and there is slim evidence, other than the notoriously unreliable iconographic, that either one was more original or had greater antiquity than the other.

Looked at from within, each of the various Anasazi pictorial traditions seems to have a parallel internal consistency. Each shows a similar pattern whereby gradual changes in form and content are punctuated periodically by some more dramatic innovations which may alter the old tradition even as it is absorbed by it. Very often those innovations correlate with other historic or archaeological events. For example, within the Southwest the Hispanic invasions, the abandonment of the Four Corners, the introduction of the bow and arrow, Mogollon movements northward, and smallpox

all correlate roughly with one or another Anasazi pictorial innovation.

At best, a correlation is no more than a coincidence that suggests possible explanations; it can never have a clear historic meaning. Often, the correlation between an artistic innovation in the Southwest during Anasazi times and an archaeologically defined event is very rough indeed, and on occasion, the two may be identical; for example, when the primary evidence for a presumed archaeological event is an artistic innovation or an architectural style. The Pueblo IV mural painting tradition, the style of painted pottery that we call Sikyatki Polychrome, and the iconography of Jornada Mogollon rock art are all cases of unexplained pictorial innovations that are also treated as archaeological events. The temptation to explain each instance in terms of its identity with itself can be overwhelming.

On occasion, artistic innovations and other archaeological events in the Southwest can be keyed with confidence to other events or activities that took place earlier in the Valley of Mexico or further south. Those correlations may be used to lend support to the notion that the stimulus for innovation in the Southwest generally came from Mexico. Without denying that possibility, the fact remains that Anasazi pictorial traditions were made by and for the Anasazi. Whatever innovations came to be adopted by Anasazi artists were not only quickly adapted to fit their ideas of appropriate form and content, but undoubtedly they were also selected from among other possible stimulants. We can only know what the Anasazi artists did; we do not know and may never know what they chose not to do. Our knowledge of the art of the Anasazi and their nearby southwestern neighbors is much more complete at present than it is for any of their contemporaries on the northern Mexican frontier. Until we learn more about those other regional pictorial traditions, we will have few clues about the formal and iconographic elements of a Mesoamerican stimulus that were rejected by the Anasazi. Yet no history of art is ever complete that fails to tell of stimuli that were rejected by artists or the people who used their products.

Metamorphosis and Transformation

Anasazi art entered art history through the mediation of Cezanne and Duchamp, Cubism, Dadaism, Surrealism, Abstract Expressionism, postmodernism, and the myriad other art movements that give the art of our times its unique and peculiar flavor. Ours is an art made by and for urban, industrial people living in crowded conditions that change with a rapidity and near universality never before experienced by humanity. The threat and promise of complex, corporately produced technologies are everywhere visible, as are the evidences of social disintegration; and we must invent new ways to reintegrate ourselves actually, metaphorically, and symbolically; thus we make new forms of art. Under the circumstances, it should not surprise us that the art of other times and societies, most especially of less crowded times and more integrated societies, should have a special appeal that is both nostalgic and progressive. Miniver Cheevy was not entirely foolish after all, and we need models for our future.

Technology, institutions, and self-interest come together as we make the effort to create new art from the old. It is only during the last century that we have had the ability to produce cheaply and, perhaps not so cheaply, circulate images of art objects and words about them as well as transform art museums into truly urban, public places where we can see and reevaluate these things. And it is only during that time that our desire to know a better past and create a better future has become so strong that we are now willing to radically alter an old and once useful art classification system.

Classification systems, like art objects, are products of the human imagination. In fact, implicit and pervasive throughout this history is the notion that one constant in the creation of art is the desire to somehow reify a class of things or concepts by picture-making; we make art in order to visualize our classification systems. When we legitimized for ourselves the creation of metamorphic art, whereby unaltered manufactured objects could become art by the simple process of reclassification, we gave respectability to any new meanings that we might impose on any old objects. But the new meanings are about us and our history, not about them and theirs.

We treat the paintings on Anasazi objects as we do all other paintings in our art museums, as permanently valuable but useless things to be preserved and curated as they are now. But we know that was not the Anasazi way, that their paintings were made to be ephemeral, useful, and, ultimately, to be taken by nature for they belonged to nature; Anasazi paintings reified the Anasazi worldview. In many other ways, our reclassification of Anasazi painting as one of our fine arts has

nothing to do with the Anasazi, and it may very well violate, as our curatorial values do, Anasazi concepts, philosophies, and ideals. And yet, what we do with Anasazi art is our legitimate business just as what the Anasazi did with Quetzalcoatl, or their Pueblo descendants did with Jesus, was their business. Anasazi art serves our purposes, and so be it.

It is another matter, however, for us to pretend that what we do with Anasazi art is what they intended, for then we become caught in the mythology of our own classification procedures. A classification system is the result of an act of imagination, and therefore it is a dynamic phenomenon; it is a way of organizing and testing reality, never to be confused with the phenomena that are being classified. Never in any sense real, a classification system becomes useless the instant it is believed to be immutable.

In the case at hand, our metamorphosis of Anasazi painting into one of our fine arts is only another way of classifying our reality, but the paintings were originally created to order quite another reality. If Anasazi art is to be useful to us as we so laboriously go about the business of trying to invent new and more useful ways to classify our universe, then we must distinguish as best we can between them and us and between what we imagine and what really exists. The Anasazi universe is not our universe, nor did they share the world that we now live in. Their pictorial solutions will be useful to us to the degree that we understand that the problems they addressed were not our problems.

Beyond utility, it must be argued on ethical grounds that we owe the Anasazi—and all other ancient peoples whose art we have made our own—their own history. And we must realize that those alien products of the imagination and intellect that we call art must not be viewed as though they were natural and irrational objects made by some not-quite-human species of naturally irrational Natural Man. All else aside, Anasazi painting was made by Anasazi people to help them visualize their place and their purpose in the universe. If we are to make use of their art, both ethics and utility require us to pay attention to its history.

REFERENCES

Abert, James W.
1848 Report of Lieut. J. W. Abert of his Examination of New Mexico in the Years 1846–1847. *30th Congress, 1st Session, House Executive Document no. 41* Washington, D.C.: Wendell and Van Benthuysen.

Ackerman, James S.
1963 Western Art History. In *Art and Archaeology,* ed. James S. Ackerman and Rhys Carpenter, 123–229. Englewood Cliffs, N.J.: Prentice Hall.

Adams, William Y., A. J. Lindsey, Jr., and C. G. Turner II.
1961 Survey and Excavation in Lower Glen Canyon, 1952–1958. *Museum of Northern Arizona Bulletin 36.* Flagstaff: Glen Canyon Series No. 3.

Anderson, Frank G.
1955 The Pueblo Kachina Cult: A Historical Reconstruction. *Southwestern Journal of Anthropology* (Albuquerque) 11, no. 4:404–19.

Bancroft, Hubert Howe.
1962 *History of Arizona and New Mexico, 1530–1888.* Albuquerque: Horn and Wallace (reprint of 1889 ed.).

Bandelier, Adolf F.
1890–1892 Final Report of Investigations among the Indians of the Southwestern United States, Carried on Mainly in the Years from 1880 to 1885. *Archaeological Institute of America* (Cambridge, Mass.), *Papers, American Series,* vol. 3 (part 1), vol. 4 (part 2).

Baumann, Gustave.
1939 *Frijoles Canyon Pictographs.* Santa Fe: Writers' Editions.

Beaglehole, Ernest.
1936 Hopi Hunting and Hunting Ritual. *Yale University Publications in Anthropology,* no. 4.

Benedict, Ruth R.
1931 Tales of the Cochiti Indians. *Bureau of American Ethnology Bulletin 98.* Washington, D.C.: Smithsonian Institution.

Binford, Lewis R.
1971 Mortuary Practices: Their Study and Their Potential. In Approaches to the Social Dimensions in Mortuary Practices, ed. James A. Brown, *Society of American Archaeology, Memoir 25*:6–29.

Bliss, Wesley L.
1936 Problems of the Kuaua Mural Paintings. *El Palacio* 40, nos. 16, 17, 18:81–87.

Bloom, Lansing B.
1937 Bourke on the Southwest. *New Mexico Historical Review* 12, no. 1:41–77; no. 4:337–79.
1938 Bourke on the Southwest. *New Mexico Historical Review* 13, no. 2:192–238. Albuquerque: University of New Mexico.

Boas, Franz.
1955 *Primitive Art.* New York: Dover Press.

Bol, Marsha Clift.
1980 The Anonymous Artist of Laguna and the New Mexican Colonial Altar Screen. M.A. thesis, University of New Mexico.

Bourke, John G.
1884 *The Snake Dance of the Hopi.* New York: Charles Scribner's Sons.

Brew, John O.
1946 Archaeology of Alkali Ridge, Southeastern Utah. *Peabody Museum, Harvard University, Papers, vol. 21* (Cambridge).

Brill, Lois Sonkiss.
1984 Kokopelli: An Analysis of His Alleged Attributes and Suggestions toward Alternate Identifications. M.A. thesis, University of New Mexico.

Brody, J. J.
1964 Design Analysis of the Rio Grande Glaze Pottery of Pottery Mound, New Mexico. M.A. thesis, University of New Mexico.
1969–1972 The Kiva Murals of Pottery Mound. In *Proceed-*

ings of the 38th International Congress of Americanists (Stuttgart–Munich), vol. 2:101–110.

1971 *Indian Painters and White Patrons* (Albuquerque: University of New Mexico Press).

1974 In Advance of the Readymade: Kiva Murals and Navajo Dry Paintings. In *Art and Environment in Native America, Special Publications no. 7,* ed. Mary Elizabeth King and Idris R. Traylor, 11–21. Lubbock: The Museum, Texas Tech University.

1977 *Mimbres Painted Pottery.* Albuquerque: School of American Research and University of New Mexico Press.

Brody, J. J., Catherine J. Scott, and Steven A. LeBlanc.
1983 *Mimbres Pottery: Ancient Art of the American Southwest.* New York: Hudson Hills Press.

Brown, Betty.
n.d. Southwest-Mesoamerican Interaction: the Kiva Murals. Unpublished seminar paper, University of New Mexico.

Bunzel, Ruth.
1929 The Pueblo Potter. *Columbia University Contributions in Anthropology,* vol. 8.

1932a Introduction to Zuni Ceremonialism. *Bureau of American Ethnology, 47th Annual Report*:467–544. Washington, D.C.: Smithsonian Institution.

1932b Zuni Katcinas. *Bureau of American Ethnology, 47th Annual Report*:837–1086. Washington, D.C.: Smithsonian Institution.

Caperton, Thomas J.
1981 An Archaeological Reconnaissance of the Gran Quivera Area. In *Contributions to Gran Quivera Archaeology, Publications in Archaeology 17* ed. Alden C. Hayes, 3–11. Washington, D.C.: National Park Service.

Carlson, Roy L.
1970 White Mountain Redware: A Pottery Tradition of East Central Arizona and Western New Mexico. *Anthropological Papers of the University of Arizona* (Tucson), vol. 19.

Cassidy, Ina Sizer.
1936 Art in New Mexico. *New Mexico* 14, no. 10:25–52.

Chapin, Frederick H.
1892 *The Land of the Cliff Dwellers.* Boston.

Chapman, Kenneth M.
1916 The Cave Pictographs of the Rito de los Frijoles, N. M. *Archaeological Institute of America, School of American Archaeology, Papers,* no. 37:1–3.

1938 Pajaritan Pictography. In *Pajarito Plateau and Its Ancient People,* ed. Edgar L. Hewett, 139–48. Albuquerque: University of New Mexico Press.

Cole, Sally J.
1984 *The Abo Painted Rocks Documentation and Analysis.* Grand Junction, Colorado: A Report Prepared for Salinas National Monument, New Mexico.

Colton, Harold S.
1939 Three Turkey House. *Plateau* (Flagstaff: Museum of Northern Arizona) 12, no. 2:26–31.

1946a Fools Names Like Fools Faces. *Plateau* 19:1–8.

1946b The Sinagua: A Summary of the Archaeology of the Region of Flagstaff, Arizona. *Museum of Northern Arizona Bulletin* 22. (Flagstaff).

1959 *Hopi Kachina Dolls: With A Key to Their Identification,* revised ed. Albuquerque: University of New Mexico Press.

Cordell, Linda S.
1979 Prehistory: Eastern Anasazi. In *Handbook of North American Indians,* vol. 9, *Southwest,* ed. Alfonso Ortiz, 131–51. Washington, D.C.: Smithsonian Institution.

1984 *Prehistory of the Southwest.* Orlando: Academic Press, A School of American Research Book.

Cosgrove, Cornelius B.
1947 Caves of the Upper Gila and Hueco Areas in New Mexico and Texas. *Peabody Museum, Harvard University, Papers,* vol. 24, no. 2.

Courlander, Harold.
1982 *Hopi Voices.* Albuquerque: University of New Mexico Press.

Crotty, Helen K.
1979 The Kiva Murals and the Question of Mesoamerican Influence. Unpublished manuscript.

Cushing, Frank Hamilton.
1883 Zuni Fetiches. *Bureau of Ethnology, Second Annual Report*:9–45. Washington, D.C.: Smithsonian Institution.

1967 *My Adventures in Zuni.* Palmer Lake, Colo.: Filter Press (reprint of 1882–83 articles in *The Century Illustrated Monthly Magazine*).

DiPeso, Charles C.
1950 Painted Stone Slabs of Point of Pines, Arizona. *American Antiquity* 16, no. 1:57–65.

DiPeso, Charles C., John B. Rinaldo, and Gloria J. Fenner.
1974 *Casas Grandes: A Fallen Trading Center of the Gran Chichimeca,* vols. 1–3. Dragoon, Ariz.: Amerind Foundation.

Dias del Castillo, Bernal.
1979 *The Discovery and Conquest of Mexico 1517–1521,* ed. and trans. A. P. Maudslay. New York: Farrar, Straus and Giroux.

Dick, Herbert W.
1965 Picuris Pueblo Excavations. *Document No. PB 177047, National Technical Information Service* (Springfield, Va.).

Dittert, Alfred E., Jr., and Fred Plog.
1980 *Generations in Clay: Pueblo Pottery of the American Southwest.* Flagstaff, Ariz.: Northland Press.

Dixon, Keith.
1956 Hidden House: A Cliff Ruin in Sycamore Canyon, Central Arizona. *Museum of Northern Arizona* (Flagstaff) *Bulletin* no. 29.

Dockstader, Frederick J.
1954 *The Kachina and the White Man.* Bloomfield Hills, Mich.: Cranbrook Academy of Science.

Dorsey, George A., and H. R. Voth.
1901 The Oraibi Soyal Ceremony. *Field Columbian Museum Publication 55, Anthropological Series* (Chicago), vol. 3, no. 1.

Douglas, Frederic H., and Rene d'Harnoncourt.
1941 *Indian Art of the United States.* New York: Museum of Modern Art.

Douglas, Mary.
1966 *Purity and Danger: An Analysis of Concepts of Pollution and Taboo.* London: Routledge and Kegan Paul.

Doyel, David E., Alan H. Simmons, and Patricia McAnany.
1989 A Painted Kiva Near Chaco Canyon, New Mexico. *From Chaco to Chaco: Papers in Honor of Robert H. Lister and Florence C. Lister,* ed. Meliha S. Duran and David T. Kirkpatrick. Albuquerque: Archaeological Society of New Mexico.

Dozier, Edward P.
1954 The Hopi–Tewa of Arizona. *University of California Publications in American Archaeology and Ethnology* (Berkeley) 44, no. 3:259–376.

Dutton, Bertha P.
1963 *Sun Father's Way.* Albuquerque: University of New Mexico Press.

Eliade, Mircea.
1964 *Shamanism: Archaic Techniques of Ecstasy,* trans. Willard R. Trask. New York: Pantheon Books.

Ellis, Florence Hawley.
1967 Where Did the Pueblo People Come From? *El Palacio* 74:35–43.

Ellis, Florence Hawley, and Laurens Hammack.
1968 The Inner Sanctum of Feather Cave, A Mogollon Sun Shrine Linking Mexico and the Southwest. *American Antiquity* 33, no. 1:25–44.

Emory, William H.
1848 Notes of a Military Reconnaissance from Fort Leavenworth, in Missouri to San Diego in California, Including Parts of the Arkansas, Del Norte, and Gila Rivers. *30th Congress, 1st Session, Senate Executive Docket 7.* Washington, D.C.: U.S. Government Printing Office.

Ferdon, Edwin N., Jr.
1955 A Trial Survey of Mexican–Southwestern Architectural Parallels. *Monographs of the School of American Research,* no. 21.

Ferguson, T. J., and E. Richard Hart.
1985 *A Zuni Atlas.* Norman: University of Oklahoma Press.

Fewkes, J. Walter.
1892a A Few Summer Ceremonials at the Tusayan Pueblos. *A Journal of American Ethnology and Archaeology* 2:1–160.

1892b A Few Tusayan Pictographs. *American Anthropologist* 5, no. 1:9–26.

1893 A-Wa'-tobi: An Archaeological Verification of a Tusayan Legend. *American Anthropologist* 6:363–75.

1894 The Snake Ceremonials at Walpi. *Journal of American Ethnology and Archaeology* 4.

1897a Tusayan Snake Ceremonies. *Bureau of American Ethnology, 16th Annual Report for the Years 1894–1895.* Washington, D.C.: Smithsonian Institution.

1897b Morphology of Tusayan Altars. *American Anthropologist* 10, no. 5:129–45.

1897c The Group of Tusayan Ceremonials Called Katcinas. *Bureau of American Ethnology, 15th Annual Report for the Years 1893–1894:245–313.* Washington, D.C.: Smithsonian Institution.

1898a Archaeological Expedition to Arizona in 1895. *Bureau of American Ethnology, 17th Annual Report for the Years 1895–1896,* Part 2:519–742. Washington, D.C.: Smithsonian Institution.

1898b The Winter Solstice Ceremony at Walpi. *American Anthropologist* 11, no. 3:65–87; vol. 11, no. 4:101–15.

1900 A Theatrical Performance at Walpi. *Washington Academy of Science, Proceedings* 2:80–138. New York: Putnam's, n.d.

1902 Minor Hopi Festivals. *American Anthropologist* (n.s.) 4, no. 3:482–511.

1903 Hopi Katcinas Drawn by Native Artists. *Bureau of American Ethnology, 21st Annual Report for the Years 1899–1901:13–126.* Washington, D.C.:13–126.

1904 Two Summers' Work in Pueblo Ruins. *Bureau of American Ethnology, 22nd Annual Report for the Years 1900–1901,* Part 1:1–196. Washington, D.C.: Smithsonian Institution.

1908 Report on the Excavation and Repair of Spruce Tree House, Mesa Verde National Park, Colorado, in May and June 1908. *Department of the Interior Annual Report for 1908,* vol. 1:490–505. Washington, D.C.: U.S. Government Printing Office.

1909 Antiquities of the Mesa Verde National Park: Spruce Tree House. *Bureau of American Ethnology, Bulletin 41.* Washington, D.C.: Smithsonian Institution.

1911 Antiquities of the Mesa Verde National Park: Cliff Palace. *Bureau of American Ethnology, Bulletin 51.* Washington, D.C.: Smithsonian Institution.

1916 The Cliff Ruins of Fewkes Canon, Mesa Verde National Park, Colorado. In *Holmes Anniversary Volume:*96–117.

1919 Designs on Prehistoric Hopi Pottery. *Bureau of American Ethnology, 33rd Annual Report for the Years 1911–1912:207–84.* Washington, D.C.: Smithsonian Institution.

1921 Field Work on the Mesa Verde National Park. *Explorations and Field Work of the Smithsonian Institution in 1920.* Smithsonian Miscellaneous Collections, vol. 72, no. 6. Washington, D.C.

1927 The Katcina Altars in Hopi Worship. *Smithsonian Institution, Annual Report for 1926:*469–86. Washington, D.C.: Smithsonian Institution.

Fewkes, J. Walter, and J. G. Owens.
1892 The La'-la-kon-ta: A Tusayan Dance. *American Anthropologist* 5, no. 2:105–29.

Fewkes, J. Walter, and Alexander M. Stephen.
1892 The Mam-zrau-ti: A Tusayan Ceremony. *American Anthropologist* 5, no. 3:217–45.

Ford, Richard I., Albert H. Schroeder, and Stewart L. Peckham.
1972 Three Perspectives on Puebloan Prehistory. In *New Perspectives on the Pueblos,* ed. Alfonso Ortiz, 19–39. Albuquerque: University of New Mexico Press.

Forde, C. Daryll.
1931 Hopi Agriculture and Land Ownership. *Journal of the Royal Anthropological Institute of Great Britain and Ireland,* no. 61:357–405.

Fraser, Douglas.
1971 The Discovery of Primitive Art. In *Anthropology and Art,* ed. Charlotte Otten, 20–36, Garden City, N.Y.: Natural History Press.

Gallencamp, Charles.
1950 The Mystery of New Mexico's Lost Cities. *New Mexico* 28, no. 6:13–15, 41–42.

Geertz, Clifford.
1973 *Interpretation of Culture.* New York: Basic Books.

Gerbrands, Adrian.
1973 The Concept of Style in Non-Western Art. In *Tradition and Creativity in Tribal Art,* ed. Daniel Biebuyck, 58–70. Berkeley: University of California Press.

Goldfrank, Esther S.
1967 The Artist of "Isleta Paintings" in Pueblo Society. *Smithsonian Contributions to Anthropology,* vol. 5. Washington, D.C.: Smithsonian Institution.

Goldwater, Robert.
1967 *Primitivism in Modern Art.* New York: Vintage Books, rev. ed.
1973 Art History and Anthropology: Some Comparisons of Methodology. In *Primitive Art and Society,* ed. Anthony Forge, 1–10. New York: Oxford University Press.

Gombrich, Ernst Hans.
1960 *Art and Illusion.* New York: Pantheon Books.

Gordon, Donald E.
1984 German Expressionism. In *Primitivism,* ed. William Rubin, vol. 2:369–403. New York: Museum of Modern Art.

Graburn, Nelson H., ed.
1976a *Ethnic and Tourist Arts.* Berkeley: University of California Press.
1976b Introduction: Arts of the Fourth World. In *Ethnic and Tourist Arts,* ed. Nelson H. Graburn, 1–32. Berkeley: University of California Press.

Gregg, Josiah.
1844 *Commerce on the Prairies,* 2 vols. New York: Henry G. Langley.

Gunnerson, James H.
1969 The Fremont Culture: A Study in Cultural Dynamics on the Northern Arizona Frontier. *Peabody Museum, Harvard University, Papers,* vol. 59, no. 2.

Hammond, George P., and Agapito Rey.
1929 *Expedition Into New Mexico Made by Antonio de Espejo 1582–1583, As Revealed in the Journal of Diego Perez de Luxan, a Member of the Party.* Los Angeles: Quivera Society.
1940 *Narratives of the Coronado Expedition 1540–1542.* Albuquerque: University of New Mexico Press.
1966 *The Rediscovery of New Mexico 1580–1594: The Explorations of Chamuscado, Espejo, Castano de Sosa, Morlete, and Leyva de Bonilla and Humana.* Albuquerque: University of New Mexico Press.

Hatcher, Evelyn Payne.
1974 Visual Metaphors: A Formal Analysis of Navajo Art. *American Ethnological Society Monograph,* no. 58. Seattle: University of Washington Press.

Haury, Emil W.
1934 The Canyon Creek Ruin and the Cliff Dwellings of the Sierra Ancha. *Medallion Papers,* no. 14. Globe, Ariz.: Gila Pueblo.
1945a The Excavation of Los Muertos and Neighboring Ruins in the Salt River Valley, Southern Arizona. *Peabody Museum, Harvard University, Papers,* vol. 24, no. 1.
1945b Painted Cave, Northeastern Arizona. *Amerind Foundation, Publications,* no. 3. Dragoon, Ariz. Amerind Foundation.
1976 *The Hohokam: Desert Farmers and Craftsmen.* Tucson: University of Arizona Press.

Hayes, Alden C., ed.
1981a *Contributions to Gran Quivira Archaeology, Publications in Archaeology 16.* Washington, D.C.: National Park Service.
1981b *Excavation of Mound 7, Publications in Archaeology 17.* Washington, D.C.: National Park Service.

Heib, Louis A.
1972 Meaning and Mismeaning: the Ritual Clown. In *New Perspectives on the Pueblos,* ed. Alfonso Ortiz, 163–95. Albuquerque: University of New Mexico Press.

Hewett, Edgar L.
1930 *Ancient Life in the American Southwest.* Indianapolis: Bobbs-Merrill Co.
1938a *Pajarito Plateau and Its Ancient People.* Albuquerque: University of New Mexico Press.
1938b The Frescoes at Kuaua. *El Palacio* 45, nos. 6, 7, 8:21–28.

Hibben, Frank C.
1937 Excavation of the Riana Ruin and Chama Valley Survey. *University of New Mexico Anthropological Series,* vol. 2, no. 1. Albuquerque: University of New Mexico.
1938 The Gallina Phase. *American Antiquity* 4, no. 2:131–36.
1949 The Pottery of the Gallina Complex. *American Antiquity* 14, no. 3:194–202.
1966 A Possible Pyramidal Structure and Other Mexican In-

fluences at Pottery Mound, New Mexico. *American Antiquity* 31, no. 4:522–29.

1967 Mexican Features of Mural Painting at Pottery Mound. *Archaeology* 20, no. 2:84–87.

1975 *Kiva Art of the Anasazi at Pottery Mound.* Las Vegas, Nev.: K. C. Publications.

Hill, W. W.

1982 *An Ethnography of Santa Clara Pueblo,* ed. and annotated by Charles H. Lange. Albuquerque: University of New Mexico Press.

Hodge, Frederick W.

1937 History of Hawikuh, One of the So-called Cities of Cibola. *Publications of F. W. Hodge Anniversary Fund,* vol. 1. Los Angeles: Southwest Museum.

Hofmann, Werner.

1972 The Magic Element in Modern Art. In *World Culture and Modern Art,* trans. Graham Fulton-Smith, 244–51. Munich: Bruckmann Publishers.

Holien, Thomas.

1974 Pseudo-cloisonné in the Southwest and Mesoamerica. In Collected Papers in Honor of Florence Hawley Ellis, ed. Theodore Frisbie, *Papers of the Archaeological Society of New Mexico,* no. 2, 157–177.

Holmes, William H.

1907 Report of the Chief. *Bureau of American Ethnology, 24th Annual Report for the Year 1902–1903.* Washington, D.C.: Smithsonian Institution.

Irwin-Williams, Cynthia.

1979 Post-Pleistocene Archaeology, 7000–2000 B.C. In *Handbook of North American Indians,* vol. 9, *Southwest,* ed. Alfonso Ortiz, 31–42. Washington, D.C.: Smithsonian Institution.

Jackson, William Henry.

1876 Ancient Ruins in Southwestern Colorado. *Bulletin of the United States Geographical and Geological Survey of the Territories Embracing Colorado and Parts of Adjacent Territories, for 1874 (Hayden Survey):*367–81. Washington, D.C.: U.S. Government Printing Office.

Judd, Neil M.

1930 The Excavation and Repair of Betatakin. *United States National Museum, Proceedings,* vol. 77, art. 5, publications no. 2828. Washington, D.C.: U.S. National Museum.

1954 The Material Culture of Pueblo Bonito. *Smithsonian Miscellaneous Collections,* vol. 124. Washington, D.C.

Kabotie, Fred.

1977 *Fred Kabotie: Hopi Indian Artist.* Flagstaff: Museum of Northern Arizona.

Kealiinohomoku, Joann W.

1980 The Drama of the Hopi Ogres. In *Southwestern Indian Ritual Drama,* ed. Charlotte J. Frisbie, 37–69. Albuquerque: School of American Research and University of New Mexico Press.

Kelley, J. Charles.

1974a Pictorial and Ceramic Art in the Mexican Cultural Littoral of the Chichimec Sea. In *Art and Environment in Native America, Special Publications,* no. 7, ed. Mary E. King and Idris R. Traylor, Jr., 33–54. Lubbock: Texas Tech University.

1974b Speculations on the Culture History of Northwestern Mesoamerica. In *The Archaeology of West Mexico,* ed. Betty Bell. Ajijic, Jalisco: West Mexican Society for Advanced Study.

Kelley, J. Charles, and Ellen Abbott Kelley.

1974 An Alternative Hypothesis for the Explanation of Anasazi Culture History. In Collected Papers in Honor of Florence Hawley Ellis, *Papers of the Archaeological Society of New Mexico,* no. 2, ed. Theodore Frisbie.

Kent, Kate Peck.

1983 *Prehistoric Textiles of the Southwest.* Albuquerque: School of American Research and University of New Mexico Press.

Kessell, John L.

1979 *Kiva, Cross, and Crown: The Pecos Indians of New Mexico 1540–1840.* Washington, D.C.: National Park Service, U.S. Department of the Interior.

1980 *The Missions of New Mexico.* Albuquerque: University of New Mexico Press.

Kidder, Alfred V.

1924 An Introduction to the Study of Southwestern Archaeology with a Preliminary Account of the Excavations at Pecos. *Papers of the Southwestern Expedition,* no. 1. New Haven, Conn.: Phillips Academy.

1927 Southwestern Archaeological Conference. *Science* 66:489–91.

Kidder, Alfred V., and Samuel J. Guernsey.

1919 Archaeological Explorations in Northeastern Arizona. *Bureau of American Ethnology, Bulletin 65.* Washington, D.C.: Smithsonian Institution.

Kirk, Ruth F.

1943 *Introduction to Zuni Fetishism.* Santa Fe: School of American Research.

Kluckhohn, Clyde.

1939 The Excavations of Bc 51 Rooms and Kivas. *University of New Mexico Bulletin, no. 345, Anthropological Series,* vol. 3, no. 2:30–48.

Kubler, George.

1962 *The Shape of Time.* New Haven: Yale University Press.

1972 *The Religious Architecture of New Mexico in the Colonial Period and Since the American Occupation.* Albuquerque: University of New Mexico Press.

Ladd, Edmund.

1983a An Explanation: Request for the Return of Zuni Religious Objects. *Exploration, Zuni El Morro: Past and Present,* ed. David G. Noble, 32. Santa Fe: School of American Research.

1983b Zuni Religion and Philosophy. *Exploration, Zuni El Morro: Past and Present,* ed. David G. Noble, 26–31. Santa Fe: School of American Research.

Lambert, Marjorie F., and J. R. Ambler.
1961 A Survey and Excavation of Caves in Hidalgo County, New Mexico. *Monographs of the School of American Research,* no. 25.

Lange, Charles H.
1968 *Cochiti, A New Mexican Pueblo, Past and Present.* Carbondale, Ill.: Southern Illinois University Press.

Lange, Charles H., ed.
1985 Southwestern Culture History: Collected Papers in Honor of Albert H. Schroeder. *Papers of the Archaeological Society of New Mexico,* vol. 10. Santa Fe: Ancient City Press.

Lange, Charles H., and Carroll L. Riley, eds.
1966 *The Southwestern Journals of Adolph F. Bandelier.* Albuquerque: University of New Mexico Press.

Leach, Edmund.
1973 Levels of Communication and Problems of Taboo in the Appreciation of Primitive Art. In *Primitive Art and Society,* ed. Anthony Forge, 221–34. New York: Oxford University Press.
1983 Gatekeepers of Heaven: Anthropological Aspects of Grandiose Architecture. *Journal of Anthropological Research* 39, no. 3:243–64.

Lévi-Strauss, Claude.
1966 *The Savage Mind.* Chicago: University of Chicago Press.
1973 *Totemism,* trans. Roger Needham. Harmondsworth, Middlesex, England: Penguin University Books.

Linton, Ralph W.
1933 Primitive Art. *American Magazine of Art* 26, no. 1:17–24.
1941 Primitive Art. *Kenyon Review* 3 (June):34–51.

Madsen, William.
1955 Shamanism in Mexico. *Southwestern Journal of Anthropology* 11, no. 1:48–57.

Mallery, Garrick.
1893 Picture Writing of the American Indians. *Bureau of American Ethnology, 10th Annual Report:*3–807. Washington, D.C.: Smithsonian Institution.

Maquet, Jacques.
1971 *Introduction to Aesthetic Anthropology.* Reading, Mass.: Addison-Wesley.
1986 *The Aesthetic Experience.* New Haven: Yale University Press.

Marshall, Michael P.
1977 *Investigations at the Mission of San Estevan Rey, Acoma Pueblo, New Mexico: A Preliminary Report.* Santa Fe: State Historic Preservation Office.

Marshall, Michael P., and Constance S. Silver.
1983 *The Mural Paintings of the Convento of San Estevan Rey, Pueblo of Acoma: State of Preservation and Prospects for Conservation.* Santa Fe: State Historic Preservation Office.

Martin, Paul S.
1936 Lowry Ruin in Southwestern Colorado. *Field Museum of Natural History* (Chicago), *Publications, Anthropological Series,* vol. 35, no. 1.
1979 Prehistory: Mogollon. In *Handbook of North American Indians,* vol. 9, *Southwest,* ed. Alfonso Ortiz, 61–74. Washington, D.C.: Smithsonian Institution.

Martin, Paul S., and Fred Plog.
1973 *The Archaeology of Arizona: A Study of the Southwest Region.* Garden City, N.Y.: Doubleday and Natural History Press.

Marwitt, John P.
1970 Median Village and Fremont Culture Regional Variation. *University of Utah Anthropological Papers,* no. 95.

Mason, Otis T.
1904 Aboriginal American Basketry. *Report of the United States National Museum for 1901–1902:*171–548. Washington, D.C.: U.S. Government Printing Office.

Matthews, Washington.
1887 The Mountain Chant, A Navajo Ceremony. *5th Annual Report of the Bureau of American Ethnology for the Years 1883–1884:*379–467. Washington, D.C.: Smithsonian Institution.

Mauldin, Barbara.
1988 The Mural Paintings of the Mission of San Estevan Rey, Acoma Pueblo. M.A. thesis, University of New Mexico.

McAnany, Patricia.
1982 "LA 17360." In Prehistoric Adaptive Strategies in the Chaco Canyon Region, Northwestern New Mexico, vol. 2, Site Reports, ed. Alan H. Simmons, *Navajo Nation Papers in Anthropology,* no. 9. Window Rock, Ariz.: Navajo Nation Cultural Resource Management Program.

McGregor, John C.
1967 *Southwestern Archaeology.* Urbana: University of Illinois Press.

Michaelis, Helen.
1981 Willowsprings: A Hopi Petroglyph Site. *Journal of New World Archaeology* 4, no. 2:2–23.

Mindeleff, Cosmos.
1897 Cliff Ruins of Canyon de Chelly, Arizona. *Bureau of American Ethnology, 16th Annual Report for the Year 1894–95.* Washington, D.C.: Smithsonian Institution.

Mindeleff, Victor.
1891 A Study of Pueblo Architecture in Tusayan and Cibola. *Bureau of American Ethnology, 8th Annual Report for the Year 1886–1887.* Washington, D.C.: Smithsonian Institution.

Montgomery, R. G., Watson Smith, and J. O. Brew.
1949 Franciscan Awatovi. *Papers of the Peabody Museum of American Archaeology and Ethnology, Harvard University,* vol. 36.

Morgan, Lewis Henry.
1877 *Ancient Society.* Chicago: C. H. Kerr.

Morris, Earl H.

1919 Preliminary Account of the Antiquities of the Region between the Mancos and LaPlata Rivers in Southwestern Colorado. *Bureau of American Ethnology, 33rd Annual Report:*155–206. Washington, D.C.: Smithsonian Institution.

1924 Burials in the Aztec Ruin: the Aztec Ruin Annex. *Anthropological Papers of the American Museum of Natural History* (New York), vol. 26, pt. 33:139–226.

1928 Notes on Excavations in the Aztec Ruin. *Anthropological Papers of the American Museum of Natural History,* vol. 26, no. 5:259–420.

Morris, Earl H., and Robert F. Burgh.

1941 Anasazi Basketry, Basket Maker II through Pueblo III. *Carnegie Institution of Washington* (D.C.), *Publication* 533.

Nelson, Nels C.

1914 Pueblo Ruins of the Galisteo Basin, New Mexico. *American Museum of Natural History, Anthropological Papers,* vol. 15, part 1:1–124.

Nequatewa, Edmond.

1947 *The Truth of a Hopi.* Flagstaff: Northern Arizona Society of Science and Art.

Newcomb, W. W., Jr., and Forrest Kirkland.

1967 *The Rock Art of the Texas Indians.* Austin: University of Texas Press.

Nordenskiöld, Gustav.

1893 *The Cliff Dwellers of the Mesa Verde, Southwestern Colorado: Their Pottery and Implements,* trans. D. Lloyd Morgan. Stockholm: P. A. Norstedt and Soner.

O'Neale, Lila M.

1932 Yurok–Karok Basket Weavers. *University of California Publications in American Archaeology and Ethnology,* vol. 32, no. 1.

Ortiz, Alfonso, ed.

1972a *New Perspectives on the Pueblos.* Albuquerque: School of American Research and University of New Mexico Press.

1972b Ritual Drama and the Pueblo World. In *New Perspectives on the Pueblos,* ed. Alfonso Ortiz, 135–61. Albuquerque: School of American Research and University of New Mexico Press.

1973 *The Tewa World: Space, Time, Being and Becoming in a Pueblo Society.* Chicago: University of Chicago Press.

1979 *Handbook of North American Indians,* vol. 9, *Southwest.* Washington, D.C.: Smithsonian Institution.

Page, Jake, and Suzanne Page.

1982 Inside the Hopi Homeland. *National Geographic* 162, no. 5:602–29.

Panofsky, Erwin.

1955 *Meaning in the Visual Arts.* New York: Doubleday and Co., Anchor Books.

Parmentier, Richard J.

1979 The Pueblo Mythological Triangle: Poseyemu, Monte-
zuma, and Jesus. In *Handbook of North American Indians,* vol. 9, *Southwest,* ed. Alfonso Ortiz, 609–22. Washington, D.C.: Smithsonian Institution.

Parsons, Elsie Clews.

1932 Isleta, New Mexico. *Bureau of American Ethnology, 47th Annual Report for the Years 1929–1930:*193–466. Washington, D.C.: Smithsonian Institution.

1933 Some Aztec and Pueblo Parallels. *American Anthropologist* 35, no. 4:611–31.

1936 Introduction. In Hopi Journal of Alexander M. Stephen (2 vols.), ed. Elsie Clews Parsons, *Columbia University Contributions to Anthropology 23.* New York: Columbia University.

1962 Introduction. In Isleta Paintings, ed. Esther S. Goldfrank, 1–12. *Bureau of American Ethnology Bulletin 181.* Washington, D.C.: Smithsonian Institution.

Peckham, Barbara.

1981 Pueblo IV Murals at Mound 7. In *Contributions to Gran Quivera Archaeology, Publications in Archaeology 17,* ed. Alden C. Hayes, 15–38. Washington, D.C.: National Park Service.

Pepper, George H.

1905 Ceremonial Objects and Ornaments from Pueblo Bonito. *American Anthropologist* 7:183–97.

1920 Pueblo Bonito. *Anthropological Papers of the American Museum of Natural History,* vol. 27.

Plog, Fred.

1979 Prehistory: Western Anasazi. In *Handbook of North American Indians,* vol. 9, *Southwest,* ed. Alfonso Ortiz, 108–30. Washington, D.C.: Smithsonian Institution.

Plog, Stephen.

1980 *Stylistic Variations in Prehistoric Ceramics: Design Analysis in the American Southwest.* Cambridge: Cambridge University Press.

Plog, Stephen, and Shirley Powell, eds.

1984 *Papers on the Archaeology of Black Mesa Arizona,* vol. 2, Carbondale: Southern Illinois University Press.

Pond, Gordon G.

1966 A Painted Kiva Near Winslow, Arizona. *American Antiquity* 31, no. 4:555–58.

Poole, Roger.

1973 Introduction. In Claude Lévi-Strauss, *Totemism:*9–63. Harmondsworth, Middlesex, England: Penguin, University Books.

Powell, John Wesley.

1903 Report of the Director, Necrology. *Bureau of American Ethnology, 21st Annual Report, 1899–1900:*xxxv–xxxviii. Washington, D.C.: Smithsonian Institution.

Prince, L. Bradford.

1915 *Spanish Mission Churches of New Mexico.* Cedar Rapids, Iowa: Torch Press.

Prudden, T. Mitchell.

1914 The Circular Kivas of Small Ruins in the San Juan Watershed. *American Anthropologist* 16, no. 1:33–58.

Reagan, Albert B.
1906 Dances of the Jemez Pueblo Indians. *Kansas Academy of Sciences, Transactions,* 20, no. 2:241–72.
1914 *Don Diego, or the Pueblo Uprising in 1680.* New York: A. Harrington Co.
1917 The Jemez Indians. *El Palacio* 4, no. 2:25–72.

Reyman, Jonathan E.
1978 Pochteca Burials at Anasazi Sites? In *Across the Chichimec Sea: Essays in Honor of J. Charles Kelley,* ed. Carroll C. Riley and Basil C. Hedrick 242–59.

Riley, Carroll L.
1971 Early Spanish–Indian Communication in the Greater Southwest. *New Mexico Historical Review* 46:285–314.
1978 Pecos and Trade. In *Across the Chichimec Sea: Papers in Honor of J. Charles Kelley.* pp. 53–64. Carbondale: University of Southern Illinois Press.

Roberts, Frank H. H., Jr.
1932 The Village of the Great Kivas on the Zuni Reservation, New Mexico. *Bureau of American Ethnology, Bulletin:*111. Washington, D.C.: Smithsonian Institution.

Rubin, William, ed.
1984 *Primitivism* (2 vols.). New York: Museum of Modern Art.

Schaafsma, Polly.
1965 Kiva Murals from Pueblo del Encierro (LA 70). *El Palacio* 72:6–16.
1972 *Rock Art of New Mexico.* Santa Fe: State Planning Office.
1975 Rock Art in the Cochiti Reservoir District. *Museum of New Mexico Papers in Anthropology,* no. 16.
1980 *Indian Rock Art of the Southwest.* Albuquerque: School of American Research and Univeristy of New Mexico Press.

Schaafsma, Polly, and Curtis F. Schaafsma.
1974 Evidence for the Origins of the Pueblo Katchina Cult Suggested by Southwestern Rock Art. *American Antiquity* 39:535–45.

Schroeder, Albert H.
1972 Rio Grande Ethnohistory. In *New Perspectives on the Pueblos,* ed. Alfonso Ortiz. Albuquerque: School of American Research and University of New Mexico Press.
1979 Pueblos Abandoned in Historic Times. In *Handbook of North American Indians,* vol. 9, *Southwest,* ed. Alfonso Ortiz, 236–54. Washington, D.C.: Smithsonian Institution.

Silver, Constance S.
1982 The Mural Paintings from the Kiva at LA 17360: Report on Initial Treatment for their Preservation. In Prehistoric Adaptive Strategies in the Chaco Canyon Region, Northwestern New Mexico, vol. 2: Site Reports, ed. Alan H. Simmons, *Navajo Nation Papers in Anthropology,* no. 9. Window Rock, Ariz.: Navajo Nation Cultural Resource Management Program.

Simpson, James H.
1852 *Journal of a Military Reconnaissance from Santa Fe, New Mexico, to the Navajo Country.* Philadelphia: Lippincott, Grambo and Co.

Sims, Agnes.
1949 *San Cristóbal Petroglyphs.* Santa Fe: Southwest Editions.
1963 Rock Carvings, A Record of Folk History. In Bertha P. Dutton, *Sun Father's Way,* 215–20, Albuquerque: University of New Mexico Press.

Sinclair, John L.
1951 The Pueblo of Kuaua. *El Palacio* 58, no. 7:206–14.

Smith, Watson.
1952 Kiva Mural Decorations at Awatovi and Kawaika-a, with a Survey of other Wall Paintings in the Pueblo Southwest. *Papers of the Peabody Museum of Archaeology and Ethnology,* vol. 37. Cambridge, Mass.: Harvard University Press.

Sofaer, Anna, Volker Zinser, and Rolf Sinclair.
1979 A Unique Solar Marking Construct, *Science:*206:283–291.

Spencer, Herbert.
1885 *Principles of Sociology,* 3d ed. N.Y.: D. Appleton & Co.

Spier, Leslie.
1918 Notes on Some Little Colorado Ruins. *American Museum of Natural History, Anthropological Papers,* vol. 29, pt. 3.

Stanislawski, Michael B.
1979 Hopi–Tewa. In *Handbook of North American Indians,* vol. 9, *Southwest,* ed. Alfonso Ortiz, 587–602. Washington, D.C.: Smithsonian Institution.

Steen, Charles R.
1977 *Pajarito Plateau Archaeolgical Survey and Excavations LASL–77–4.* Los Alamos, N.M.: Los Alamos Scientific Laboratory of the University of California.

Stephen, Alexander M.
1936 Hopi Journal of Alexander M. Stephen, ed. Elsie Clews Parson, 2 vols., *Columbia University, Contributions to Anthropology,* vol. 23.

Stevenson, James.
1883 Illustrated Catalogue of the Collections Obtained from the Indians of New Mexico and Arizona in 1879. *Bureau of American Ethnology, 2nd Annual Report for the Years 1880–1881.* Washington, D.C.: Smithsonian Institution.

Stevenson, Matilda Coxe.
1887 The Religious Life of the Zuni Child. *Bureau of American Ethnology, 5th Annual Report for the Years 1883–1884:*533–55. Washington, D.C.: Smithsonian Institution.
1894 The Sia. *Bureau of American Ethnology, 11th Annual Report for the Years 1889–1890.* Washington, D.C.: Smithsonian Institution.
1904 The Zuni Indians. *Bureau of American Ethnology, 23rd Annual Report for the Years 1901–1902.* Washington, D.C.: Smithsonian Institution.

Stirling, Matthew W.
1942 Origin Myth of Acoma and Other Records. *Bureau of American Ethnology, Bulletin* 135. Washington, D.C.: Smithsonian Institution.

Talayesva, Don C.
1942 *Sun Chief: The Autobiography of a Hopi Indian,* ed. Leo Simmons. New Haven: Yale University Press.

Tedlock, Barbara.
1978 *Quiche Maya Divination: A Theory of Practice.* Ph.D. diss., State University of New York.

Tichy, Marjorie F.
1938 The Kivas of Pa-ako and Kuaua. *New Mexico Anthropologist* 2, nos. 4–5:71–80.

Titiev, Mischa.
1937 A Hopi Salt Expedition. *American Anthropologist* 39:244–58.

Varnedoe, Kirk.
1984 Contemporary Explorations. In *Primitivism,* ed. William Rubin, vol. 2:661–85, New York: Museum of Modern Art.

Villagra, Gaspar Pérez de.
1933 *History of New Mexico,* ed. and trans. Gilberto Espinosa. Los Angeles: Quivera Society.

Villagra Caleti, Agustín.
1971 Mural Painting in Central Mexico. In *Handbook of Middle American Indians,* vol. 10, pt. 1, ed. Gordon Eckholm and Ignasio Bernal, 135–56. Austin: University of Texas Press.

Vivian, R. Gordon.
1935 The Murals at Kuaua. *El Palacio* 38, nos. 21, 22, 23:113–19.

Vivian, R. Gwinn, Dulce N. Dodgen, and Gayle H. Hartman.
1978 Wooden Ritual Artifacts from Chaco Canyon, New Mexico. *Anthropological Papers of the University of Arizona,* no. 32. Tucson: University of Arizona Press.

Voll, Charles.
1961 *The Glaze Paint Ceramics of Pottery Mound.* Master's thesis, University of New Mexico.

Voth, Henry R.
1901 The Oraibi Powamu Ceremony. *Field Columbian Museum Publication 61, Anthropological Series,* vol. 3, no. 2.
1903 The Oraibi Oaqol Ceremony. *Field Columbian Museum, Publications 84, Anthropological Series,* vol. 6, no. 1.
1905 Traditions of the Hopi. *Field Museum of Natural History, Publications 96, Anthropological Series 8.*
1912 The Oraibi Marau Ceremony. *Field Museum of Natural History, Publication 156, Anthropological Series,* vol. 11, no. 1.

Wade, Edwin L., and Lea S. McChesney.
1980 *America's Great Lost Expedition: The Thomas Keam Collection of Hopi Pottery from the Second Hemenway Expedition 1890–1894.* Phoenix: Heard Museum.

Webb, William, and Robert A. Weinstein.
1973 *Dwellers at the Source.* New York: Grossman Publishers.

Weber, David J.
1985 *Richard H. Kern: Expeditionary Artist in the Far Southwest, 1848–1853.* Albuquerque: University of New Mexico Press.

Wellmann, Klaus.
1979 *A Survey of North American Rock Art.* Graz, Austria: Akademische Druck-u, Verlagsanstalt.

Wheat, Joe Ben.
1955 Mogollon Culture Prior to A.D. 1000. *Memoirs of the Society for American Archaeology* (Salt Lake City), no. 10.

White, Leslie A.
1932a The Acoma Indians. *Bureau of American Ethnology, 47th Annual Report for the Years 1929–1930:17–192.* Washington, D.C.: Smithsonian Institution.
1932b The Pueblo of San Felipe. *American Anthropological Association, Memoirs, no. 38:1–69.*
1935 The Pueblo of Santo Domingo, New Mexico. *American Anthropological Association Memoirs, no. 43:1–210.*
1942 The Pueblo of Santa Ana, New Mexico. *American Anthropological Association Memoirs, no. 60:1–360.*
1962 The Pueblo of Sia, New Mexico. *Bureau of American Ethnology Bulletin 184.* Washington, D.C.: Smithsonian Institution.

Willey, Gordon R., and Jeremy A. Sabloff.
1980 *A History of American Archaeology.* San Francisco: W. H. Freeman and Co.

Williamson, Ray A.
1984 *Living the Sky.* Boston: Houghton Mifflin Co.

Wilson, Lucy W. W.
1917 This Year's Work at Otowi. *El Palacio* 4, no. 4:87.
1918a Hand Sign or Avanyu. *American Anthropologist* 20, no. 3:310–17.
1918b Three Years' Work at Otowi. *El Palacio* 5, no. 18:290–94.

Woodbury, Richard B.
1956 The Antecedents of Zuni Culture. *Transactions of the New York Academy of Sciences,* 2d series, vol. 18, no. 6:557–63.
1979 Prehistory: Introduction. In *Handbook of North American Indians,* vol. 9, *Southwest,* ed. Alfonso Ortiz, 22–30. Washington, D.C.: Smithsonian Institution.

Wright, Barton.
1973 *Kachinas: A Hopi Artist's Documentary.* Flagstaff, Ariz.: Northland Press.
1976 *Pueblo Shields: From the Fred Harvey Fine Arts Collection.* Phoenix: Heard Museum.
1979 *Hopi Material Culture: Artifacts Gathered by H. R. Voth in the Fred Harvey Collection.* Flagstaff, Ariz.: Northland Press.

Wroth, Will.
1982 *Christian Images in Hispanic New Mexico.* Colorado Springs: Taylor Museum.

Yava, Albert.

1978 *Big Falling Snow: A Tewa–Hopi Indian's Life and Times and the History and Traditions of His People,* ed. and annotated by Harold Courlander. Albuquerque: University of New Mexico Press.

Young, M. Jane.

1985 Images of Power and the Power of Images: the Significance of Rock Art for Contemporary Zunis. *Journal of American Folklore* 98, no. 387:3–48.

1988 *Signs from the Ancestors: Zuni Cultural Symbolism and Perceptions of Rock Art.* Albuquerque: University of New Mexico Press.

Young, M. Jane, and Nancy L. Bartman.

1981 *Rock Art of the Zuni–Cibola Region.* Philadelphia: Pueblo of Zuni.

Zarate Salmeron, Fray Geronimode.

1962 Relaciones de Todas las Cosas que en el Nuevo México se han visto y sabido asi por mar como por tierra, desde el año 1538 hasta el de 1626. In *Documentos para la historia México.* Madrid: José Porrua Turanzas.

Index

Abert, J. W., 4

Abo Painted Rocks, 116; form and subject of petroglyphs at, 116–22. *See also* Open-air sites; Pictographs; Rock art. *Illustration, Plate 30*

Acoma Pueblo: access to religious ceremonies at, 9; early account of wall paintings at, 99; wall paintings in San Esteban Mission at, 147–49; first kiva at, 157–58

Altars, 158–64. *See also* Form and content. *Illustrations, 9, 155–57, 159–61; Plates 37–38, 40*

Anasazi: defined, 17; regional distribution of, 26; painted objects, 27–28, 47–51; painted pottery, 28–34, 51, 53–54, 57, 95–96; rock art, 36–37, 68–77; pictorial styles, 41–42; influence of, on neighboring peoples, 45–47; mural painting, 57–68; Pueblo IV dispersals of, 81–82. *See also* Architectural forms; Form and content; History and iconography; Rock art

Anglo-American expeditions, 4

Anthropology and studies of art, 15–16

Archaeological expeditions, 5–6

Archaic period, 8, 21–25. *See also* Barrier Canyon Anthropomorphic Style; Pecos River Style

Architectural forms, 53–54. *See also* Form and content. *Illustrations, 46, 55, 85, 87–88*

Art: character of Pueblo, 1–3; Pueblo, in Catholic mission churches, 9; as artifact (1800–1900), 9–12; anthropological study of, 15–16; preagricultural, 21–25; early village life and, 25–27. *See also* Catholic church

Art history: creating, 1–3; twentieth-century redefinitions in, 12–17; procedural issues in, 17–19; metamorphosis and transformation in, 176–77. *See also* History and iconography

Atsinna, murals at, 66–67, 104

Awatovi, murals at, 16. *See also* Mamzrautu curing society; Oa'quol Women's Society

Aztec Pueblo: painted grave goods at, 48; wall paintings at, 65

Bancroft, H. H., 6

Bandelier, Adolph, 6

Barrier Canyon Anthropomorphic Style, 23, 40–41. *See also* San Juan Anthropomorphic Style

Basketmaker II, 8; village sites, 25–27; rock art, 40–41. *See also* San Juan Anthropomorphic Style

Basketmaker III, 27; rock art, 36

Baumann, Gustave, 129

Bc 51, wall painting at, 59

Betatakin, rock art at, 48, 50

Bourke, John G., 10, 140–41, 145, 147

Bunzel, Ruth, 15

Cañon de Chelly, murals at, 65

Casa Rinconada, kiva at, 51

Casas Grandes: influence of, on pottery painting, 57; influence of, on Mogollon rock art, 76; decline of, 84

Casteñada, Pedro de, 4

Catholic church, wall paintings and, 140, 147–49. *See also* Franciscans; History and iconography; Spaniards. *Illustrations, 10, 89*

Cézanne, Paul, 12–13

Chaco Canyon, 4, 45; architecture at, 53; mural paintings at, 59, 63–64; rock art at, 69. *See also* Bc 51; Casa Rinconada; Chetro Ketl; LA 17360; Pueblo Bonito; Tseh-So

Chetro Ketl: painted objects at, 47, 50; wall painting at, 64

Coronado, Francisco Vásquz de, 3–4, 84–85

Coronado State Monument. *See* Kuaua

Cummings, Byron, 6

Cushing, Frank Hamilton, 5–6

Design systems, 41–42. *See also* Form and content; Painted objects; Painted pottery; Rock art

Dry paintings, 164–65. *See also* Ephemeral art and ritual structures. *Illustrations, 163–64*

Dutton, Bertha, 16–17

Emory, William H., 4

Ephemeral art and ritual structures, 154–64. *See also* Wall paintings